PERFORMING IRITY

Performing Interdisciplinarity proposes new ways of engaging with performance as it crosses, collides with, integrates and/or disturbs other disciplinary concerns. From Activism and Political Philosophy to Cognitive Science and Forensics, each chapter explores the relationships between performance and another discipline.

Including cross-chapter discussions which address the intersections between fields, *Performing Interdisciplinarity* truly examines the making of meaning across disciplinary conventions. This is a volume for performance practitioners and scholars who are living, learning, writing, teaching, making and thinking at the edges of their specialisms.

Experience Bryon, PhD, is a performance practitioner and Senior Lecturer at the Royal Central School of Speech and Drama. She specialises in Practice as Research, interdisciplinary performance practice(s), physical/vocal praxis, and performance as it engages across disciplines. She is also author of *Integrative Performance: Practice and Theory for the Interdisciplinary Performer* (Routledge 2014).

PERFORMING INTERDISCIPLINARITY

Working Across Disciplinary
Boundaries Through an
Active Aesthetic

Edited by Experience Bryon

Routledge
Taylor & Francis Group

LONDON AND NEW YORK

First published 2018
by Routledge
2 Park Square, Milton Park, Abingdon, Oxon, OX14 4RN

and by Routledge
711 Third Avenue, New York, NY 10017

Routledge is an imprint of the Taylor & Francis Group, an informa business

British Library Cataloguing-in-Publication Data
A catalogue record for this book is available from the British Library

Library of Congress Cataloging-in-Publication Data
Names: Bryon, Experience, editor.
Title: Performing interdisciplinarity : working across disciplinary
boundaries through an active aesthetic / [edited by] Experience Bryon.
Description: New York : Routledge, 2017. | Includes index.
Identifiers: LCCN 2017023872| ISBN 9781138678842 (hardback) | ISBN
9781138678859 (pbk.) | ISBN 9781315558639 (ebook)
Subjects: LCSH: Performing arts--Philosophy. | Theater--Philosophy.
Classification: LCC PN1584 .P47 2017 | DDC 791--dc23
LC record available at https://lccn.loc.gov/2017023872

ISBN: 978-1138-67884-2 (hbk)
ISBN: 978-1138-67885-9 (pbk)
ISBN: 978-1315-55863-9 (ebk)

Typeset in Bembo
by Saxon Graphics Ltd, Derby

CONTENTS

CONTRIBUTORS

Antonia (Tania) Batzoglou, PhD, is an actor, performance artist, storyteller, lecturer and a drama movement therapist. She works and teaches across different genres merging personal stories and collective myths, movement, multiple senses and artifacts.

Experience Bryon, PhD, is a performance practitioner and Senior Lecturer at the Royal Central School of Speech and Drama. She specialises in Practice as Research, interdisciplinary performance practice(s), physical/vocal praxis, and performance as it engages across disciplines. She is also author of *Integrative Performance: Practice and Theory for the Interdisciplinary Performer* (Routledge 2014).

Selina Busby, PhD, is Principal Lecturer in Community Performance and Applied Theatre, and course leader for the MA Applied Theatre at Royal Central School of Speech and Drama, University of London. She is an applied theatre practitioner who works in prison settings and with young people both in the UK and internationally. Her research focuses on theatre that invites the possibility of change, both through contemporary plays and participatory performance.

Luis Campos, PhD, is an artist, a lecturer and a researcher. He lectures in European Theatre Arts at Rose Bruford College of Theatre and Performance. His research interests focus on the intersections between performance and philosophy, installation art and photography. He also researches contemporary modes of staging in European theatre practices, particularly the use of intermedial dramaturgies and the cross-pollinations between dance and theatre.

Rachel Cockburn, PhD, is a researcher, artist and teacher based in London, UK. Her research is situated within the field of performance philosophy, specifically the intersection of philosophy, political theory and performance practice. She holds a PhD (2015) from the University of London.

Jessica Hartley, PhD, is a Lecturer in Theatre and Performance Studies at the Royal Central School of Speech and Drama. Primarily involved in teaching pedagogy, she can also be found advising on risky projects in circus and actor training.

Deirdre Mclaughlin is a PhD candidate in Acting and Cognitive Science at The Royal Central School of Speech and Drama, University of London, the Director of the MA Acting programme at Arts Educational Schools, and a founding member of the Embodied Cognition, Acting and Performance Symposium at AISB (The Society for the Study of Artificial Intelligence and the Simulation of Behaviour).

Nando Messias, PhD, is a performance artist based in London. He received his PhD in queer theory and performance from The Royal Central School of Speech and Drama. His research focuses on the sissy body and social violence.

Joanne Scott, PhD, is an intermedial practitioner-researcher and Lecturer in Performance at the University of Salford. She is the author of Intermedial Praxis and Practice as Research (2016) and is currently working on a practice-as-research project, exploring the intersections of her intermedial practice with issues of heritage, tradition and regeneration in her adopted home of Salford, in Greater Manchester.

Konstantinos Thomaidis, PhD, is Lecturer in Drama, Theatre and Performance at the University of Exeter. He is joint founder of the Centre of Interdisciplinary Voice Studies and founding co-editor of the Journal of Interdisciplinary Voice Studies and the Routledge Voice Studies book series. His latest book is *Theatre & Voice*, (2017).

ACKNOWLEDGEMENTS

Routledge has been wonderfully supportive of this project, especially Kate Edwards and Ben Piggott. Without the insightful conversations and helpful suggestions of Alix Atwell, Al Byrne, Lior Lerman, Farokh Soltani-Shirazi this would not have been so much fun. Abigail Darton, our preparation editor, and Robert Wilkes helping with the proofs, were wonderful at spotting those pesky errors that we authors tend to make. David Wolfson served lovingly again as my comma police, and of course my dear husband and diagram designer Paul Zacharek put up with yet another project. Thanks so much to you all.

FOREWORD

Claire Colebrook

The twenty-first century is the century of the performative. Whatever else one may notice about the transition from the twentieth to the twenty-first centuries, which would include the increasing awareness of climate change, the escalation of terrorism and a widespread sense of imposed globalism, one thing that ties all these events together is a new relationship between life and performance. One might sum this up by saying that rather than living beings who *then* happen to act, there are actions from which living bodies emerge. One might go further and refer to these actions as *performance* precisely because rather than being governed by function, life is overwhelmingly a milieu of display, play and simulation (Grosz 2008).

In its twentieth-century articulation, the philosophical concept of the performative established a new conception of meaning, and with it a new way to think about relations among humans (Austin 1962). The performative is a speech act: to utter a performative is not to convey information, nor is it to reason or calculate. A performative brings a state of affairs into being: 'I now pronounce you man and wife,' 'I declare the games open', or 'You are now a citizen of the United States.' The concept of the performative did not only add another type of linguistic event. It opened up a new way of thinking about all language. Perhaps language is best thought of as performative in general. Even when we seem to be conveying information, we are doing things and bringing about states of affairs. To say, for example, that 'all lives matter', is not really a claim about the significance of life; it is more like a move in a game, or a placard (Deleuze and Guattari 1987: 361). It's not the content of what one says that has force, but the relations among utterances and bodies that brings about (and changes) a world. One can imagine, for example, that the slogan 'all lives matter' might very well have been the speech act deployed by black Americans to object to the killing of unarmed black men; but the claim that 'all lives matter' was used in counterpoint to 'black lives matter'. To say that

language is performative in general is to insist upon speaking as a form of doing that only makes sense in a world of social action. In the twentieth century, the performative was a way of tidying up our way of thinking about language; it's not that I have an idea or mental content and use language as some sort of vehicle to convey information, but rather that to live and speak is to be a part of a world of accepted gestures and expectations. The phrase 'I'm sorry', for example, could allow one to avoid violence if I have lightly bumped into you on the subway; it could just as easily be used to intensify conflict if I use it in response to your claim that black lives matter: 'I'm sorry?' In neither case am I conveying information. I am doing something that relies upon, maintains and disturbs forces.

Insofar as the twentieth century saw the emergence and waning of modernism and post-modernism it was a century that desperately resisted full-blown performativity. The high European modernists mourned a world that had become so many circulating sounds, images and copies – desperately attempting to retrieve the meaning and origin of language; postmodernism, for all its parody and simulation, nevertheless presented the world of the merely performative as an empty and ruthlessly capitalist world. Late capitalism, sadly, is a world in which anything can be detached from its meaning, its intent, its function, and become nothing more than a commodity. And to buy and display such commodities is performative: wearing Nike, Prada or refusing identifiable brands is a move in a game, a marking of territory, a way of creating and reconfiguring values and attachments. If all that is so, why would I still claim that this century, and not the last is the truly performative era? Surely the real has returned with a vengeance? The world is not a human construct, and events such as climate change, the destitution of refugees, global financial kleptocracies, and resource depletion are all too real and all too resistant to our world of meanings and values. Yet here is where the concept of the performative needs to be intensified and released from the mournful relation it retained to the world and meaning.

The twentieth century was a performative still bound to the world, and still disciplined. In its original conception the 'felicitous' performative required a context. It's not only the case that 'I pronounce you man and wife' can only work if the phrase is uttered in a ceremony by an appropriate authority (and not in a play or other quotation); it's also the case that broader conceptions of the performative relied on formed and normative structures of recognition. Perhaps the most significant transformation of the performative was Judith Butler's critique of the sex/gender distinction (Butler 1990). It's not that we are born with a biological sex and then behave in certain ways. Rather, in the beginning is the doing or performing from which one assumes that there must have been a sexuality that was the cause or origin of the doing. While Butler was directing her argument against notions of a real/natural/original world that is then constructed in a certain way, and while the focus of her work was on the necessary instability of the performative – or the ways in which repeating a norm would also create unmanageable and unpredictable differences – the last decades of the twentieth-century increasingly confirmed her insistence upon recognition. To be a self requires a world of

recognition: in order to be able to say 'I' one does not simply need to speak and act, but to be recognised by others as taking part in a relatively stable structure of norms. One can challenge, distort, disturb and refuse the normative relations of one's milieu, but to refuse a norm, or to act otherwise, is nevertheless still a gesture that only makes sense *in relation* to an already distributed field of forces and powers.

Beyond Butler's work one might note an even broader uptake of the primacy of relations, *and* the performative nature of those relations. To be a self is not to be an isolated body or mind that then somehow comes to know the world; in the beginning is the 'doing' – a movement that creates a body in relation to world. From infants whose tongues, hands and eyes become organs that make up a self only through tasting, touching and seeing, to microbes and rocks that have the form that they do in relation to a cosmos of forces, it is possible to regard life as such as performance. There are not beings who act, and there is not a world that is populated by actors; there are actings and doings *from which* something like a world is composed, but always a world in motion. Karen Barad has referred to this as 'agential realism' (Barad 2007). The *world* then is not an organism, a relatively closed whole where all parts interact to maintain ongoing life and stability. Life is performativity: not a noun but a verb, and not a verb that proceeds from a subject, and not an act that proceeds from an agent. Rather, there is life as interaction, relation and ongoing composition that generates a world; the world, then, is not some static object that precedes actions but is a horizon of expectations or meanings.

In the original theory of the performative, one utters a phrase in order to achieve a certain end; the expectation of what language will do relies upon an assumption of relative stability, and the anticipation of an ongoing context of shared anticipations and norms. As the theory of the performative develops it is not only language that is explained in terms of shared and repeatable practices, but all life. To be able to say 'I' is to act, move, speak and feel in a way that has a certain repeatable stability over time; to *be* anything at all is to be nothing more than a pattern, rhythm or refrain of responses. If life is nothing other than its doing or performing, and if there is no doer behind the deed, there is nevertheless a world: a performative never occurs in isolation, but always as a singular aspect of a horizon of expectations and responses. In this respect, one would need to contrast the classical concept of performance with the modern conception of the performative. A virtuoso performance proceeds from an artist whose skill and learning precedes and commands the activity. In the famous definition offered by Flaubert, an artist is God-like – always 'above and beyond' his creation, a point of stillness and integrity that is distinct from the work (Flaubert 1980). By contrast, in the performative, there is neither distinct artwork that remains the same through time, still in a gallery or grand tradition of great work, nor artist whose signature, intent and mastery govern the ongoing sense and value of what is created. Just as the performative composes and is inextricably tied to a sense of world (or ongoing, meaningful, responsive relations), so classical performance was other-worldly – with the genius artist, performer or auteur always distanced from the grubby world of reception, markets and commodities. More importantly, classical performance

was *disciplined*. Going back to Kant's theory of beauty and sublimity that would be so important for Romantic and modernist aesthetics, a certain *purposiveness without purpose* was required for a genuine aesthetic experience. One might think here of high modernist art: one would experience colour as such, sound as such, the pure saying of language, without these purely formal events ever being reducible to something as functional as communication. If such works were in communication with other arts or disciplines they were so only to intensify autonomy. A poem might be likened to an urn, standing apart and self-contained, or a poem might use the figure of a dancer, but still to signal that poetic language was *not* caught up in a world of communications.

The performative in its twentieth-century mode – as I have already suggested – is in part a liberation from classical conceptions of the autonomy and discipline of performance: both as a speech act, and as a more general conception of the way in which lives, bodies and events unfold, the performative was a relational and dynamic concept. What something *is* does not lie in a preceding essence or identity, but in an ongoing repetition that occurs in a horizon of recognition, anticipation and retention. For Judith Butler it is this iterability combined with recognition that gives the performative revolutionary power: to be a self or body is to perform some type of recognisable norm, and yet in that very repetition norms can be destabilised and transformed to new forms of recognition. For all its radical and revolutionary potential the performative is still disciplined and worldly: to be is to do, but always in relation to a relatively stable horizon of expectations and recognition.

What might it mean to think of performativity beyond the world and in a distinctly *undisciplined* manner? Rather than think of disciplines encountering each other to combine expertise or to share information, *performing interdisciplinarity* generates relations from active encounters. Rather than combining skills and techniques, the emphasis on performativity opens an experimental space that rises to the challenge of twenty-first-century horizons. In an era where knowledge and expertise become ever-more refined, generating new disciplines honed to the threats of climate change, terrorism, resource depletion and injustice; in an era of think-tanks, policy centres and databases; and in an era of unprecedented knowledge-sharing, communication, dissemination and surveillance, there appears to be very little *doing* in terms of what matters. We know, only too well, about the disasters that may befall us, and yet increasingly the distribution of power, resources and life remains the same. To perform interdisciplinarity would require a singular *not-knowing* and *not-being*, an experimental undoing of all the securities and recognitions by which we live. What might it mean to abandon recognition and normativity, to *do* beyond the thinking and logic of the disciplined self? Such questions cannot be posed in the standard discourses and practices of the arts and humanities, but demand a certain undoing that the essays in this volume embark upon, with all the risk, chaos and misrecognition that the *world* refuses.

In *What is Philosophy?* Gilles Deleuze and Felix Guattari draw a contrast between active and passive vitalism:

Vitalism has always had two possible interpretations: that of an Idea that acts, but is not-that acts therefore only from the point of view of an external cerebral knowledge (from Kant to Claude Bernard); or that of a force that is but does not act – that is therefore a pure internal Awareness (from Leibniz to Ruyer). If the second interpretation seems to us to be imperative it is because the contraction that preserves is always in a state of detachment in relation to action or even to movement and appears as a contemplation without knowledge. This can be seen even in the cerebral domain par excellence of apprenticeship or the formation of habits: although everything seems to take place by active connections and progressive integrations, from one test to another, the tests or cases, the occurrences, must, as Hume showed, be contracted in a contemplating 'imagination' while remaining distinct in relation to actions and to knowledge. Even when one is a rat, it is through contemplation that one 'contracts' a habit. It is still necessary to discover, beneath the noise of actions, those internal creative sensations or those silent contemplations that bear witness to a brain.

Deleuze and Guattari 1994: 213

The standard conception of the performative is thoroughly in tune with an active vitalism: speaking, moving, gesturing, writing, acting, singing or dancing would be ways in which something like life furthered and sustained itself. A self comes into being through doing, and doing is grounded on life's maximisation. One might think here of all the late twentieth- and early twenty-first-century work that explains all forms of art, from narratives to landscapes, as methods for survival (Boyd 2009; Dutton 2009). If, in modernism, the art work was the result of an other-worldly discipline that commanded form from on high, twenty-first-century theories of evolution and art ground the artwork in the broader impulse of human survival. In both cases, though, the work is an effect of a life that seeks to master and sustain itself. A self or living being would be nothing more than its decisions, and art would both be a way in which life sustained and maximised itself and would be aligned with a *pure* mastery such that the artist would be *nothing* other than the controlling or creative force behind a work. Throughout *What is Philosophy?* Deleuze and Guattari not only develop a passive vitalism of 'a force that is but does not act-that is therefore a pure internal Awareness', they also do so by way of an active aesthetic. If the performative is tied to an active vitalism where there is no self other than the actions that bring into being – God-like, and with a pure self-generating power – then active aesthetics is tied to a passive vitalism. Here, there are not pure actions that bring a self into being but sensations, becomings, forces that *in their undisciplined activity* are generative of the patterns, rhythms or habits that compose life. In this respect a certain type of aesthetic *activism* is at odds with the active vitalism of the performative. If one elevates the performer, as did high modernism, then the materials and sensations of artworks are nothing more than the medium through which the pure power of formation is brought to the fore, with the aim of art being a reactivation of the elevated and

cerebral subject. Interdisciplinary practices and active aesthetics abandon the purity, discipline and haughty elevation of the artist subject to allow the forces, matters, sensations and qualities to enter into unpredictable relations. By coupling activism with aesthetics rather than life, activity is no longer in the service of some pre-given value (life, humanity, survival); rather, the aesthetic bears its own power and in doing so generates forces and powers irreducible to the disciplined master performer. One might conclude (and begin) by suggesting that in the beginning is the aesthetic, but this is not to say that in the beginning is the artist, or the artwork or even life; it *is* to say that in the beginning is a multiple or relation from which the relative stability of artworks and artists emerge.

References

Austin, J. L. (1962) *How to Do Things with Words*. Oxford: Clarendon Press.

Barad, K. (2007) *Meeting the Universe Halfway*. Durham, NC: Duke University Press.

Boyd, B. (2009) *On the Origin of Stories*. Cambridge, MA: Harvard University Press.

Butler, J. (1990) *Gender Trouble*. London: Routledge.

Deleuze, G. and Guattari, F. (1987) *A Thousand Plateaus*. (Trans. Massumi, B.) Minneapolis, MN: University of Minnesota Press.

Deleuze, G. and Guattari, F. (1994) *What is Philosophy?* (Trans. Tomlinson, H. and Burchell, G.) New York: Columbia University Press.

Dutton, D. (2009) *The Art Instinct: Beauty, Pleasure, and Human Evolution*. London: Bloomsbury.

Flaubert, G. (1980) *The Letters of Gustave Flaubert: 1830–1857*. (Trans. Steegmuller, F.) Cambridge, MA: Belknap Press.

Grosz, E. (2008) *Chaos, Territory, Art: Deleuze and the Framing of the Earth*. New York: Columbia University Press.

INTRODUCTION

Experience Bryon

This volume explores the problematic of interdisciplinarity when one of the disciplines lies within the purview of performance. It is for performance practitioners and scholars who are living, learning, writing, teaching, making and thinking at the edges of their specialism(s). It is also for those wishing to harness *practice*, as a way of doing, to activate and interrogate knowledge. In this book you will find a new way of engaging with performance as it intersects, collides and/or integrates across disciplinary boundaries.

Through the *active aesthetic*, an analytical conceptual model deriving from performance practice, the problematic nature of knowledge is reconsidered as an act of *knowledging* – a concept intrinsically valuing process and practice as generators of knowledge and further as interrogators of a process of knowledge exchange and capture.

The book is organised into two parts, with the first being an extended critical history of disciplinarity. It explores the ways in which practice and process have been systematically delegitimised for centuries starting with Antiquity, through the Middle Ages to the very formation of scholarly institutions. This compromising situation was embedded in the establishment of a formal account of science, through the explosion of the interdisciplines under the general umbrella of social constructivism, within the discussions around the 'science wars', ironically within the subject specialism called 'Performance Studies', and finally even within select discourses around Practice as/and/based/led Research in the arts. In parallel to the critical history, Part I introduces the *active aesthetic* as a concept which, while embracing a space of epistemological pluralism with a recognition of multiple ways of knowing, in line with many of the treatises on interdisciplinarity, differs from many in that it does not aim to integrate or arrive at a type of democratic, utopian epistemology. In fact, at its core is the embracing of conflict, the rubs and collisions that occur in the engagement across disciplines. Importantly too, rather than being

designed as an advocate for the performance-practitioner/researcher helping to validate practice within the unfolding story of disciplinarity, it offers an approach of enquiry born *from* performing practice for possible application across other disciplines.

This introductory chapter argues that the knowledge of any discipline does not reside in the object of that discipline, nor does it reside in its crafts/faculties/texts/ departments/methods/techniques/evaluations, but rather in the *practises* of its practice(s). Since what one actually does one actually gets good at, the ways in which people actually practice within a discipline largely determine the qualities and rigour of that disciplinary movement at any one time. Any discipline's rigour, in this way, lives within its own *active aesthetic* as it *practises* its knowledge.

Part II includes nine chapters, each titled with a 'problematic word' serving as a fulcrum between performance and another discipline. The word is chosen because it sits within a field of performance in one way and in the other discipline in another; and, significantly, as the two disciplines engage with each other the word is transmuted into yet another thing. Each contributor is an expert in their field, working across disciplinary boundaries with a specialism in a *practice*, which interestingly, in its activation often reconfigures what we even mean by the term 'performance'.

There has been no attempt to homogenise the language or style between these chapters. As the editor of this project, I have made every effort to allow the expressions of language, the ways of entering into the discussions, and the architecture of the arguments within the chapters to stay within the thought styles of the authors and their (inter)disciplines. The nine chapters explore relationships between Performance and the Digital, Installation Art, Social Geography, Pedagogy, Cognitive Science, Psychology, Activism, Political Philosophy and Forensics, through the problematic words virtual, mediation, utopia, role, embodiment, story, visibility, 'the subject' and voice.

At the end of each chapter, this book contains something a little unusual: cross-chapter discussions. The authors leave their interdisciplinary spheres to visit another's, sharing in an informal discussion with another chapter author, adding a further layer to the inter/transdisciplinary nexus. These offer samples of interdisciplinary exchanges activating the very issues that the volume speaks about. Again, these have not been altered or edited to create consistency in tone or conversational style, as the ways in which these disciplines cross and their distinct modes of discourse help to reveal the nature of the interdisciplinary dynamic. Here we explore what happens when different thought styles, sets of vocabularies, skills and methodologies struggle to engage across the boundaries of disciplinarity, interdisciplinarity and in some cases transdisciplinarity.

Joanne Scott, through the term **virtual**, addresses and problematises discipline-specific formulations and understandings of virtuality in digital culture and performance, turning to moments of live media practice to witness the virtualities that emerge there, which are multiple, hybrid, powerful and active. She reveals the ways in which the digital as a *prescribed* text collaborates with the performer's *way[s]*

of doing and other *doings* in live media performance events, and is made anew within this process, generating fresh meanings, affects and possibilities.

Luis Campos' **mediation** exposes the problematics of a traditional understanding of mediality in relation to the colliding boundaries between installation art and theatrical performance. It coins the term *installative performance* as a platform to explore mediality within a constructivist reading of epistemology and pays full attention to the conditions of emergence of medial experiences, particularly in relation to the binary between work of art and human subject.

Selina Busby shifts the conversation with her chapter, **utopia**, which explores the notion of theatre and change by discussing the concepts of applied theatre, social geography and a pedagogy of utopia, attempting to find *the middle field* in participatory drama.

The following chapter, by Jessica Hartley, turns to pedagogy, dancing with the notion of power within pedagogic discourse through engagement with the term **role** to reveal the complex and imprecated cultural narratives that proliferate the divisions between teacher and student.

Deirdre Mclaughlin's chapter utilises popular conceptions of **embodiment** from actor training alongside theoretical contributions from embodied cognition to problematise how one might approach the doing of embodiment within the framework of an active aesthetic. Within the chapter metaphors are offered as a tool towards a living language of the mind while serving as building blocks of action, perception and cognition within, between and beyond both fields of research and practice.

In Antonia Batzoglou's chapter, the term **story** is explored and witnessed as it emerges between the disciplines of performance practice and psychology. This active and dynamic process is referred to as *storying* and acknowledges meaning as it emerges from self-manifestation and the intangible qualities of being and doing.

Nando Messias writes about his piece *The Sissy's Progress*, which lives between performance and activism, problematising the word **visibility**. He describes his process of imagining as he selects the music, explores movement, dreams up costumes and organises these elements in what appears to him as an ordinary creative process. When conceiving the piece, he had not set out for it to take on the social dimension it has since he began performing it. However, the process of developing the performance, taking it out onto the streets and unleashing it into the world has interestingly led him down a path toward *performance actuated activism*. He shares that rather than merely demonstrating, the practice of the performance activates the social dynamics of queer living.

Rachel Cockburn's chapter, '*the subject*' engages and practises the practice of the *scholar subject*, and the necessary struggle with/within disciplinary authority/authorship.

Finally, Konstantinos Thomaidis's chapter **voice** activates an interdisciplinary encounter between performance studies and audio forensics. The aim is to destabilise preconceived methodologies of voice reception and problematise analyses of voice premised on voice as sign and/or object.

PART I

active aesthetic

Knowledge Performing

Experience Bryon

> The episteme is not a general developmental stage of reason, it is a complex relationship of successive displacements.
>
> *Foucault 1991: 55*

This book is an object made of paper and ink, or, if you are reading this online, it could be reduced to a series of 1s and 0s. However, if you were to understand or capture the various knowledges that this book might offer – to explore it *actively*, as an *event*, with an embedded series of happenings, resistances, disturbances, actions, and possible emergent ideas, rather than as an object of knowledge, you would be more likely to *capture*, even briefly, some of the knowledge within it. You would be *actively* engaging with it as an *active* aesthetic, rather than arbitrarily looking at or possessing it as an aesthetic *object*. The *ways* in which we engage with books or other objects, artifacts or modes of documentation largely determine what we get from them. The ways in which objects engage with us may also make a difference; for instance, there is research that suggests that reading print rather than digital expressions offers different types of retrieval results (Mangen, Walgermo and Brønnick 2013). It is in the leaning into the idea of disciplinarity and knowledge as active and processual that we begin to understand the basis of the *active aesthetic* – and with this a slightly different way of *knowledging*.

When we engage with this book as more than a mere object of knowledge we may see there are things *happening* within the pages of it, various crosses, collisions and intertwinings *occurring* as nine practitioners/researchers who come from different fields of performance cross disciplinary boundaries to engage with other fields of study. At the end of each chapter, these authors further leave their interdisciplinary spheres to visit another's, sharing in informal discussions and grappling with some of the vocabularies and skillsets that emerged from their own interdisciplinary project while contributing a new layer of complexity to the inter/transdisciplinary nexus.

Before we go further, as this is a book partially about crossing disciplinary boundaries, it will be useful to briefly explore what *disciplinary-ness* even is: some of the ways in which it is enacted, how it has acted upon us, and how we have acted upon it throughout the centuries, including some of the ways we have organised, captured, evaluated, expressed and disseminated *knowledge*, a key currency of this problematic word – discipline.

Disciplinarity

It is not the point of this section to offer a new definition or a comprehensive history of the tricky concept we call discipline. There are many excellent ways to tell the story, each with its own merits and correlative agendas. Some of the finest can be found in: Klein 1990; Shumway and Messer-Davidow 1991; Messer-Davidow, Shumway and Sylvan 1993; Fuller 1993; Fuller and Collier 2004; Krishnan 2009; Gould 2011; Moran 2010; Weingart 2010 and Frodeman 2010 & 2014. This selective and brief reading of the story functions to highlight some of the instances that have made disciplinarity resistant to a conceptual and analytical framework such as the *active aesthetic* while at the same time primed for such a shift:

> Socially and conceptually, we are disciplined by our disciplines. First, they help produce our world. They specify the objects we can study (genes, deviant persons, classic texts) and the relations that obtain among them (mutation, criminality, canonicity). They provide criteria for our knowledge (truth, significance, impact) and the methods (quantification, interpretation, analysis) that regulate our access to it.
>
> *Messer-Davidow, Shumway and Sylvan 1993: vii*

If we agree with this as a basic starting point, it does not take us much further to see how we both practice our disciplines and are likewise disciplined into our practices, and that perhaps disciplinarity is at its core a process – as suggested in the introductory quote, a *successive set of displacements* of the *ways* in which we organise and capture knowledge(s) or engage in an *act* of *Knowledging*. With this we can begin to look at disciplines not only as a set of categories of human knowledge, sometimes defined as 'a particular branch of learning or body of knowledge' (Moran 2010: 2), 'knowledge territories' (Krishnan 2009: 12), 'division of knowledge into units' (Frodeman 2014: 19) or 'branches of knowledge', but also as practices of 'generally accepted methods and truths' (Shumway and Messer-Davidow 1991: 202). Of course *truth* is always a problematic word, but when we consider, as imbedded in the concept of discipline, the parallel definition that speaks to issues of both punishment and order, we see how the vying for *truth* may be the defining practice of the concept of discipline as it is 'caught up in questions about the relationship between knowledge and power' (Moran 2010: 2). This was most famously articulated by Foucault as a practiced 'system of control in the production of discourse' (Foucault 1972: 224) and aptly interpreted as a 'process

aimed at limiting the freedom of individuals and as a way of constraining discourses' (Bridges 2006: 268).

All of these definitions and conceptual understandings become particularly interesting when we examine what happens when we actively engage *across disciplinary boundaries*. Metaphors of war are not unusual when discussing disciplinarity. So many writings on interdisciplinarity speak of 'turf wars' across 'territories', 'factions' and 'borders', with 'boundaries' defended by those 'entrenched' in their own disciplinary 'silos' or 'fiefdoms', 'fortified' by validating knowledge within their closed epistemological perspectives. There are also disciplinary 'revolutions' and 'migrations'. We will speak later about the 'science wars' as a pivotal turning point during the onset of postmodernism, and question whether a conceptual and analytical mechanism like the *active aesthetic* might have come sooner if there had been such a strange occurrence as 'performance practice wars'.

For now, however, as a counterproposal to metaphorically killing each other, in this chapter we explore how can we most effectively *capture*, document and/or comprehend knowledges that come from or emerge from the inter-relationships of different paradigms and thought styles (two terms that will be explored in more detail further on). What would a conceptual mechanism born of performance practice look like? Could it shake us from the kind of thought styles that rest on the martial metaphors towards more of an agonistic[1] epistemological pluralism that does not dilute or compromise rigour nor, as Lyotard warned about interdisciplinarity, erode disciplinary authority? (Lyotard 1984: 53)

Knowledge, its organisation, practice and capture, occurs across other cultural contexts and has existed since before antiquity, evidenced for instance as sophisticated chemistry in the practice of embalming and tools made of complex metal compositions, and also the geography and design of ancient maps. The following brief dip into Western disciplinary culture stays in the West largely because the *active aesthetic* was developed in response to and within this story as part of an interdisciplinary proposition across Western performance practice(s). (However, as we will learn later, the *active aesthetic*, when used with responsibility, can be applied across non-Western constructs too.)

Our Western notions of discipline start with the ancient Greeks, namely Plato and Aristotle. Where Plato framed philosophy as a force for unifying knowledge and its scholarly practice as a synthesiser for all branches of learning, Aristotle was the first to designate knowledge into categories and, importantly, also hierarchies of importance. His three intellectual virtues, *episteme, techne and phronesis*, set the stage for a series of separations. Where *episteme* can be aligned to theory, thinking, the understanding of a matter, or more generally knowledge, *techne* is more about the technical, technology, the practical, suggesting the act of making, skill, art and workmanship. *Phronesis*, a concept that goes beyond *episteme* and *techne*, is a hard concept to align to a discrete discipline or subject. It can translate to 'prudence' or 'practical wisdom', having to do with what is good and/or bad for mankind.[2] What is important is that there were divisions perpetrated and with this values placed on activities of knowledge. 'This first division of "philosophical" knowledge prepared

the way for the uncountable further divisions of knowledge into more and more specialised fields of science. The unity of knowledge was apparently lost irreversibly' (Krishnan 2009: 13).

The notion of unity with some grounding utopian communion among disciplinary knowledge(s) is not the goal of this book. Rather, the uncomfortable places, the friction, and the occurrences of obstacles encountered while engaging across disciplines are largely where I will later show that the *active aesthetic* helps us to witness and *capture* those chosen moments before the landing, the grounding and the naming of knowledge(s): a middle space, where I will argue that knowledge *happens* as an *act* of *practising*.

Aristotle's categorising, whether he quashed any hope for a unity of knowledge or not, did set us on the path towards exponential drilldowns of specialisms, with specialisms of specialisms being delineated along correlative vyings for power that set up a series of value distinctions. This, I will argue, remains with us as part of an ongoing prejudice against the *act* of *practice* as a *field* of knowledge generation, rather than a mere skill or activity of creativity and representation serving mostly within the bounds of hermeneutics:

> In *episteme*, the resolving power of the mind is stretched to the limit in the quest for truth. In *techne*, the ingenuity of the mind may be extended beyond the yield-point in the search for self-expression. Thus a major difference emerges, and with it the awareness that 'understanding' and 'workmanship' are, from this angle, incommensurable.
>
> *Rawlins 1950: 390; added emphasis*

With Aristotle, *episteme* came to represent a higher categorisation of subjects, with theology, mathematics, and physics more important than practical subjects such as ethics and politics, for instance. The lowest in the rung were attributed to the *techne* category, which included arts, poetics, and other activities of making, including engineering. As Moran points out, this categorisation was conflicted even back then, as he did not completely drop the Platonic meta-positioning of philosophy:

> [Aristotle] positioned *philosophy* as the universal field of inquiry which brought together all the different branches of learning, a notion of unity in difference which also influenced the formation of the disciplines within the modern university. As Aristotle's system makes clear, anxieties about the harmful specialization of knowledge are as old as the scholarly disciplines themselves.
>
> *Moran 2010: 4*

However, specialisation had been set on its way, plotting a path of a hierarchal development in which those aspects aligned with the Aristotelian category *techne* were consistently pushed down to a lower rung every time they began to climb in relevance. The Stoics (c.300BC), developing philosophy not so much as an intellectual pastime but rather as a form of 'practice or an exercise (*askêsis*) in the

expertise concerning what is beneficial' (Baltzly 2014: 4), overlapped with the Aristotelian view. The medieval *trivium* (grammar, rhetoric and dialectic) and *quadrivium* (arithmetic, geometry, astronomy and music) were born in the concept of the *artes liberals*, a system of knowledge that was thought to be the most comprehensive.

However, as Frodeman astutely reminds us, 'understanding "discipline" as merely a taxonomic or analytic category neglects historical, institutional, and political elements that are central to the concept' (2014: 19).

When we think about how knowledge exchanges are *enacted* in *practice* rather than situated as discipline, we get another take on the story. For instance, from the first university structure of education (circa 1088, Bologna) up until the eighteenth century, there were 'faculties'. They included the 'higher', comprising those of medicine, theology and law and a 'lower', comprising that of a combination of philosophy and humanities. Interestingly:

> Professors would cycle through these faculties across the course of their careers, moving from the lower faculty of philosophy to the three higher faculties. Such movement discouraged specialization and narrowly focused conversations and encouraged an orientation toward broad-based learning.
>
> *(Frodeman 2014: 20*

Important, also, is that the ways knowledge was evaluated and *captured* were distinctly different from our current labours of knowledge, which favour new knowledge evidenced through citation accumulation and research outputs and are judged against mercurial definitions of 'innovation' and 'impact'. In the first university structures:

> professors lectured (from the Latin *lectus*, past participle of *legere*, to read). This was in part a matter of technology: with books at a premium the oral transmission of knowledge was a necessity. The power of the church played an important role as well, in that professors were expected to promote a set of perennial truths – a *philosophia perennis* – rooted in religious orthodoxy.
>
> *Frodeman 2014: 20*

The act of *knowledging* as a practice was quite different. The *ways* of disseminating, learning, evaluating, and even processing knowledge had a different set of activities and executions. In the notebook of an English student learning in the middle of the seventeenth century we get an inkling of the divisions of subjects and the experience of their values in practice:

> The disciplines which dispose man toward understanding things are two-fold… directive and objective. The former was art and the latter, science. The arts were concerned with the ordering of activity, or the right conception of things to be made, whether these were liberal, involving solely the mind,

for example, logic, the 'making' of demonstrations, or the servile... which were... of two kinds: practical and fine, according as they were directed toward the production of the useful... or... the beautiful.

Costello 1958: 37–38

Here we get the beginnings of what will become entrenched for centuries, a notion that the practice of arts is aligned with action (*techne*) and the sciences are concerned with knowledge (*episteme*), with the later considered to be of a higher status.

In addition to the university structures, from the fourteenth to the eighteenth centuries there are many surviving letters showing substantial activity of knowledge exchange and production that lay outside formal learning institutions. Much of the primary activity happened within various societies and the culture of the salon and coffee house (Frodeman 2014 and Grafton 2009):

> Communication in the Republic of Letters was primarily carried out through letters, hundreds of thousands of which survive to this day. And while such letters would certainly announce the latest scientific discoveries in, for example, optics or mathematics, this system of communication was not constituted along disciplinary lines.
>
> *Frodeman 2014: 21*

These types of interdisciplinary exchanges were many. However, for the purposes of this book, which speaks to how performance works across disciplinary boundaries, the example of how opera was born seems particularly apt.

Operatic history traditionally begins with the theories and musical innovations developed and debated by the Camerata, a Florentine group of scholars, scientists and musicians, from which many letters and journals survive. The majority of the meetings were held at the home of Giovanni Bardi (1534–1612) and were attended by such figures as Vincenzo Galilei (father of the famous astronomer and physicist), Giulio Caccini (1545–1618) (a well-known singer and composer), Jacopo Peri (1561–1633) (credited by many with the composition of the first opera), Ottavio Rinuccini (1562–1621) and Jacopo Corsi (1561–1602). The group's enquiry was situated against a perceived problem of a loss of proper meaning in music. The complex polyphonic music of the time made it difficult to discern the words. They hoped to resurrect the written word in a position of primacy over what had become a too layered construction of technical musical composition, and also to rein in the supposed abuses of the singers, who through their performance practice had became unruly and egotistical, muddying the 'purity' of the poetry. They turned to Aristotle and ancient Greece for their authority in such a matter[3]:

> I would advise you, therefore, to fix forever in your memory what Aristotle says, that in rhythms are images of fortitude and... above all else your principle objective should be not to spoil the verse in singing by making a

long syllable short, or a short one long, as is habitually done every time; and
what is worse, it is done by those who consider themselves great men in this
art, with such poor grace and style that any connoisseur of good poetry reacts
with great pain and distress, something unworthy of our century, surely.

Bardi 1578: 121

What is of interest here is the fact that though surviving documentation of antiquity
includes descriptions, sculptures and paintings, there are no comprehensive
accounts of performance *practices*. The defining ideals underpinning the creation of
the interdisciplinary genre of opera and, interestingly, also reforms such as Wagner's,
have been perpetrated by those who have never experienced or witnessed the
practices that they refer to. No operatic or theatre creator, composer, director,
librettist or performer either living or dead has been privy to the *practice*. In effect,
the classical foundation, which has been repeatedly drawn on to solve problems
and to achieve deeper meaning and unity in theatre, can be said to be more
mythical than practical. Here we begin to uncover an assumption that to know
about a practice or *of* a practice as an aesthetic *object* of practice, rather than having
knowledge of the actual practice *within* a practice, was sufficient – a type of '*episteme*'
about '*techne*' perhaps. As we will see later in this chapter, the analytic and
conceptual model of the *active aesthetic* turns this on its head and might even be
viewed as a way to consider the '*techne*' of an '*episteme*'. What will be discussed later
is how knowing about the aesthetic *object* may offer a different type of knowledge
than the witnessing or capturing of an aesthetic in *activation*, a practice of a practice
or a *way* of doing, rather than the *what* of doing, which seemed to suffice in the
above example of operatic reform.

Returning to the discussion on disciplinarity: as the Enlightenment got
underway there was a substantial move towards theoretical knowledge, the 'know-
why' of *episteme*, in the guise of analytical reason and rationality against a perceived
distrust of the emotional, spiritual, the interpretive, the artistic, and arguably
'feminine' ways of 'know-how', often attributed to the notion of *techne*:

> For disciplinarity to triumph required the retreat of theology. In the
> Enlightenment, religion went from being the queen of the sciences and the
> end of all knowledge to being one among many types of knowledge... The
> depersonalization of knowledge was also necessary. Rather than knowledge
> being attached to the person and thus a matter of status or personal charisma,
> knowledge was increasingly grounded in data that the world gave up through
> empirical investigation.
>
> *Frodeman 2014: 22*

Science as knowledge and knowledge as science

Disciplinarity as we now understand it became more established. The Enlightenment
'overlapped and drew on a "scientific revolution" ... led by scientists such as

Copernicus, Kepler, Galileo and Newton, which overturned the view of natural order established by the ancient Greeks' (Moran 2010: 5). The natural sciences proceeded on the foundational view that nature was a 'well-ordered machine' (ibid.) and the empirical method, which 'aimed to deal with problems within specific parameters, based on new methods of induction and deduction to test hypotheses and new experimental apparatus' (ibid.). Ironically, although not the usual story told, Newton's belief system included a commitment to rules, which for him constituted the 'reason of God'. Infamously, he was also obsessed with alchemy and wrote many mystical works about turning iron into gold. There is certainly a trace of theology, religion and even magic in the foundation of the scientific disciplines.

Nevertheless, the codification, systemising and categorisation of knowledge developed along the lines of *episteme*, with the capture and accounting of knowledge being formed around models that reinforced the supremacy of *know-that* and *know-why*. The first editions of the Encyclopedia, the best known of course being Diderot's *L'Encyclopédie* (1751–80), are prime examples of this manner of capture.

This time of the legitimisation of science coincided with a formal exclusion of women, despite their previous participation in intellectual life during the Renaissance courts and within select aristocratic traditions. 'The Royal Society, founded in 1662, did not admit a woman until 1945, and the Académie des Sciences, founded in 1666, did not admit women until 1979' (Shumway and Messer-Davidow 1991: 205). Further, it took until the 1860s in Switzerland, the 1870s in England, the 1880s in France and the 1900s in Germany for women to even be admitted in to universities (ibid.). Unless working under the radar, taught by fathers or assisting husbands, women were excluded. It is hard to plot a comprehensive and transparent path of the influence of women in the production and development of knowledge. As most social epistemologists and certainly feminist epistemologists will tell you, this has had a profound impact on the way we *perform* knowledge.[4]

After the Enlightenment, new subjects and specialisms emerged as the success of the modern scientific project took hold. Moran speculates as to why this mode of disciplinarity has been so successful even to this day: 'it is that they [the sciences] are able to limit themselves to certain closely defined fields and controlled situations, and thus produce apparently clearer, more rigorous and effective examples of "useful knowledge"' (Moran 2010: 7).

The collection, collation, systematising, delineating and organising of vast amounts of the above mentioned accounts of 'useful knowledge' led to an inevitable explosion where 'The number of experiential data and theories of science grew to a critical mass which generated innovations and motivated further research' (Weingart 2010: 5). Around the 1800s, not surprisingly, as this is where organising modes of research and knowledge categories started to get specialised, the separation of teaching and learning into disciplinary boundaries and specialisms became formalised as subject specialisms. With this, those within the specialisms came to be the group determining what was rigorous or 'useful' knowledge within their own

specialism. Through a culture of peer review, generated within academic associations, journals, citations and research frameworks, a semi-incestuous situation was established.

> As the communication turned inward and became self-referential the disciplinary community became the relevant public. At the same time this process generated a division between specialists and laypersons that has become increasingly pronounced since then. Popularization emerged as a separate activity not intended to contribute new knowledge but limited to the broader (educated) public.
>
> *Weingart 2010: 6*

With this division between 'specialists and laypersons' there also grew a sort of ironic conceit that the most 'useful' knowledge was born of the universities through the vocabularies of the specialists, articulated in various models of dissemination by way of the values of *know-that* and *know-why*, rather than the *know-hows* often deemed characteristic of the 'layperson'. Here we begin to see dualisms emerge, generalised often in inaccurate ways, between those who think and those who do. Some examples might include: theoretical knowledge vs. embodied knowledge, theory vs. practice, hard vs. soft or pure vs. applied, with the latter of these pairs being often perceived to have a lesser position based on their methodological rigor, exactitude and objectivity.

Rawlins brings up an interesting point with regard to this pattern:

> For thus, in the main, has arisen our pattern of academic training in mathematics, philosophy, and the exact sciences, with this their insistence upon first principles, often achieved only by working under conditions of *artificial simplification*. Surely it is here that contact, conscious or unconscious, is made with technological processes. It may well be that skill will show itself more forcibly in applied knowledge, if by skill we mean a certain dexterity (not only of hand, but of mind), in dealing with *ad hoc* situations. The very fact that something *tangible* is in view makes 'manipulation' easier than in abstractions.
>
> *1950: 393*

This 'artificial simplification' and 'tangibility' will be addressed later, countered with conditions of *complexity*. It will also be recognised that research and the *acts* of *doing* science are indeed also *practices*, regardless of the fact that their *ways* of doing are not always a transparent part of the evaluations of measurement and rigour (as evidenced in the current problems around repeatability and falsifiability even within science's own terms, to be discussed in the next few paragraphs). I will draw from select scholars who speak of interdisciplinarity as complex, rather than complicated, and with this offer a dynamic non-linear approach in the use of a new analytic/ conceptual model, the *active aesthetic*. Among other things, we will learn that the

concept of the *active aesthetic* functions to allow *events* of knowledge to *float* in a space between the subject of the discipline and the object of the knowledge, temporarily held there to be *witnessed* as an active dynamic before grounding its knowledge 'tangibly' within vocabularies shared by any one of the discrete disciplines.

Traditionally, however, the concerns outlined above around the patterns of knowledge division are not the ones that pop up throughout history. Rather, historically we see repeated discussions around the lack of a philosophical overview providing a 'unity of science and knowledge', many of which could be seen as harking back to the epistemological architectures of Plato and Aristotle mentioned earlier. Klein summarises nicely:

> Though not yet phrased in terms of interdisciplinarity per se, the problem was apparent in the work of a number of writers from the sixteenth through nineteenth centuries, including Francis Bacon, Descartes, the French Encyclopedists, Kant, Hegel, and Comte. Each of them expressed concern about the fragmentation of knowledge, and each, in his own way, articulated a vision of the unity of Knowledge.
>
> *Klein 1990: 20–21*

The movement of logical positivism (sometimes referred to as logical empiricism, occurring during the 1920s and 30s in Europe and 40s and 50s in the US) corresponds with the forming of the kinds of university structures that we now understand, with the pure sciences, for the most part, considered a separate faculty from the humanities (and any of their interdisciplinary breakouts).

Before Kant '[p]hilosophers typically understood the nature of knowledge and the nature of reality as two sides of the same coin' (Fuller 2002: 40). With Kant, philosophy shifted from metaphysics towards a critique of knowledge.[5] This was for many logical positivists a jumping off point that took disparate groups of scholars in various directions, not necessarily agreeing on any one crucial concept, but elaborating on a post-Kantian philosophical sensibility towards a field of epistemology.

> What held the group together was a common concern for scientific methodology and the important role that science could play in reshaping society. Within that scientific methodology the logical empiricists wanted to find a natural and important role for logic and mathematics and to find an understanding of philosophy according to which it was part of the scientific enterprise.
>
> *Creath 2014: 1*

Even through the various counterarguments that occurred during this philosophic movement a 'standard account of Science' was born, one that rests on the premise that 'science is a form of knowledge that produces facts and fact-like statements' (Erickson 2005: 55), and with this tenet it was assumed that science and knowledge was to be considered as one and the same. The logical positivists, particularly the

branch of the Vienna Circle, started with the notion of verification, which posited that 'a theory is proposed and the theory makes predictions that can be tested through observation. Scientists will sceptically adopt a theory, and will then test the theory by making observations. As the observations that confirm the theory accumulate, the theory achieves a scientific status' (ibid.: 56).

Popper famously resisted this premise and took things a step further with falsification, a theory of logic that despite seeming critical of the work of the Vienna Circle worked to fortify their logical positivist account of the world. He posited that experiments and observations are not there to verify but rather to falsify theories, and that if and until they are proved false, they are considered true. This arguably 'leaned more towards naturalism, … the idea that all observable effects have natural causes, opposing the logical a priori claimed by the logical positivists' (Krishnan 2009: 14).

This process of verifying a study and/or the results of an experiment as fact and therefore as knowledge has recently come into question. Cracks have been found in the system via the *ways* in which this mode of verification is *practised* within our current research culture, one that relies on reproducibility. Recently, Nosek's Reproducibility Project included 270 scientists repeating 100 published psychological experiments. The results were surprising, with only about a third of the experiments able to be repeated effectively:

> There exists very little evidence to provide reproducibility estimates for scientific fields, though some empirically informed estimates are disquieting (Ioannidis 2005). When independent researchers tried to replicate dozens of important independent studies on cancer, women's health, and cardiovascular disease, only 25% of their replication studies confirmed the original result (Prinz, Schlange & Asadullah 2011). In a similar investigation, (Begley & Ellis 2012) reported a meager 11% replication rate.
>
> *Nosek 2012: 657*

Inevitable discussions around these findings go from the unlikely case of outright fraud to more likely ideas such as publication bias, the thought that journals prefer to report positive results, and of course the fact that funding is not given generally to prove something wrong, especially when the positive result serves pharmaceutical companies and institutional research profiles.

> Considering its central importance, one might expect replication to be a prominent part of scientific practice. It is not (Collins, 1985; Reid, Soley & Wimmer, 1981; Schmidt, 2009). An important reason for this is that scientists have strong incentives to introduce new ideas but weak incentives to confirm the validity of old ideas (Nosek, Spies & Motyl 2012). Innovative findings produce rewards of publication, employment, and tenure; replicated findings produce a shrug.
>
> *Nosek 2012: 657*

Reproducibility could be seen to live in the field of *process* and *practice*, perhaps even aligned with the values of *techne*, a way of doing, rather than what or how was done. We will see in later pages that this is the conceptual underpinning of the *active aesthetic*, where there is no conflict between scientific or other disciplinary modes, but rather for each a concentration on knowledge as process, an activity of *knowledging*.

Bridging a 'gulf'

In the first quarter of the twentieth century A.N. Whitehead, in his *Science and the Modern World*, boldly claimed that 'a brief, and sufficiently accurate description of the intellectual life of the European races during the succeeding two centuries and a quarter up to our own times is that they have been living upon the accumulated capital of ideas provided for them by the genius of the seventeenth century' (Whitehead 1967: 39).

At this time the socio-cultural-epistemological ramifications of the scientific account of knowledge came under scrutiny again, posed as new questions to do with how it really functions and how we function within it. Hard and fast tenets began to give way, or at least were challenged. It would take the rest of the century, influenced by two world wars and the discovery of new science, to play out a complicated power game unravelling centuries of dualisms (and, arguably, creating new ones). Discriminations to do with what was considered 'real' knowledge and what was not gave way to a series of epistemological displacements, even within science's own terms, particularly in developments with the 'new physics':

> Developments in quantum physics and 'chaos theory' have even been taken to mark 'the death of materialism' that is, of the mechanistic model of the properties and behaviour of matter which had been dominant since Newton (a dramatisation of the implications of this work which many working in these fields would reject) ... the very nature of the revolutionary work in theoretical physics, astronomy, and cosmology has helped to challenge the model of scientific thinking which represented it as proceeding by a combination of rigorous deduction and controlled inferences from empirical observation.
>
> *Collini 1998: xlviii*

In an (in)famous lecture which took place on 7 May 1959 in Cambridge, titled 'The Two Cultures and the Scientific Revolution', C.P Snow illuminated, and some might argue took a semblance of romantic license, laying out a contentious narrative concerning the tensions between 'literary intellectuals' and 'research scientists'. Although the history of Snow's lecture, with its subsequent criticism, could be dismissed as an out of touch elitist conversation held within an Oxbridge parochialist privileged landscape, Snow articulated something that had not been so outrightly stated within the scholarly elite, the notion of 'a gulf' between science

and other types of knowledge, articulated as 'two cultures'. After the lecture, Snow rightly stated that 'Just as the concept of "the two cultures" has been accepted, so has the existence of a gulf between them' (1960: 217). The lecture was perhaps more influential, not because of its original content, but in that it set off 'the mother of all academic shouting matches' (Gould 2011: 89).

Much of the 'two cultures' tradition is still with us and in our institutions, if evident only in the way the distinctions between the sciences and humanities influence decisions on policy, funding, career progression, project approvals, knowledge, publication and, importantly for this publication, also influencing modes of documentation, along with practices of capturing knowledge. Within the next pages you will see how Snow's notion of 'two cultures' presaged an even more contentious discussion behind what would be referred to as the 'Science Wars'.[6]

Within the ten years following Snow's lecture, the student uprisings in France disturbed modernist ideology and confronted political doctrine, historic materialism and social reality. Complex socio-cultural networks were recognised while established modernist hierarchies dissipated. This was a time ripe for the birth of interdisciplinary scholarship, but also of great resistance. Debates across politics and education were many, and the 'Science Wars' carved out newly minted categories on both sides of the 'gulf'. German Social Theorist Wolf Lepenies' statement exemplifies the type of stance that got things so heated:

> Science must no longer give the impression it represents a faithful reflection of reality. What it is, rather, is a cultural system, and it exhibits to us an alienated interest-determined image of reality specific to a definite time and place.
>
> *Collini 1998: 1*

Sentiments such as this became exemplified as coming from those within an 'academic leftist' camp comprised of humanists, social scientists and radical feminists. With the emergence of the inter-disciplines Cultural Studies and Literary Studies, there came a blurring of boundaries, with an increasing development of cross-disciplinary activity among the humanities and sciences. It is from these roots that Performance Studies, Feminist Studies, Gender Studies, Urban Studies, Women's Studies, American Studies, Cognitive Studies and Science and Technology Studies were developed:

> the many *new histories* of the mid-twentieth century, share cognitive studies' concern with linking mind and mentality, social theory, and new methods, often quantitative, to explain past behavior. They include, for example, new social, political, economic, cultural, racial, ethnic, and gender histories.
>
> *Graff 2015: 18*

Developments such as these posed a threat to some, articulated most succinctly by Lyotard when he introduced the aforementioned concern that interdisciplinarity

erodes disciplinary authority (Lyotard 1984). As I have argued in past publications, however: 'How can we erode what we do not know, what we have not *practised*, and what is not embodied?' (Bryon 2009: 136).

Regardless, the 'Science Wars' gained traction along the lines that any muddying of knowledge would threaten the very rigour and influence of the formal account of science. 'Scientific realists' such as Gross and Levitt became aggressive defenders against any view of science that favoured social context over pure logic of argument. For them this was akin to an intellectual nihilism:

> Many notable historians and sociologists of science have long held misgivings about intellectual nihilism that offers itself as 'cultural constructivism'; but they have been reluctant to challenge it for fear of gaining a reputation as sissies, too weak-kneed to play the exhilarating game of 'epistemological chicken'.
>
> *Gross and Levitt 1998: xiii*

This game of 'epistemological chicken' was played dirty, but to great effect in the controversial stunt perpetrated by physics professor Alan Sokal. Inspired by Gross and Levitt's depiction of the academic left as being 'permeated by jargon, philosophical dogma, and political attitudes drawn from the world of postmodern literary criticism' (ibid.: 81) and their pointed statement:

> The notion of 'cultural critic,' in its postmodern form, embraces a certain kind of sociologist as well as a certain kind of literary scholar. They publish in the same journals and appear at the same symposia, speaking the same language and sharing the same attitudes.
>
> *Gross and Levitt 1998: 81*

Sokal posited that quantum gravity was a social and linguistic construct in a nonsensical article titled 'Transgressing the Boundaries: Towards a Transformative Hermeneutics of Quantum Gravity'. It was published in the journal *Social Text* in its spring/summer edition in 1996. It was accepted and published and as such proved, for many, that the leftist, postmodern, subjective, and relativist humanities was an incestuous, non-rigorous melting pot of pretentious mumbo-jumbo. It exposed for others that *Social Text* had not yet put in place a proper peer review process, and as such no physicist had read the paper prior to its acceptance.

As we have seen within the previous pages, the sciences also have incestuous practices of evaluation with intra-articulations of 'truth' that have prompted questions about rigour (recall the above regarding repeatability). Perversely, this might well be seen as a working definition of what a discipline even is. However, at this time this was seen as a threat to the sciences coming from the humanities, influenced by the de-authorisation and deconstructing philosophies of the postmodernists. Fuller posits a bigger picture:

> Knowledge producers first stake out a domain about which they make claims, which they then test with special procedures to arrive at truths about the domain. Even in this simple account, a psychology is imputed to the knowledge producer which, in turn, tends to favor a psychologistic reading of his activities. The crux of this psychological account is that *theory formation precedes method selection*.
>
> *2002: 22*

We will see in the last section of this chapter that the methodological/analytical framework of the *active aesthetic* takes this pattern into account, turning the process on its head where and when possible, considering *method* and *process* as a primary source of capture prior to grounding its content within the disciplinary formations.

For now, returning briefly to the 'Science Wars', the threat to the formal account of science instigated creative attacks on the human condition, targeting selects groups' ability to even perceive, think and believe. In John Gray's highly provocative account of human nature, *Straw Dogs: Thoughts on Human and Other Animals*, an account of knowledge that arguably eats its own tail, he perpetuates the above mentioned 'gulf' to the point of condemning humanity as a solipsistic exercise largely perpetrated by notions of misplaced belief.

> Outside of science, progress is simply a myth. In some readers of *Straw Dogs* this observation seems to have produced a moral panic. Surely, they ask, no one can question the central article of faith of liberal societies? Without it, will we not despair? Like trembling Victorians terrified of losing their faith, these humanists cling to the moth-eaten brocade of progressive hope. Today religious believers are more free-thinking. Driven to the margins of a culture in which science claims authority over all of human knowledge, they have had to cultivate a capacity for doubt. In contrast, secular believers – held fast by the conventional wisdom of the time – are in the grip of unexamined dogmas.
>
> *Gray 2002: xi*

Here lines are drawn between science and the humanities, with the scientists often regarded as positivists rather than relativists, naturalists rather than humanists, realists rather than constructivists, empirical thinkers relying on logic and evidence rather than interpreters valuing aesthetics, with proper science on the side of falsifiable truth and New Age pseudo-science on the other; and with this also a peculiar political penchant to label the Humanities category as Leftist, with science on the Right. This entire set of dualisms and generalisations, not excluding the aforementioned 'weak-kneed sissies and trembling Victorians', is, ironically, a perfect example of the type of socially constructed reality created by those that so ardently fought to eradicate it[7]:

> At stake in this debate is the very nature of science: for scientific realists, science proceeds by discovering and verifying empirical realities; for social

> constructivists, science proceeds by inventing a plausible means of interpreting nature and then persuading colleagues and the general public to believe in it.
>
> *Christensen 2005: 2*

The 'Science Wars' were an important debate, largely because prejudices against *practice* often come couched in the type of logic that fuelled it. The debate also worked effectively towards the assumption that science lives more properly on the side of epistemology and objective knowledge, with the humanities now on the side of hermeneutics and subjective representation. However, when we consider the *practices* or activities of science… it is not so simple.

> The activities conventionally referred to as 'the sciences' do not, it is argued, all proceed by experimental methods, do not all cast their findings in quantifiable form, do not all pursue falsification, do not all work on 'nature' rather than human beings; nor are they alone in seeking to produce general laws, replicable results, and cumulative knowledge.
>
> *Collini 1998: xlv*

What too is interesting, and often disregarded, is that practices, especially those of performance, from which the *active aesthetic* was developed, have always needed to be exact in much the same ways that the sciences have revered themselves for being. This conceit that exactitude, falsifiability, repeatability and methodological accounts of knowledge are of the purview of science only might need to be expanded. The practices within performance are not that dissimilar in cases where the performer needs to reliably enact and repeat complex feats in the doing of singing, dancing and acting (for instance) without fail night after night, and in which years of training for these acts must be exact, or the results rendered useless.

One could certainly argue that performance practitioners experiment and establish clear processes and feedback as to what works, what is repeatable and what is physically/emotionally feasible, narrowing the range of what is possible. Further, within the pedagogies and practices that are born as part of their experimentation, knowledge emerges that has as part of the discipline a necessity for clear interpretations and articulations of the ways one enacts *practice as a doing*. Arguably, this could be considered as not so much a hermeneutic exercise as an epistemological one. However, when performance enters the scholarly environment, it is rarely from this account of its rigour that it is evaluated, considered, documented and/or scrutinised.

The studies (science and performance)

In this next section we will take a brief look at what happens to *practice* when the disciplinary 'subject' of performance and the disciplinary 'subject' of science get absorbed into the ongoing interdisciplinary experiment of 'the studies'. Here we will briefly look at the difference between Science and Technology Studies (from

here on out referred to as STS) and Performance Studies, and at what occurs between their practice(s) and theories when engaged in and absorbed within their respective 'studies'.

Performance Studies, with a lineage drawing from anthropology and literary studies, and STS emerged from the same climate as Cultural Studies. Anthropologist Clifford Geertz, often cited article 'Blurred Genres: The Refiguration of Social Thought' in *American Scholar*, Spring 1980, introduced approaches to social thought surrounding behaviour. Jackson identifies Geertz's notions of 'game', 'drama' and 'text' within the context of ritual and human behaviour as a grounding influence. Through Geertz, who 'came to symbolize "anthropology" for a generation of non-anthropologists, wax[ing] eloquent about the blurring, particularizing, and analogising of social thought, the discipline of performance studies secured an institutional hold' (Jackson 2004: 147) ... as did STS.

The formation of these 'studies' was influenced by Poststructuralism. Derrida, one of the central figureheads of the postmodern exercise, fortified by the aforementioned concerns around the ways in which the practice of disciplinarity is bound up in self-affirming incestuous cycles, dedicated much of his work in one way or another to targeting and offering provocations around the authority of grand narratives, authorship, form, hermeneutics and any subject or object as a representational 'custodian' of knowledge or meaning summarises this postmodern stance within the concerns of disciplinarity:

> Derrida's arguments about philosophy are connected to his concerns about the nature of the university as an institution. He suggests that the problem with both academic disciplines and universities as a whole is that they set themselves up as sites of disinterested knowledge by virtue of the axiom that 'scholars alone can judge other scholars' (Derrida 1992b: 5), which disconnects the disciplines from each other and from the world outside academia. Derrida's undermining of the intellectual certainties of the disciplines thus has the explicitly political purpose of questioning the traditional separation of scholars from the broader social sphere, which in turn only tends to call on them when their disciplinary expertise is required.
>
> *Moran 2010: 84*

In this landscape STS has taken a variety of anti-essentialist positions, imbued with scepticism of the natural as an essential custodian of knowledge and of any notion that states that there are inherent properties that contain 'truths'. The field investigates how scientific knowledge and technological artifacts are *constructed*.

> The source of knowledge and artifacts are complex and various: there is no privileged scientific method that can translate nature into knowledge, and no technological method that can translate knowledge into artifacts. In addition, the interpretations of knowledge and artifacts are complex and various; claims, theories, facts, and objects may have very different meanings to

different audiences. For STS then, science and technology are active processes, and should be studied as such.

Sismondo 2010: 11

The Graduate Program at Vancouver British Columbia's prospectus of their STS Program gives a good account of the topics for study within a current STS program. It will generally include such things as how laboratories work, how to understand the development of scientific practices and technological objects in social context, examination of the ethics of science and technology, analysis of expertise and the authority of science in democracies, understanding relations between science and public policy, and exploring representations of science and technology (University of British Columbia 2016). At the core of this social-constructivist approach to science is the notion that scientists, with their network of technologies, artifacts and ideas within an institutional culture, and operating within dynamics of social interactions, *construct* truth and facts rather than discover, find or uncover them.

> Many, or even most, people who are involved in producing scientific knowledge and new technologies *do not subscribe to the story* that STS tells. For them, science is a progressive neutral activity that produces true knowledge and facts about the natural world through application of a standard method. Most scientists do not think that the knowledge they produce is contingent on social factors or conditions, only that it is constrained by the limits of scientific possibility, material and technical resources, of funding.
>
> *Erickson 2005: 2; added emphasis*

This may be because within the scholarly institutional framework the standard account of formal science still holds a privileged position. Formal science rarely competes with STS for funding or status, and for the most part relies on different modes of dissemination, vocabularies and analyses. STS has not re-defined the research languages or institutional parameters and modes of evaluation of formal science, although it can influence framings of these. This cannot be said for Performance Practice, as it has been institutionally absorbed by Performance Studies, especially when one wishes to leave the realm of the conservatoire and enter the realm of scholarship. The practice of science has not been as compromised by becoming an *object of study* as the practice of performance has when Performance became an object of study.

Performance Studies, while having in common a shared ideological enquiry to do with the socially constructed ways in which we use, activate and interpret knowledges within our fields while questioning the responsibility of agents of knowledge production and their applications of various technologies and methodologies including practices of documentation and archiving, differs in an important way. Performance Studies holds a peculiar epistemological hold over the very doing of the practices from which it draws its currency. One wonders what

might have happened if there had been such a peculiar occurrence as 'performance wars', akin to the 'science wars'.

Seemingly obvious but still needing to be stated is the fact that Performance Studies is *not* the study of Performance Practice, but rather (and importantly there is no one definition of the interdiscipline as it is still evolving; however, for the sake of making clear the difference and in recognition that this is a very general statement), more a mode of investigation, study, scholarship, and/or theorising into discursive, gender, cultural, social, and even disciplinary dynamics that have been deemed 'performative' or of the 'liminal'.[8] Performance Studies has a direct heritage from the aforementioned branch of interdisciplines that was derogatorily referred to within the 'Science Wars' as coming from the 'academic left'. It is greatly influenced by poststructuralism and postmodernism and has roots in literary theory and anthropology, with discursive criss-crossings in areas concerned with meaning, language, ritual, identity, society, behaviour and culture.

Although a fascinating enterprise that has offered much in the way of shaking us from embedded linguistic-socio-cultural assumptions, Performance Studies presents some serious problems with respect to how performance practitioners are characterised within scholarly contexts. 'It is particularly of interest when looking at how our *way* of practice is often pulled away from subtle understandings of process, and instead categorized as a *performative object* that is embedded or positioned in the construction of a performance' (Bryon 2014: 38; added emphasis).

At a most basic level, some of the difficulty is in the adoption and adaption of defining the term 'performance'. You will see that the following nine chapters rightly pause to re-define the term within and across their own interdisciplinary enquiries. Generally, the word 'performance' can be understood as a theatrical form, practice or event, such as a play, an opera, a piece of musical theatre or a dance; however, within Performance Studies everything that *does*, or is *done onto* and/or generates *meaning* can be seen as performance, and therefore used as a way to create hermeneutic readings and representations while examining theories of reception and repetition across many events, texts, and/or identities. STS does not have this same problem with the term 'science'. However, as the founding scholar of the interdiscipline of Performance Studies defined *performance*, or arguably un-defined it:

> One cannot determine what 'is' a performance without referring to specific cultural circumstances. There is nothing inherent in an action in itself that makes it a performance or disqualifies it from being a performance… every action is a performance… What 'is' or 'is not' performance does not depend on an event in itself but on how that event is received and placed.
>
> *Schechner 2002: 30–31*

Another, more recent definition, a little less strictly attached to the original anthropological and literary philosophical underpinnings of Performance Studies, offers this:

> Performance is both a practice and a mode of analysis. It is a communicative behaviour for which there is no other name (that's to say, if you can call it acting you treat it as acting). It is a mode of analysis that works by framing, thinking of, its material as if it were performed, which is to say as if it were a deliberate communicative practice.
>
> *Shepherd 2016: 222–223*

Although a more inclusive definition, it importantly does not speak to that type of practice that is purposefully NOT about communicating, that practice at the core of Performance Practice that must precede communication: the scales, the barre work, the way of being in the doing of the doing so that one is in the flow of process, the act of the act. Although, if looked at from the outside as an object of study, it like anything else could be seen to 'communicate', being in the practice of the act is the practice for many performance practitioners, NOT the looking at it as an object. This subtle distinction is at the core of what *active aesthetic* embraces. The space before knowledge is grounded within the various disciplinary constructs with which it might intersect.

At a very basic level the variety of understandings of what 'performance' is presents confusion and arguably an embedded prejudice against the *practice* of practice, one that is vital to the subject of this book. If one *practises* performance with any of these definitions, what is the practice exactly? With STS, the practice of science, even if put under a microscope, still maintains some sense of stability. Importantly, most *practitioners* of science are not required to adapt articulations of their practice(s) through the critical lenses of the theories expounded by STS to be deemed rigorous in scholarly contexts. This is not so for the performance practitioner when engaging in Practice as Research (for instance) at the postgraduate level.

In the final section of this chapter, with the introduction of the *active aesthetic*, this book introduces the concept of a *middle field* where one can sit with what is for many an uncomfortable place of process and practice, allowing one to witness knowledge as process before grasping at the modes of observation, archiving and documentation that derive from critical lenses that trap process as object. Practice as/based/and Research can offer some models (to be discussed later), but until we get *inside* of the thing, recognising knowledges born of interdisciplinary exchanges may be losing something important and valuable. Even within Performance Studies some have pinpointed this problem, but there has yet to be a satisfactory arrangement.

> A performance studies agenda should collapse this divide and revitalize the connections between artistic accomplishment, analysis, and articulations with communities; between practical knowledge (knowing how), propositional knowledge (knowing that), and political savvy (knowing who, when, and where). This epistemological connection between creativity, critique, and civic engagement is mutually replenishing, and pedagogically powerful. …The ongoing challenge of performance studies is to refuse and

supercede this deeply entrenched division of labor, *apartheid of knowledges*, that plays out inside the academy as the difference between thinking and doing, interpreting and making, conceptualizing and creating.

Conquergood 2002: 153; added emphasis

Unlike STS, what Performance Studies has taken from Performance Practice is profound and what it has given back is negligible and difficult. There has been an institutionally organised '*apartheid of knowledges*' (ibid.) In the linking all things performance to 'performative' meaning as linguistic and/or socially constructed metaphors. This mode of scholarship often dilutes or bypasses the very things that make the *way* of practice, rather than the *what* or *situ* of a practice of value. In the instance of Science and Technology Studies and its relationship with formal accounts of science, although STS has in some instances re-contexualised the latter it remains a distinct research exercise from that of empirical science practices. In addition, the word 'science' maintains a certain operational distinction even as it has been influenced by the riches of its correlative 'studies'. In the case of Performance Studies in relation to the work of the performer-practitioner/ researcher, this is not so much the case. Science and Technology Studies is *not* funded from the same pot as Science; neither are they evaluated as scholarship in the same manner. One cannot say the same for Performance Practice when it enters the scholarly environment. Having never had a dialogue resembling that of the 'science wars', Performance Practice has been absorbed by Performance Studies and as such is not, in many instances, recognised for the knowledges that it generates or its rigorous process(s) of *knowledging* on its own terms.

Performed prejudices

Paul Boghossian, author of *Fear of Knowledge: Against Relativism and Constructionism*, argues against what he terms *equal validity*, which he defines as a 'radically counterintuitive doctrine', a doctrine that posits that '[t]here are many radically different, yet "equally valid" ways of knowing the world, with science being just one of them' (Boghossian 2006: 2). To illustrate his concerns, he speaks of American prehistory and cites a 1996 *New York Times* article titled 'Indian Tribes' Creationists Thwart Archeologists'. He discusses a dissonance between the scientific consensus, proven through archaeological findings, that humans first entered the Americas from Asia, crossing the Bering Strait around 10,000 years ago, and a Native American creation myth which tells the story of a people who emerged from within the earth as descendants of the buffalo people after supernatural spirits prepared the world for human kind. This concerns him because:

> we have a variety of techniques and methods – observation, logic, inference to the best explanation and so forth, but not tea leaf-reading or crystal ball-gazing – that we take to be only legitimate ways of forming rational beliefs on the subject. These methods – the methods characteristic of what we call

'science' but which also characterize ordinary modes of knowledge-seeking – have led us to the view that the first Americans came from Asia across the Bering Strait... For this sort of deference to science to be right, however scientific knowledge had better *be* privileged – it had better not be the case that there are many other, radically different yet equal ways of knowing the world, with science being just one of them.

Boghossian 2006: 4

Clearly disturbed by this, he further speaks to the notions of *credibility* and the problem with seeing Zuni creationism in line with archaeology and evolution in line with Christian creationism.

Equal validity, then is a doctrine of considerable significance, and not just within the confines of the ivory tower. If the vast numbers of scholars in the humanities and social sciences who subscribe to it are right, we are not merely making a philosophical mistake of interest to a small number of specialists in the theory of knowledge; we have fundamentally misconceived the principles by which society ought to be organized.

ibid.: 5

Even though unpacking the many difficulties here, including the equating of crystal ball reading with the people of the Lakota tribe, would be somewhat enjoyable, staying on point: comparing an active disorganisation of society with 'the ivory tower', evoking the leftist intellectual camp, has a certain hypocrisy, as the creationism story generally touted by the 'right' (which he touches on only briefly, fluffing over this) could be seen as the same play with different props.

A most important question to be asked here: is equal validity even a thing? Perhaps this is the wrong conversation, especially when it comes to fostering productive and rigorous scholarly environments able to allow for the emergence of new knowledges. Is 'equal' so important? Equal to what exactly? Why not just different? And is something not made valid only by its own terms and culture, and with this, its discrete modes of evaluation?

In the final section of this chapter you will see how the analytic methodological framework of the *active aesthetic*, while embracing a space of epistemological pluralism with a recognition of multiple ways of knowing, in line with many of the treatises on interdisciplinarity, differs in that it does not aim to integrate or arrive at a type of democratic, integrated utopian epistemology. In fact, at its core is the embracing of conflict, the rubs and collisions that occur in the engagement across disciplines. This is more in keeping with Mouffe's model of the *agonistic*, which embraces conflict as a dynamic for engagement across realms of discourse: 'the lack of "agonistic channels" for the expression of grievances tends to create the conditions for the emergence of antagonisms which, as recent events indicate, can take extreme forms and have disastrous consequences' (Mouffe 2005c: 230).

Before we can begin to discuss the possibility of a methodological analytic drawn from performance practice as an interdisciplinary tool, we need to recognise a practised antagonism played out as a systematic epistemic prejudice. This antagonism extends beyond the arguments of 'equal validity' into a more personal (discrete disciplinary) attack, first against the very aptitude of the humanist and next the performance practitioner as scholar. Recalling the discourse during the 'Science Wars', the following quote resonates still:

> In order to think critically about science, one must understand it at a reasonably deep level. This task, if honestly approached, requires much time and labor. In fact it is best started when one is young. It is scarcely compatible with the style of education and training that nurtures the average humanist, irrespective of his or her political inclinations.
>
> *Gross and Levitt 1998: 5*

Here they are targeting 'the studies'; however, as mentioned previously, the scholarly practices within Performance Studies do not equate to the practice(s) that performance practitioners undergo and continue throughout their entire careers, day in and day out. Interestingly, the very type of exactitude, early training, rigour and commitment intimated by Gross and Levitt's somewhat insulting comment above is absolutely required of the ballet dancer, the opera singer and the actor, for instance.

That performance practitioners are not able to engage nor interested in engaging in theory and scholarly enquiry can also come from within our own camp. Pavis states: 'Theory must be guided with real epistemological and methodological care. The crisis of academic research, particularly historical and dramaturgical research, probably stems from the sad conclusion that it doesn't seem to interest theatre people' (Pavis 2001: 156). Here he expresses a perceived divide between what Jackson eloquently describes as 'She-Who-Is-Preoccupied-With-Making-Meaning' and 'He-Who-is-Preoccupied-with-Meaning' (Jackson 2004: 111).

Further, William Newell, Executive Director of the Association for Integrative Studies at the Miami University of Ohio, writes:

> While the notion that interdisciplinarians study complex systems tends to resonate well with natural and social scientists, it tends to sound strange (even alien) to humanists, not to mention those in the fine and performing arts for whom anything systematic is anathema.... The humanities and arts are more concerned with behavior that is idiosyncratic, unique, and personal—not regular, predictable, and lawful. If the natural and social sciences focus on the rules that govern behavior, the arts and humanities focus on the exceptions to those rules. Systems thinking seems more relevant to the practical, real-world problem solving of the sciences than to the probing and expression of meaning by humanists.
>
> *Newell 2001: 3–4*

As I have pointed out in previous publications, such stances are quite problematic (Bryon 1998, 2005, 2009, 2014, 2017). Perhaps the physical theatre circus performer, the dancer who is practising catches, the actor who needs to repeat systematic feats of emotional availability night after night and the opera singer reaching consistent high Cs might know a little about the necessity of regular, predictable and lawful systematic analysis and practices born of the complex system of the emotive breath/body. In fact, very often the *way* of practice is a serious matter of health and safety. Here we enter into misunderstandings about the values and operations to do with knowledge, especially as activated within Performance Practice(s).

Interdisciplinarity and performance

There is no one model for interdisciplinary scholarship, neither would any such one model necessarily enrich us. Since interdisciplinarity as one of its defining characteristics, subverts the rules and agreements of disciplinarity by provoking the emergence of new modes and models along with new processes of knowing, embracing vocabularies and skill-sets that lie outside the purview of any one discipline – if one is doing it with integrity and rigour, they are probably redefining it.

> 'Interdisciplinarity' often functions apophatically; it announces an absence, expressing our dissatisfaction with current modes of knowledge production. It contains a collective unconscious of worries about the changing place of knowledge in society, and expresses a feeling that the academy has lost its way.
>
> *Frodeman 2010: xxxii*

This section, in fact this entire book's function, is not to survey or critique the various modes, models or articulations of interdisciplinarity, but rather to share real-life examples of how performance engages across disciplinary boundaries while exploring a new mechanism of capture and analysis that allows a witnessing of knowledge as process – a tool born of Performance Practice – and with this, the possibility of new emergent knowledge(s). There are some excellent accounts written around the problematics and riches of interdisciplinary scholarship, including: Klein 1990 & 2006; Sousslouf and Franko 2002; Nicolescu 2002 & 2008; Miller et al. 2008; Moran 2010; Foshay 2011; Frodeman, Klein and Mitcham 2010; Repko 2012; Holland 2014; Weingart and Padberg 2014; and Graff 2015. Without these foundational texts we would not be able to have the conversations that take place within this book, conversations which allow a component of Performance Practice, in the *active aesthetic*, to act as the fulcrum through which we articulate new knowledge(s) born from the places between disciplines.

Up to this point, this chapter has looked at disciplinarity, plotting a path from the early Greeks through the Middle Ages, through the Enlightenment, to the development of a formal account of science and then to the blurring of boundaries in the last century and with this the formation of the interdisciplinary programmes

of the 'studies' and the development of prejudices against performance practice as a valuable mode of knowledge production. Throughout this journey we have seen a reoccurring set of separations around expressions of knowledge which have included tensions between *techne* and *episteme*, *epistemological* and *hermeneutic*, *theory* and *practice*, *meaning* and *meaning making* and *doing* and *thinking*.

Barthes was not wrong when he stated that interdisciplinarity is 'not the calm of an easy security; it begins effectively (as apposed to a mere expression of a pious wish) when solidarity of the old disciplines breaks down'. And with this he refers to an 'epistemological slide', opposing this to an all important 'break' (Barthes 1977: 155):

> He did not want to suggest some conscious decision to re-ground theory on a new foundation. Instead he sought to challenge the very notion of *foundation* through the *event of structure*. Once one takes the idea of structure seriously, one has to recognise that knowledge and learning are the effects of movements that are not within the *realms of decision and knowledge*.
>
> *Bryon 2009: 139–140; added emphasis*

The institutional versions of the realms of decision and knowledge help determine the ways in which we measure, support and evaluate knowledge and knowledge production. They also determine modes of acquisition:

> The object of inquiry is often defined by one discipline, thereby entitling their methodological approach and epistemology, imposing a particular set of values – epistemological sovereignty.
>
> *Miller et al. 2008: 46*

The British Academy's 2016 Report *Crossing Paths: Interdisciplinary institutions, careers, education and applications* recognises this problematic, but at the same time encourages researchers to engage across disciplines only *after* establishing themselves in an 'academic home' (please note, IDR refers to Interdisciplinary Research):

> We recommend that researchers should aim to develop an academic home, a secure base from which to carry out IDR. An academic home consists in those critical elements that allow researchers to build a career, including expertise in core methods; a set of publications within a disciplinary area; ability to teach core courses in a discipline; and professional networks forged by attendance at conferences.
>
> *British Academy 2016: 3*

This gets complex when the models of evidencing knowledge and the processes of knowledge production live within completely different aesthetics, vocabularies and ways of documenting/capturing valuable outcomes across disciplines. Throughout this chapter I have been attempting to illustrate that disciplines are not the custodians of knowledge, but that knowledge is an active process often born of the crossing

and colliding of disciplinary concerns. Further, the need for a solid establishment within an 'academic home', which customarily is situated within a home of departmental 'study', often fails to adequately recognise identifying modes and processes of knowledge. This becomes particularly difficult especially for performance practitioner/researchers, when the institutional home of your discipline resides in an epistemic community that does not necessarily hold practical expertise in your discipline and further, when it is the leadership within this epistemic community that validates or negates one's production of knowledge.

The British Academy report recognises this to some extent:

> Evaluation is key to many of the barriers to pursuing IDR. Many of the reasons for avoiding interdisciplinary projects relate to the fact that it is harder to publish outputs; such work is perceived to have less value to hiring and promotion panels; and one is less likely to be selected for submission to REF. However, none of these barriers is an essential aspect of IDR and they can be addressed by better and more appropriate evaluation.
>
> *British Academy 2016: 4*

What constitutes better and more appropriate evaluation across the sciences and humanities has yet to be determined, and despite recognition that interdisciplinary exchanges offer productive spaces for innovation and impact, HE institutions and government, at the most basic of levels, perhaps unknowingly, impede this type of work systematically. The Stern Report (an independent review of the last cycle of UK-based research evaluation exercises) reveals a sense that interdisciplinary work has been disadvantaged through disciplinary 'silos', which we can safely assume are directly correlative with disciplinary constructs:

> interdisciplinary work was often regarded less favourably than mono-disciplinary research. Such perceptions may have contributed to the relative underrepresentation of interdisciplinary outputs in RAE/REF compared with the known proportion of such work revealed by other bibliometric surveys of UK interdisciplinary research. In contrast the interdisciplinary contributions to impact case studies featured strongly.
>
> *Stern 2016: 15*

The Stern report states that despite the British Academy's aforementioned report, which identified the essential role of interdisciplinary research in addressing complex problems and research questions posed by global social, economic, ecological and political challenges, '… [t]here is a concern that institutions were risk averse in submitting interdisciplinary work. We think that it is vital that interdisciplinary work is submitted, assessed and rewarded through the REF…'. (Stern 2016: 28)

When it comes to interdisciplinary exchanges between performance and other disciplines, it is worth remembering, as Frayling so clearly pointed out, that '[t]he

concept of humanities research as discovering new perspectives, or new information, is actually a very recent formulation'. In addition, 'prior to the turn of the century the word [Research] predated the division of knowledge into arts and sciences' (Frayling 1993: 4).

In advocating for the arts some strategies, while meaning well, can cause more harm than good. Senator Kim Carr, at the time Northern Australia's Minister for Innovation, Industry, Science and Research, said of the creative arts: 'We should support these disciplines because they give us pleasure, knowledge, meaning, and inspiration. No other pay-off is required' (Carr 2008). This is not an uncommon approach for many hoping to champion the arts; unfortunately, it does not necessarily help the situation. To say that the arts, especially when engaged in as part of scholarship and research, should merely be permitted to exist because they give a different sort of 'pleasure, knowledge, meaning, and inspiration' is undermining. This gives the impression that it is difficult to measure rigour in the arts. Such reasoning perpetuates the previously mentioned misperception of the arts living solely on the side of subjective meaning making and hermeneutics, with the sciences on the side of objective knowledge production and epistemology.

When the 1998 Australian Strand Report tried to address 'a way forward as agreed by the academic creative arts community, by which government and institutions could address inequities and marginalisation within their respective spheres of operation', similar problems occurred. As Wilson points out, in the 'years since its release only limited progress has been made and many of the same concerns remain'. This may be because the nature of this inequity is not really understood. She proposes that 'the creative arts should be recognised not because of their similarity or equivalence with the prevailing disciplinary powerbase, but for their contribution to the furtherance of knowledge in their own fields and their value to Australian society as a whole' (Wilson 2011: 75).

This would certainly go some way towards solving the problem; however, it still remains that even though we are getting better at evaluating within our own fields, when we cross disciplines, challenges of and prejudices within evaluation are still present.

Frodeman, reflecting on the assumptions to do with 'rigour' as measured across disciplinary 'camps' offers this:

> we should be alive to the dangers of disciplinary capture, where new questions become just one more regional study or specialist's nook, as has happened with most new attempts to make connections across varied domains. At the very least, if we are going to have a philosophy of interdisciplinarity, it should be complemented by philosophy *as* interdisciplinarity.
>
> *Frodeman, Klein and Mitcham 2010: xxxiii*

In looking at the notion of philosophy *as* interdisciplinarity, or *as* disciplinarity for that matter, the research project identified as *Practice Theory*, (Schatzki, Knorr and Savigny 2001), while seemingly a possible avenue into understanding of knowledge

as process, a movement that some of the work included in this book could possibly fit within, at this juncture is too wide a project to offer a rigorous organised operational lens for the context of this project.[9]

However, the collective research project, active largely in the UK and throughout Europe, concerned with 'Practice − (as/based/led/and) − Research' in the arts has been a veritable breakthrough. You will find that most of the contributors to this book have passed through some version of this collective research project in one guise or another, and as a result the community within this book project comes from Europe and the UK. However, there is no reason why this work could not also be applied further afield. It was deemed at least in this first instance more effective to disturb conventions within a shared language and culture of evaluation with this conceptual understanding as to what interdisciplinary scholarship and 'Practice − (as/based/led/and) − Research' is in the arts solidly before rippling out.

One can begin to plot the journey of the research project 'Practice − (as/based/led/and) − Research' in the arts through an examination of the working papers and documents published on the websites of PARIP (Practice as Research Performance) and PALATINE (Performing Arts Learning and Teaching Innovation Network) and also in the influential books of such advocates as Smith and Dean 2009, Barrett and Bolt 2010, Biggs and Karlsson 2010, Kershaw and Nicholson 2011, and Nelson 2013. These scholars are all champions of research in the arts who have helped to bring arts practitioners into the realm of rigorous scholarship, offering case studies from such expressions of knowledge making as studio-based work, applied applications and intermedial performance while elaborating on methodologies, theoretical contextualisations, and framing of processual outcomes. They offer advice and examples on modes of archiving and documentation for the artistic practitioner/researcher and share how research can impact positively on creative practice through research-led practice.

Nelson's book is of particular note, as he interrogates issues concerning what knowledge is and how it is expressed across disciplines. Committed to 'creative cross overs in an interconnected academy' that includes arts research that 'demonstrates a rigour equivalent to that of the sciences', he argues for a 'both-and' type of epistemological space which includes 'a more fluid "knowing"... which might be located on the spectrum between types of knowledge rather than on the reverse side of an impervious "knowledge/not knowledge binary"' (Nelson 2013: 23 & 39).

In his oft-cited diagram titled 'modes of knowing: multi-mode epistemological model for PaR' (2013: 37), Nelson triangulates a conceptual relationship among know-how ('Insider' close-up knowing), know-what (the tacit made explicit through critical reflection) and know-that ('outsider' distant knowledge), with Arts Praxis (theory imbricated within practice) at the centre as a dynamic for the practitioner/researcher working within the current institutional, funding and scholarly paradigms. This is an interesting way to negotiate the *episteme/techne* tensions that have been traced in the previous pages through the history of disciplinarity.

However, and understandably, even while advocating for the performance-practitioner/researcher, things get a little muddled when framing the various dynamics of 'performance' and their functions within the operations of Practice as Research. When Nelson addresses how performance arts pose challenges for inclusion in an 'already contested site of knowledge-production' (Nelson 2013: 3), he offers:

> Numerous instabilities in the diversity and ephemerality of *performing arts practices* pose particular challenges to ideas of fixed, measureable and recordable 'knowledge'. At the same time however, the concept of *'performance'* has contributed a new *conceptual map – and mode of knowing –* to the academy and to research. In McKenzie's formulation, 'performance' will be to the twentieth and twenty-first century what discipline was to the eighteenth and nineteenth, that is an onto-historical formulation of power and knowledge. Indeed, *'performance'* and the *performative* have become influential concepts in a number of academic disciplines.
>
> *ibid.: 4; added emphasis*

Connecting 'Performance Practice' and 'Performance', and, through the drawing on McKenzie, 'Performance Studies', we see another example of the *ways* Performance Practice as a *process of knowledge making* can get absorbed into and mutated within the faculties and academic environment of Performance Studies, especially when, to be considered rigorous, one needs to bend to Performance Studies' *conceptual maps – and modes of knowing –* modes of knowing that do not necessarily hold expertise or even correlate with the *way* Performance Practice *activates* knowledge. As argued in earlier sections, Performance Studies can often appropriate 'performance' as an *object of*, rather than *process as* study. As a result, although there have been new opportunities for the performance-practitioner/researcher working within scholarly environments, they can come at a cost. Performance practitioner/researchers often have to *adjust* the scholarly records of their processual work into a disciplinary culture that does not necessarily hold the expertise to evaluate, capture or recognise the *ways* that their *practise* generates knowledge in the *act* of practise. So often active aspects of practise, *the actual doing of the practise*, gets left behind as arbitrary or moulded into archival and documentary[10] modes of capture in line with philosophical lenses and methodological frameworks that can skew the operational content of its knowledge as it is *activated* in the *act* of practise. The performer practitioner/researcher often finds that they have to leave key ineffable, non-hermeneutic, pre-representational aspects of their knowledge behind, as there are few accepted rigorous ways to articulate or document these elements within the academic culture for which they are being evaluated.

The *active aesthetic* aims to offer a complementary tool, which could be used alone or alongside documentary practices and also applied philosophical and methodological frameworks such as phenomenology, performativity, liminality,[11] embodied cognition and other branches of cognitive science.

Perhaps one of the most important possibilities in the offer of an *active aesthetic* is that rather being designed as an *advocate* for the performance-practitioner/ researcher helping to *validate* a practice within the unfolding story of disciplinarity, it offers an approach of enquiry born *from* Performing Practice for possible application across other disciplines. Recalling the embedded issues around the received *techne* and *episteme* divide, this may require a slight shift in *thought style*. Ludwik Fleck's notion of *thought style* speaks to one's:

> *Readiness for directed perception*, with corresponding mental and objective assimilation of what has been so perceived, characterized by specific problems of interest, by judgments which the *thought collective* considers evident and by methods which are applied as a means of cognition.
>
> *Wojciech 2016: 11; added emphasis*

Fleck's work predates Kuhn's much quoted notion of a 'paradigm shift' (Kuhn 1962). With this book, we are not calling for a Kuhnian revolutionary 'paradigm shift', which tends to indicate a break or a '*gestalt* change in which a new interpretation of the body of existing facts replace, and is *incommensurable* with, an existing theory' (Weiss 2003: 168). The *active aesthetic*, to be described in the next and final section and explored in the following chapters, *is* certainly *commensurable* with existing disciplines and theories. It is designed to be plural and inclusive. However, it might require a Flecktian *readiness for directed perception*, with a little shift in *thought style*, especially when encountered in the context of modes of evaluation and capture that are derived from *thought collectives* about performance and practice that stem from the select prejudices embedded in the history of disciplinarity revealed in the previous pages as perceived tensions between *techne* and *episteme*, *epistemological* and *hermeneutic*, *theory* and *practice*, *meaning* and *meaning making*, and *doing* and *thinking*.

As mentioned previously, Performance Practice can offer more than simply modes of representation and/or hermeneutic metaphors. The actual *practise* of the practices of performance need be not only self critical and intelligently contextualised but also often exact, falsifiable, repeatable, and methodologically rigorous in much the same ways that the sciences need to be. When Performance Practice is situated within disciplinarity solely for its hermeneutic and/or representational aspects and not for its activation of knowledge – operationally executed as hypotheses around what is possible, requiring well-organised experiments, testing and failing and then adjusting to constantly create new emotive, vocal and physical possibilities within a myriad of aesthetic, technological, embodied and disciplinary challenges – we lose some possible riches and rigour in its *ways* of *knowledging*.

Active aesthetic

As we begin the final section of this introductory chapter, I hope that we have enough evidence to conceive of knowledge as largely *activated* through natures of

exchange. Knowledge does not *reside* in a discipline as an object. Knowledge is *process*, is *active*, and *dynamic*. It is from this understanding that the concept of an *active aesthetic* was developed.

Importantly, no conceptual understanding, application or analysis of knowledge *capture*, mode of articulation or model of representation will *ever* be without *embedded ideological underpinnings*. The analytical/methodological concept of an *active aesthetic* was born in the West, and derived from an interdisciplinary enquiry around Western performance practices, originally opera, one of the most Western, exclusive and arguably elitist genres still in existence, which is ironically perhaps one of the reasons why it was conceived to cut so clearly across swaths of historical, textual, cultural and gender based assumptions. The analytical/methodological concept of an *active aesthetic* has been developed and articulated in the English language and has a heritage of publication, funding and practice that has resided within the conservatoire and university contexts in the US, Australia and the UK. It has been validated within the very programmes of the 'studies' (literary and performance) that were critiqued earlier, and the work deriving from it has been strategically framed as research projects within the exercise of 'Practice as Research' discussed earlier.

However, as you will see in the following pages, an *active aesthetic* is non-linear, does not subscribe to conventional rules of cause and effect, does not require narrative, includes both non-human and embodied forces of knowledge generation and acquisition, and does not discriminate between the physical or the ephemeral. Most importantly, it is self-reflexive, as, when applied to do so, it critiques both its applier and its application. While this does not render it (*as nothing can be totally*) unbiased and without social-cultural-linguistic-technological ideologies, if used mindfully, it can carve out a space to witness dynamics at play across and within disciplines, with somewhat less of an unintended influence of one's cultural baggage than perhaps other modes of knowledge capture that are born of disciplinary environments that are self-referential, self-mediating, self-confirming and self-evaluating.

It is these characteristics that make it particularly of value when looking at the ways knowledge *happens* across different scholarly cultures with differing languages, models of representation, skill sets and modes of evaluation:

> Interdisciplinarity represents the resurgence of interest in a larger view of things. As such, interdisciplinarity is inherently philosophical, in the non-professionalized and non-disciplined sense of the term ... It is a twentieth-century irony that just when antidisciplines were most needed the humanities withdrew into specialization. To be clear: this is not to place the discipline of philosophy over the other disciplines. It is rather to state that, in an ex post facto manner, the very search for and challenging of disciplinary standards is (or at least, was) philosophy. The corollary is that insofar as a field becomes disciplined it cannot offer the peculiar kind of insights that our times require... there never will be the interdisciplinary method any more that

there exists the scientific method…. [It] is a matter of *manner rather than of method,* requiring a sensitivity to nuance and context, a flexibility of mind, and an adeptness at navigating and translating concepts.

Frodeman 2010: xxxi; added emphasis

The *active aesthetic* is at its core a matter of *manner* rather than of *method* or *technique* – which is why we so often refer to the *way* of doing or a *practise* of a practice (to be explained in full in the next pages). As mentioned previously, it does not call for a revolutionary Kuhnian 'Paradigm Shift' but rather more a Flecktian adjustment to established '*Thought Styles*'. Also, it is not antagonistic but rather, again as already discussed, more *agonistic*.

Some background

The initial inquiry into an *active aesthetic* began in the last century with a PhD project on Integrative Performance Theory, which offered 'an anti-hermeneutic approach to opera' (Bryon 1998). Opera was chosen partly because it offered a complex relationship between skills and knowledges required, in addition to the multiple 'texts' that constitute its record. As mentioned earlier in this chapter (p. 12), opera was founded on the wish for an integrated art form but had systematically resisted the recognition of the *operations* of performance through which to realize this ideal. I argued that the history of opera could be seen as a history of a prejudice against the performer and the act of performance, largely because the received thinking and structures around teaching, doing, making, practising and performing opera revolved around the basic premise that the meaning of the work *resided* in the texts. So often, the texts of opera (music and libretto) are seen to be the custodian of meaning. In fact, the history of opera can be seen as a 400-year-old history of power struggles privileging word over music or music over word as primary custodians of a meaning seen as inherently residing in the texts – that the performer then has had to *depict* (Bryon 2005). To look at the dynamics of what creates meaning in the performance of opera, I expanded the notion of 'text' to include elements of the design, the directorial concept, certain dramaturgies, and even certain performance practices (especially when they adhere to set aesthetics, such as authentic instruments or gestural conventions). In essence, anything pre-scribed or pre-written became text.

What I argued was that meaning *happens* in the *act* of performance, rather than in the text(s). And further, within the Integrative Performance Theory, that this *actioning* happens between, across and among many aspects, including the *act* of performance, the *act* of lighting, the *act* of sets, the *acts* of the audience, the *acts* of front and back stage crew… and the *act* of the texts as they are engaged with as part of a dynamic non-linear web of an event.

Since it is the *event* that *happens* on the stage through the *act* of performance, to choose or be aware of the fields of *operations* that contribute to a *happening*

is essential if the desired effect is to have all these operations working together in a network to allow for that event.

Bryon 1998: iii

It is the *manner* of these operations that first brought forth the notion of an *active aesthetic* as a *way* of doing. What was once articulated as an anti-hermeneutic argument focused around the idea that meaning is not inherent in the text(s) and the texts are not the custodian of meaning. In this book project we have expanded the analysis from 'text' and hermeneutics to the problematics of disciplinarity, knowledge and epistemology. In this book we look at knowledge and disciplines and begin to consider how we may be able to articulate, through our interdisciplinary exchanges, knowledge as *activated* across disciplinary boundaries. This chapter has plotted a path that reveals how knowledge does not reside in a discipline. Knowledge is *process*, is *active*, is *dynamic*, and does not need to privilege or be designated as meaning in order to be considered as a process of *knowledging*. In the last three sections, 'The studies', 'Performing prejudices', and 'Interdisciplinarity and performance', we shifted the conversation regarding practice from that of representation and hermeneutics to more of an epistemological enquiry, exploring how '*ways* of doing' or '*practises* of a practice' are still not given their proper due as sources of unfolding knowledge, especially when practice becomes an *object* of enquiry.

Returning for a moment to the first two paragraphs of this introductory chapter, in discussing the act of reading this book and also this book as an active event of knowledge, one could ask: Where does the knowledge reside? How is it generated? How do you get it? How would you know? Is this book's knowledge within the print on a page, in the pixels on your screen? Does knowledge change with the way you hold the book or device? Is it affected by whether you own the book or are borrowing it? If you are in a library do you engage with it and it engage with you differently than if you are reading on the train? If you are reading it to find a quote does it perform differently than if you are considering its content on its own merit? If you are ill will the knowledge present in a different way than if you are relaxed, healthy and satisfied?

As you are reading this page there is you, the *reader* and the content, the *read*. The *active aesthetic* lives in a space between this: the *act of reading*. I posit that it is through the *act of reading* that the *reader* and the *read* will emerge. As you are *doing* the *act of reading*, what is involved in your *way* of doing? Are you skimming the pages to get the basic idea? Are you searching for things that apply to you? Are you connecting the ideas on this page to your own knowledge base? Are you trying to make sense of the ideas? Are you criticising the text as it unfolds? Are you thinking about what you might have for dinner tonight? Are you trying to focus as there are kids screaming in the background? What do you bring to the act of reading as far as attitude? Are you suspicious, eager, dispassionate, interested? What is involved in the *way* of doing?

In this thought exercise we ask what is the *doing* of your reading, the *doing* of the doing, the *practice* of the practice of this event of reading. What is involved in

your *way* of reading? This is the stuff of the *middle field* (to be discussed in the next section). You are not simply reading, but rather you are engaged in a *way* of reading, from which both you, the reader, and the book, as read, will emerge. Any knowledge gained or lost will be an emergent property not of the book, or of you, but activated in your *way* of the *act* of reading.

Middle field – an active field

Throughout this book, each chapter considers disciplinarity through a designated *middle field*, one of performing, practising, activating and/or making which happens before the product or outcome or knowledge is evaluated. We aim to witness and temporarily capture ways of *doing* as *process*, the qualities within the *activation* of *generating* a *process* before making an evaluation or grounding any dynamic within our own terms.

In my last book, which articulated an interdisciplinary performance practice (Bryon 2014), I introduced a new approach for analysing and working across physio-vocal-emotive performance practices. In this book I expand the idea to include different disciplines as they engage across various understandings of 'performance'.

A *middle field* can be considered as a field of 'performing', which lives *between* a 'performer' and the 'performance'; it is an *active* field. I posited that a performer does not do performance, but rather *does something* (performing) from which the performer and the performance emerge. In the last book, I argued that this *middle field* – which can be equated to the *doing* of the doing, or the *practice* of the practice, or the *way* of doing as opposed to the what, why and how of doing – is where a practitioner and their discipline can emerge, often simultaneously (Bryon 2014).

This is not to be confused with the notion of a liminal field, often called upon as a central tenet of Performance Studies. Unlike the liminal space, the *middle field* within the concept of the *active aesthetic* is not a between space linking a *linear* journey from performer to performance, but rather a dynamic middle space (a space of between-ness designated as a chosen event of temporary and subjective capture) where both the subject and object emerge. In fact, often one does not even know what the who/self/'subject'[12] (performer) or what the outcome/'object' (performance) are until after they emerge from a *middle field*. Knowledge and meaning can occur accidentally, surprisingly and serendipitously, which is exciting especially when considering the possibilities not only of interdisciplinary but transdisciplinary exchanges, to be discussed in the following pages.

In this work the *middle field* helps to collapse the subject and object binary. The *middle field* may live between the doer and the done, the maker and the made, the writer and the written, the reader and the read, the designer and the designed, the constructor and the constructed, the researcher and the research and the knower and the known.

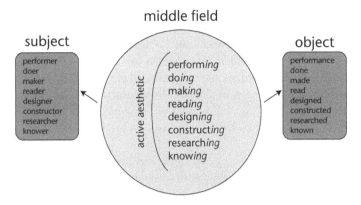

FIGURE 1.1

However, not every scientist, teacher, psychologist, cultural theorist, philosopher, applied theatre specialist or intermedial artist (all disciplines represented in the following chapters) carry out their practices in the same way. In fact, the knowledge of any discipline does not reside in the object of that discipline, nor does it reside in its crafts/faculties/texts/departments/methods/techniques/evaluations, but rather in the *practises* of its practice(s). Since what one *actually* does one actually gets good at, the ways in which the people *actually practise* within a discipline largely determine the qualities and rigour of that disciplinary movement at any one time. Any discipline's rigour, in this way, lives within its own *active aesthetic* as it *practises* its knowledge.

Declaring a *middle field* as a discrete category is exciting but also problematic, in that it does not fit easily into fundamental Western concepts such as reason, objectivity, reductive measurement and paradigms of cause and effect, or even intent. However, it is the stuff of the *middle field*, our *way* of doing, where I posit that knowledge *happens*.

Not surprisingly, conversations around interdisciplinarity often evoke notions of between-ness and middle spaces, largely because much of the exercise is that of witnessing the spaces between as the disciplines *practice* across and among each other. A common theme is in the embracing of the uncomfortable spaces of disciplinary exchanges. As Moran summarises, it's inherent in the terminology:

> As Geoffrey Bennington points out, 'inter' is an ambiguous prefix, which can mean forming a communication between and joining together, as in 'international' and 'intercourse', or separating and keeping apart, as in 'interval' and 'intercalate' (Bennington 1999: 104). This ambiguity is partly reflected in the forging connections across the different disciplines; but it can also mean establishing a kind of <u>undisciplined space in the interstices between disciplines,</u> or even attempting to transcend disciplinary boundaries altogether.
>
> *Moran 2010: 14; added emphasis*

The *active aesthetic* certainly carves out a space that is temporarily 'undisciplined' – not to be confused with unrigorous. Working with it is not a process of ordering, but rather a process of witnessing a semblance of disorder, a non-linear set of activities that do not easily fit into disciplinary categories or can necessarily be attributed to meaning in the ways that we have been conditioned to value. This is one of the ways that it allows for the discoveries of new knowledge and transdisciplinary possibilities. It is also why we, working within an *active aesthetic*, often refer to this as an 'uncomfortable space'. Others too have perceived it as a bit 'messy':

> But if a certain messiness goes with the territory of interdisciplinarity, this is also what makes that territory worth occupying. Interdisciplinarity, as Cathy N. Davison and Theo Goldberg put it, could be seen as 'a function of the uncontainability of what, in the history of ideas, is called 'the real.' It derives from the sense that objects (and subjects) of social and cultural life (real life, real conditions, real relations) exist beyond the constraints of analytic singularity and methodological rules' (Davidson and Goldberg 2004: 50). In its constant search for the uncontainable 'real', interdisciplinarity can disrupt the deceptive smoothness and fluency of the disciplines, questioning their status as conveyors of disinterested knowledge by pointing to the problematic nature of all the claims to scientific objectivity and neutrality.
>
> *Moran 2010: 180*

There is a modicum of discomfort in the resisting of certainty, with landing, categorising and labelling of things before one has a chance to witness dynamics in action. However, this is what makes it an *active* aesthetic rather than an aesthetic.

The process of working with an *active aesthetic* encourages the resistance to justifying things into tidy theoretical constructions, or post evaluations constituted within a scholarly *aesthetic*. Rather we aim, where and if possible, to allow things to *float* as active while witnessing what happens for as long as we can before any grounding or boxing or evaluating. We ask, what is happening? What is the doing of that doing, what is the practice of that practice? What is the doing of *my* doing as I witness this? What is my *doing* of my witnessing?

In fact, to live these questions, activated as a mode of awareness when executing difficult physical, vocal and emotive feats, is the often well-honed skill of the performance practitioner, a skill that as mentioned in the previous sections has been historically overlooked for its rigour and analytical merit, and would be arguably helpful at this time of disciplinarily development.

Practice (of practice)

This is not just an annoying tautology, I promise. The work of performance practitioners is often misunderstood when practice is considered and/or appropriated as an *object* of study. In Performance Studies, for instance, I argued previously that:

When Schechner looks at modes of performance that take years of training, such as ballet, Western opera, Chinese opera, and Noh, he calls these 'codifed acting', because such disciplines are for him 'based on semiotically constructed gestures and movements, songs, costumes, and makeup set by tradition and passed down from teacher to student by means of rigorous training' (Schechner 2002: 156). He says that in order for codified acting to be mastered one needs to 'begin very young when both mind and body are flexible' (158). Somehow Western acting training, no matter how rigorous, is excluded because 'one can begin to learn realistic or Brechtian acting relatively late in life because people have 'practised' daily behavior all their lives' (158)... I argue that, on a most basic level, is it not true that in actuality, codified or not, the years of training needed are not about the learning of positions and sequences of dance, or the memorizing of notes and phrasing of music, but rather the *way* in which to do these anew each time? It is not the signs and signifiers or the codes of performance that render the learning of these disciplines time-consuming, but rather the *act* of the doing, the *way* of practice. The codified performance emerges out of this way of doing, an active aesthetic, not as the performative object of an 'actor' activating codes. It is this *way* of doing, the *practice* of the practice that is passed down from teacher to student. It is this that takes the time and requires exactitude: not the learning of codes.

Bryon 2014: 49–50

Practice is not about what one appears to do, or even what an audience might receive as meaning. Performers at the top of their game do not just do what we often perceive. An actor does not do emotions, neither does a dancer do moves, or a singer do notes. There are a whole series of actions and tensions and happenings that must occur *before* any of these outcomes *emerge*. In fact, any performance practitioner or voice, acting and movement teacher will tell you that by the time a pirouette, a high C, or a dramatic line is executed it is too late to do anything about it. The work starts *before* this, anew each time as a dynamic set of actions, obstacles and happenings. (The usage of these terms, actions, obstacles and happenings, will be discussed more fully later.) It takes years to master and is sometimes ineffable and is not always linear and encompasses some things that are not of our bodies and some things that are. It also encompasses many aspects that are not of the realm of representation. What lives within this *middle field* can include felt senses, highly technical physical patterns of learned behaviour, involuntary muscle groups firing in exact ways, productive tensions, conscious acts, unconscious actions, the room, the floor, the nervous system, one's history, the day of the week, muscle and also emotional memory... and so much else.

Despite the fact that the words 'performer-performing-performance' can on the face of it indicate intention (as in from performer to performance), the *middle field*, as mentioned before, includes actions, obstacles and happenings that are not of the embodied or the intended kind. Within the *active aesthetic*, as mentioned earlier, prescriptions can include the movement of a set piece, a throw of light, the cough of an audience member – these all *perform* and live in the *middle field* of performing,

contributing to the event of the performance. Taking this a step further, out of the discipline of performance one could also apply this concept to the meditator, who meditates from the *middle field* of meditating, or to the driver, who drives from a *middle field* of driving. In each, what occurs in the various actions, obstacles and happenings within the *middle fields* of meditating and driving both allow for and determine the nature or quality of the driver and the drive and the meditator and the meditation. The knowledge is activated within the *middle field*, in the *practice* of the practice. Finally, to do with practice, an accomplished performance practitioner knows that one cannot repeat that note, that move or that line, but rather needs to return to a doing of the doing (which is never the same), in order to keep it alive and their practice one of excellence.[13]

Transdisciplinarity and emergence

As mentioned previously, an undisciplined space may not need to be unrigorous, especially if it allows for the emergence of new knowledge. Emergence, a term used in philosophy and in the human and physical sciences, is widely applied in discussions on interdisciplinarity, complexity and systems theory. It describes what parts of a system do together that they would not do alone, or how collective properties arise from the properties of parts. It can also speak to a system's function in that it can describe what something might do in relationship to its environment that it would not do by itself. Disciplines can be considered as such systems. In this way emergence is very much about the dynamic relationships between things and is an essential aspect in the application of an *active aesthetic*.

When we look at inter-, cross-, and trans-disciplinary concerns, where there is more than one practitioner, practice or discipline, new knowledge often happens in the *ways* of doing across, between and against disciplines. The *middle field* within the *active aesthetic* is about resisting the act of constructing, ordering, collating, categorising, labelling, determining, or evaluating the elements within a chosen event as much as possible, while understanding of course that no construct of capture that relies on any discursive pattern or is instituted by any agent or mediated by anything can ever completely escape these. It offers *a productive pause*.

The notion of transdisciplinarity sits at the heart of this concept. Nicolesu defined disciplinarity as one practice concerned with itself, as opposed to multidisciplinarity, a relationship which transgresses disciplinary boundaries while its goal remains limited to within the framework of disciplinary research. For him, interdisciplinarity transgresses the boundaries of disciplines while its goal still remains within the framework of disciplinary research. Interdisciplinarity even has the capacity to generate new disciplines, such as quantum cosmology, chaos theory and embodied cognition. Transdisciplinarity, however, 'concerns that which is at once between the disciplines, across the different disciplines, and beyond all discipline. Its goal is the understanding of the present world, of which one of the imperatives is the unity of knowledge' (Nicolescu 2002: 44). While the *active aesthetic*, as mentioned earlier, has no necessary agenda for a 'unity' and in fact

embraces conflict in much the way expressed in Chantal Mouffe's conceptual model of the agonistic,[14] the notion of emergence as applied by Nicolescu is apt. McGregor, speaking of transdisciplinarity, offers that a '*complicated* problem is hard to solve because it is intricate and detailed. A *complex* problem has the additional feature of emergence, the process of deriving some new coherent structures, patterns and properties' (2004: 2 added emphasis).

Coming from a feminist perspective, we get an aligned but differently positioned view, an important one in that it recognises *practice* as of the dynamic construction of knowledge:

> Nina Lykke delineated the concept of interdisciplinarity as transgressing 'borders between disciplinary canons and approaches in a theoretical and methodological bricolage that allows for new synergies to *emerge*' and is, thus, juxtaposed to the 'additive' approach of 'multidisciplinarity' and to 'transdisciplinarity' which goes 'beyond disciplines and beyond existing canons' (2010: 27). Interdisciplinarity, for most feminist theorists, *involves working at the interstices of disciplines, in order to challenge those boundaries as part of extending possible meanings and practices.*
>
> *Demény et al. 2006: 54; added emphasis*

When we try to evaluate and/or fit the languages, skill sets, processes and practices of different disciplines from and into one another before giving *pause* to work within and witness an *undisciplined space*, this often becomes complicated and unrigorous. Working at the interstices of disciplines in order to challenge those boundaries as part of extending possible meanings and practices can be *complex*, but is at the heart of knowledge generation.

Events, actions, obstacles and happenings

The use of the words 'event', 'action', 'obstacle' and 'happening' derive from various established text analysis methods designed for the actor and playwright, stemming from variations on Stanislavski's 'method of physical actions'. Because of this lineage they could be fraught with pitfalls of interpretation and representation. However, in the work of Integrative Performance Analysis their mechanisms were purposefully reconfigured, drawing from select poststructuralist theories (to be discussed in the following pages) towards wider applications across the disciplines of dance and voice and also for non-narrative theatre works including the postdramatic and intermedial (Bryon 2014). Here we take things a step further, towards a temporary *capture*, allowing for a witnessing of dynamics within *events* across disciplines that lie outside that of performance. The usage of these terms is extended to not solely create a 'reading' or 'construct' a meaning, but rather to *capture* a chosen set of dynamics in action. For this usage, as part of an *active aesthetic*, they help to hone in on the activities within the *middle field* and as such are non-linear and non-narrative and as little *depictorial* as possible.

As many of the authors within this book do, one can work with the concept of the *middle field* without utilising the exact terms 'event', 'action', 'obstacle' and 'happening'; however, a little insight into the conceptual underpinnings of these terms is useful in order to understand in which ways the conceptual model of the *active aesthetic* allows one to drill down, excavate and/or zoom out around a chosen *event*. The terms also show how the *active aesthetic* offers an active mechanism of capture for chosen *moments* and to witness the *ways* of doing before landing, categorising, or evaluating within disciplinary constraints.

Most simply, an *event* is what happens. It is made up of a series of *happenings*. Happenings are made up of *actions* against *obstacles* (not necessarily bad things, they can also be productive resistances). I try to do something, I hit resistance, and something happens. A series of happenings make up an event. But it does not necessarily have to be embodied in or even perpetrated from an 'I'. An object, a chemical, an atom can come up against resistance as an obstacle and happenings will also emerge, and, importantly for cross-disciplinary work, so can *thought styles* and *thought collectives*, along with the actions and obstacles that live within their *events* of disciplinary structure (recall Fleck mentioned earlier on p. 36).

The notion of *event* is in this instance not a 'story' in service of a narrative, but rather a temporary bracketing to contain the shifting template allowing for the witnessing of dynamics within the *middle field*. Every event is singular and subjective, offering a possibility for observation around forces of *knowledging* and its *ways* of practice. In my last book, drawing on Jacques Derrida (1988) and Roland Barthes (1977), who laid the groundwork for a possible reversal in the order of aesthetic interpretation, I speak to the notion of *event* and the ways it can offer an integrative performance analysis across the disciplines of dance, singing and acting as part of an *active aesthetic*.[15]

> After exploring an expanded understanding of what we mean by *text*, we as performers might find a newfound freedom. Within this freedom there is also *responsibility*. Derrida argues in *Signature Event Context* that a text's essential undecidability leads to an intensified interpretive responsibility. No interpretation or reading can appeal to some context as a pre-given ground, for a context itself is an issue of interpretation. As performers we both interpret and re-interpret our directors', choreographers', conductors' and teachers' readings of everything from the play, the song, or the combination to the instruction of an exercise in the studio. Each interpretation or reading is, therefore, a decision. If texts are essentially undecidable, and if each reading is an event—and not just the replication of a pre-given meaning— then this raises the stakes of interpretation.
>
> *Bryon 2014: 43–44*

Within the *active aesthetic* the idea of responsibility is crucial. As mentioned earlier, there can be no hiding behind the objects of disciplinarity when one considers the *way* of doing as the dynamic from which knowledge emerges. As such, a text, a

move, a sound, a device, a mode of experimentation, a mode of analysis or a methodology is an event that has a certain force and effect that exceeds intention, but for which we nevertheless and most importantly need to be responsible. It is in this way that the *active aesthetic*, drawing from performance practice, is responsible and also able to respond to the dynamics for and from which it operates, while holding other disciplinary devices and their operators under the same scrutiny.

While Derrida and Barthes were prime forces in the discussion of event within the poststructuralist tradition, Gilles Deleuze, who identified as a transcendental philosopher, saw things from other angles partly because, unlike Derrida and Barthes, he was not a literary theorist. His concepts have influenced the notion of the *middle field*. Like Derrida and Barthes, he argued that there was no given grounding or authorising foundation by which we act/perform or perceive, but rather that *what meaning is* is created and generated in a between place. Colebrook summarises this alternative position: 'we can select and assess our values, not by giving them some ultimate meaning, or foundation but by looking at what they *do*. Ask, he insisted, not what a text means but *how* it *works*.' She further explains that 'Art, Deleuze argued, is not just a set of representations; it is *through* art that we can see the *force* and creation of representations, how they *work* to *produce* connections and 'styles' of thinking' (Colebrook 2002: xxxii; added emphasis).

In addition to this, for Deleuze, event is about *becoming*. It is *dynamic*, in *process* with both the particular and the whole, happening simultaneously in a *live web*. Deleuze's *becoming* is not the leaving of one thing and landing in another, but rather a characteristic of every aspect within an event. So for Deleuze it is not about measuring event by the change that happens from one to another but that rather we live in a sort of constant production of change-ness, or in the flow of becoming. Events are events because they live in change, in a constant becoming, as they produce in the flow of becoming. In this way we could conceive that everything is a series of *ways* of doing; *middle fields* to *middle fields* to *middle fields*, with constant emergences of subjects and objects becoming determined as the subjects and objects of disciplinarity – and further that that event of *becoming determined* also has a *way* of doing, a *middle field*.

The non-linear aspects of this active architecture relate to the notion of a *live web* and are somewhat holographic in nature.[16] The happening of one moment can at the same time be an obstacle of another moment and the action of yet another.

Taking the example of reading this book in the first pages, one could look at it as an event of 'scholar reads'. Everything within this event, including the comfort or discomfort of the clothing that the reader is wearing, to the noise or quiet of the library they are sitting in, to the content of the paragraph they are reading, to the familiarity or unfamiliarity of the terms in the text, to the flickering light in the ceiling, to the company they have with them, will perform a function as an action, obstacle and/or happening at any one time. The flickering of the light might be a *happening* deriving from the *action* of electricity hitting the *obstacle* of an electrical short within the library's walls; and that flickering (happening) could then also, at the same time, be an *obstacle* for the reader as she endeavours to engage in the *action*

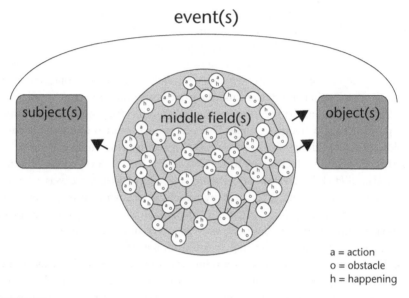

event(s)

subject(s)

middle field(s)

object(s)

a = action
o = obstacle
h = happening

FIGURE 1.2

of comprehending the text, creating the *happening* of heightened concentration, which could be an *obstacle* for her friend doing the *action* of trying to get the reader's attention, creating the *happening* of frustration; this in the *event* of Scholar Reads. The *middle field* is like a shifting template that can be zoomed out and/or drilled down. The above could simply be one little happening in a larger event, 'a day of study', or could be drilled down into, allowing one to get even more specific for the event 'library lighting fails'.

In this way everything is considered under the temporary umbrella of a chosen event as part of an active framework, to allow for the witnessing of things that may lie outside the usual disciplinary thought styles and methodological filters. The first step when exploring the implications of an interdisciplinary exchange as an event is to ask: What happens when this event occurs? What happens in the middle space between the doer and the done? What are the *doings* of the doings, the *practises* of the practices? Where are the resistances, and what are emergent properties of these actions against these obstacles? Of course, as mentioned multiple times now, this is going to be subjective and will not offer a perfect non-biased perspective, but if approached from a spirit of witnessing rather than judging or diagnosing or justifying or pinning down to one's own disciplinary methodology, and rather from a spirit of entering into the middle of the thing as a mode of practice, this way of noticing and exploring disciplinary activities as they work across disciplinary boundaries as they clash, cross and collide and *perform* could possibly offer new insights. We of course need to take into account and be responsible for and able to respond to our own disciplinary filters and also of course those embedded even in this notion of an *active aesthetic*.

The exercise is not about finding labels, correlative behaviours/practices, common or uncommon languages, but rather noticing dynamics in action as content before allowing them to get too sticky and attaching to stories, or narrative, or a linear cause and effect paradigm, allowing instead for temporary capture and reflection. We resist the need to work out what each element's role is in the context of our own disciplinary thought style, and rather just pause for a moment to allow a space to witness the possibility that *everything* is doing *something active* within the *event*, helping to create all that we conceive of as knowledge. And further it is the *doing* of this doing, the *ways* of this doing, the *practice* of this interdisciplinary exchange that *generates* a *process* of *knowledging*.

Notes

1 Here the term *agonistic* borrows directly from the works of Chantal Mouffe (2000a; 2000b; 2005a; 2005b; 2005c). Her conceptual model takes into account the complexities of the human condition, and embraces conflict, in much the same way the *active aesthetic* does to engage across realms of discourse: 'the lack of "agonistic channels" for the expression of grievances tends to create the conditions for the emergence of antagonisms which, as recent events indicate, can take extreme forms and have disastrous consequences' (Mouffe 2005c: 230).

2 Flyvbjerg (2001), however, resurrects this virtue in the effort to 'redress the imbalance between the intellectual virtues by submitting the concept – to a current reinterpretation in terms of the needs of contemporary social science' (p.4). For the purposes of the chapter, the imbalance is the context whereby the various sets of dualisms to be discussed were created.

3 For a critical look at the history of opera and the ways in which the genre has resisted the *act* of *practice* as the custodian of meaning see: Bryon (2005).

4 For a good summary of the key arguments surrounding 'gendered situated knowledge' see Anderson (2015).

5 Although beyond the scope of this book, it is interesting to note that Descartes and Kant both based many of their purportedly 'scientific' ideas on religion. Kant's ethics essentially requires a god. However it could be said that in Kant's third critique he actually sought to subjugate aesthetics to make it understandable solely on epistemological grounds.

6 The following three sections are adapted from my recent article, *Transdisciplinary and interdisciplinary exchanges between embodied cognition and performance practice: working across disciplines in a climate of divisive knowledge cultures* (Bryon 2017: 2–20). The article offers specific account of the complexities of working across the disciplines of Cognitive Science and Performance Practice(s) but in these next sections is expanded to speak to the problematics of disciplinary validity when performance practice crosses disciplinary boundaries, more generally setting the stage for the following nine chapters within this book.

7 Interestingly, even Sokal, after drawing so strongly from Gross and Levitt with the epithet 'right wing', had to clarify – however, only in a footnote. 'In this footnote I have also engaged in the habit – followed ritually throughout the essay – of tagging Gross and Levitt with the epithet 'right wing'. Of course, this epithet is inaccurate: Gross is a curmudgeonly old-fashioned liberal and Levitt is a member of the Democratic Socialists

of America. But even if Gross and Levitt were hard-core right-wingers, how would that affect the validity or invalidity of their arguments?' (Sokal 2008: 28).

8 For a more detailed analysis of the development of Performance Studies and its key tenets, including performativity and liminality, see (Bryon 2014: 35–52). In it, I posit that the very fact that Performance Studies has roots in social sciences and literary theory is significant to the way in which performance has come to be defined and performance practice has been somewhat compromised.

9 At this juncture to fully align this work with that of 'practice theory' may be premature. I expect that we would land in the same difficulty as we have with Performance Studies, for many of the same reasons articulated within the previous section, including the problem that the term 'practice' has been appropriated and very widely redefined. In the introduction of *The Practice Turn* (2001), Schatzki writes 'Practice theory is one horizon of present social thought. This introduction has sought to articulate this approach as a loose, but nevertheless definable movement of thought that is unified around the idea that the field of practices is the place to investigate such phenomena as agency, knowledge, language, ethics, power, and science. Despite this shared conviction, practice thought encompasses multifarious and often conflicting intuitions, conceptions, and research strategies' (2001: 22–23).

10 While there has been valuable work done in this area most notably in the work of Henk Borgdorff, outlined in his *The Conflict of the Faculties: Perspectives on Artistic Research and Academia* (Leiden University Press: 2012), and Robin Nelson's *Practice as Research in the Arts: Principles, Protocols, Pedagogies, Resistances* (Palgrave Macmillan: 2013), both leading advocates for artistic practice led/as/based research and both offering solutions around the problematic of knowledge capture for artistic practice, as Nelson points out: 'Piccini and Rye have in parallel concluded that, unless praxis can be directly experience[d], assessment is typically made by way of documentation that always inevitably (re)constructs the practice such that the thing itself remains elusive' (2013: 5).

While we are all working to find a way, we have yet to find an equitable solution especially in those instances where we get scholars who do not practise measuring the value of knowledge in the *act* of practice within research and funding exercises. In working with practitioner/researchers for many years now there are concerns when one is asked to 'represent' their practice in multi-modal, often visual, audio, and text based ways. When one masters these practices of 'representation' through discursive media and select technologies, they can be deemed rigorous. In these instances an erudite audio/visual representation of a 'practice' can get funding and recognition way beyond the scope of its actual field of 'practising' and likewise, interesting and dynamic practices can be overlooked when the practitioner does not practise the disciplines of visual, audio or discursive/technical representational modes. While there is not likely to be a perfect solution in such instances, the *active aesthetic* may be able to offer a complimentary tool for expressing the processes of generating knowledge in the act of practice.

11 For a more detailed examination of the problems around the uses of the term 'liminal' in relation to performance practice, see the section 'Liminality and the Interdisciplinary Event' in (Bryon 2014: 47–49).

12 For a more detailed discussion of the concept of the 'performing self', see Bryon (2014: 20–34).

13 For a more detailed discussion of ways to work with presence and repeatability, see Bryon (2014: 63–95).

14 See endnote 9.

15 For more on how this type of extended analysis across the performance practices of dance, singing and acting is possible, see Bryon (2014: 191–214).

In place of the old linear, mechanistic thinking, new conceptual frameworks have evolved that view the world more as a network of regulating dynamic relationships and patterns. Complexity theory, nonlinear dynamics, systems theory, chaos theory, the holographic principle and emergence theory are just a few. In my previous work the holographic principle is featured, as 'the way a holographic film or plate looks to the eye is nothing like the picture of what it will project; instead, it looks like a bunch of irregular ripples, reflecting the collision of and crossing between the two split beams, like the ripples made by two separate stones being thrown into a pond. The criss-crossing of these 'ripples' is called the interference pattern, and this is what creates the hologram. Where this gets really interesting is that if you hold a holographic film or plate projecting an image of, say, a hat in your hand and then drop it to the ground, shattering it into pieces, not all is lost. With a hologram, if you were to project a portion of the film you would not see a small part of the hat but rather the entire hat, just faded. The crux here is that all the information from the interference pattern is distributed evenly across the surface, offering a record of the entire image even from a small portion of the film/plate. In essence: the part is in the whole and the whole is in the part. When working with the *active aesthetic* one often observes that a happening or action contains the information of the entire event and visa-versa' (Bryon 2014: 56–57).

References

Anderson, E. (2015) Feminist Epistemology and Philosophy of Science. In: Zalta, E. N. (Ed.) *The Stanford Encyclopedia of Philosophy*. Available at: https://plato.stanford.edu/archives/fall2015/entries/feminism-epistemology

Bardi, G. (1578) Discorso mandato a Giulio Caccini detto romano sopra la musica antica, e '1 cantar bene. In: Palisca, C. V. (Ed. & Trans.) (1989) *The Florentine Camerata: Documentary Studies and Translations*. New Haven, CT: Yale University Press.

Barrett, E. and Bolt, B. (Eds) (2010) *Practice as Research: Approaches to Creative Arts Enquiry.* New York, NY: I.B. Taurus.

Baltzly, D. (2014) Stoicism, In: Zalta, E. N. (Ed.) *The Stanford Encyclopedia of Philosophy*. (Spring 2014). Available at: https://plato.stanford.edu/archives/spr2014/entries/stoicism/

Barthes, R. (1977) *Image, Music, Text*. London: Fontana Press.

Begley, C. G. and Ellis, L. M. (2012) Raise standards for preclinical cancer research. *Nature.* 483. pp. 531–533. doi:10.1038/483531a

Bennington, G. (1999) 'Inter'. In: McQuillan, M., MacDonald, G., Purves, R. and Thomson, S. (Eds) *Post-Theory: New Directions in Criticism*. Edinburgh: Edinburgh University Press. pp. 103–119.

Biggs, M. and Karlsson, H. (Eds) (2010) *The Routledge Companion to Research in the Arts.* Abingdon: Routledge.

Boghossian, P. (2006) *Fear of Knowledge: Against Relativism and Constructivism*. Oxford: Oxford University Press.

Borgdorff, H. (2012) *The Conflict of the Faculties: Perspectives on Artistic Research and Academia.* The Hague: Leiden University Press.

Bridges, D. (2006) The disciplines and the discipline of educational research. *Journal of Philosophy of Education*. 40(2). pp. 259–272. Available at: http://onlinelibrary.wiley.com/doi/10.1111/j.1467-9752.2006.00503.x/full

British Academy. (2016) *Crossing Paths: Interdisciplinary institutions, careers, education and applications*. Available at: www.britac.ac.uk/sites/default/files/Crossing20Paths20-20Executive20Summary.pdf

Bryon, E. R. (1998) *The Integrative Performance Theory: An Anti-Hermeneutic Approach for Opera*. PhD. Melbourne: Monash University.

Bryon, E. R. (2005) Pedagogy, performance theory & historic prejudice in opera. *Voice and Speech Review*. 3. pp. 287–294.

Bryon, E. R. (2009) Experience interdisciplinarity and embodied knowledge: Towards an active aesthetic using integrative performance practice. In: *Tanz im Musiktheater – Tanz als Musiktheater. Beziehungen von Tanz und Musik im Theater*. Bericht über ein internationales Symposion, Hannover 2006. Würzberg: Königshausen & Neumann. pp. 135–146.

Bryon, E. R. (2014) *Integrative Performance: Practice and Theory for the Integrative Performer*. Abingdon: Routledge.

Bryon, E. (2017) Transdisciplinary and interdisciplinary exchanges between embodied cognition and performance practice: Working across disciplines in a climate of divisive knowledge cultures. *Connection Science*. Vol. 29:1. pp. 2–20.

Carr, K. (2008) *The art of innovation: Address to the national press club*. Available at: http://archive.industry.gov.au/ministerarchive2011/carr/Speeches/Pages/THEARTOF INNOVATION-ADDRESSTOTHENATIONALPRESSCLUB.html [Accessed 22 August 2016].

Christensen, B. (2005) *The problematics of a social constructivist approach to science*. CLCWeb 7.3.1. Available at: http://docs.lib.purdue.edu/clcweb/vol7/iss3/1

Colebrook, C. (2002) *Understanding Deleuze*. Crows Nest, NSW: Allen & Unwin; London: Orion [distributor].

Collini, S. (1998) Introduction. In: Snow, C.P. (Ed.), *The Two Cultures (canto classics)*. Cambridge: Cambridge University Press, pp. vii–xxiii.

Collins, H. M. (1985) *Changing order*. London: Sage.

Conquergood, D. (2002) Performance studies, interventions and radical research. *The Drama Review* 46(2). (T174). New York University and the Massachusetts Institute of Technology. pp. 145–153.

Costello, W. T. (1958) *The Scholastic Curriculum at Early Seventeenth-Century Cambridge*. Cambridge, MA: Harvard University Press.

Creath, R. (2014) Logical Empiricism. In: Zalta, E.N. (Ed.) *The Stanford Encyclopedia of Philosophy* (Spring 2014). Available at: https://plato.stanford.edu/archives/spr2014/entries/logical-empiricism/

Davidson, C. and Goldberg, D. T. (2004) Engaging the humanities. *Profession*. pp. 42–62. Available at: www.jstor.org/stable/25595777

Demény, E., Hemmings, C., Holm, U., Korvajärvi, P. and Pavlidou, T-S. (2006) *Practising Interdisciplinarity in Gender Studies*. York: Raw Nerve Books.

Derrida, J. (1988) *Limited Inc*. Evanston, IL: Northwestern University Press.

Erickson, M. (2005) *Science, Culture and Society: Understanding Science in the Twenty-First Century*. Cambridge: Polity Press.

Fleck, L. (1979) *Genesis and Development of a Scientific Fact*. In: Trenn, T. and Merton, R. (Eds) (Trans. F. Bradley and T. Trenn). Chicago, IL: The University of Chicago Press.

Flyvbjerg, B. (2001) *Making social science matter: Why social inquiry fails and how it can succeed again.* (Trans. Sampson, S.). Cambridge: Cambridge University Press.

Foshay, R. (Ed.) (2011) *Valences of Interdisciplinarity: Theory, Practice, Pedagogy.* Edmonton: AU Press.

Foucault, M. (1972) *The Archaeology of Knowledge and the Discourse on Language.* (Trans. Sheridan Smith, A. M.). New York, NY: Pantheon Books.

Foucault, M. (1991) Politics and the Study of Discourse. In: Burchell, G., Gordon, C. and Miller, P. (Eds) *The Foucault Effect: Studies in Governmentality.* Chicago, IL: University of Chicago Press. pp. 53–72.

Fuller, S. (1993) *Disciplinary Boundaries and the Rhetoric of the Social Sciences.* In: Messer-Davidow, E., Shumway, D. R., Sylvan D. J. (Eds). *Knowledges: Historical and Critical Studies in Disciplinarity.* Charlottesville, NC: University of Virginia Press. pp. 125–149.

Frayling, C. (1993) *Research in Art and Design.* Royal College Research Papers, 1(1). pp. 1–5.

Frodeman, R. (2014) *Sustainable Knowledge: A Theory of Interdisciplinarity.* London: Palgrave Macmillan.

Frodeman, R., Klein, J. T. and Mitcham, C. (2010) *The Oxford Handbook of Interdisciplinarity.* Oxford: Oxford University Press.

Fuller, S. (2002) *Social Epistemology,* 2nd edn. Bloomington, IN: Indiana University Press.

Fuller, S. and Collier, J. H. (2004) *Philosophy, Rhetoric, and the Edge of Knowledge: A New Beginning for Science and Technology Studies,* 2nd edn. Mahwah, NJ: Lawrence Erlbaum Associates.

Geertz, C. (1980) Blurred genres: The refiguration of social thought. *American Scholar.* 165–179.

Gould, S. J. (2011) *The Hedgehog, The Fox and the Magister's Pox: Mending the Gap between Science and the Humanities.* Cambridge, MA: Harvard University Press.

Graff, H. J. (2015) *Undisciplining Knowledge: Interdisciplinarity in the Twentieth Century.* Baltimore, MD: Johns Hopkins University Press.

Grafton, A. (2009) A sketch map of a lost continent: The republic of letters. *Republics of Letters: A Journal for the Study of Knowledge, Politics, and Arts.* 1(1). pp. 1–18.

Gray, J. (2002) *Straw Dogs: Thoughts on Humans and Other Animals.* London: Granta Books.

Gross, P. R. and Levitt, N. (1998) *Higher Superstition: The Academic Left and its Quarrels with Science.* Baltimore, MD: John Hopkins University Press.

Holland, D. (2014) *Integrating Knowledge Through Interdisciplinary Research: Problems of Theory and Practice.* Abingdon: Routledge.

Ioannidis, J. P. A. (2005) *Why most published research findings are false.* Available at: from http://journals.plos.org/plosmedicine/article?id=10.1371/journal.pmed.0020124 [Accessed 16 August 2016].

Jackson, S. (2004) *Professing Performance: Theatre in the Academy From Philology to Performativity.* Cambridge: Cambridge University Press.

Kershaw, B. and Nicholson, H. (eds) (2011) *Research Methods in Theatre and Performance.* Edinburgh: Edinburgh University Press.

Klein, J. T. (1990) *Interdisciplinarity: History, Theory, & Practice.* Detroit, MI: Wayne State University Press.

Klein, J. T. (2006) Resources for Interdisciplinary Studies. *JSTOR.* 38. pp. 50–56. Available at: www.jstor.org/stable/40178186

Krishnan, A. (2009) What are academic disciplines? Some observations on the disciplinarity vs. interdisciplinarity debate. *National Centre for Research Methods Working Paper Series.* 3/09. Retrieved from http://eprints.ncrm.ac.uk/783/

Kuhn, T. (1962) *The Structure of Scientific Revolutions*. Chicago, IL: University of Chicago Press.

Lykke, N. (2010) *Feminist Studies: A Guide to Intersectional Theory, Methodology and Writing*. Abingdon: Routledge.

Lyotard, J-F. (1984) *The Post Modern Condition; A Report on Knowledge*. (Trans. Bennington, G. & Massumi, B.). Minneapolis, MN: University of Minnesota Press.

Mangen, A., Walgermo, B. R. and Brønnick, K. (2013) Reading linear texts on paper versus computer screen: Effects on reading comprehension. *International Journal of Educational Research*. 58. 61–68. Retrieved from www.sciencedirect.com/science/article/pii/S0883035512001127

McGregor, S. L. T. (2004) The nature of transdisciplinary research and practice. *Kappa Omicron Nu Human Sciences Working Paper Series*. Available at: www.kon.org/hswp/archive/transdiscipl.pdf

McKenzie, J. (2001) *Perform or Else: From Discipline to Performance*. London: Routledge.

Messer-Davidow, E., Shumway, D. R. and Sylvan, D. J. (Eds). (1993) *Knowledges: Historical and Critical Studies in Disciplinarity*. Charlottesville, NC: University of Virginia Press.

Miller, T. R., Baird, T. D., Littlefield, C. M., Kofinas, G., Chapin, F. III and Redman, C. L. (2008) Epistemological pluralism: Reorganizing interdisciplinary research. *Ecology and Society*. 13(2). p. 46. Available at: www.ecologyandsociety.org/vol13/iss2/art46/

Moran, J. (2010) *Interdisciplinarity: The New Critical Idiom*, 2nd edn. Abingdon: Routledge.

Mouffe, C. (2000a) *The Democratic Paradox*. London: Verso.

Mouffe, C. (2000b) Deliberative democracy or agonistic pluralism. *Political Science Series*. 72. pp. 1–17.

Mouffe, C. (2005a) *On the Political*. New York, NY: Routledge.

Mouffe, C. (2005b) Some reflections on an Agonistic Approach to the Public. In: Latour, B. and Weibel, P. (Eds) *Making Things Public: Atmospheres of Democracy*. Cambridge, MA: MIT Press. pp. 804–807.

Mouffe, C. (2005c) The limits of John Rawls's pluralism. *Politics, Philosophy & Economics*. 4(2). pp. 221–231.

Nelson, R. (ed.) (2013) *Practice as Research in the Arts: Principles, Protocols, Pedagogies, Resistances*. Basingstoke: Palgrave Macmillan.

Newell, W. H. (2001) A theory of Interdisciplinary Studies. *Issues in Integrative Studies*. 19. pp. 1–25.

Nicolescu, B. (2002) *Manifesto of Transdisciplinarity*. (Trans. Voss, K.). Albany, NY: State University of New York Press.

Nicolescu, B. (ed.) (2008) *Transdisciplinarity Theory and Practice*. Cresskill, NJ: Hampton Press.

Nosek, B. (2012) An open, large-scale, collaborative effort to estimate the reproducibility of psycho-logical science. *Perspectives on Psychological Science*. 7(6). pp. 657–660.

Nosek, B. A., Spies, J. R. and Motyl, M. (2012) Scientific utopia: II. Restructuring incentives and practices to promote truth over publishability. *Perspectives on Psychological Science*. 7. pp. 615–631.

Pavis, P. (2001) Theatre Studies and Interdisciplinarity. *Theatre Research International*. 26. pp. 153–163.

Prinz, F., Schlange, T. and Asadullah, K. (2011) Believe it or not: How much can we rely on published data on potential drug targets? *Nature Reviews Drug Discovery*. 10. pp. 712–713. doi:10.1038/nrd3439-c1

Rawlins, F. I. G. (1950) Episteme and Techne. *Philosophy and Phenomenological Research*. 10(3). pp. 389–397.

Reid, L. N., Soley L. C. and Wimmer, R. D. (1981) Replication in advertising research: 1977, 1978, 1979. *Journal of Advertising*, 10. pp. 3–13. doi:10.1016/S0149-2063_03_00024-2

Repko, A. F. (2012) *Interdisciplinary Research: Process and Theory*, 2nd edn. Thousand Oaks, CA: Sage Publications.

Schatzki, T. R., Knorr, K. K. and Savigny, E. (Eds) (2001) *The Practice Turn in Contemporary Theory*. London: Routledge.

Schechner, R. (2002) *Performance Studies, an Introduction*. New York, NY: Routledge.

Schmidt, S. (2009). Shall we really do it again? The powerful concept of replication is neglected in the social sciences. *Review of General Psychology*. 13. pp. 90–100. doi:10.1037/a0015108

Shepherd, S. (2016) *Performance Theory*. Cambridge: Cambridge University Press.

Shumway, D. R. and Messer-Davidow, E. (1991) Disciplinarity: An introduction. *Poetics Today*. 12(2). pp. 201–225. Available at: www.jstor.org/stable/1772850

Sismondo, S. (2010) *An Introduction to Science and Technology Studies*. Chichester: Wiley-Blackwell.

Smith, H. and Dean, R. T. (Eds) (2009) *Practice-led Research, Research-led Practice in the Creative Arts*. Edinburgh: Edinburgh University Press.

Snow, C. P. (1960) Afterthoughts on the 'Two cultures' controversy. In: *Encounters: An anthology from the first ten years of encounter magazine*. New York, NY: Basic Books. pp. 216–225.

Sokal, A. (2008) *Beyond the hoax: Science, philosophy and culture*. Oxford: Oxford University Press.

Souss0ff, C. M. and Franko, M. (2002) Visual and performance studies: A new history of interdisciplinarity. *Social Text*. 73(20,4). pp. 29–46. Available at: https://muse.jhu.edu/article/38473

Stern, Lord N. (2016) *Building on Success and Learning from Experience: An Independent Review of the Research Excellence Framework*. Available at: www.gov.uk/government/uploads/system/uploads/attachment_data/file/541338/ind-16-9-ref-stern-review.pdf. [Accessed 13 August 2016].

Weingart, P. (2010) A short history of knowledge formations. In: Frodeman, R., Klein, J.T. and Mitcham, C. (Eds) (2010) *The Oxford Handbook of Interdisciplinarity*. Oxford: Oxford University Press. pp. 3–14.

Weingart, P. and Padberg, B. (Eds) (2014) *University Experiments in Interdisciplinarity: Obstacles and Opportunities*. Bielfeld: Transcript Verlag.

Weiss, K. (2003) Ludwik Fleck and the art-of-fact. *Evolutionary Anthropology: Issues, News, and Reviews*. 12(4). pp. 168–172. DOI 10.1002/evan.10118.

Whitehead, A. N. (1967) *Science and the Modern World: Lowell Lectures 1925*. New York, NY: The Free Press.

Wilson, J. (2011) Creative arts research: A long path to acceptance. *Australian Universities' Review*, *53*(2). pp. 68–76.

Wojciech, S. (2016) Ludwik Fleck. In: E. N. Zalta (ed.) *The Stanford Encyclopedia of Philosophy* (Summer 2016), Available at: http://plato.stanford.edu/archives/sum2016/entries/fleck/

PART II

virtual
Performance and Digital

Joanne Scott

A preamble

As my fingers hover above the laptop keyboard, I am aware of a number of things – the people watching my actions, the choice I have to make and what that will do to this moment we are experiencing, the technical requirements of interacting with a digital interface to activate a video image and the range of footage available, which appears on the laptop screen as a series of small square windows, each with its own picture. As I select one of those windows, through a mouse click, the video instantaneously appears, huge on the shifting white cloth screen in front of me, mixing its pixels with those of a clip that is already in place, washing and moving over it, suffusing the area we occupy with coloured light and movement, meeting the weave of the cloth and the bodies of those present, cloaking us and shifting according to my touch.

In the words above, I describe activating a digital image that you could call virtual, as part of a performance event that you might say is suffused with virtual things – sounds that are 'synthetic', images formed of pixels, everything made of digital code that we can't see – not real at all really. And yet… as this preamble indicates, when I practise, something happens to this material – it takes on a life and energy and movement, which I as the practitioner, feel and experience, as a fluid and enveloping quality, as something playful, energetic, responsive, which bursts into life, when I intersect with it.

Introduction

An insistent issue with the consideration of the digital in the context of performance is that digital material is often seen as something entirely different from and in opposition to the act of live performance, weighed down with its own meanings and politics, which it drags into the performance space – at once, both loaded and immaterial, both heavy and impossibly light. However, this chapter does not

witness the digital in the act of performance in this way. Rather, it understands the digital as a '*prescribed*' (Bryon 2014: 193) text, which, in its collaboration with the performer's 'way[s] of doing' (60) and other 'doings'[1] in the performance event, is made anew, generating fresh meanings, affects and possibilities in that moment. In this writing, I consider these moments of collaboration, as they happen in the middle field of 'performing', a place where I can 'witness or evaluate the *way* of *doing* in process' (12) and the different knowledges, related to the fields of digital and performance, that emerge here. The chapter addresses the intertwining of digital and performance through considering live media events. In live media practice, digital technologies are employed to generate audio-visual or intermedial[2] spaces, 'on the fly' (Cooke 2010: 10). In the writing that follows, I consider a productive clash that happens in the live media 'field of performing' (Bryon 2014: 61), using the term virtual as a point of crossover and considering what happens when virtual materials – images and sounds – which are generated through digital means, cross and collide with the 'virtuality' of performing.

I begin by outlining the two fields of interest – live media performance and the digital. Both are considered in relation to virtuality, a term which has different meanings in these two disciplinary spheres. The virtual, in digital terms, relates to the opposition we might see and experience between something which is actually present and that which is computationally represented (the virtual) – the apple that you touch and taste, as opposed to the one that appears on your screen when you Google 'apple'. In performance terms, virtual is related to the capacity of a performance event to represent and evoke a different reality, world or set of circumstances. In the case of the digitally virtual, focus is often given to the nature of a virtual manifestation and how it differs from its 'real' counterpart – a mode of immateriality, or a lack of substance in opposition to the real or actual. In the study of performance, there is a focus on how the performance act represents and how effectively it evokes other worlds/spaces/realities – whatever they may be – and therefore the quality of the performance resultant. As a live media practitioner, both of these perspectives are problematic for me, in that they elude what is at stake in the practice of my practice, when digital things and acts of performing collide. As referenced in the preamble, the way I make performance, in a broadly improvised mode, using digital tools, makes virtualities happen in quite different ways to those outlined above.

I explore these issues in more detail in the second section of the chapter, before using an active aesthetic as a tool to think about and witness two different types of live media performance, paying attention particularly to emergent virtualities in these types of events. This also aligns with what we are doing within this book, as a whole and with the aims set out by Bryon, in the opening chapter, namely to use an active aesthetic 'to witness and *capture* those chosen moments before the landing, the grounding and the naming of knowledge(s): a middle space, where… knowledge *happens* as an *act* of *practising*' (10). As a practitioner, similarly to Bryon, I contend with discourses that frame and delineate the performance events I create as aesthetic objects and 'object[s] of study' (24) that can be understood and analysed as products

of my actions and the elements present. Rather, as throughout the book, we are interested in the middle field of performing, practising, activating, making and 'the steps before the product or outcome is usually evaluated' (Bryon 2014: 12). I am specifically interested in the force and energy of moments of live media performance – witnessed from *within* those moments – to reconfigure a view of how this practice works and particularly, what meaning and knowledge *happens* there.

Live media performance

Performance, in the context of this chapter, is live media performance. This umbrella term covers a range of practices, which involve 'the live and improvised performance of audio-visual media' (Cooke 2010: 194) using digital tools. Live media forms involve performers activating digital technologies in the presence of an audience to create mixes of sounds and/or images, which are often improvised – conceived of, constructed and received in the moment. This is a significant feature of these practices – a particular 'way of doing' – creating a 'powerful' and highly active 'middle field' of 'performing' (Bryon 2014: 53). These are also evolving forms, which exist in what Joe Moran (2002) might term an 'undisciplined space in the interstices between disciplines' (15) and are not accounted for satisfactorily by much performance theory. As Grayson Cooke (2010) points out, 'live media performance remains under-theorized, in part because it sits eternally in between traditional modes of production and performance' (194) and this generates an 'unease in classification' (Barthes in Moran 2002: 16). Because of this, live media performance is fertile ground for an interdisciplinary exchange of knowledges, in that it consistently raises questions about the nature of performance, the position of the digital within this and the experience of the audience and performer in relation to both. Though these modes of performance have a rich heritage in experimental, improvised and technologically engaged performance practices[3], they also represent, in the forms explored here, relatively recent phenomena, which in their emergence, have coincided with and profited from the rise of the digital as a 'way of doing'. Digitality prompts such practices, enabling the real time mixing and merging of sound and image, through its common language of binary code.

The different modes of live media practice addressed in this chapter are live coding and live intermedial practice. A live coding event involves performers 'writing and modifying computer programs that generate music [or images] in real time' (Brown and Sorensen 2009: 17). Often, this coding process is exposed, as it happens, through projected images of the coders' screens, which show the algorithms[4] being activated and manipulated. I talk about my experience of this practice from the perspective of a relatively uninitiated and uniformed audience member, witnessing the events from outside the vibrant and collaborative culture that has grown up around such practices, through events such as 'algoraves'.[5]

In contrast, I adopt an insider position and perspective in considering live intermedial events. Live intermedial practice is a mode of live media practice that

I have developed for the past five years and involves me, as performer–activator,[6] interacting with a range of digital technologies in order to activate, generate and mix shifting combinations of sound, image, body and text. Unlike a live coder, whose interactions tend to be confined to writing code on a laptop, I have gathered a range of different digital interfaces to generate my mixes. These include a laptop to mix pre-recorded and live video footage, a sampler to activate and loop fragments of pre-recorded sound, a microphone and loop pedal to create layered vocal soundscapes and a synthesizer which I use to activate pre-programmed digitised sound in real time. Like live coding, it is a largely improvised practice, but its 'way of doing' also involves collaborating with a set of '*prescribed*' (Bryon 2014: 193) materials, which include images, sounds and words gathered in advance, to be mixed as part of the event, as well as the programming of the digital machines referenced above. In both these practices, the digital, in its *prescribed*, 'convergent' (Jenkins 2006) binary language, intersects with the present decisions, actions and shifts of improvised performing. In the middle field of live media practice, digitised materials and digital technologies entangle (Barad 2007) with human ideas and interactions, from which the event emerges. In this context, the digital is always made and re-made anew through its various activations.

The knotty and problematic term that provides the catalyst for this chapter is virtuality. Occupying moments in these two modes of live media practice, I see virtuality as a 'knot of tendencies or forces' (Levy 1998: 34), 'eventuating into ever new forms in a cavalcade of emergence' (Massumi 2014). These 'tendencies' and 'forces' exist in the possible ways the event can unfold in each moment, connected to the improvised mode of generation in live media work – the '*Practice* of the *practice*' (Bryon 2014: 50). In addition and as alluded to in the preamble to the chapter, the 'ways of doing' in these practices are bound up in modes of technological activation to make digital materials present in a performance space. This can involve pressing a pedal to loop the human voice, adjusting a slider to mix one video image with another, or using a computer keyboard to write and adjust programming code, through which digital sounds are made. In these moments, the digitised 'virtual' images or sounds produced are not empty, and immaterial, but 'pressing and passing' (Massumi 2014: 55). They do not sit in opposition to, but are entwined with, the actual actions and doings through which they emerge. Virtuality here is relational, lively and shifting. It is also affective and haptic – felt by the performer, in the act of activation.

The digital and digitality

In this next section of the chapter, I address the impossibly wide and shifting sands of the digital. While I do not claim to set out all the important and interesting things that could be said about digital culture here, I am looking to address a few broad ideas, which help to frame what digital materials and technologies do when they happen in the middle field of live media performing. If the active aesthetic offers a way to 'witness or evaluate the *way* of *doing* in the process, the qualities

within the *activation* of *generating* a *process*' (Bryon 2014: 61), then it can also be a useful way to address the sphere of the digital, through ways of doing and as a 'way of doing'. The digital world is an 'active field', comprised of actions and processes, from which 'aesthetics' arise and from which we, as digital beings, also emerge (Bryon 2014: 60). In some ways, this circumvents a clear definition of the digital as a discipline in itself, or 'a particular branch of learning or body of knowledge' (Moran 2002: 2). Rather, similarly to performance itself, which forms the other part of the interdisciplinary discourse of this chapter, I am addressing 'learning' and 'knowledge' which arise through consideration of both as sets of practices using an active aesthetic as a tool to achieve this.

A key feature of digital systems, identified by Peter Lunenfeld, is that they 'translate all input into binary structures of 0s and 1s which can then be stored, transferred or manipulated at the level of numbers, or "digits"' (in Lavender 2010: 126). This means that 'the digital offers the possibility for the universal and limitless interconversion of data' (Hansen 2004: 2). Vincent Mosco describes a process of digitisation as a 'transformation of communication, including words, images, motion pictures, and sounds into a common language' (in Lavender 2010: 126). This process of digitisation is a familiar one to many of us, as we phase out analogue objects, such as photos, vinyl records and books in favour of their conveniently ephemeral and far more portable equivalents, stored in the common binary language of the digital.

This is a much considered, much theorised shift, as are the 'ways of doing' that arise from the capacities of this common language. For instance, my ways of listening and consuming music have shifted radically in the wake of the digital revolution. As Ben Ratliff points out, 'Now, we can hear nearly everything, almost whenever, almost wherever, often for free' (2016: 3). However, I witness and dislike my restless scrolling through digitised songs, and contrast this with my perception of the patient consumption of one side of an album, before flipping the vinyl to hear the next. The capacity to sift endlessly through a collection of music that I do not 'own' or 'have' in any tangible sense is what digitisation affords me and yet, in my eyes, this means that I do not listen to music 'properly'. My ambiguity in relation to this particular 'way of doing' – a dissatisfaction with my own acts of digital restlessness, which intersects with my delight at digital convenience and availability – is part of how I emerge, as a bifurcated listener and consumer, in the digital world. Equally, there are 'aesthetics' which emerge from this particular way of doing, including an ephemerality and intangibility, coupled with hypervisibility and accessibility, reminiscent of the binary code itself, which as Andy Lavender points out, 'is comprised of entities that are irresolvably different and yet always conjoined in relation to each other' (2010: 130).

In relation to this, Charlie Gere states that '[d]igital refers not just to the effects and possibilities of a particular technology. It defines and encompasses the ways of thinking and doing that are embodied within that technology, and which make its development possible' (2008: 17), while N. Katherine Hayles (2012), following the work of Andy Clark (2008), pursues a model of 'extended cognition', where

'human agency and thought are enmeshed within larger networks that extend beyond the desktop computer and into the environment' (2012: 3). Through this lens, she sees technical objects, not as 'static entities', but as 'constantly changing assemblages' (13) and 'temporary coalescences in fields of conflicting and cooperating forces' (86), which seems particularly applicable to the 'ways of doing' found in live media performance. In this middle field, technologies and virtualities are themselves 'doings' and form a range of 'assemblages' with an activating performer, through the touch of fingers on a computer keyboard or the sounding of a voice into a microphone. Through these networks of agency and thought, through changing assemblages and virtual manifestations, we start to see a picture of an active digitality that is made 'lively' because of the field of performing in which it happens and crucially, this is also how it feels to be part of one of these moments. Hayles' theories are productive and helpful in breaking down any false divisions or binaries between analogue and digital or actual and virtual elements; instead considering all the forces which are at play as a network happening in the middle field of live media performing.

In the same text, Hayles also presents a distinction between physicality and materiality, stating that the latter 'comes into existence... when attention fuses with physicality to identify and isolate some particular attribute (or attributes) of interest'. She describes materiality as an 'emergent property', which 'cannot be specified in advance, as though it existed ontologically as a discrete entity. Requiring acts of human attentive focus on physical properties, materiality is a human-technical hybrid' (2012: 91). She offers an example of working with clay to throw pots, in order to develop this idea. Hayles describes how any idea she may have in advance of what the pot could look like is always modified and shifted in the middle field of making. Here, a 'fluid dance' is enacted between 'what the clay has a mind to do', the functioning of the wheel and her actions and ideas. The pot emerges between and from these processes, as a 'material' entity, or 'human-technical hybrid' (92).

Such an example also helps to reveal what happens in the acts of improvised activation in a live media event. Here, human-technological interactions also generate *materialities*, which emerge at the intersection of technologies and actions. Like the potter, who responds to the feel of the clay and the capacity of the wheel, the live coder responds to the feel and nature of the laptop and computational algorithm as tools and processes, creating something 'material', which emerges at the intersection of human and technical spheres, as a 'hybrid'. This materiality does not exist prior to the engagement of the middle field, but happens there. Crucially, it also shifts what the digital is doing in this moment and how virtualities emerge, as explored below.

The digital virtual and virtuality in performance

This consideration of digital modes and their intersection with performance acts leads us to the term virtual, which is the key to prizing open the charged moment

of the live media performance, in order to witness what meaning is happening there. As discussed at the beginning of this chapter, digital or computational virtuality can be defined in a number of ways, but often it is seen in opposition to a mode of physical reality, as 'not physically existing as such but made by software to appear to do so' (Oxford University Press 2016), or as 'synthetic, made of text, mathematical formulae' (Giannachi 2004: 7). In these definitions, there is something about virtuality, which pertains to and reinforces through its opposition, what is actually or physically present. Similarly to Philip Auslander's (2008) discussion of 'liveness' as only being a significant concept in the light of recording technologies, we could also see the terms 'actually' or 'physically present' as only relevant in a world where we can, in a range of ways, be virtually present.

It is important at this stage to say that this is not how I experience the virtual images and sounds I activate in a live media performance – they don't feel in the act of performing like they are synthetic, empty or lacking. They do feel tangible, forceful and affective in the act and maybe this is something about the *materiality*, which emerges between us. The acts of pressing buttons on a machine may seem prosaic and functional from outside that act, but when the action is a creative one and something emerges there – a sound, shifting image combination or text, that is visible and open and expansive – then a more powerful, energetic, *material* virtuality emerges than that described above.

Moving across to performance, in this disciplinary sphere, as referenced in the introduction, the term virtuality is bound up with dramatic theatre's function to generate a representational space, where a non-present reality is evoked through the actual actions and interactions of performers on stage. As Cormac Power points out, 'one of theatre's distinctive qualities (and pleasures) is frequently that of watching actions and objects in *our* space-time represent actions and events in a *representational* space-time' (2008: 173), while Steve Dixon states that 'theater has always been a virtual reality where actors imaginatively conspire with audiences to conjure a belief' (2007: 363). Here, dramatic virtuality is being positioned in relation to the act of mimesis and the 'illusory' capacity of a set of actions between actual people in real time, which are formulated to 'virtually' evoke another place or time.

However, virtuality of this nature is not a pre-determined property of performance and any type of virtuality or representation emerges in the middle field. This is where virtuality happens and in live media performance, crosses and collides with acts of digitality and the types of virtual manifestations described above. Live media performance, unlike dramatic theatre, does not attempt to evoke a singular, non-present world. Rather, as Klich and Scheer comment, these and other modes of intermedial performance or 'new media installation', are more likely 'to immerse the audience sensually, not in an artificial world, but within the immediate, real space of the performance' (2011: 131). The 'immediacy' and visibility of acts of representation or virtuality are crucial within live media practice. In these events, we watch the performer press buttons, push sliders, type, make and construct the virtual spaces and sounds that we see and hear. If in a dramatic mode,

the virtuality of the world created fuses and aligns with the actions of the actor in the audience's experience of that event, then in live media practices, the process of making the 'virtual' spaces of the event is laid bare. The live media performer does not make a distinct and separate character and world present for the audience. Rather, she 'makes in the present',[7] revealing the processes of creation. Power characterises this as 'a theatrical process of *world-making*', as opposed to the 'presentation of a fictional "world"' (2008: 163), aligning with an active aesthetic, in focusing our attention on a middle field of doing, performing and making.

We can see above a productive division between understandings of virtuality as a digital phenomenon and as a property of performance. The digitised virtual, though it manifests in a variety of forms, has a common underlying binary structure. It is often set up in opposition to notions of physical reality or actual presence and therefore as 'synthetic' or in some way inauthentic – a version of reality which is not real in itself. This chapter is attempting to unpick some of these perspectives, specifically through occupying the middle field of performing, where different meanings and experiences are made to those that might be set out in advance of the event. In such moments, all that is in process through the 'way of doing' is also in the process of changing because of its collaboration with other 'doings' in that powerful and active space.

It is also here that our evolving concept of *material* virtualities meets a sense of virtuality in and of performance. Though we might reject a notion of dramatic virtuality in live media practices, virtuality still happens in such events through, for example, the touching of buttons on my sampler to make a sound present in the space, or the moving of my hands underneath a camera, to create a projected image of them on a screen. Rather than these acts cohering into a singular virtuality, as they might when an actor speaks, moves and interacts, in order to represent a character, these multiple acts create a variety of representations, which meet and intersect in the middle field of performing, where they come alive and offer new meanings. Live media events do not escape representation. On the contrary, here, the acts of representation and creation are laid bare and examined, are elongated and vulnerable, are placed at the heart of the experience for maker and audience.

It is this combination of virtualities, entwined in the practice of the live media event, which can be positioned in relation to Brian Massumi's writing on the virtual. He talks of the virtual as 'that which is maximally abstract yet real... whose reality is that of potential – pure relationality, the interval of change' (2002: 58). In addition, virtual and actual are understood, in his writing, 'not as different "spaces" that are in opposition to the same *event*', but as 'different ways of being in the act' (2014: 59). Like Hayles, Massumi positions his thoughts on virtuality in relation to its process of 'being in the act'. Both Hayles' and Massumi's theories, exploring materiality and virtuality respectively, intersect productively with Bryon's 'active aesthetic', which threads together the chapters in this book. Bryon describes an active aesthetic as 'a quality of the *way* the *doing* of a process is *practised* in *action*' (2014: 60), which 'privileges a field of doing' and works from the premise that '"meaning" *happens* in the *act* of performance' (61). Similarly to Massumi's characterisation of virtual and

actual as 'different ways of being in the act' (2014: 59), or Hayles' focus on the 'fluid dance' of making, an active aesthetic 'privileges a field of doing'. As I address live media events below in more detail, the focus is on how virtualities in live media events happen 'in the act' of performing. As such, I am not necessarily seeking to categorise, pin down or define the aesthetic product of this exchange, but rather to witness and note how virtualities, as emergent material properties in the event, shift, move and re-formulate within the 'field of doing'.

The production of material virtualities: digital and performance in live media events

In this next section, we see material virtualities as they happen in the middle field of live media performing. Here, the nature of the virtual act or image is not predetermined, either by the digital nature of the materials employed or by the capacity of performance to create virtual representations. The digital materials with which live media performers work are *prescribed* texts, which have been (to some extent) written before the event and which then are part of the meaning made in the act of performing, where they come alive and 'set themselves free', as 'active partners' (Bryon 2014: 193) in a particular way of doing. In occupying the middle field, we see the performer 'collaborate' with these digital texts in the doing of performing, generating virtualities that are made and exist in that moment and nowhere else.

The first practice I am exploring is live coding, which I have experienced in a range of settings, from a club night, to a live internet link-up between live coders in different locations, to the beginnings of an algorave, as well as attending a live coding workshop.[8] I still though consider myself an outsider in this world, as I am not a live coder myself and do not regularly attend such events. However, they do hold some fascination for me, perhaps because of how they relate to and differ from my live intermedial practice. The physical set-up for live coding events is mostly very simple. The coders sit behind their laptops in front of the audience and interact with their respective keyboards, generating a series of sounds, through 'set[ting] up computational processes that generate an ongoing stream of musical output' (Brown and Sorensen 2009: 20). The software code 'represents the musician's ideas and describes the musical outcome to the computer and to those with the knowledge to read it' (Brown and Sorensen 2009: 18), though many (including me) would just see a set of alpha-numeric combinations appearing on the screens, without necessarily understanding fully what that code is *doing*.

The digitally virtual sounds and projected images of the screens of the coders are the main focus in the live coding events I have witnessed, as the actions of the coders themselves are often effectively hidden behind the lids of their laptops. However, it is significant that I witness the digital virtual emissions in relation to these actions, as it is their intertwining that shifts the nature of the virtual here. The digital coding language, being written and re-written, is, as Massumi describes it, both 'pressing' and 'passing', both generative and, in a moment, eliminated or

shifted beyond recognition, through the coder's manipulations. This is echoed in the digital sounds produced – moving and never finding a familiar shape and somehow always 'formative', as they hold potential and never quite manifest.[9] As the ghostly faces dance behind their screens, my awareness of their activity never fully aligns with the output I witness and hear – the fingers tapping on the laptop keys cross and collide, often in divergent ways with the digital sounds created and the streams of code being generated and appearing on the coders' screens.

So, what is the network of 'doings' in operation here, and what virtualities are emerging, through the practice of the live coding practice? There are performers typing on laptop keyboards, there is the code they are writing and re-writing and sounds being created by the computer, through the instructions that the code offers, and then amplified through speakers. There is an audience, experiencing the sounds, watching the performers and reading the code, which is revealed to us through another active 'doing' in the space – the projected images of coders' screens. As an audience member then, there are a number of modes of virtuality emerging in these moments, as I try to make something of the code I read, as I watch the performers' fingers moving on the keys and listen to the sounds produced by these interactions.

Firstly, I do not feel like I am occupying a virtual world or that I am becoming immersed in a non-present reality through the performers' actions. Also, despite the insistent digitality of the tools and emissions, this does not feel like a synthetic space, made from something different to me. Rather, there is something insistently *material* about live coding, about watching the performer interact with the technology and watching them making – making decisions, making code, making sound and then erasing, shifting and re-writing that. There is something insistently real, actual and grounded about these prosaic acts, which intersects with the pervasive mystery of the code that I watch being written. There is also the flickering cursor on the projected screen – a particularly active 'doing' for me in such events, with its indication of expectation and potential, of the numerous possibilities for what might happen next.

This is Massumi's virtuality of possibility and potential, with the practice of this practice active in a collaboration of doings – thought, choice, action, code, sound, audience. The network of these forces generates strings of virtuality, including the form of the code and the nature of the sound, which are distinctly material, tinged and coloured with their human creation – 'human-technical' hybrids that are cultivated before us, as opposed to 'behind the scenes' or indeed in our absence. Virtualities here are insistently and sometimes uncomfortably formative, as they move, without arriving, 'maximally abstract yet real' (Massumi 2002: 58) – in some ways, endlessly unsatisfying, in other ways, holding a fascination and an energy that I never quite access.

This also resonates with my experience of performing as part of a live media event. However, in live intermedial events, as described in the first section of the chapter, my digital doings are dispersed across a set of technological interfaces, from a laptop, to a microphone and loop pedal to a live feed camera, under which objects

can be manipulated and a projected representation of this action shown on a screen.[10] Again, in terms of the different 'doings' in play here, we have multiple actions happening. There are my thoughts, feelings and responses and the *prescribed* materials I have brought to the event – objects, video clips, bits of text, fragments of sound – awaiting their moment of activation. There are also the technical objects, such as the laptop, sampler and loop pedal, with their prescribed programming and affordances. These 'temporary coalescences' in the 'conflicting and cooperating forces' (Hayles 2012: 86) of the event, are active in the possibilities they offer as to what could be created – a large moving image of another space and time for instance, a live feed image of actions in the now, my voice in amplified harmony with itself, an object moving, a word, written digitally or spoken aloud. Then there is the audience, watching close up or at a distance, standing in the path of the image or to one side of it, talking or being silent. My 'way of doing' in these moments is a collaboration with these forces and different 'doings' in the space – it involves intersecting with them to create and act and then, in turn, to respond to a new set of emergent actions and doings. This invests not just my actions but also what those actions produce – the digitally virtual sound and image combinations – with energy, potential and power. These emissions are material in their virtuality, in the choices and thoughts and responses I see and experience played out in their activation – fulsome and active and strong. They are not in this moment made of something different from me – they are an intersection with me – a hybrid emerging between our doings and held there momentarily before being replaced or erased.

Virtuality here is also a range of potentialities – Levy's 'knot of tendencies and forces' (1998: 34) – that are present and forceful in the possibilities for action in a single moment. Through acts of attention, the materiality of the virtual spaces and forms emerge. The selection of a piece of video footage to show, a lyric to sing and loop, or a digitised sound sample to play, offers that act of digital emergence a particular energy and materiality that forms, as suggested by Hayles, at the intersection of human attention and the possibilities offered by the materials and technologies in play, as a hybrid formed of all those forces. In the middle field of performing, the audience members are also part of this intersection, adding another vector of attention and an active set of 'doings' to the network of forces already present in the space.

At various points in live intermedial practice, the 'knot of tendencies and forces' present in the event 'temporarily coalesce[s]' into formulations of material virtuality – this may be a vocal harmony in combination with the writing of digital text, which appears, as it is written, on the projection screen. It might also be the combination of pre-recorded video footage, with live feed images of objects in this space and time, playing across the screen and the bodies of those present. Whatever the combination created, it is always a 'human-technical' hybrid, formed in the active middle field and existing in the network of forces between the different agencies, human and technological, in the event. The virtual spaces and sounds I activate may be formed of binary code, conveniently hidden from me by the capacities of the technologies I use. They may therefore also be conceived of as

'synthetic' in some way – opposite to or distinct from the reality they represent or reproduce – but crucially, this is not how they happen in this practice. Here the 'practice of the practice' intersects with the digital materials and from this arises virtualities, which are possible, full, sometimes expansive and always, for me as their collaborator or 'active partner' (Bryon 2014: 193), affective – full of a capacity to move, to still, to disappoint, to surprise.

As a largely improvised practice, the 'quality' of the 'ways of doing' in live media practice is always formulated in response to my felt experience of and entanglement with the developing event as a whole. Like a live coder, the choices I make in the moment are fundamental to how the event develops, but such choices are always in conversation with the nature of the digital technologies at my disposal and how these can formulate and frame the material chosen, as well as the presence and actions of others in the space. While the live coder engages with generative algorithms, the performer-activator, somewhat at a remove from the workings of digitality, interacts with a range of digital interfaces. Despite this distinction, both form 'human-technical hybrids' at the intersection of an act of attention and the means by which the digitally virtual is produced, which in turn prompts material virtualities to emerge. The layered and shifting space that is created – 'maximally abstract yet real' (Massumi 2002: 58) – is always in the process of emerging, as an insistent and shifting set of relations formed of digital technologies, material virtualities and the restless actions, which collaborate with them. As I occupy the middle field, as performer or audience member, the colliding of digitality and performing manifests as a complex and densely interconnected set of virtualities, in process and play. Crucially, this experience is not one that can be divided into digital and non-digital, virtual and actual elements – the field of performing breaks down these distinctions into a charged and fizzing material-virtual present.

Conclusion

As the writing above indicates, virtuality in live media events is not synthetic or empty. Equally, the live media event itself never coheres into a distinct and singular virtual experience. Rather, in each moment, a sense of potentiality and possibility recedes into attention and selection – a 'temporary coalescence' (Hayles 2012: 86) of material virtualities – which soon, in turn, disassembles again into a 'knot of tendencies and forces' (Levy 1998: 34). The energy and force of virtuality in these events is formed of possibility, attention and a range of 'doings', generating complex moments of entanglement between elements. There is an affective quality to the virtualities in play, as they 'press' and 'pass', because of their emergence through the performer's improvised response to the developing event.

Virtuality is atomised and dispersed in the charged experience of these events, broken down and threaded through. Here, the virtual does not lie passively like a blanket over the whole event, transforming the present actions into those from another time and place. Rather, it is the active and emergent presence of possibility,

potential and, as such, possesses a real, material and human quality. The digital virtual spaces, which in so many discourses are set in opposition to actuality or reality, do not emerge as lacking, synthetic, or in opposition to what is actually present in the space. Instead, within live media events, the relationships between actual action and virtual representation are exposed and lively, whether that is the expectant flickering cursor and the fingers in the process of touching the keys or the intake of breath and pushing of the loop pedal before the voice is heard and then digitally reiterated. The virtual things made here – digital sound, images formed of binary code and light, or the digitally looped human voice – are full of energy, force, potential and affective capacity.

The emergent, shifting and interrelated set of ideas above, similarly to the dynamic networks of live media events themselves, do not result in a singular definition of the virtual, which can exist and persist outside the moments described. Rather, conceptions of this problematic term, as it intersects with the active aesthetics of digital and performance, have been allowed to dance, exchange, coalesce and meet in my subjective experience of witnessing and making live media practice, remaining in process there. This term, which on one hand is insistently slippery and inaccessible, on the other offers a solid opposition in a binary formulation, which is used to divide the bifurcated world in which we exist into different qualities of engagement and experience. In live media performance, this is not how virtuality happens. Here it is multiple, always emerging in different material hybrid modes. It is also powerful, energetic and active – present in all the possible choices the improvising performer has for action and in all the possible 'doings' contained within the digital materials and technologies. Here, it reaches, moves, changes and never quite achieves definition.

Notes

1 Bryon describes how actions or 'doings' in performance are not just those of the performer – they also include 'the throw of a light, the cough of an audience member, the extension of a leg, the swell of the orchestra, the projections of an image' (2014: 194). In the context of live media work then, all elements, from the performer and audience, to the technological objects, to the images and sound created are active and 'doing'.

2 Though intermediality can refer to 'the interrelations between media as institutions in society' (Jensen in Bay Cheng et al. 2010: 16), as well as to work which falls 'between media' (Higgins 1966), in this writing it is employed specifically to refer to the discourse between mediums – sound, image, object and body – as part of the live media event.

3 Within his writing, Grayson Cooke acknowledges the 'antecedents of contemporary live media', referencing Cage, Stockhausen, Dada and Fluxus artists and Kaprow's happenings, as well as expanded cinema and colour organs (2010).

4 An algorithm is described by Cormen et al. (2001) as 'any well-defined computational procedure that takes some value, or set of values, as *input* and produces some value, or set of values, as *output*' (5). Live coders use these computational procedures to generate, manipulate and shift a range of (often) musical outputs in real time.

5 Algorave is short for 'algorithmic rave' and involves 'systems built for creating algorithmic music' being used to create a space where the focus is 'on humans making and dancing to music' (Algorave 2016).

6 As a solo, improvising performer I am also the activator of materials and mediums. In order to foreground the instability of the role, I employ the term performer-activator, as an acknowledgement of the shifting duality of the state of the performer within this practice. This term is also relevant to other live media practices, where the primary role and action of the performer is to activate technology, in order to generate audio-visual spaces.

7 'Making in the present' is a formulation directly related to live media practice and coined in response to Power's category of presence, 'making present'. Where 'making present' refers to a 'fictional mode of presence' (Power 2008: 9), 'making in the present' highlights that the live media practitioner makes in and in response to the present moment.

8 There are many documented examples of live coding practice, which exist online. The live code research network is a good place to start – www.livecodenetwork.org – and TOPLAP holds a great set of resources, including discussions around live coding and documentation of events – http://toplap.org.

9 It is worth noting here that live coding can play with much more recognisable and conventional musical sounds, such as that of a piano, which can be re-created through the coder's language. However, the events I have witnessed placed more emphasis on the production of shifting electronic sounds, which had no obvious relation to an analogue instrument and were clearly 'computational', in nature and origin.

10 For documented examples of live intermediality in practice, please visit my website at: www.joanneemmascott.com.

References

Algorave. (2016) *About*. Available at: from http://algorave.com/about/ (Accessed on: 13 March 2016).

Auslander, P. (2008) *Liveness: Performance in a Mediatized Culture*, 2nd edn. Abingdon: Routledge.

Barad, K. (2007) *Meeting the Universe Halfway: Quantum Physics and the Entanglement of Matter and Meaning*. Durham, NC & London: Duke University Press.

Bay-Cheng, S., Levender, A., Kattenbelt, C. and Nelson, R. (Eds) (2010) *Mapping Intermediality in Performance*. Amsterdam: Amsterdam University Press.

Brown, A. and Sorensen, A. (2009) Interacting with generative music through live coding. *Contemporary Music Review*. 28(1). pp. 17–29.

Bryon, E. (2014) *Integrative Performance: Practice and Theory for the Interdisciplinary Performer*. London & New York: Routledge.

Clark, A. (2008) *Supersizing the Mind: Embodiment, Action, and Cognitive Extension*. London: Oxford University Press.

Cooke, G. (2010) Start making sense: Live audio-visual media performance. *International Journal of Performance Arts and Digital Media*. 6 (2). pp. 193–208.

Cormen, T., Leiserson, C., Rivest, R. and Stein, C. (2001) *Introduction to Algorithms* (2nd edn). Cambridge, MA/London: MIT Press.

Dixon, S. (2007) *Digital Performance: A History of New Media in Theater, Dance, Performance Art, and Installation*. Cambridge, MA: MIT Press.

Gere, C. (2008) *Digital Culture*, 2nd edn. London: Reaktion Books.

Giannachi, G. (2004) *Virtual Theatres: An Introduction*. Abingdon/New York: Routledge.

Hansen, M. (2004) *New Philosophy for New Media*. Cambridge, MA/London: MIT Press.

Hayles, N. K. (2012) *How we Think: Digital Media and Contemporary Technogenesis*. Chicago, IL/London: Chicago University Press.

Higgins, D. (1966) 'Intermedia' in *Something Else Newsletter*. 1(1). Available at: www.withoutbordersfest.org/2010/intermedia.html (Accessed on: 12 May 2014).

Jenkins, H. (2006) *Convergence Culture: Where Old and New Media Collide*. New York/London: New York University Press.

Klich, R. and Scheer, E. (2011) *Multimedia Performance*. Basingstoke/New York: Palgrave Macmillan.

Lavender, A. (2010) Digital Culture. In: Bay-Cheng, S., Lavender, A.,Kattenbelt, C. and Nelson, R. (eds) 2010. *Mapping Intermediality in Performance*. Amsterdam: Amsterdam University Press.

Levy, P. (1998) *Becoming Virtual: Reality in the Digital Age* (Trans. Bononno, R.). New York: Plenum Publishing.

Live Code Research Network. (2016) www.livecodenetwork.org [Accessed 11 July 2016].

Massumi, B. (2002) *Parables for the Virtual: Movement, Affect, Sensation*. Durham, NC/London: Duke University Press.

Massumi, B. (2014) Envisioning the Virtual. In: Grimshaw, M. (Ed.) *The Oxford Handbook of Virtuality*. Oxford: Oxford University Press.

Moran, J. (2002) *Interdisciplinarity*. London/New York, NY: Routledge.

Oxford University Press. (2016) *Virtual*. Available at: www.oxforddictionaries.com/definition/english/virtual [Accessed 13 April 2016].

Power, C. (2008) *Presence In Play: A Critique of Theories of Presence in the Theatre*. Amsterdam/New York, NY: Rodopi.

Ratliff, B. (2016) *Every song ever: Twenty ways to listen in an age of musical plenty*. New York, NY: Farrar, Strauss and Giroux.

TOPLAP. (2011) Available at: http://toplap.org [Accessed on: 11 July 2016].

Cross-Chapter Discussion

virtual and mediation

Joanne Scott (JS) and Luis Campos (LC)

Joanne Scott: Hi Luis. So… my first question is about relationality in your chapter. I really enjoyed reading about this idea in what you wrote and I think it is something that we are both interested in.

Luis Campos: Yes, we do. I see relationality as a relation in the making, not as an establishing of a connection between pre-given elements that are also completed. I have been reading Erin Manning, the wife of Massumi by the way, and she speaks of this, which I think also fits beautifully with your work and also can be related to the 'middle field' of the active aesthetic.

JS: Yes – I know I need to read some Erin Manning. She sounds great. Can you talk about the relationality you experienced in Foster's work? What was made there in terms of these relations?

LC: I experienced it in relation to how I wanted to activate it since I was able to access the work from a wide variety of angles. I could revisit any experience at any time, but the experiences were never the same, if that makes sense. I could move around and activate the work differentially.

JS: Yes it does. So there were relations between you and the options the installation offered to you?

LC: Yes.

JS: I know that feeling!

LC: I think this is somehow similar to what you call the synthetic.

JS: That's interesting. 'Tell me more', as they say in *Grease*!

LC: Synthesis as an amalgamation in the making of how the elements are being experienced. In this sense, synthesising becomes relational, as a verb, as opposed to a noun.

JS: I see. I never really thought about the relationships between synthetic and synthesis. I need to think about that a bit more!

LC: For example, in fashion, something synthetic is something that has been manmade – there is a creation process involved in the synthesis.

JS: Yes… so you're bringing the synthetic back to the process and its making – I like that.

LC: Now, I think in your chapter the synthetic, in its incorporation of things in the making, incorporates the human and non-human agencies. Also, one thing that I love about your chapter is that the synthetic implies a temporality. The work is activated in a present time, present as doing, but it is also an extended time, since this is a time that brings back past activations of any given element that you have used. In this sense, your work, I'd say, is temporally relational.

JS: Thanks, Luis – loads for me to think about there! Let's talk a bit first about the non-human agencies you mention, because this is something I am very much interested in, within your chapter too. I think I have a sense of what non-human agency feels like in my practice – the insistence of the affordance of a machine for instance, or the possibility for an object to be present in a range of different ways – how they are lively and full of potential in the act of making.

LC: I am coming to it from a rather philosophical angle, which I still have to figure out how to fully incorporate it into my chapter without sounding philosophical.

JS: I am interested in the philosophy!

LC: I see it as the qualifying aspect of the non-human element to impact on the other non-human elements, along with the human elements. My philosophical angle comes from Deleuze mainly and how his scholarship has developed into what now is presently called materialist realism and materialist ontologies. These are reverberations of what Deleuze calls transcendental empiricism.

JS: Ok, so there is something about how these different agencies are constantly impacting on each other in a moment? I'm also thinking about Barad's definition of agency, which I can't quite remember now… but that agency is something that you do rather than have?

LC: I look at it in my chapter as 'a constructivist reading of epistemology'. Yes – as vitalism, a form of life, which is very similar to how you look at it.

JS: Right – good. So everything in the event has that vitalism?

LC: Yes. The event is vital – a life that incorporates the worlding as process, as a fielding in the making, as Manning would say. I think I call this afforded from within, clearly drawing on Manning yet again.

JS: Great… So coming back to Foster's installation. Is there a good example of that vitalism you can share?

LC: I think the whole piece is vitalism, but one in which I experienced more intensively (I use this word purposefully) is when I was in one the small rooms and I was reading material, seeing the 'live' performance through live feed and listening through a set of headsets to him taking about how he created the process. There was a sense there of clear amplification of my being there.

JS: Ooh… I love the idea of amplification of your being there – that's such a lovely phrase.

LC: I experienced this in the latest pieces of yours that I saw – I had to divert my attention to so many potential angles.

JS: Really? So what does that feel like? Is it part of how you emerge within the event?

LC: Yes. The potentiality of the event was emergent. I was in control of deciding what I wanted to pay attention to. Having said this, I had more freedom in Foster's piece.

JS: So… do you think this type of amplification of the subject can happen in any type of work or are some events more likely to produce that?

LC: I think some events are more likely to produce a more intensive amplification, but all events produce that sense within the dramaturgical parameters that we are exploring

JS: Ok – great. That makes sense.

LC: And this is one of the angles that I qualify as installative – almost the impossibility of capturing the totality of the piece. This was evident in Foster's work.

JS: Can we link this at all to the notion of a media ecology (I really like this phrase that you use) and how that emerges as an interconnected set of relations within the event?

LC: I think so – an ecology in geology, for example, is a combination of interlinking environments. Also if you look at the Greek root of the term, eco means life and logy kind of means structure, understanding.

JS: And in this case, combinations in the making, processual and always shifting in nature?

LC: Yes. 'In the case of the digitally virtual, focus is often given to the nature of a virtual manifestation and how it differs from its "real" counterpart' – this is a quote from your chapter. I like this idea of the virtual manifestations.

JS: Yes, which I query in the chapter, as I feel the virtual manifestation shifts in terms of its positioning in the ecology of the event, where distinctions between real and virtual are more porous, relational and to some extent broken down.

LC: For example, for Deleuze and Massumi, the real is a combination of the actual and the virtual.

JS: Can you explain that a bit more?

LC: This is rather complex, but very roughly, the real is the actualised and the possibility of the development of that actualisation (the virtual). The virtual for Deleuze is the possibility of, the potentiality of something, very broadly explained.

JS: Ok… so actualisation is key from this philosophical perspective, which means a coming into being? An emergence?

LC: Yes – the Deleuzian immanence is the real.

JS: Great. So I was thinking about terms like digital and virtual and actual and real. Are these to some extent redundant in your argument, in that there is an insistent vitality across elements?

LC: Yes, it is because Deleuze uses the virtual philosophically. It does not mean virtual reality as in intermediality. It is his response to Kant. Massumi conceptualises this along the same lines.

JS: Yes – it is a much broader, more vital term from these perspectives.

LC: 'Digitality prompts such practices, enabling the real time mixing and merging of sound and image, through its common language of binary code', from your chapter. I like this idea of prompting, as how the conditions of possibility are encountered.

JS: Yes – I do feel that digitality is a different mode of vitalism, creating distinct possibilities for actualisation, in the event.

LC: We coincide clearly on this.

JS: Yes!! Where do you think we differ?

LC: Mainly in two things: 1. You seem to anchor your ideas a bit in the notion of the posthuman.

JS: Yes – I do like a bit of posthuman.

LC: 2. The manner in which you sometimes talk about the event.

JS: Ok… shall we talk about the event?

LC: Ok. For me, the event is a construction, an emerging construction between human and non-human.

JS: 'The epicentre of the argument, then, is a theory that understands the aesthetic event not in terms of an attending subject that apprehends an object but a subject who is generated alongside dramaturgically generated orchestrations such that both "prehend" one another', from your chapter. Not sure I disagree with that.

LC: Yes – attending to, for instance, is a very Husserlian manner of understanding phenomenology, because it implies that I am already constituted and I am attending to something that it is also constituted already, casually speaking.

JS: Yes – this is all about the idea of the unstable and unfinished subject, right?

LC: Yes – in the prehension between the human and non-human the event happens.

JS: So… do you think I write about the event in a different way to that?

LC: Just a bit, particularly towards the end, when you say things like 'I witness' for example. This witnessing implies, in my opinion, a position of the subject.

JS: Yes – I see, so there is something about that language, which suggests a pre-constituted subject?

LC: Yes.

JS: What verb would you use instead?

LC: I co-construct, I am constructing, I am constructed along with. I think this verbal form implies duration and time, and therefore process.

JS: Ok – I get that completely, but it is a bit strange to write in that way about an experience.

LC: Yes, I can see that.

JS: I guess I don't feel like I am co-constructing it and it requires me to upend some of my deep seated human feelings about watching something happen in

front of me. I like it though; it is challenging in a good way to think like that and to question language in that way.

LC: The watching is haptic and implies feelings and knowledge, ideas and concepts in the making.

JS: I get that completely and I understand that all that is happening between me and the other elements. It's just difficult to write about an experience like that. It requires a different mode of writing about something, I think.

LC: Yes. I think so too. It is a way of doing – the doing is constructing.

JS: Agreed – I just need to somehow (at some point in the future) think about how that translates into the written word, which is also a practice!

LC: Exactly.

JS: Can you talk about 'prehending', Luis?

LC: Ok, remember that my whole PhD was about this.

JS: Ok... the short version then, please!

LC: A prehension is also a grasping, a co-interaction. I guess it also has a similarity with what you called prompting.

JS: Ooh... I like that. So, all the elements are grasping each other? Grasping implies effort, difficulty.

Luis: Yes. It implies an investment and this investment is the co-construction, as a wording, fielding and subject-enabling. This is very similar to what Experience calls the active aesthetic as requiring a responsibility from the participant.

JS: Right, so as I participate in the construction of the event, I am in a process of grasping, investing, making, in combination with the other elements.

LC: Yes – that is how I see it. 'The way of doing' as in the active aesthetic.

JS: Does this happen when I look at a painting too?

LC: Very hard question because the painting is already fixed, finished. However, one could say that the materiality of the painting, its significance and interpretation emerge in the encounter.

JS: Right... it's still vital and I think that it grasps at me too.

LC: I would say so, but not in a Kantian manner as you 'being disinterested' but rather in a complete process of investment that is vital.

JS: Yes – so the meeting is vital, the exchange.

LC: Yes – exactly.

JS: But I also see that something different happens in the live event in terms of the idea of prehending.

LC: Yes – I agree.

JS: Ok... so you mention the posthuman in my chapter... and I do draw on Hayles quite a lot. Do you feel that this is in some way antithetical to what we are discussing here?

LC: Both yes and no. Although she fully acknowledges the encounter as formation, to put it this way, she is still reliant on understandings of experience (and phenomenology) in a Husserlian manner – that is a subject that 'attends and intends to' a given world. This attending to and intending to implies a pre-established position. I think this position is still very steeped in Kantian

understandings of the attending subject to a given experience – that is why I think that the prehension as investment and co-construction is lovely. That is what I quoted Deleuze as 'a subject that no longer says I'.

JS: Yes – lovely quote! I agree, but I want to know the implications of being 'a subject that no longer says I' in the context of an event. This could be seismic! We would have to consider performance in a completely different way!

LC: Yes, I know. It has massive implications.

JS: It really does... and I can't get my head around them yet, but I know that I think it's important.

LC: In reality, it fits in a lovely manner with your understanding of the live intermedial – the live in live intermediality is a form of vitalism.

JS: Yes!! I want to have a go at writing from this perspective about an event and I really struggled to make that happen this time because it involves a real re-wiring.

LC: I think what you have is very lovely – I enjoyed it very much.

JS: Thank you, Luis. I thoroughly enjoyed reading your chapter too.

mediation

Performance and Installation Art

Luis Campos

Rory Foster's *I Write, and You Read* (2014) can be broadly described as an installation-performance piece that incorporates intermedial elements.[1] The work, the artist discusses, is an interrogation of how installation art principles can be used as a platform to explore dramaturgical modes of presentation, particularly stressing notions of interactivity and the creation of haptic environments, defined here as that activation of the whole human sensorium.

In general, the work of Rory Foster can be practically and conceptually positioned into dramaturgical areas of critical analysis of what may be termed cross-pollination of/from performance; that is, the intersections of theatrical performance with other artistic fields of practice such as photography, fashion, installation art and digital aesthetics. *I Write, and You Read* as a live performance event, in its cross-pollination mode of interdisciplinary practice, refuses to put any of its given disciplines in hierarchical isolation and brings forth a mode of aesthetic creation through which the participating elements are co-dependent and inter-related in the activation of processes of medial construction.

Originally performed at The Barn Theatre, set up as an art gallery environment, at Rose Bruford College of Theatre and Performance by Tim Harris and Joe Keeley, the piece engages the participant subjects with a complex relationship between physical and virtual spaces, structures that create a rich polyphony of multiple temporal orchestrations and narratives that present a multiplicity of performative arrangements through three different spaces within the venue: the main space, the corridors inside the theatre and three small backstage rooms. Through the use of mediatised elements such as video and audio recordings and live feed, the participant subjects engage in a world of fluctuating parameters that combined with the live action. The audience is free to move through a series of dramaturgical landscapes and is also able to interact and influence the development of the emergent narrative within the parameters set by the author. In stressing the

positionality of the audience and the performers, Foster's piece highlights the relationality of the compositional fragments while emphasizing the unreachability of the dramaturgical totality. In this sense, the activation of the mode of presentation cannot be fully grasped at once and the attending subjects are left to make choices in relation to how and what material is accessed. Foster discusses,

> I wanted to create a 'performance', which presents itself in such a way that the participating subjects are placed into a position of ownership of the work – emphasising the dynamic form of the hybrid artwork. This is an artwork, which is in constant flux, shifting between each artistic medium, expanding the notion of 'medium specificity' and becoming a site of perpetual experimentation. I wanted to move away from what may be described as the 'pureness' of a given artistic medium and to place the participating subjects into a relational environment where the medial reality of the piece is always incomplete – therefore, troubling the manner in which the artwork is engaged with and experienced.
>
> *Foster 2015*

From these starting parameters, this chapter looks at the way in which the encounter between the spectator/viewer/activator and the artwork in Foster's piece requires a new mode of understanding and re-configuration of the term mediality. In this sense, this chapter, as the following shall discuss, proposes the term 'installative performance' as a novel platform to conceptualise the interrelated artistic boundaries between installation art practice and theatrical performance as one that shares the defining parameters of an emergent dramaturgy and pays fully attention to the emergence of process of interdisciplinary mediality.

To introduce the terms this chapter engages with from the onset and to offer a now-standard definition of theatrical performance, specifically within a phenomenological reading of liveness and ontological modes of being, Erika Fischer-Lichte (2008) states, 'the central focus … [lies] on the bodily co-presence of actors and spectators and the so-called "liveness" of performance' (67). For her, 'it is necessary that actors and spectators assemble for a particular time span at a particular place and do something together' (2005: 23).

From this perspective, she posits:

> The bodily co-presence of actors and spectators to be the fundamental, essential defining factor, between and through which the performance happens as well as the bodily actions which both parties perform. This dynamic and, in the end, unpredictable process, during which unplanned and completely unforeseen things arise, excludes the notion of representation, expressing and mediating given meanings from elsewhere.
>
> *2005: 25*

She continues:

> It [performance] is ephemeral and transitory; however, whatever happens
> and takes shape in its course comes into being *hic et nunc* (here and now) and
> is experienced by its participants as being present in a particularly intensive
> way … performances exhaust themselves in this presentness, that is in their
> permanent emerging and passing.

2010: 31

In this sense, Fischer-Lichte further develops what in performance studies has been
termed the 'liveness debate' by emphasising the performative and coming-into-
being of the theatrical event, although, as the following paragraphs shall discuss, her
interpretation of the event is based on a foundational reading of an ontological here
and now and an aprioristic understanding between subject and object. She, however,
clearly posits that '[p]erformance does not consist of fixed, transferable, and material
artifacts; it is fleeting, transient, and exists only in the present. It is made up of the
continuous becoming and passing of the autopoietic feedback loop' (2008: 75).

Performance, according to her, generates itself through the interactions between
actors and spectators, which, she says, can neither be planned nor predicted.
Performance relies, she proposes, on an autopoietic process characterised by its
contingency. The autopoietic feedback mechanism, she explains, determines
performance as a reciprocal and dialogical relationship of co-emergence between
performer and spectator. She writes, 'the relationship between actors and spectators
[is established] as one of co-subjects' (Fischer-Lichte 2008: 44).

Additionally, and to continue clarifying this chapter's terms, in relation to
installation art practices, it can be stated that, principally spanning from the 1970s
within Fine Art backgrounds, installation art has been said to require a different
framework of conceptualizing than other Fine Art practices such as painting and
sculpture, mainly due to the manner in which the artwork addresses its viewers and
the specificity of the aesthetic encounter as a mode of phenomenal experiencing,
its ontological conditions of being and its mode of enabling epistemic intelligibility.
Catherine Elwes (2015) defines the aim of installation art:

> Conventional wisdom postulates that the aim of installation art is to produce
> in spectators an expanded spatial awareness, a phenomenological sensitivity
> to all that is actual and present within a bounded space … [highlighting in
> the gallery space] the haptic and vestibular senses dedicated to the orientation
> of the subject in space.

1

Claire Bishop (2008), one of the main scholars in installation art offers another
perspective:

Installation art is a term that loosely refers to the type of art into which the viewer physically enters and which it is often described as 'theatrical', 'Immersive' or 'experiential' ... the word installation has now expanded to describe any arrangements of objects in any given space to the point where it can be happily applied even to a conventional display of paintings on a wall ... [the term installation] highten[s] the viewers' awareness of how the objects are positioned (installed) in a space and of our bodily response to this.

6

In this sense, it can be argued that an installation art draws attention to the act of doing in a given space and time where and when the ephemerality of the activation ensures that the viewer is not a simple spectator but clearly an active agent in how the artwork is encountered, experienced and comes into being. In doing so, this emergent act of doing, as the encounter between the pre-established elements of the artwork and the participating subject, repositions (and problematises) notions of artistic representation, semiotics, hermeneutics and epistemic relationships. Bishop further observes that '[installation art] introduces an emphasis on sensory immediacy, on physical participation (the viewer must walk into and around the work), and on a heightened awareness of other visitors who become part of the piece' (2008: 11).

Suitably drawing on Bishop's proposals, Foster also explains how:

> I wanted to engage the spectator/viewer/participant as much as possible, in something more than just an act of contemplation – for the participant to have an always-evolving relationship with the piece, as an 'emancipated and democratic spectator', as Rancière would discuss. The idea of breaking apart any hierarchy of any medium within the piece was very important. For me the 'performance' was a fluid territory – one which highlights the non-anthropocentric nature of the performance environment and created a link between the human and non-human.

2015

Along the same veins, in *Aesthetics of Installation Art*, Juliene Rebentisch (2012) discusses how installation art:

> resists an objectivist concept of the work by transgressing the boundaries of the traditional arts into ever new fields of intermedia hybridity ... what is create under the umbrella term installation is not so much works but models of the possibility of works, not so much examples of a new genre but ever new genres. Installation art offers resistance to an objectivist concept of the work also by transgressing the boundaries that separate the traditional, the organic work of art from the space that surrounds it.

14–15

Drawing on these definitions, the enabled emergent mediality, defined here as the conditions of being and experiencing of a given phenomenon in the act of doing, confines itself primordially to what is given in aesthetic experience to an attending human subject. From these critical angles, it can be said that Bishop's and Rebentisch's proposals in relation to installation art's processes and theatrical performance's understanding such as Fischer-Lichte's of mediality are clearly informed by Marshall McLuhan's propositions (1964), which, very broadly, highlight the way in which mediality, as a channel and mode of communication, impacts in manner in which a given aesthetic transaction may be said to address its audience. In other words, how the different attending variables transmit meaning and create the conditions for a certain mode of experience as part of the event.

However, these above-presented understandings of mediality in both installation art and performance critical perspectives, in my opinion, become problematic when both disciplines are discussed together in an interdisciplinary manner because they are still heavily reliant on how a given subject interacts with the pre-given artwork, therefore, highlighting a duality between object and subject. Departing from these views and drawing on the writings of Timothy Barker (2012), this chapter re-calibrates the emergence of mediation in installation art and theatrical performance as the manner in which the experience of a given phenomenon is influenced by the modality in which the intertwining agencies of both human and non-human participating elements – mediatised or not – to a given artistic transaction enable processes of phenomenal experiencing and epistemic intelligibility in the becoming process of the aesthetic entity.

In the context of mediation as a process, Barker explains that medium as a process 'provides the conditions for media entities to take form' (2012: 11). He also writes:

> Mediation is a process that draws one media entity into a relationship with other pieces of media. By this it establishes a media ecology, where the relationships within the ecology direct the becoming of the singular media entity [the many become one] … the character of an entity it's gained through its involvement in a system.
>
> *2012: 11*

Agreeing with Barker's position, I would like to stress that mediation as a process can be also considered a generation of process because each new mediated entity sets 'the conditions for the becoming of entities. This is a temporal process generating particular conditions for becoming' (Barker 2012: 13). In this sense, the becoming flux of the process of mediation causes a medial re-conditioning. In other words, and to clarify this point by following the philosophical writings of Erin Manning (2013), the conditions of emergence of the artwork and the subject activate in the middle field of an ecology of the intervening elements that self-form in their own architectural environment (Manning 2013: 10–15).[2]

Seen thus, the interdisciplinary link between installation art and theatrical performance, as a construction of mediality, emerges in the flow of the act of doing while being afforded and created from within – happening and emerging from within the emergent parameters 'as a quality of the way the doing [performing] of a process is practised in action' (Bryon 2014: 60) – the experiential moment of the creation of the medial scaffolding at the moment of the encounter. Regarding the notion of emergence, Experience Bryon (2014) offers a solid standard definition. She explains how:

> emergence describes what parts of a system do together that they would not do alone, or how collective properties arise from the parts. It can also speak to a system's function in that it can describe what something might do in relation to its environment that it would not do by itself. In this way it is very much about the dynamic relationships between things.
>
> *Bryon 2014: 14*

In its emergent mode, the emergence of mediality is brought forth through the activation of the aesthetic event, in which the attending practices to the artistic phenomenon cross-pollinate to enable a relational and interdisciplinary mode of encounter – an encounter that fully considers the ontological and phenomenal mode of being of the practice. This is a medial encounter that fully accounts for the conditions of its own epistemic, phenomenal and ontological being to emerge and that takes into full consideration the mode and the parameters-within of 'the way of doing in process, the qualities within the activation of a generating process' (Bryon 2014: 61). Put simply, mediality is understood here as being in the making, where the ontological and epistemic modes of being (both the organic and non-organic elements and the entanglement of agencies) are formed and experienced in, through and within the blossoming of a relational execution.

As mentioned in the opening paragraphs of this chapter, the term 'installative performance' comes here not as a need to create a new nomenclature and/or neologism. Rather, it is simply used in this chapter to discuss the manner in which installation art and performance practices enable a new mode of artistic experience in the colliding of disciplines, particularly offering a distinct critical perspective on the above-mentioned problematics of the term mediality. Very broadly, first, I define it as an installation art piece that also incorporates performers in its presentational mode. Second, installative performance is also defined as a relational mode of theatrical 'composition', 'structure' or 'fabric' (Turner and Behrndt 2008: 3), that has been staged using principles of installation art and stresses the mutual relationships between the enabling and participating elements in the production of emergent processes at the very moment – in the act of experiential doing – of the event. The term, third, is employed to specifically highlight the operative strategies that make possible the realisation of a given performance-installation event as an assemblage of narrative lines, points of connections and an intertwining of divergent

materials into a compositional scaffolding. Finally, and fourth, I propose a reading of installative performance from a constructivist reading of epistemology.

Without fully entering into the philosophical complexity of a constructivist reading of epistemology, epistemology is broadly understood as the philosophical enquiry into the nature of knowledge and the examination of the subjective contribution to the event where the subject is grasped in a constitutional role. The constructivist understanding of epistemology that this chapter employs as a critical framework is not to be understood in terms of the classical 'idealist' epistemological tradition, as discussed in the Kantian Critiques, but in terms of Deleuzian's philosophical positions. Constructive epistemology, roughly defined, discusses epistemology and ontology as non-separated philosophical fields – it recognises onto-epistemic features and/or onto-epistemic conditions of possibility – and conceives processes of actualisation and individualisation as an onto-epistemic construction in which object/world and subject get constructed as a unity and as an event in the act of doing, strongly and fittingly highlighting the intertwining of agential human and non-human entities.[3]

Put simply, a Deleuzian reading of epistemology posits a clear and precise articulation of both the participating subject and the artistic transaction. It aims to describe the unity of these two phenomena in terms of an onto-epistemic event. Conceived thus, performers and spectators are seen here as equal partners in the acts of constitution. Let's put aside notions of a passive spectator that absorbs performance processes. Instead, the notion of spectatorship/participant shared here highlights its agential participation, investment and active responsibility in the constitution of the event during the act of doing. As such, and most importantly, henceforth references to the term 'event' will imply the eventual construction of both participating subject and installative phenomenon. I do not emphasise here the event of installative performance as an artwork as opposed to static works of art; nor do I stress a phenomenological point of view of an attending subject (performer and spectator) attending to a given worldly structure – an installative dramaturgy, in this instance. Instead, I highlight how the term event, within a constructivist reading of epistemology, encompasses the constitution of both the installative dramaturgy and the participating subject as an evental unity that fully accounts for the entanglement of agencies in the constant creative process of evental execution afforded from within the act of doing, fully recognizing that, for instance, 'meaning happens in the act of performance rather than being [already] situated ... to be passively transferred' (Bryon 2014: 61). In this sense, the participant subject in the installative performance event is a subject that, as opposed to Kantian classical epistemology, 'no longer says I' (Deleuze 1994: 276) and it is not conceived as a disinterested and contemplative observer of a pre-given and pre-established work of art, as Kant discusses in the Third Critique. This is not a subject that 'attends to' and 'intends to' – paraphrasing Husserlian terminology – a given aesthetic transaction. Instead, I propose a conceptualisation of the subject whose, on the one hand, identity is executed as a set of continuously renewed relations and instantiations between himself and the environment in which he is situated in the

act of doing, and whose, on the other hand, process of constructing subjectivity is continually generating consciousness, perception and modes of experience and interpretation – all of these instantiated at the very moment of practice, in which the participant subject is invested into and has a responsibility in the event's activation. The epicentre of the argument, then, is a theory that understands the aesthetic event not in terms of an attending subject that apprehends an object but a subject who is generated alongside dramaturgically generated orchestrations such that both prehend one another.[4] This is a subject that is neither pre-existent nor stable, but always in the process of becoming, individuated by the way of doing 'the sets of doings that result in the emergence of [the installative event]' (Bryon 2014: 61).

Throughout the duration of Foster's piece, Tim Harris and Joe Keely choreographically move from one area of the space to the other. This forces the audiences to invest and have a responsibility in the manner in which they want to experience the installative event. Furthermore, the audiences are free, and I may say, encouraged to take their own position within the space and decide how they want to experience it. At times, the audiences can even decide not to watch the choreographic unfolding and, instead, read some presented literature, engage with Tim Harris and Joe Keeley's personal items of clothing and or eat some of their sampled favourite foods. In this sense, the installative performance event created by Foster operates in a manner of creating different and simultaneous planes of composition and in what Delueze and Guattari call 'fundamental encounters' (1994: 208).

Deleuze and Guattari's notion of the 'plane of composition' (Deleuze and Guattari 1994: 183) is roughly defined here as an aesthetic field of possible sensations, affects, ontological arrangements and the creation of thought. For Deleuze and Guattari, an artwork is both thought and pure sensations and affects. They explain how 'composition is the sole definition of art' (1994: 191). Furthermore, the plane of composition of a given aesthetic event expresses both the becoming of the artwork and its real conditions, conditions that define the genesis of a given aesthetic experience and not the conditions of a possible aesthetic experience, as in Kant. In doing so, the plane of composition enables art to 'create the finite [each activation] that restores the infinite [all the possible articulations and configurations that may enter into the constructive equation]' (Deleuze and Guattari 1994: 197). In this sense, through the active construction of each plane of composition an aesthetic emerges by way of an active dynamic throughout an act of doing.

The plane of composition in art is also the 'fundamental encounter' between the attending variables to a given work of art and the participating subject (Deleuze and Guattari 1994: 208). In this sense, each internal execution – the functioning of this constant creation of each plane of composition, as a fresh and renewed plane, is a construction in a constant process of self-positing and re-activation. Deleuze and Guattari write:

> The work of art only applies by its internal consistency according to the principle that wants the self-position of the created (its independence, its autonomy, its life by itself). As such, by virtue of this principle, the work resembles nothing, mimics nothing. It must 'subsist by itself', on its own, without pointing or referring back to a world outside it, which it would reflect, or to a subject which it would express.
>
> *1994: 163*

The argument here, although it fittingly acknowledges the encounter as constitutive of an aesthetic experience, does not emphasise an 'enabler'/viewer attending to the work of art, which comes into being by the operational association between a human and an artwork – independently if the artwork has been originally created to be interacted with, as Fischer-Lichte and Bishop discuss.

Here, I account for how, through the emergent nature of the aesthetic, the two, the artwork and the subject, emerge together in the co-constitutive relation between the human and the non-human without being preoccupied about any dominating and hierarchical terms and stressing the agency of both at the very moment of evental activation – this is an interaction between artwork and subject that happens as a middle field of relations. To quote Alberto Toscano:

> the interactionist position affirms instead that the modelling of the operations of individuations, and of the manner in which each and every time they bring heterogeneous interactants together, means that any single condition of individuation … is necessary but necessarily not sufficient.
>
> *2006: 149*

Furthermore, he writes, 'individuation creates a relational system that holds together what prior to its occurrence was incompatible' (Toscano 2006: 139). In this sense, Toscano's interactionist position clearly accounts for the emergence of both human and non-human elements – a similar argumentative line as to what, as discussed earlier, Deleuze and Guattari call the 'fundamental encounter'. Toscano is here influenced by Horst Hendriks-Jansen's writings. Taking from a biological theory referred to as 'constructivist interactionism', Hendriks-Jansen (1996) explains how:

> Dynamical systems theory has made it impossible to conceive of complex behaviour as arising interactively from the structures of the environment in conjunction with the creature's internal dynamics. We no longer need a hierarchically organized planning system to explain intricate temporal structure. A natural creature's behaviour does not need to be pre-planned. It does not have to exist as an abstract internal representation in the creature's head before it can be executed. The complex structure emerges as and when it happens from the dynamic coupling between an organism and its environment.
>
> *325–326*

In this sense, individuation cannot be understood without the simultaneous actualisation of the installative elements. Put simply, actualisation and individuation are intrinsic parts of the same mediating and evental process. I highlight the execution of the event through an active aesthetic – as a tool for enquiry – as a clear co-implication where immanent relations perpetually determine new individuation and actualisations on each specific encounter

As such each activation of the installative plane of composition can be also grasped as a creative interaction where the simultaneity of producing and being co-produced happens in the ongoing and interfacial process of the active aesthetic proposed in this volume: the participant, the participated event – in, the process of participating and the participating installative elements are constructively entangled, creating, as Hendricks-Jansen points out, dynamics couplings. These couplings can be considered as an autopoietic feedback loop that is internal to the system, but this proposed autopoietic system, as opposed to Fischer-Lichte's postulates, implies constructive co-constitution as an emergent plane of installative practice. Here, through the use of the active aesthetic as a critical tool, I put the emphasis on how the emergence of the complex structures comes into being as internal to a system that fully acknowledges the human subject and its environment (the dramaturgical and installative structures in this instance).

Hendriks-Jansen explains that these dynamic couplings between organism/subject and system/worldly structures occur in what he terms 'situated activity' and 'interactive emergence' (1996: 11). He discusses that 'all behaviour is situated activity and all situated activity results from interactive emergence' (1996: 30). He describes:

> Behaviour cannot be adequately described in terms of events that take place inside a creature's head. It cannot be explained by rules that formalize neural activity or mental activity, for it comes into existence only when the creature interacts with ... its environment ... Emergence thus becomes important as an explanatory principle because of use. It is because the emergent phenomena open up the possibilities for behaviour that did not exists prior to their emergence that an interactive explanation is essential.
>
> *1996: 30*

Within these remarks of emergence and situated activity, this chapter finds physicist and feminist scholar Karen Barad's concept of 'intra-action' (2007: 33) – as opposed to the more 'hierarchical' concept of interaction – more appropriate because it 'recognizes that there is actually no between as such [between subject and object] and that human and non-human organism ... emerge only through their mutual co-constitution' (Kember and Zyliska 2012: 12). Barad (2012) develops her proposals regarding intra-activity in relation to a philosophical position that she terms 'agential realism'. Without entering into the complexities of such a critical perspective, it can be defined, very broadly, as crucially acknowledging the agential potentialities of both matter and human subject as constantly emerging in processes

of transformative entanglements, without considering them as given *a priori* to the moment of the encounter when installative mediality is generated. Barad describes the crucial difference: 'instead of there being a separation between subject and object, there is an entanglement' (2012: 52). In this sense, Barad clearly stresses how:

> agency is not held, it is not a property of persons or things; rather, agency is an enactment, a matter of possibilities for reconfiguring enactments ... agency is about the possibilities for worldly re-configurings ... it enlists, if you will, humans and non-humans.
>
> *2012: 54–55*

In *Life after New Media, Mediation as a Vital Process*, Sarah Kember and Joanna Zyliska (2012) further describe the concept of intra-action:

> the concept of intra-action postulates a more dynamic model of [subject] emergence of and with the world, whereby 'the boundaries and components of phenomena become determinate' and the particular concepts [that arise with, in and through the intra-action] become meaningful only in active relation. Intra-action thus points out to the inherent performativity of [human and non-human] matter, and of the relations it enters into on many scales.
>
> *81*

Put simply, the notion of intra-action conceptualises that there is agential action occurring between the human and the non-human. In this sense, the fundamental encounter in installative practice, seen through the lens of an active aesthetic as a tool to capture emergent phenomena, is conceived as a non-hierarchical relation, as both Toscano and Hendricks-Jansen stress. Conceived thus, through the act of doing, the entanglement of their agencies during the emergence of the aesthetic event is fully accounted for. Each intra-action, as a plane of composition, acknowledges the active construction of experience and intelligibility as emergent.

What an active aesthetic as a tool for capturing enables us to do is to suitably put forward an understanding of installative performance in the work of Foster as a form of vitalism that is different from Fischer-Litche's autopoietic theoretical framing. Deleuzian scholar Claire Colebrook (2010) discusses that this limited and reductive reading of vitalism, as the one observed in Fischer-Lichte's writings, 'in its narrow sense might be identified ... as the ways in which systems ... have their origin in animating life but then come to operate independently of the thought and sense that is their condition of emergence' (Colebrook, 2010: 1). In this sense, within a given environment, subject and object are co-dependent of each other but still present independent characteristics.

With this is mind, Fischer-Lichte's ideas on autopoiesis are informed by a flawed reading of biological notions of autopoietic organisms as explored by Humberto Maturana and Francisco Varela (1980). She sees autopoiesis as a constant dynamic

process of re-formation and re-configuration, which she then uses to justify the temporal self-forming and transformational dynamic of the performance event. The physicist Fritjof Capra (2003) fittingly defines the concept of autopoiesis within scientific backgrounds. He writes:

> According to the theory of autopoiesis, a living system couples to its environment structurally, i.e. through recurrent interactions, each of which triggers structural changes in the system. For example, a cell membrane continuously incorporates substances from its environment into the cell's metabolic processes. An organism nervous system changes its connectivity with every sense perception. These living systems are autonomous, however. The environment only triggers the structural changes; it does not specify or direct them.
>
> *Capra in Bryon, 2014: 32*

However, on a close reading of Capra and Maturana and Varela's writings, they do not explain autopoiesis as a mechanism of continual transformation, but rather the opposite, they describe autopoiesis as a mechanism that, although autonomous, tends towards stability. They clearly point out how a given biological organism changes its internal dynamic and re-configures itself only when being affected by external – and the word external needs to be stressed – elements to the internal components/parts/cells of such organism.

In relation to understanding autopoiesis as vitalism, and as Deleuze and Guattari (1994) remark, '[l]ife alone creates such zones where living beings whirl around, and only art can reach and penetrate them in its enterprise of co-creation' (173). Similarly, Deleuze (2001) bluntly states, 'What is immanence? A life' (28–29). Claire Colebrook (2010) stresses that it is important to notice the use of the word 'a'. By using it, Deleuze does not refer to life in general, but to a singularity, an evental instantiation (Colebrook 2010: 1–2) – or to what this research calls a constructivist generative frame. In other words, within the constructivist aesthetic proposed here, each aesthetic plane of composition is an instantiation of life. In fact, for Deleuze and Guattari, 'all art becomes creatively vital precisely through the plunging into the pure immanence of Life ... [for them, art is] an act of co-creation with the vital and autopoietic forces of immanence' (Ambrose, 2009: 112). In this context, autopoiesis as the process of life, following Steven Shaviro (ibid.: 2009), can be described as the processes of an entity that 'is alive precisely to the extent that it envisions difference and thereby strives for something other than the mere continuation of what already is ... Rather, life must be understood as a matter of "originality in response to stimulus"' (ibid.: 92).

Furthermore, as Deleuzian scholar Simon O'Sullivan points out, in the interaction between the subject and the artwork, 'art is not just made for an existing subject in the world, but to draw forth a new subject from within that which is already in place' (O'Sullivan 2010: 204). In this sense, the encounter between an artwork and a subject is not 'the production of actual art-works or simply composed

things in the world, but also the practices of a life and of treating one's life as a work of art' (ibid.: 206).

In relation to Deleuze's understandings of art as creatively vital, as opposed to essentialist and foundational readings of vitalism as implied in both Fischer-Lichte and Bishop's critical debating, Deleuzian vitalism, John Protevi (2006) explains, conceives life as concerning the capacity for emergent properties in the self-positing and construction of a given organic and non-organic vitalist system; it also means the creation and constant renewal of a complex system, engaging in constant processes of relational activity. Colebrook (2010) offers a clear explanation:

> A living being, as a being, must have its own membrane or border and a milieu; but as a living being must be also open to a life that can never be reduced to any single form ... [vitalism here] is at one and the same time committed to ... the emergence of the milieu in which thought takes place while also confronting the thousand other plateaus that pass life through ... for vitalism is at once an imperative to account for the dynamic emergence of forms, ideas, sense and structures ... while acknowledging that which cannot be generated from within thought itself.
>
> 7

Furthermore, she writes:

> vitalism has, in its dominant mode, always been a theory of internal relations, and has, therefore, been tied to organicism: something is what it is only because of its relation to a living whole, and the living whole is just the equilibrium, system or set of relations that grants each moment its individuation. On this picture, nothing could be understood as having an essence or potentially outside its definitive relation... Deleuze and Guattari's vitalist philosophy stresses that relations are extrinsic: nothing has a proper potential that it strives to actualize, for various encounters will redefine any singular potential, and once actualized ... singularities could always enter into other relations.
>
> *2008: 130*

Along the same veins, in *Of Life as a Name of Being, or, Deleuze's Vitalist Ontology*, Alain Badiou (2000), explains:

> the key injunction of Deleuzian ontology is this: being cannot be bound to any category, to any fixed disposition of its immanent distribution. Being is univocal insofar as beings are never classed or distributed ... this is the fundamental reason why being deserves the name of life.
>
> *192–193*

From this point of view, the proposed notion of activation of the installative event encourages us to think of the pre-individual attending variables and the individual as producing themselves creatively and in unexpected ways through their continuous mediating connection and interaction.

Drawing on his distinction, the medial definition sought here, following the philosophical positions of Timothy Barker (2009), posits that when we think about the active nature of both human interaction and installed objects, 'the distinction between the way in which something is performed and the way in which something is aesthetically comprehended cannot be maintained' (17). As Barker suggests, we also highlight the manner in which the activating nature of the event:

> unfolds both understanding and performing, the knowledge gained from the interaction cannot be separated from the performative action that provided the condition for this knowledge to emerge. Hence, process and experience are implicated in one another.
>
> *2009: 17*

He further clarifies the nature of such implications discussing how 'the processes of systems, organisational structures, affects and the relationality of entities are important, not consciousness per se, which is merely an outcome of these processes' (21). Extracting from these theoretical perspectives, this chapter stresses that the active and creative characteristic of the execution of the installative performance event makes it impossible to distinguish a clearly separated agency between the human and non-human participating elements in the event. To quote Manning (2016):

> [b]y making everything an event, by emphasizing that there is nothing outside of or beyond the event, the aim is to create an account of experience that requires no omnipresence. The event is where experience actualizes. Experience here is in the tense of life-living, not human life per se, but the more-than human: life at the interstices of experience in the ecology of practices.
>
> *3*

Hence, process, experience and knowledge-making are mutually and inseparably implicated in a constant process of re-formation, disrupting classical understandings of hermeneutics and transforming classical notions of representation into notions of re- presentation.

From this now-defined installative performance perspective, I put forward a conceptualisation of mediality as a process that in its active manner emerges in the flow of the act of doing while being afforded from within the experiential moment of the creation of mediality. Mediality in installative performance emerges in the activation of the aesthetic event, in which the attending practices to the dramaturgical phenomenon cross-pollinate to enable a relational mode of encounter

– an encounter that fully considers the ontological and phenomenal mode of being of the installative practice. This is a mediation encounter that, in its being afforded at the very moment of its own active unfolding, fully accounts for the conditions of its own epistemic, phenomenal and ontological being to emerge. Put simply, mediality is understood here as being in the making, where the ontological modes of being of both the organic and non-organic elements; the entanglement of agencies; and the epistemic conditions of intelligibility are formed and experienced in, through and within the blossoming of the interdisciplinary way of doing.[5]

In this sense, the ontological and epistemic conditions of mediality in installative performance, as onto-epistemic conditions, that come into being do not refer uniquely to the specifics of what has been dramaturgically and installativelly pre-set by the artist to be experienced and activated by a viewer. Rather, we see mediality, as a part of an activation of an aesthetic, as the process of constant cross-modal experiencing between the different agencies. In this sense, the work of Foster can be categorised as an event of complexity of dramaturgical durations and inter-linking between different modes of compositional strategies, whose 'artfulness emerges most actively in the interstices where the world has not yet settled into objects and subjects' (Manning, 2016: 59). Here, the activation of the medial aesthetic is experienced and comprehended in the instantiation of a relational medial event – not in the activation of what has been pre-established by Foster and rehearsed by Tim Harris and Joe Keeley, but in the coming into being of emergent territories of co-constitution and the very moment of the active event, where the sensible is neither 'in the thing' nor 'in the human being', but in the intrinsic intra-active relation between them.

An active aesthetic, as a tool for capturing, enables me to see how, in the work of Foster, this activating is always caught in the act of forming, which is itself emergent due to the active nature of the installative formations. In this sense, mediality moves across the actualised of the already existent to the about-to-be actualised. It emerges in the active coming-together of the elements that enable the constituted to be immediately re-constituted in an environment of co-composition as an all-encompassing relation, while occupying a field of potentialities. In this mode of contributory relations, the term installative performance enables me to discuss mediality outside the problematics above-stated and reposition the conceptualisation of mediality as the way and the manner of the becoming of human and non-human relational artistic worlding. In other words, this field of emergence of mediality is not aprioristic in its ontological and epistemic mode of being; rather, it is a field of interaction between the human and non-human in an agential process of formation – a process of formation where the conditions of medial emergency are also the ontological and epistemic conditions of the emergence and re-conditioning within the potential field of experiencing-thinking within the intra-actionings of the installative event.

The mediality of installative performance proposed here cannot be categorised as a pre-established dramaturgy of already-embedded elements, but as a structure that folds in, and through, a multiplicity of spatio-temporal orchestrations of

experience. In the work of Foster, what emerges is a dynamic dramaturgy of complexity. What emerges is the medial characteristic of a generative and active environment of human and non-human agential relations. What emerges is an onto-epistemic generation of mediality as 'a life'. What emerges is the mediality of life as a work of art.

Notes

1 I do not enter in this chapter into a full discussion of the term 'intermediality' in theatre and performance. However, and to offer a short but distinct definition, I refer to Peter Boenisch (2006a) who describes intermediality as 'an effect performed in- between mediality, supplying multiple perspectives and foregrounding the making of meaning rather than obediently transmitting meaning' (Boenisch 2006a: 103).

2 The work of Erin Manning has been a great influence in my recent research. Her beautifully complex engagement with Gilles Deleuze and Alfred Whitehead has had a clear impact on my understanding of process philosophy, new materialisms and a constructivist reading of epistemology, particularly her discussions in *Always More than One* (2013) where she makes a strong case in a novel and philosophical understanding of experience, perception and processes of individuation.

3 The epistemic relationship between subject and object/world proposed in this chapter is not a transcendental reduction to the subject, as in Kant and Husserl. However, there is one aspect that I take from this tradition, that is, the impersonal or pre-individual conditions that make any experience the experience that it is. However, the position highlighted here is that these conditions are not given *a priori*, as Kant explains, but rather, these conditions, this chapter proposes, agreeing with Deleuze, cannot be dissociated from the actual way they are encountered. Hence, on the one hand, the ontological side which emphasises the moment to moment of the encounter; and on the other hand, the epistemological that seeks the relationship between the non-subjective conditions which are bound to the moment of the event's emergence – its generative structures – and the subjective conditions also understood as generative. In this sense, the Deleuzian onto-epistemic, in seeing the epistemological as a supplement of the ontological and both as a construction, accounts for the ontological moment to moment, and the subjective and non-subjective structures – the epistemological – of the generative encounter.

4 Deleuze can be considered a process philosopher. Nicholas Rescher (2000) describes process philosophy as a doctrine in which 'becoming is no less important than being – but rather the reverse ... [the] ever-changing nature [of reality] is to be seen as crucial to our understanding of reality ... [a reality in which] processes are not "agents" but "forces" [that create the process]' (Rescher 2000: 4). Furthermore, 'reality is not a constellation of things at all, but one of processes. The fundamental "stuff" of the world is not material substance, but volatile flux ... process is fundamental ... everything is a matter of process, of activity, of change (*panta rhei*). Not stable things, but fundamental forces and the varied and fluctuating activities they manifest constitute the world' (Rescher 2000: 5).

5 I take inspiration here from the recent work by philosopher Jane Bennet (2010), particularly her proposals regarding what she terms a 'flat ontology' emphasising the

relationship between the organic and non-organic elements in life-world ontological processes.

References

Ambrose, D. (2009) Deleuze, Philosophy and the Materiality of Painting. In: C. Boundas (Ed.). (2009) *Gilles Deleuze: The Intensive Reduction.* London and New York, NY: Continuum, pp. 101–122.

Badiou, A. (2000) Of Life as a Name of Being, or, Deleuze's Vitalist Ontology. (Trans. Toscano, A.). *Pli.* 10: 191–199.

Barad, K. (2007) *Meeting the Universe Halfway,* Durham, NC: Duke University Press.

Barad, K. (2012) 'Interview with Karen Barad'. In: R. Dolphijn, R. and van der Tuin, I. (Eds). (2012). *New Materialism: Interviews & Cartographies,* Ann Arbor, MI: Open University Press, University of Michigan, pp. 48–70.

Barker, T. (2009) *Process and (Mixed) Reality: A Process Philosophy for Interaction in Mixed Reality Environments.* Paper presented at the IEEE International Symposium on Mixed and Augmented Reality, Arts, Media and Humanities Proceedings, Orlando, Florida, 19–22 October 2009, pp. 17–22.

Bennet, J. (2010) *Vibrant Matter: A Political Ecology of Things.* London and Durham, NC: Duke University Press.

Bishop, C. (2008) *Installation Art: A Critical History.* London: Tate Publishing.

Boenisch, P. (2006a) 'Aesthetic Art to Aisthetic Act: Theatre, Media, Intermedial Performance', in F. Chapple and C. Kattenbelt (Eds). (2006) *Intermediality in Theatre and Performance.* Amsterdam and New York, NY: Rodopi, pp. 103–116.

Boenisch, P. (2006b) 'Mediation Unfinshed: Choreographing Intermediality in Contemporary Dance Performance', in C. Kattenbelt and F. Chappel (eds). (2006). *Intermediality in Theatre and Performance.* Amsterdam and New York: Rodopi, pp. 151–166.

Bryon, E. (2014) *Integrative Performance: Practice and Theory for the Interdisciplinary Performer.* London: Routledge.

Capra, F. (2003) *The Hidden Connections.* London: Flamingo.

Colebrook, C. (2008) Beauty as the Promise of Happiness. In: Zepke, S. and O'Sullivan, S. (Eds). (2008) *Deleuze and Guattari and the Production of the New,* Deleuze Connections. London and New York: Continuum, pp. 128–138.

Colebrook, C. (2010) *Deleuze and the Meaning of Life.* London: Continuum.

Deleuze, G. (1984/1994/2001/2004) *Difference and Repetition.* (Trans. Patton, P.). London and New York, NY: Continuum.

Deleuze, G. (2001) Immanence: A Life. In: Deleuze, G. *Pure Immanence: Essays on A Life.* (Trans. A. Boyman). New York: Zone Books, pp. 25–34.

Deleuze, G. and Guattari, F. (1991/1994) *What is Philosophy?.* (Trans. Burchill, G. and Tomlinson, H.). London: Verso Books.

Elwes, C. (2015) *Installation Art and the Moving Image.* New York: Columbia University Press.

Fischer-Lichte, E. (2005) *Theatre, Sacrifice, Ritual: Exploring Forms of Political Theatre.* New York: Routledge.

Fischer-Lichte, E. (2008) *The Transformative Power of Performance: A New Aesthetics.* London: Routledge.

Fischer-Lichte, E. (2010) Performance as Event – Reception as Transformation. In: Hall, E. and Harrop, S. (Eds). (2010) *Theorizing Performance: Greek Drama, Cultural History and Critical Practice*. London: Duckworth Publishers, pp. 29–42.

Foster, R. (2014) *I Write and You Read*. Performance. Rose Bruford College, London, UK.

Foster, R. (2015) *Rory Foster in Conversation with Luis Campos*. London, UK.

Hendriks-Jansen, H. (1996) *Catching Ourselves in the Act: Situated Activity, Interactive Emergence, Evolution and Human Thought*, Cambridge, MA: MIT Press.

Kember, S. and Zylinska, J. (2012) *Life after New Media, Mediation as a Vital Process*. Cambridge, MA: MIT Press.

Manning, E. (2013) *Always More Than One. Individuations Dance*. Durham, NC and London: Duke University Press.

Manning, E. (2016) *The Minor Gesture*. Durham, NC and London: Duke University Press.

Maturana, H.R. and Varela, F.J. (1980) *Autopoiesis and Cognition: The Realization of the Living*. Boston: D. Reidel.

McLuhan, (1964) *Understanding Media: The Extensions of Man*. London: Routledge.

O'Sullivan, S. (2010) From Aesthetics to the Abstract Machine: Deleuze, Guattari and Contemporary Art Practice. In: Zepke, S. and O'Sullivan, S. (Eds). *Deleuze and Contemporary Art*, Deleuze Connections. Edinburgh: University of Edinburgh Press, pp. 189–207.

Protevi, J. (2006) Deleuze, Guattari, and Emergence. *Paragraph: A Journal of Modern Critical Theory*. 29 (2). pp. 19–39.

Rebentisch, J. (2012) *Aesthetics of Installation Art*. London: Stenberg Press.

Rescher, N. (2000) *Process Philosophy: A survey of Basic Issues*. Pittsburgh, PA: University of Pittsburgh Press.

Ricoeur, P. (1986) *Lecturers on Ideology and Utopia*. (Ed.) Taylor, G. New York: Columbia University Press.

Shaviro, S. (2009) *Without Criteria: Kant, Whitehead, Deleuze, and Aesthetics*. London: MIT Press.

Toscano, A. (2006) *The Theatre of Production: Philosophy and Individuation Between Kant and Deleuze*. New York: Palgrave McMillan.

Turner, C. and Behrndt, S.K. (2008) *Dramaturgy and Performance*. Basingstoke: Palgrave.

Cross-Chapter Discussion

mediation and utopia

Luis Campos (LC) and Selina Busby (SB)

Luis Campos: Hi there! First of all, I would like to say that I have enjoyed your chapter very much and found some really interesting and crossover areas of discussion between our disciplines.

Selina Busby: I also enjoyed your chapter and agree that there were some interesting areas for cross-disciplinary discussions, although our fields are very different. Our works seem to connect around the area of performers and spectators being equal partners of constitution and active responsibility.

LC: Yes, I agree. I think this is where our different practices connect and cross-pollinate. A good point where conversation/discussing could start.

I was particularly interested in your engagement with Pinder and his take on applied theatre practices as requiring a new way of seeing. Also, in your chapter you say: 'Bringing together Ricœur and social geography theories with my practice in applied theatre allows me to think of that practice as one which allows participants to see the world in which they live, critique the social structures which bind them and create imaginative variations on those structures and therefore invites the possibility of change.' This I also found very interesting and feel like it links very well with my proposed understanding of mediation.

SB: Your description of mediation as a process that links to Bryon's idea that it emerges in the flow of the act of doing reminds me of Pinder's concept of needing new ways of seeing and I believe that although we are talking about fundamentally different art practices these concepts are at the core of what underpins our work. When you say, so beautifully, that 'mediality is understood as being in the making where … modes of being are formed and experienced in, through and within the blossoming of a relational execution' that climes with what I think is happening in my practice when I am making theatre with non-professionals. The process hopefully, creates for them a situation where this is possible and a new way of seeing their relationships and circumstances can develop.

LC: Yes, lovely. I do agree with this. I also think that this places the emphasis in the positionality of both actors and spectators within a work of art and how any given work of art can be considered as emergent at the very moment of practice, particularly the development at the moment of coming into being of the conditions that make that work of art being created within the interaction of actors and spectators and where materiality and semioticy are activated. In this sense, my understanding of medially has a clear similarity, in my opinion, with the critical points that you raise when engaging with Ricoeur – 'A utopia is always in the process of being realised (Ricoeur 1986: 273)'. This sense of a process being realised is what changed my perspective in the understanding of what I call installative performance and how it, in my opinion, shifts the discourses regarding, for instance, notions of relational aesthetics.

SB: I think when you talk about the activation of the installative plane of composition as being a creative interaction where the simultaneity of producing and being co-produced happens, is a similar concept. We are both looking at processes that allow for a capacity of change, things are not fixed, they are always unfinished, or as you say so eloquently, not pre-established but 'the coming into being of emergent territories of co-constitution. It is through the co-constitution that a new way of viewing the world, or the self becomes possible. It's the interaction, or the 'co', that allows this to happen.

LC: Yes, I agree. Beautiful! The 'co' is the interesting link between our practices and discussions. I think this links very well with what you introduced as a 'nebulous utopia'. I love that metaphor of the 'nebulous' as being transient and fleeting and as unfinished and state of becoming – the nebulous as transformational and constantly shifting. This is fittingly similar to my understanding of a constructive reading of epistemology and what the discourse terms the 'onto-epistemic conditions' of emergence. The act of doing is being placed in the middlefield of practice and constitution. Now, I have a question for you? Is the nebulous something that is difficult to grasp in practice? Is it through the investment of the subject participants that the nebulous becomes clear in its emergence?

SB: That is a really interesting question; yes, I think the 'nebulous' is very difficult to grasp in practice. Utopia is described as being either fantasy or concrete by Bloch, I think often the participants sometimes see a concrete alternative way of life. But it is only just glimpsed or it is fleeting. Changing their lives to move towards this new version of themselves is very difficult, and often seem to be impossible goals. For me the nebulous is the tiny flashes where they see with clarity the changes that they want, but outside the drama workshop it is all too easy to let these visions slip between their fingers. They are not impossible to reach but they are hard to find – and because we are always in a state of 'coming into being' they are never reached. It is as you say where 'mediality moves across the actualized of the already existent to the about to be actualized' – is it ever actualized? The nebulous is the idea that emerges through the drama work but never sets – there is always the next stage, the new version of oneself, that

is always just out of reach. You talk about 'the active coming together of the elements that enable the constituted to be immediately re-constituted … whilst occupying a field of potentialities' that is for me the 'field of the possible'. Where people might be able to see what is possible or the potential for change is in sight.

It is very interesting to me that we are using our problem words of medial and utopia in very similar ways. They involve a co-intentionality and a realm of potential with no fixed end just re-co-constitution – or maybe you are more optimistic and see a more closed loop in the process?

LC: Perfect! You are completely right. Is there ever a final moment in the potential/possible in the always-emergent sense of the performance/artwork and the participants? This is something that I constantly ask myself too, particularly in relation to how we account for the already-established elements of an artwork, for instance, some designed has already been preset before the encounter between actors and spectators. In my chapter, I discuss the notion of relationally, which I also think it has some links with your critical points. Where does the relational finish? I think, reading your positions, even cultural geography becomes a process of doing – is it culture ever completed? Along the same veins, I do like your points, following Bloch, of the subject as a being in a longing for another way of being. In this sense, this longing is the potential for the subject to emerge and come into being in the doing of the practice, the culture and the artwork.

SB: Exactly art and culture, or applied theatre and installation art, are processes of doing and as such they don't end. In both of our work each activation: workshop exercise, viewing, performance, or discussion produces something new that only happens in the that process of doing the thing and each is a new product, or vision and that is for me the utopian aspect to the work. The art work is never complete without the interaction of the spectator, and/or participant and each experience will change those involved in the process. The field of the possible or the potentialities are limitless and that is hopeful.

LC: Yes, I agree with you fully. I also loved how one of your headings for the chapter is 'finding the space'. I like your use of the gerund as a verb tense; it implies time and temporality and, in this regard, it also implies doing and investing in the act of doing. On another, and maybe final note, I am interested in your use of the term 'thirdspace'. Do you see it as similar to what Bryon calls the 'middlefield'?

SB: Yes, I think there is a synergy between the two and in fact it's Bryon's concept of the 'middlefield' that first interested me about her work, the important work happens in this space – both terms imply an activation or an exploration. In applied theatre, its often called a 'safe space; which allows people to work co-intentionally and dialogically but I think it is closer to the 'middlefield' and I want a riskier space than the safe space implies – one where risk can be taken and I think Bryon's middle space nicely encapsulates this. Let me ask you, where the impact of the middlefield in your own thought processes?

LC: Beautifully put. I think the middlefield in installative performance is located in the moment of emergence of the practice – practice including the participant subjects and the artwork itself. I believe that the middlefield, in my thinking, is also a questioning of the term participation in theatrical practices because I do not see this participation as a pre-established subject attending to an already constituted installation artwork as some classical phenomenological readings would discuss it; rather, the middlefield enables me to explore the emergence of subject and the installation artwork, questioning at the same time notions of liveness, immediacy and subject and object intentionality as posited by critical theatrical, art and philosophical discourses in the past. For me, after this discussion, it has become clearer that the middle is potentiality and emergence in the experiential doing.

utopia: Performance and Social Geography

Shattering the real with utopian dreams

Selina Busby

It was late afternoon in a suburb on the outskirts of Mumbai. Later that day the monsoon started, but in that moment it was humid beyond belief, even my eyelids were sweating. A performance had just finished; the performers, a group of young women living in a Half-way House for abused women, were jubilantly hugging each other and everyone else in the room. The usual post-show euphoria was in full flow – young women in saris were whirling around the room and whooping with excitement, when just a moment ago the room had been silent, still and the spectators tearful. It was a women only space: a multipurpose sleeping, cooking, working, sewing space that had turned into a performance space for fifteen actors and an audience of twenty. The show, created by the young women, had been in Hindi and involved poetry, dance, mime and song; even though I do not understand Hindi it had been beautiful to watch. It had no lighting, sound or costumes, the performances were stilted, hesitant and awkward, and yet to the tiny audience it was beautiful. As the women twirled about the room celebrating the end of a five-week rehearsal process they proceeded to collect items of food saved for the event: mangoes 'foraged' from next door's tree, pickled chillies, crackers, sambals, dried fruits and sweets that I couldn't identify appeared as if by magic. A higgledy-piggledy feast was laid out on the floor – a triumphant picnic for everyone who had participated or witnessed this process. As we all moved to the centre of the room, actors and audience merged into one mass of women – all smiling, laughing and hugging each other. One young woman in a blue sari, trimmed with gold thread, darted from person to person offering each a teaspoon and a large jar of lime pickle; everyone dipped the spoon into the jar and licked off the pickle as if it were ice-cream. She reeled round making sure everyone had a taste – suddenly I was next. 'Didi, Didi you must try', she said, standing in front of me, her eyes shining with excitement and the joy of giving, both a performance and now the pickle… I hesitated just for a second – would it be too hot for me? Would it make me ill? I opened my mouth to speak, and in that moment she suddenly, and without thinking, popped a large spoonful of the green chutney straight into my mouth. In a second she was gone, moving on to the next person, while I stood still, shocked, with a blob of sweet and savoury chilli pickle gently burning my

mouth. I was astonished, truly astonished: just days ago I had been a stranger, a stranger from a different culture and country. Meena had been shy and wary of my arrival, now she called me 'Didi', which I believe means an elder sister, and was spoon-feeding me. In the overall scheme of things this was a tiny event, but in that moment and in reflection since, it has become a moment of deep significance for me and my practice as an applied theatre practitioner. It was then, and is now, a moment of utopia.

Utopia is a difficult word to use: it is controversial and dangerous, yet twee and naïve. Jill Dolan makes the claim, in her book *Utopian Performance: Finding Hope at the Theatre* (2005), that utopia and live theatre are linked. Dolan draws on the idea of the active spectator, observing that when audiences come together, there may be a 'capacious sense of a public, in which social discourse articulates the possible rather than the insurmountable obstacles to human potential' (Dolan 2005: 2). This concept of a utopian 'social discourse articulating the possible' is attractive, but at the same time idealistically optimistic; and yet conversely it is at the centre of my practice in the field of applied performance or *social* theatre. It is also a concept debated in the field of social geography.

This chapter will consider how the collision of social geography and applied performance theories surrounding utopia leads to a new understanding of how participatory theatre may create change. The chapter will therefore consider the problematic concept of utopian applied performance and the ways in which the discipline of social geography might enhance our understanding of how performance practices might bring about societal change through what Experience Bryon describes as the 'active aesthetic' (2014).

Applied Theatre

Applied Theatre/Applied Drama are themselves contested and somewhat vague academic terms (Nicholson 2005; Taylor 2003; Thompson 2003). Helen Nicholson, writing in 2005, describes it 'as a discursive practice – as a way of conceptualising and interpreting theatrical and cultural practices that are motivated by the desire to make a difference to the lives of others' (Nicholson 2005: 16). This is a useful description as the intentionality implied by this 'desire to make a difference to people's lives' conveys the social implications and motivations that this type of performance is often centred around, or which may be the by-product of theatre practices undertaken by and for communities. Yet it also resists the closing down or narrowing of the field. A second useful term here is Social Theatre, as described by James Thompson and Richard Schechner in 2004:

> Social theatre sells itself by asserting that it 'supports self-esteem,' 'builds confidence,' 'manages anger,' 'heals sociopsychological wounds,' 'creates new approaches to learning,' 'promotes participatory community development,' and/or 'can operate constructively in the face of all kinds of

traumatic experiences.' The work is thus explained—translated—to fit its specific social contexts.

Thompson and Schechner 2004: 12

In this chapter, the performance I will discuss is theatre created to 'fit its specific social context' with a 'desire to make a difference' to the lives of those participating, who live in the halfway house in Mumbai. When thinking about integrative performing and applied theatre, we could say that the meaning happens for the participants in the practice, and not the performance. The purpose of applied and social theatre might be described as the generation of meaning through performance in order for participants to better understand themselves and the world in which they live.

Two students and I had been invited to work, for five weeks, with a group of women living in the care facility for abused and abandoned young women. The non-government organisation who financed the home wanted us to create an applied theatre project that would create a bond between the women, in the hope that this would enable them to 'face' the traumatic experiences of their pasts together while building self-confidence and self-esteem. As such it is a fairly typical applied theatre project, since its aim was to make a difference to the lives of the women. I am troubled by the intention to change participants that is a recurrent focus of applied theatre and yet I am, conversely, increasingly aware that despite this unease, there is an ethos of 'hope' that underpins my practice: the hope that the participants may create different lives for themselves.

While preparing to work on this project I had been thinking about the work as a 'pedagogy of utopia'. In this, I was drawing on Paul Ricoeur's thinking and definition of utopia, in which the word does not mean the hope of a better place, but the ability to recognise the current situation and from here develop the capacity and desire to change reality. He claims 'the utopia is not only a dream, it is a dream that wants to be realised' (Ricoeur 1983: 289). It is an active quality that seeks to create change. I have also been influenced in my thinking on utopia by social geographers.

Social geography, like applied theatre, is also an indistinct discipline. Rachel Pain et al. claim that there can be no 'clear distinctions' between social, economic, political and cultural geographies, although they do assert that social geography is:

> Concerned with the ways social relations, social identities and social inequalities are produced, their spatial variation and the role of space in constructing them. It places particular emphasis on the welfare issues which affect people's lives, and aims to expose forms of power which lead to social and spatial inequality and oppression.
>
> *Pain et al. 2001: Loc 292 of 77752*

Social geography and social performance theorists are both troubled by social injustice, the distribution of power and the implications that these have on individuals. Applied or social performance practitioners, in their desire to create change with their participants, are directly or indirectly questioning the power

dynamics at play in the lives of those they work with. I suggest that there is a good deal of hope – or even a utopian desire – in this aim.

Utopia, theatre and geography

As 'utopia' is a controversial term it is one I do not use lightly. It has been dismissed as both an obsolete or impossibly naïve concept in a society where the growth of neoliberalism dictates that change is no longer possible (Levitas 1982; Jacoby 1999) and as a dangerous route to totalitarian masterplans. In an article written in 2002, geographer David Pinder, when outlining some of the problems with the concept of utopia, observes, quoting Sandercocks, that the utopian impulses at the heart of 'so many experiments in city-building has always proved disappointing, if not down-right disastrous, in actual flesh and stone' (229). Pinder's own aim was to defend the value of the utopian perspective. He makes the claim that to do this it is 'necessary to rethink its definitions' which have traditionally been fixed 'around notions of an ideal state or spatial plan for a perfect future' (238). He suggests a move to thinking of utopia as a desire for a better way of living. In 2005, Russell Jacoby suggested the concepts of utopia as either a *plan* for the future or as a *desire* for a better future are the basis of two distinct schools of thought. The introduction to his book *Picture Imperfect* (2005), in which he describes his aim for the restoration of utopia, states that:

> I wish to save the spirit, but not the letter, of utopianism. I am drawing a distinction between two currents of utopian thought: the blueprint tradition and the iconoclastic tradition. The blueprint utopians map out the future in inches and minutes…. I turn instead to iconoclastic utopians, those who dreamt of a superior society but who declined to give it precise measurements.
>
> *2005: xx*

I too 'turn to iconoclastic utopias' and suggest that applied theatre invites participants to imagine a 'superior society' or at least a different future for themselves without precise measurements. To do this, I draw on the writings of Ernst Bloch. In *The Principle of Hope* (1986), Bloch describes people as being 'unfinished', or living in a state animated by dreams or desires of a better life, or utopian longings for another way of being. He describes this longing as 'anticipatory consciousness' and argues that it may move beyond the abstract fantasy or dream which is nothing but an 'idle bed of contemplation' (Bloch 1986: 158), to become a concrete utopia which 'opens up, on truly attained summits, the ideologically unobstructed view of human hope' (Bloch 1986: 158). Drawing on Bloch, Pinder claims that:

> utopia is understood as an expression of a desire for a better way of being and living. It is a desire that moves beyond the limitations of aspects of the present, seeking spaces and worlds that are qualitatively different from what exists.
>
> *Pinder 2005: 18*

Applied theatre projects are also often rooted in a 'desire that moves beyond' the present and seeks a different future for its participants. Pinder also claimed in his 2005 book *Visions of the City* that 'a talisman of the Thatcher government', which has 'become depressingly well ingrained into contemporary consciousness... is that there is no alternative to present social order' (Pinder 2005: 14–15). He suggests that utopias shatter this concept by inviting new ways of seeing. Many of the participants in applied and social theatre projects are also conditioned by their circumstances to think that alternatives are not possible; that their futures are set.

At the beginning of the Halfway House project I had begun to think that applied performance may be utopian precisely because it can critique the social order, and that this critique creates the possibility for alternatives to be conceived. Applied performance is instilled with a utopian spirit when it 'function[s] as a social and political criticism raising questions about the present' (Pinder 2005: 17). It can be seen to disrupt dominant assumptions and this opens the way for other possibilities to be imagined. In this I am also drawing on Paul Ricoeur's definition of utopia as outlined in *Lectures on Ideology and Utopia* (1986):

> The result of reading a utopia is that it puts into question what presently exits; it makes the actual world seem strange. Usually we are tempted to say that we cannot live in a different way from the way we presently do. The utopia though, introduces a sense of doubt that shatters the obvious.
>
> *Ricoeur 1986: 299–300*

Ricoeur lists three levels of utopia: the first is where utopia 'is fancy – the completely unrealizable' (ibid. 310). The second is where utopia can be seen to construct an 'alternative to the present power' (ibid. 16). This second level is one in which a *better* power replaces the one that exists. In the third level, 'utopia is the exploration of the possible' (ibid. 310). It is at this level that real change becomes possible and this definition is the most pertinent to my thinking. Ricoeur sees third level utopia as concerning the possibilities that I have been considering, regarding applied theatre work as a 'pedagogy of utopia'. Key to this concept is Ricoeur's thinking and definition of utopia, in which the word does not mean the hope of a better place, but the ability to recognise the current and from here develop the capacity and desire to change reality. He claims 'the utopia is not only a dream, it is a dream that wants to be realised' (ibid. 289). Bringing together Ricoeur and social geography theories with my practice in applied theatre allows me to think of that practice as one which allows participants to see the world in which they live, criticise the social structures which bind them and create imaginative variations on those structures – therefore inviting the possibility of change.

The Halfway House Theatre Project

There are more than 11 million abandoned children in India; over 90 per cent of them are girls. The home we were working in housed girls between the ages of 14

and 21 who had been neglected, discarded or abused for a variety of reasons that included sexual activity, mental illness, physical disabilities, severe poverty, or the remarriage of mothers whose second husbands refused to house their wife's children from previous marriages. The girls were mainly from the Dalit caste. Twenty or so girls in this home had shelter, food and were learning a trade in order to support themselves, but inside the home they were recreating the conditions of their lives outside the home. They had recreated a pecking order where the weak and different were bullied and victimised. The refuge envisaged by the non-government organisation who created the home was in truth a competitive and often dangerous space of isolation and violence. Our role was to build a community spirit within the house where the young women could support and comfort each other, where they could gain strength in solidarity with each other.

An Indian practitioner, Divya Bhatia, and I planned the project; two female applied theatre students then delivered workshops for the girls. We all wanted to work with a dialogical interdisciplinary performance practice that would enable the girls to play creatively together with the students, and to exchange theatre and performance skills. We were interested in the development of what Ramion Panikkar might call a 'pluriverse': a place in which intercultural dialogue is a 'mutual opening up to the concern of the other, a sharing in a common higher value that both parties acknowledge and neither party controls' (1995: 78). Our aim was to facilitate an applied performance process in the half-way house where its inhabitants and the Royal Central School of Speech and Drama students could engage in such dialogue and then create a piece of performance together that would celebrate this pluriverse.

The group worked together for three hours every afternoon, for five weeks. The sessions involved a range of theatre games, devising techniques and skills-sharing, often starting with a song and then some focus exercises. In the first sessions the young women were wary of the outsiders, often self-conscious and hesitant to play with the students. They were withdrawn and shy. As is usual in applied theatre projects with participants who have not performed before, session by session they became more relaxed. The students worked on storytelling games, creative writing exercises and some gentle performance skills for the first two weeks. As time moved on, the participants began to become more playful, and share Bollywood dance routines and Indian Bollywood songs that were swapped for the UK songs the students introduced. A key part of this process was the chai break mid-way through each session. The exchange of food became integral in these crucial moments. Food became a meeting point, with the students bringing biscuits and sweets from back home in the UK and the participants bringing mangoes that had been picked from next door's tree – each offering was exchanged as gifts. In these tea breaks the divisions between both groups of girls was relaxed; they laughed together and shared food and stories about their lives – they became friends.

As the weeks progressed, the young women decided they wanted their performance to be about the power of female friendship or sisterhood. Dance sequences were created, poetry was written, backcloths were designed on sheets

and the room decorated with painted paper plates. The play became a series of skits: some funny, some based on real and distressing events, some in Hindi and some in English, some in mime and some with a strange mixture of languages unique to this group of women.

The participants' confidence grew day by day; in the lead-up to the performance it was hard to tell who was facilitating and who was participating. The women also worked as a team to celebrate what they began to describe as 'the power of sisterhood'. This, too, is a complex term that does not necessarily translate culturally, but here the women perceived it as a bond created through shared experiences and living space. They acknowledged that it's a concept with both merits and flaws but one that united them while they lived in the shelter together. As the women, both students and participants, worked together their own bonds of friendship grew. The students became a part of the sisterhood – temporarily, fleetingly – but while they were there, they became part of group. The women found commonalities in experiences of being women, across, or perhaps in spite of, the geographical, cultural, economic and social divides that would usually keep them apart. Together they could celebrate the commonalities they found in their womanhood and sisterhood as a group.

As a result, the NGO's aim of developing a community spirit within the home appeared to be working. The women were emerging as a confident friendship group who supported one another. They taught each other difficult dance moves, worked on harmonies, helped one another to write poetry and script scenes. More than this, the women started to make future plans for continuing to work together, writing and dancing once the project was over. They talked together, looking back over the past and the project and began to move forward, imagining the strength that the bonds of sisterhood might manifest in the future. There was an optimism here in this newly found friendship and developing self-awareness, and this community bonding was, I suggest, potentially utopian.

In her book *Integrative Performance*, Bryon states that meaning happens in doing, or in the act of performance. Bryon makes the claim that:

> The field of performing (B) in many ways is a field of the unknown, as it does not settle. It lives in motion, as process. For this reason, it is easier to grasp onto some stable idea of performer (A) or performance (C) instead. Field (B) can be uncomfortable to work in, as it offers no easy answers or quick fixes. It is a practice, not a 'thing' to attain, an identity to make, or a goal to achieve. There is no getting it – it is a practice that is returned to anew each time. It is a way of doing; however, through this way of doing the self may alter and the goal may be achieved – something will emerge.
>
> *Bryon 2014: 14*

The performers in this project emerged, as did the performance itself, in the *doing* of the work. In this applied theatre project where acting, singing and movement were developed as combined practices, the performance that was devised was

unique to these performers and their stories; it was performable by these women and only possible because of the specific participants involved in the making of the work. During these making stages, the boundaries between the performer, performing and performance were completely dissolved and the middle ground described by Bryon as 'an active and live field from which performer and performance emerges' became the essence of the work. In this volume Bryon describes the manner in which the middle field 'helps to collapse the subject and object binary'; here there was no binary, by the end of the process there was no participant and facilitator, 'no maker and the made' and in the moments after the performance, no actors and audience, just a middle ground of performing.

Finding the space to be equal

Central to the creation of this work was the halfway house space itself. Lefebvre's argument – that the social meanings of space are constructed through their social practices and that spaces impose an order – is useful here. Lefebvre argues that spaces are, 'tied to relations of production and to the "order" which those relations impose' (Lefebvre 1991: 33). In other words, they are tied to knowledge and codes and as such conceal their own vulnerabilities with an apolitical and an historical positioning. Conceived spaces therefore conform to hegemonic processes. In this sense, the home could be described as a representation of space. It is a perceived space, defined by the routines or social production and reproduction by the daily lives of the women. In Lefebvre's words, spaces are 'defined by what people are doing in them'. Spatial practices are those practices which 'embrace production and reproduction' (Lefebvre 1991: 33). They are practices in which people passively accept the signs and symbols that have been placed on specific places, while also allowing for the resisting of social regulations as they are used and adapted by those frequenting them. The room we worked in had multi-purposes: it was a bedroom, a workspace, an eating space, a play area and now a rehearsal room. It was an example of representational space, a lived space, that was defined by its 'users' (ibid. 39). As such, the space obtains its significance through the uses that people attribute to it. This makes the space 'alive... quantitative, fluid and dynamic' (ibid. 42). In other words, spaces can be changed. Individuals inscribe their meaning rather than the technologies of power, or in spite of the hegemonic forces at play in society. This allows spaces the possibility to become counter-hegemonic, or to be spaces or geographies of resistance, whereby spatial practices of a specific location may be altered. The rehearsal room in the Half-way House was such a space. The students and participants 'inscribed' it with a new meaning, one of play and creativity in a place that appears to have little room for play; one of equality for the women who came together as women without caste or class.

Cultural geographers Matthews, Limb and Taylor, in an essay entitled 'The Street as Thirdspace' (2000), consider the perceived 'progressive retreat from the street by urban children' in the UK (Matthews et al. 2000: 63). They suggest that young people are 'increasingly confined to acceptable "islands" by adults and so are spatially

outlawed from society' (ibid.). This is a development of the 1995 argument presented by Sibley. The participants in the Half-way House had been forbidden to live outside the house – banned or outlawed from society at large. The space in the home was these women's 'acceptable island'. The drama workshops turned this space into an outlawed space, a space where the young women could meet in a free and less supervised or more unregulated area. Matthew, Limb and Taylor assert that these areas are 'an important part of [adolescents'] everyday lives, a place where they retain some autonomy over space' (ibid. 64) and in the drama workshops these young women could be seen to have autonomy. They made the rules, they decided what was to be included in the performance and what was not. In this way the multipurpose room became a 'thirdspace', a space in which the young women could 'gather to affirm their sense of difference and celebrate their feelings of belonging' (ibid. 64). It was a 'lived space' where they developed their own identities and challenged hegemony by contesting social conventions and asserting their independence.

It was a temporary reprieve, but for a while each day that June it become a 'thirdspace' that represented Ricoeur's third level of Utopia. In the workshops, albeit only for a brief part of the day, this group of young people could be seen to be 'exploring the possible', as they explored the 'possibilities of living without hierarchical structure and instead with maturity' (Ricoeur 1986: 310). They were still living within the ideological circle of Indian patriarchy, but not entirely conditioned by it in the workshops and performance. In the rehearsal room, as we worked as a group of eighteen people, the Central students and I struggled internally with the complex ethical dilemmas in the project. We focused on the work; we focused on the making of theatre. The students shared their performance skills as facilitators, devisors and directors, and the participants shared their performance skills and traditions: theatre was created. Not entirely beautiful theatre, but a performance with some beautiful moments along the way; perhaps it even has some of Dolan's 'exquisite moments' (2005: 5). Nobody in the room talked about creating a community bond or worked towards that goal as a strategic aim, but by the end of the project the sense of community spirit was tangible in the room, in the content of the performance, in the care the performers took of each other and in that jar of lime pickle.

Ricoeur claims that 'the thrust of utopia is to change reality' (1986: 289). A utopian theatre practice, and a pedagogy of utopia, might thus be interpreted as a theatre practice that confronts the challenge of creating a better future by exploring what could be, by questioning social reality, and by challenging the assumption that there are no alternatives. A utopian theatre reflects Ricoeur's view that a utopia is 'fundamentally realizable', and it is 'only when it starts shattering order that it is a utopia. A utopia is always in the process of being realised' (Ricoeur 1986: 273). I suggest that the thrust of this theatre project was also to change reality, or at least to create an environment that invites the kind of reflection in which change may be both desirable and conceivable. These women discovered the value of sisterhood and of sharing experiences together. They questioned their isolation and competitiveness and sought a new way to exist together.

In order to explain how the critical distance required for such questioning is possible, Ricoeur draws on the original meaning of 'utopia' as being 'no-where'; as described by More, 'a place which exists in no real place, a ghost city; a river with no water' (Ricoeur 1986: 16). From this no-where there appears to be a distance from what is, and it becomes possible to see things from a different perspective. The circle becomes a spiral, and utopia, therefore, exposes the ideologies that encircle us and which are taken for granted as givens. This questioning results in a sort of uncomfortable space that is aligned with Bryon's field of performing, as quoted above, which is uncomfortable to work in, but through which 'the way of doing the self may alter' (Bryon 2014: 14). For Ricoeur, the uncomfortable space reveals social constructs and, once revealed, ideologies can be questioned; their authority may subside and alternatives may be envisioned (Ricoeur 1986: 17). Ricoeur goes on to suggest that:

> We start from the kernel idea of the nowhere, implied by the word utopia itself. From this 'no-place' an exterior glance is cast on our reality, which suddenly looks strange, nothing more being taken for granted. The field of the possible is now open beyond that of the actual; it is a field, therefore, for alternative ways of living.
>
> *1986: 16*

From a distance or position of no-where, the observer can cease to take for granted the present reality. So 'no-where' becomes a reflexive space in which we can look at ourselves and our society. I suggest that this is what was happening in the Half-way House rehearsal rooms: the cultural exchanges are taking place in a no-where, a place distanced from the everyday realities for both groups of young people, a place and time where reality looks strange. A thirdspace where the young women were testing the possibilities and contemplating change.

I watched Meena move back through the room offering her teaspoon of lime pickle to others. It was a moment of utopia. Meena and the other women were on an equal footing with my students and myself. Together they had created a performance that celebrated sisterhood across nations and cultures. As the girls all moved together, swirling and giggling, one of the others started the cry 'Big Booty, Big Booty'; within seconds all of the young women chimed in together with 'We want Big Booty', the chaos reorganised into a circle – a circle of women around one of my students who started singing a call and response version of 'Big Booty' – all the participants eagerly joined in the refrain and all of the sari-clad young women completed the actions to the song which included a good deal of 'twerking' type movements. I have never been so astonished. Each took her turn at leading the call for responses and each confidently and 'sassily' waved her bottom in the air. But as I witnessed this amazing display of liberated women finding both joy and comfort from their fellow women, I also felt my sense of utopia slipping away.

These women had recreated their new reality, they had changed both individually and as a group but this was surely a temporary reprieve. This new found confidence could not be taken beyond the wall of the Half-way House into

everyday society. Both Bloch's concrete utopia and Ricoeur's third level utopia, are here merely illusions. The applied theatre project, informed by theories from social geography, cannot withhold the test of time; these women cannot change the society they live within simply because they have looked at it from a different perspective. When I bring the disciplines of applied theatre and social geography together a gap forms between reality and utopia that seems unbridgeable. The utopic dream of my practice is just a dream that is unrealisable. Or is it?

A nebulous utopia

If I look at what happened in the doing of the Half-way House project at the intersection of applied theatre and social geography, it's not a concrete utopia, or a permanent change – but a shift has taken place that is evident in not just the performance itself but in the performance of the after-show celebration. I would suggest that these women are caught between an alternative version of themselves and the old version.

I would further suggest that the transition between level two and level three utopia is more nuanced than social geographers and Ricoeur asserts and that there is a more phased progression or process to reaching a concrete utopia. For concrete utopia to be achieved, a testing period of a *nebulous utopia* is negotiated through an active aesthetic. In Ricoeur's words, the participants' social imagination has been engaged; they might be on the route to a concrete utopia, as he tells us, the role of the social imagination, activated by utopian endeavour, is to 'impassionate society … to move and motivate it' (1986: 296). As a result of this motivation, it may be possible to deinstitutionalise human relations. For Ricoeur, this deinstitutionalising of human relationships is the kernel of all utopias. And for me, the training of these theatre practitioners and the theatre they create is a nebulous utopian endeavour to deinstitutionalise human relationships: it is a radical performance, a pedagogy of utopia.

I believe that the Half-way house participants were at a level of nebulous utopia although, as discussed earlier, people are *unfinished* or in a state of *becoming* (Bloch 1986); this *un*concrete utopia will be fleeting, a temporary respite before the process starts anew. I would also suggest that this nebulous utopia is common in applied theatre projects with an intention to create change. In projects such as these, an active aesthetic is at the core of the work. Applied theatre, like the notion of the active aesthetic as described by Bryon (2014: 61), privileges the field of doing. It shifts the ways that participants 'consider the interaction' with the idea of self and performance towards a discussion that allows for choices to be made about real life through the work of performing. Therefore, applied theatre has an active aesthetic that forms a nebulous utopia and allows participants to see the potential for change in themselves, even if this change is not instantly reliable.

References

Bloch, E. (1986) *The Principle of Hope*, Volume 1. (Trans. Plaice, N. Plaice, S. and Knight, P.). Oxford: Blackwell.

Bryon, E. (2014) *Integrative Performance: Practice and Theory for the Interdisciplinary Performer*. Abingdon: Routledge.

Dolan, J. (2005) *Utopia in Performance: Finding Hope at the Theatre*. Ann Arbor, MI: University of Michigan Press.

Jacoby, R. (1999) *The End of Utopia*. New York: Basic Books.

Jacoby, R. (2005) *Picture Imperfect: Utopian Thought for an Anti-Utopian Age*. New York: Columbia University Press.

Lefebvre, H. (1991) *The Production of Space*. (Trans. Nicholson-Smith Basil, D.). Oxford: Blackwell.

Levitas, R. (1982) Dystopian times? The impact of the death of progress on utopian thinking. *Theory, Culture & Society*. 1. pp. 53–64.

Matthews, H., Limb, M. and Taylor, M. (2000) The Street as Thirdspace. In: Holloway, S.L. and Valentine, G. (Eds) *Children's Geographies: Playing, Living Learning*. London: Routledge. pp. 63–79.

Nicholson, H. (2005) *Applied Drama: The Gift of Theatre*. Basingstoke: Palgrave.

Pain, R. et al. (2001) *Introducing Social Geographies*. London: Routledge.

Panikkar, R. (1995) *Invisible Harmony: Essays on Contemplation and Responsibility*. Minneapolis, MN: Augsburg Fortress Publishers.

Pinder, D. (2002) In defence of utopian urbanism: Imagining cities after the end of utopia. *Geografiska Annaler*. 84(3–4). pp. 229–241.

Pinder, D. (2005) *Visions of the City*. Edinburgh: Edinburgh University Press.

Ricoeur, P. (1986) *Lecturers on Ideology and Utopia*. (Ed.) Taylor, G. New York: Columbia University Press.

Taylor, P. (2003) *Applied Theatre: Creating transformative encounters in the community*. Portsmouth, N.H.: Heinemann.

Thompson, J. (2003) *Applied Theatre: Bewilderment and Beyond*. Oxford: Peter Lang.

Thompson, J. and Schechner, R. (2004) Why 'Social Theatre'? *The Drama Review*. 48(3) (T183). Fall. pp. 11–16.

Cross-Chapter Discussion

utopia and role

Jessica Hartley (JH) and Selina Busby (SB)

Jessica Hartley: I am struck by three elements that intersect between our practices when reading your chapter. Firstly, the way that we 'dance' with the issue of empowerment; secondly and most significantly the way that vulnerability and power are present with us alongside the people we work with.

Selina Busby: I think that starting from our own vulnerability is tied to our belief in the political nature of teaching and in a practice that is one of critical pedagogy and that positions our students as agents of change. We are acutely aware that the power relations at play in the production of knowledge and teaching styles can both close down, rather than open up engagement. I think we use our own experiences to demonstrate that things could be different for our participants or students we are working with so-called 'vulnerable' or 'at risk' groups. Both of our chapters have an ethos of hope that is rooted in a practice that aims to engender optimism in our participants, or as I say in the chapter that our work invites them to into 'the field of the possible'.

JH: Yes, precisely. We utilise a similar critical framework to unsettle the discourses of power that are at play within the different environments where we work. I can see that at the heart of these two chapters is a complex paradoxical relationship between the way power is perceived, and the way power is experienced within our practices of teaching and Applied Theatre. The paradox is housed within the contentious term empowerment, and the way that you and I have been troubled by the assertion that our work is empowering. It is clear that power is a potent force within our practices – the traditional perception is that the practitioner has power, they work with marginalised or disempowered people – and empower them. The perception is that you and I are privileged, powerful and that we believe that education is a power for 'good'.

SB: I think we are both basing much of our practice on the concepts outlined by Paulo Freire but that we are skirting around his concepts in our discussion

because as you rightly say, we are not comfortable with the word empowerment that is so bound up in his writings. Empowerment is troubling because it implies power is there to be bestowed and this then forecloses agency on the part of the students. Power is not ours to be gifted, but it may come through as our participants critically engage with the world *with* us.

JH: In my chapter I discuss Michelle Fine's practice of 'working the hyphen' as a way of destabilising the normative power dynamics within pedagogy. And what becomes interesting for me therefore is the nature of this ability to be *with*; others, from a position of equality. More than a position, an active and at times stubborn and singularly all encompassing fight for equality. But we do not fight *for* the participants/students, as a barrister or doctor might. We fight with them in order to assert their ability to as Cahill articulates 'open... the possibility that things could be otherwise'.

Last time you and I met we discussed an exceptional student that we are supporting on an MA. I looked to you for advice about creative ways the student might reimagine the dissertation elements he was so fearful of. On paper this student is an academic 'failure', he has a history of stopping and starting courses, he submits work late, he fails to answer the unit brief. On paper. In our conversation, however, we spoke about the ways that we learn from him, his creativity and his passion. I was struck by the optimism you had, and most significantly for your aggressive fight for the value of his intellectual knowledge.

SB: We know that the education system privileges specific intelligences and modes of learning. The student you are talking about is creative and gifted student and if our classrooms and workshop spaces are to embrace neural-diversity we need to create more diverse ways for learning to take place. The education system is quick to label learners as being 'at risk' of failure. The notion of 'at risk' is one that troubles me; it focuses on what the student cannot do and is associated with low expectations.

I think that both our practices are influenced by the notion of social justice and believe that a more just society might be achieved through education. I would suggest that the 'vulnerability' we have identified in our pedagogical stance stems from a belief that all our participants or students have something to offer and from our dialogical student centred approach to learning. This in turn allows us to be vulnerable in the work. In many ways we are far from vulnerable in our classrooms and workshop spaces – rather we are secure enough to present ourselves as vulnerable in the sense that we are not the omniscient font of knowledge, but that we don't know all the answers and that we are very comfortable with that as we facilitate inquiries with our groups. This is where Bryon's notion of the active aesthetic is useful – a live field where the learning and the learned, or perhaps discovered emerge and change becomes possible.

JH: Precisely – we do work from a position of stable instability. We are able to encounter each student or participant and support the destabilisation of our *role* (my troublesome word), in order to support their emerging practice.

Because my experience is the reverse of what would be the expected norm of a teacher. School represented a rupture for me, and within the field of education my sense of identity was fragmented and I learnt that I was 'not good enough'. I was vulnerable within education. It did not gift my needs. I was not rule abiding. I was not successful. At school I learnt that I was a failure.

So, I begin from another side.

Despite formal education, I learnt.

And THAT has shaped the active aesthetic within both our practices. We work from a position of experienced vulnerability. And therefore, we do not, from a distant and critical position ascribe the participants or students we work with as 'vulnerable people needing empowering' – we work from a position of 'I am like you, and if I can do it, then anyone can'.

SB: Absolutely, and within that is hope, or my own troubling word, utopian endeavour at the heart of our practice, if I can then you can too. But for our participants to truly believe that then we must appear to be as vulnerable as they are seen to be by others.

JH: This vulnerability is perpetuated by the fact that many groups of individuals are considered to be continuously 'at risk' of hazard. Moreover, that the notion 'vulnerability' itself, by taking away the individual's relationship to risk and safety communicates passivity to the groups involved. The autonomisation of fear is associated with two factors: the imperatives of a neoliberalist age that makes specific adults accountable and, therefore, fearful of litigation or blame, and the moral and availability heuristics that magnify the body as a site to be fearful for. Both signal the person as intrinsically vulnerable, and it is assumed to be an essential quality of specific individuals, as something which characterises the person's identity and personhoods – in my chapter I talk about this being an Objectification, and a denial of humanity. So, if we start from a position of our own vulnerability, in relation to the students' creative potential – then how does that change the middle-field?

SB: I might suggest that the middle-field for us is a place where those usually thought of as being marginalised are invited to move to the centre and we place ourselves at the margins.

JH: The weaponised love that Paolo Freire talks about, the armed love that means we leap in alongside people to fight for their voice to be heard.

I also suggest that the middle field is *done* with empathy. The etymology, of the term empathy is modelled on German *Einfühlung* (from ein 'in' + Fühlung 'feeling'), which was coined 1858 by German philosopher Rudolf Lotze (1817–1881) as a translation of Greek *empatheia* 'passion, state of emotion,' from assimilated form of *en* 'in' and *pathos* 'feeling' . What is interesting about the root of this term is the way that feeling are both within the feeler (in) and projected towards the Other – it is a way of knowing the other, in feeling. Within empathy there resides a desire to reconcile the radical alterity of existence, to say that 'you and I are the same'. Whether it be with a student actor, or a young woman from India, there is the active pursuit towards sameness

through being with the participant empathetically. I want to caution here, that we do not empathise directly; but utilise empathy as an active element within our relation. We work the hyphen between them and us.

SB: I think the hopefulness in my theatre practice is rooted in empathy. Theatre is a sensuous embodied image-oriented medium for effecting empathy. That's what makes it good for having difficult conversations. The workshop space of my drama teaching asks participants to stand inside someone else's story. Once inside a story we become implicated. Once we feel for another we can't separate ourselves as easily from them and their situation; their questions become our questions. And the distance between the other and the self, diminishes.

These identifications crack open own our comfortable everyday identities, generate questions and reactions... when we grapple with these questions we are in effect asking questions about what it is to be human, we are questioning, the way things are orchestrated, once we question things the way is open to critique and change things. In my work and yours we are inviting our students and participants to see themselves differently.

JH: We both dance with power in our practices, revealing the way that it functions within spaces. We work towards a Utopian vision, that is both helpful and unhelpful; and we use the concept of a role (as function and character) to mobilise a conversation about change. Within which, the participant or student and facilitator or teacher are stitched together. This stitching and dancing is a useful way of considering how the middle field of our practice is engaged.

role: Performance and pedagogy

Dancing the Hyphen: Pedagogy and Performance

Jessica Hartley

Dear Student;

I see you there, looking at me and seeming to expect me to give you something: a passport to your future or fulfilment of your potential.

How sobering. How terrifying!

Alas, we are separated into unhelpful categories: I am the teacher, the academic; you are the student, the learner. Yet I do not feel any different from you; I simply play a very specific role. You are expecting to learn from me and there is a high value placed on this exchange called 'education' that I am contracted to and thus compelled to deliver. Our time together then is precious, so let us begin.

The beginning of a new academic year is always exhausting. I feel burdened by the overlapping experiences of separation from the cohort I have fallen in love with who are finishing and the responsibility for meeting and introducing myself to the new students. Each year brings exciting new possibilities for us both, through which we can learn and with which we will be changed. By the end of the year we will have all moved, shifted. Teaching is a complex dance, a duet with another person around a thing called knowledge. This chapter restages that pedagogical dance with other people through the lens of Experience Bryon's 'active aesthetic' (2014: 6) to reveal how my *middle field* is practised and performed in order to cultivate a learning environment. This middle-field is 'our alchemy, where the magic happens' in the practice, it is the unstable, mobile and precarious 'doing' of teaching, which destabilises the teacher, and keeps them learning too (Bryon 2017: 15–19). As Bryon articulates in the beginning, '[t]he middle field may live between the do-er and the done, the maker and the made, the writer and the written, the reader and the read, the designer and the designed, and the constructor and the constructed, the researcher and the research and the knower and the known' (Bryon 2017). Each year, I meet a new cohort of students and each year I engage

in dialogue with them. Together we wrestle with the discourses in education that restrict, dehumanise, empower and free us. And every year, when working in this way, I fall in love with the students through the practice of intellectual equality. We make the practice of our learning together.

I ask you, as the reader, to be my partner, to dance with the distance between teachers and students and the roles that we generate as an emergent property of being together. A focus on role places me between the disciplines of performance and pedagogy, because role is both the constructed 'character' that is assumed or presumed when one is experienced by another, and the function that the person and the subject plays for the other. My purpose in this chapter is to reveal how I destabilise the role that I play, because how I teach does precisely that. I politically engage with drawing students consciously towards the dynamics of pedagogic exchanges in order to challenge and uncover the ways that they may take ownership of their learning.

In addition to being a pedagogue with an interest in the practices of teaching, I am a performance practitioner working in the areas of circus, clown, physical theatre, participatory and immersive performance and text-based theatre. While the latter is not the practice that this chapter focuses on, my grounding in performance practice(s) informs an interdisciplinary perspective. How I occupy a *role*, be it as a performer or teacher, is suffused with interesting dynamics of script and character, and beyond that, with powerful narratives that disable students.

I have structured the chapter as a rumination upon conversations between not subject and object, but people. I do this in order to stitch the voices together in dialectical, rather than objectifying relation. In so doing, the teacher and the student become the opposite at different points in time, the teacher learns and the student teaches. Paulo Freire also juxtaposes these roles by calling the teacher the Master Student, and the student the Student Master (1970: 68). The role that we play for and with each other can be used to reveal and diminish the cultural discourses of power that may dehumanise us both; and so the pedagogic conversations that we have laminate us together.

In this letter to students, I hope to humanise us both through a series of hypothetical encounters which recreate many other encounters that I have had in my career. Each encounter reveals a different significant element of the multi-layered pedagogic dance I *do*. The conversations are contradictory, demanding, revealing, and some recognise blocks. I have taken the encounters from different aspects of my practice; some are direct quotes from emails or conversations, some are amalgams from different experiences, they typify the way that each student demands to be heard. The way that I 'hear' (and by that I also mean feel, experience, witness, block, encounter, judge and am judged by) the voices of the students I teach and may perform a role to unsettle their expectations about what teaching is and what learning may be. Under this rumination I provide the conditions from which a new *conception* of teaching and learning may emerge.

Dancing with others

What will you teach me? You ask.
*What are we here to learn **together**? I reply.*

There is no escaping the fact that teaching (rather than learning) happens between people. Even the autodidact has at some point been shown the way towards new understanding by a teacher; has been shown the way to books even if allowed to teach themselves to read. The etymological root of the word pedagogy is a complex fourteenth-century intertwining of Greek and French. I particularly enjoy hearing within the Greek lineage that the pedagogue was the slave that walked alongside the young boy on their way to school; *peda* deriving from the word foot. The French etymology places onus on the end of the word, *agogos:* to lead, and the *pedo* coming from the word child. My etymological and lexical pleasure comes from recognising the interrelationship of the pedagogue as both leader and slave, as the Master enslaved by the job they are expected to do. The theme of enslavement feels pertinent and apposite, not because it is enforced in my case, but because it is a chosen career that I value, in which I take an ideological position of servitude.

There is also the significance of the literal journey that is taken by two people on foot alongside one another, walking towards a 'school' in which education happens. The historical pedagogue was charged with making the child's journey to gaining knowledge a safe and clear one. They are enslaved and indentured to their purpose – their role is as slave, and their function is insight. The role is never challenged. The slave leads the child; they are enslaved by a social role, as well as a function, but the slave's job is not to question their enslavement, or their duty. I take an oppositional position in my practice. In the tradition of radical pedagogues (such as Paulo Freire, Jacques Ranceiere and particularly bell hooks),[1] I perform the role of a teacher by revealing the structures of our performance, and thereby hope to cultivate a critical engagement with academia from students. I practise the enslavement through revealing the chains that enslave the students and I *together* within discourse.

I practise pedagogy by destabilising my *role* as a teacher.

Frequently, discussions of education create distance between a powerful *us* and powerless *them*: I (we, us), the academic; they (them), the student. We know more: they are ignorant. We already understand: they have the potential to understand. Students are gauged, judged, organised, placed, stratified and reduced to numbers on a page, to grades and to measured outcomes. I am also stratified in collusion with their success, their grade, their satisfaction and their productivity. We are both deconstructed and constructed through the encounter: Us and Them. As the ethnographer Michelle Fine would articulate, we define each other by 'searching relentlessly for pigeonholes' in which we can restrict and categorise each other (1994: 72). Fine's suggestion is that in order to destabilise the power discourses that oppress and marginalise the 'subjects' of our research we must 'work the hyphen' between self and other (1994: 70). She does this by 'writing against othering' to

reveal the elitist epistemological narratives that give the 'illusions of objectivity' within key texts (1994: 75). She places herself within the narrative to give a better appreciation of subjectivity, and to destabilise the authority given to distance.

I therefore dance with the hyphen and shout:

But what if we simply say we?

In 1990, bell hooks[2] dared us to 'stop talking about the "Other", to stop even describing how important it is to be able to speak about difference' (1990: 151) in the classroom. This was not an attempt to deny the significance of gender, race, (dis)ability or class factors upon individuals, but instead she wanted us to antagonise the way that certain discourses focus solely upon the classification of peoples as different from each other; her argument is that as an academic, I need to work beyond difference to reveal the ways that humans actively engage with other humans in classrooms. She suggests that separation of Others is 'a mask, an oppressive talk, hiding gaps, absences' and moreover that 'this speech annihilates, erases' people (1990: 152). bell hooks demands that those who write about Others, also place themselves within that writing as equal to those talked *with*. As teachers we can either actively place students' voices into discussions of pedagogy, or we can render them absent, invisible through reliance on classification.

At the same point in history, within a radically different cultural framework from bell hooks, Jacques Rancière was asking us to be 'ignorant' with students, in order to create situations where we could act in dissensus to discourses that 'stultify' students into believing that they are not equal to us. By stultify, Rancière suggests that through explication (or mechanisms that explicate), the student is rendered stupid. Rancière's issue with explication can be captured in the following quote: 'the master's secret is to know how to recognize the distance between the taught material and the person being instructed, the distance also between learning and understanding. The explicator sets up and abolishes this distance – deploys it and reabsorbs it in the fullness of his speech' (1991: 5). What he is suggesting is the way that a 'master' does explication, i.e. how they observe, diagnose, judge and then create lessons, makes students deeply aware of the distance between them and the teacher. Rancière asserts that this awareness renders students stupid. Moreover, he claims that the master explicator utilises the distance created to reiterate and reproduce the distance in every learning encounter. The alternative is to refuse this distance. Rancière dreamed of a different type of society:

> Such a society would repudiate the division between those who know and those who don't, between those who possess the property of intelligence. It would only know minds in action: people who do, who speak about what they are doing, and who thus transform all their work into ways of demonstrating that is in them as in everyone.
>
> *1991: 71*

His rally-cry for radical equality comes from a position as white, male, intellectual elite; and yet, his practice is one that fights for the voices of students to be manifest in equality with the teachers, who use their position to engage with the student's 'will to learn'. Rancière challenges teachers to recognise the way that their practice inhibits the ability of students to see themselves as creative agents within education, and therefore see themselves as an authority in their field of practice.

I want to take up these challenges, mindful of the complexity of the task.

Working the hyphen between Them and Us.

Dancing with dialogue

> *Tell me what I should think. You ask.*
> *Talk to me. I invite.*

The practising of dialogue within education is not new. Within Plato's *Symposium* (2008) conversations about beauty form a poetic evocation of what Plato considered educative discussions. In it, young men discuss the purpose and nature of love. They do this to celebrate and honour Eros. In so doing, Plato characterises the purpose of education, to reveal the complexity of human experience, while also recognising that there is no higher love than that which comes from honouring another's intelligence and wisdom. Plato offers a way of educating through problematizing. For example, the character of Pausanias explores the way that love can become parasitical (when linked with the base elements of sex) or transcendent (when linked with intellect and nobility). So, when I talk about being in *loving* relation to a student, whom I love – it is from this element of intellectual validation. It is, and must be, divorced from the base, corporeal or objectifying potential for sexual love.

Pugh would call this way of constructing and revealing education a 'dialectic of love' (1993: 1). Pugh asserts that for Plato and also for Fredrick Schiller there is a division between the material world and the mental world; we are caught up by 'the material world that is human habit and in which we are entrapped by our human corporality' (1993: 3). In this way, I suggest there is a hyphen between rational and corporeal ways of knowing. Pugh suggests that through their practices of dialogue (for Plato) and poetry (for Schiller), the two pedagogues place the two worlds of 'intuition and nature loving' and 'cerebral and rigoristic' in dialectical relation through their discussions of beauty and the sublime (1996: 24). The dialectic is therefore a way of making manifest the interrelation between knowledge and the way knowledge is *constructed in relation to* doing, thinking and being. The student in these formations understands their own possibility through dialectical relation between body and mind. And particularly in dialogical relation with others.

The dialectical relation in this view of education is the struggle and the middle field of the educator's practice because it is the 'doing' of the pedagogic conversation between the educator and the student: the dance. In the case of Plato and Schiller

this dialectic is formed through the interrogation of love and love becomes manifest from the intellectual engagement between equals. The application of the term dialectic is also helpful here. The student is working to reconcile the embodied experience of knowing in relation to knowledge (the larger category) and the pedagogue is a part of that dynamic that can either synthesise the dialectic, or create distance between rational and corporeal knowledges. The teacher must fight to ensure that the student understands the value of the knowledge that they have already, rather than recognising the distance between that, and some 'correct' way of articulating knowledge.

Dancing with profanity

I can't do this. You reiterate. I am not an academic. I can't get the language right.
Fuck that. I say. Fuck getting it right and start getting it wrong on purpose.

The way that language is used in academia really hurt me when I was a student. I felt as if it was a cant, a vernacular that I would never learn. I understood that I would never be able to write correctly. I was too messy. I was too unstructured. I was too bold, or too tentative. I repeated myself and said the same thing in four different ways. There is not an argument, I was told. So you therefore fail. You are too polite with your sources. You are too impolite with your sources. Don't attack Freire. Critically engage with Freire. Don't give your opinion. Your opinion is not important.

Fuck that.

Fuck it all to hell.

I currently swear a fair amount when I teach and I am aware that this 'script' has an affect on the audience. I make it a policy to swear within the first fifteen minutes of meeting a new class. I often use the word 'fuck' to signify three areas that I find are often absent within academic discourse. Firstly to signal a passionate engagement with ideas, I may say 'what a fucking brilliant idea. Great' to a student who has contributed to the discussion in an original, surprising or contentious manner. The second purpose is to signal frustration, I may look at a quote by a famous theorist we are discussing and question 'what the fuck does that mean? Why does s/he have to write in a way that makes me feel so fucking stupid?' Before slowly and meticulously, often painstakingly discussing each word of the quote before placing it back to the students for discussion of meaning. The last example also houses the third element that I use to antagonise students' expectation, and that is self-deprecation. The articulation that academic language can make me (the teacher) feel stupid makes explicit an often concealed narrative concerning the struggles people may have to learn, to read, or to create. I swear in order to demonstrate that this way of talking is a performance, just like any other, and that they can take charge of the script using language they understand.

Michelle Fine would articulate the academic jargon as an 'uppity' voice (1994: 75) because it ignores the relationship between the writer, the writing and the discourses

that surround the 'correct' formulations of this trope. Rancière may understand my profanity as an act of 'dissensus' to the discourses that surround academic performance. His proposition is that teachers must act in constant dissensus to the established patterns of correct behaviour in order to reveal them as constructions to students. Gert Biesta (2010) emphasises that, for Rancière, radical equality entails a rupture within the order of things and is, therefore, understood as a process of subjectification; it is very different from identification. Biesta states that 'identification [for Rancière] is about taking up an *existing* identity, that is, a way of being and speaking of being identifiable and visible that is already possible within the existing order' (2010: 47). It positions the student within an uncritical relation to cultural politics, i.e. the lecturer arrives and talks very formally (with no profanity) about things that the student may, or may not understand. Biesta clarifies that identification reinforces a domestication of the student within a given social order. Subjectification, however, which is felt when the student is ruptured from a given social order without being told how to think or feel about it, 'decomposes and recomposes the relationships between the ways of doing, or being and of saying that define the perceptible organization of the community' (Rancière 1995: 40). Thank Fuck!

I work the linguistic hyphen between the academic and the colloquial, in order to make visible the possibility of identification and subjectification that the discourse itself can construct. I reveal the tensions that I have when trying to do things 'correctly' in order to destabilise the **role** that students expect me to take. I do this by placing disruptive words into the script, and by revealing an often hidden subtext of struggle.

The affect that my swearing has is significant. There is usually an audible gasp and a giggle. Most recently I was told that I had done 'everything wrong' and when I questioned what they meant, I was told that they 'expected lecturers to talk properly, and be very serious'. I have also been told to 'take [my]self more seriously, because I must have worked very hard to get where [I am]'. I take these comments as a compliment and an admonishing recognition of the constraints placed around 'academic' discourse. I take it as a signal that the students themselves were reifying the constraints of that discourse. I take it as moments when students 'decomposed and recomposed' their expectations of academic performance because I did not perform the *role* that they were expecting. I take *this* responsibility very seriously and throw the student back towards the way they understand me in relation to their own journey through academia. We dance together along the road to school.

Dancing with myself

> *I can't do this. You say because you believe that to be true.*
> *I believe that you can, I say. I know this to be true because I have.*

I once was told by a Jungian dramatherapist that I teach by transference. Although I do not have time to discuss Jung in great detail here (I recommend Antonia Batzoglou's chapter in this volume for a more knowledgeable appreciation of the

discipline), I appreciate the suggestion that when I teach, I consciously imbue the student with the feelings of uncertainty I felt (and feel) within my own journey through education. I know that the theories of transference, counter transference and co-transference are complex, contested and contradictory. But, what I want to emphasise how my own experience of education is generative to how I teach. I must recognise that my dehumanisation within education that I evoked (and swore at) earlier is formative. Academic discourse made, and makes, me feel stupid. And so the conversations I have with students, are conversations that I have with a much younger Jessica, who I wish to support. Fine's assertion is that a *'double splitting'* happens when we split ourselves as if we are 'contained, stable, and separable' from the 'subjects' of our practice/research (1994: 78). I am working to repair and reveal the splitting that happens within education.

In this way, I am working the hyphen between teacher and student, adumbrating the edges. I also recognise that in so doing, I am endowing students with a new *role*. It is different from the traditional role of student because it invites the student to place themselves wherever they like within the complex oppositions of success and failure; revealing the middle territory where they dance with the hyphen and may also become an 'academic' like me. If they want to.

But I also have to question why they might want to, and what it might mean for them. I am mindful of what Lauren Berlant calls 'cruel optimism' when I attest to students that they can. She is cited in Keguru Machiaria's gloriously troubling article *On Quitting*, in which he inhabits the dangerous ambivalence he experiences when working within an academic institution.

> We are trained to hang in, hang on, hang together. This, after all, is the lesson of graduate training. 'It will get better,' we assure students who struggle to learn. We are so definite. Were we more honest, we would say, 'it might get better,' 'perhaps,' 'maybe,' or, simply, 'we don't know.' Instead, we say, 'there are no guarantees, but'. And that 'but', that barely uttered, barely hearable 'but' carries so much weight. Everyone wants to hear the 'but'. Everyone invested in the academy is always hearing the 'but'. We are a community organized around 'but'. Lauren Berlant calls this 'cruel optimism'.
>
> *Machiaria 2013: NP*

Macharia's article places onus on the way the 'system' of education forces everyone involved to 'look upwards' as an aspiration, to graduate, postgraduate, research, Professorship and beyond. He poetically evokes the distance that this may create between what people may want, and what they are told to want.

In the assertion that *I believe you can*. I must be mindful of the potential for cruelty therein. The potential that in so doing, the student may sacrifice something in order to become like me. Working the hyphen between self and other in this instance may work to compose the student into the identifying construction of the *role* of student that I am trying to unsettle.

I do not want them to be like me. I want them to be like them.

Dancing with metaphor

I can't do this. You say.
Take tiny steps. I encourage. Go backwards, go forwards, go sideways, gently move
on the spot, move in circles, take to the sky — it is up to you.
And then we may find ourselves dancing.

The metaphor of dance, dancing and dancers forms part of the lexicon through which I teach and am taught. I have appropriated it from my teacher Geoffrey Coleman, who once stated that 'at MA Level students dance with the knowledge that they learnt at BA level' (2013). The clarity of this metaphor comes into its own when thrown against the desire to work a hyphen. Am I instead *dancing* with the hyphen between myself and the student?

When I teach I use metaphor frequently and the dancing metaphor is my favourite. It serves as a way of bringing the material of knowledge to students so that they can engage with it on a corporeal level: they know dancing because they have danced, they comprehend it viscerally. Metaphor no longer evokes the 'fugitive' elements of hook's Other, where one person is seen as distant from an other. The ambiguity of metaphor precipitates a drawing together of people in recognition of the different meanings evoked descriptively (1991: 6). Mobile meanings are questioned and challenged through the course of the speaking by both the speaker and listener. For Rancière, poetry offers emancipatory opportunities for the listener, student or other with whom you are communicating because it does not explicate. He states that speech, by attending to personal experience, 'decomposes and recomposes' notions of reality and produces a 'fresh sphere of visibility for further demonstrations' (1999: 42). The language of metaphor can, therefore, make a number of things visible: the culture within which the speaking is happening, the relation that the speaker has to the material being discussed and the cultural and ideological presumptions (or heuristic judgements) of the listener in the hearing of it.

So my pedagogical script includes openings provided by metaphor, and in so doing the *role* that I take changes because it enables the understanding of the student to be individual, rather than fixed. I ask you to dance with knowledge, and somehow, you create your own moves. Asking you to dance makes it seem less rigid, more playful. You can know yourself in a dance.

Dancing with race

I can't do this! You shout. You don't know, because you're not me.
Who are you? I ask. Tell me your story. Where are you from?
You freeze. And say quietly. What do you mean?
I freeze at my transgression. At the remembrance of my whiteness.
We are blocked.

Shelby Steele writes about the way that overt racism has been replaced by epistemological and disconscious racism. His argument is that the threat of being perceived as a racist can mean that certain issues are glossed over. He argues that avoidance of conversations about how 'race' may be imbricated within communications between people can further marginalise the people that we are all striving to support. 'Efforts to appease or dispel [white guilt] will only engage the society in new patterns of dehumanisation against the same people who inspired guilt in the first place' (2007: 16). So the question becomes: how can a (white) teacher engage in a conversation about 'race', without reproducing white guilt and white privilege? Indra Dewan acknowledges this tension too, stating that within societies in schools, there is a racialised appreciation of 'inside/outside' knowledge. She suggests that '[t]his raises epistemological, representational and ethical issues about who can legitimately and effectively research whom' (Dewan in Bhopal and Preston 2012: 103). She suggests that questions are responded to differently according to the race of the person asking it. She utilises the question 'where are you from?' to typify this. Asked by a white person it is 'heard' differently, as in a judgment of 'difference' – and when asked by a more racially ambiguous person – it is heard as an acknowledgement of 'sameness'. Steele and Dewan both suggest that 'race' is a presence and absence within institutions that has no clear rules to help white teachers navigate.

And so, desperate that this becomes a transparent discourse I employ what King and Akua (2012) call for:

> By unquestioningly accepting the status quo, this mind-set, which is identified as an outcome of miseducation, prevents teachers, for example, from questioning the existing racial order and leaves no room for them to imagine practical possibilities for social change or their role as change agents.
>
> *14*

I must dance with the tension of inside and outside of not being black and of being white. I cannot work the hyphen between black and white, but in naming it – I may begin to dance with it. To begin the work that may decompose its discursive authority.

In the conversation above, I did two things: the first was to acknowledge the racial tension between us.

'Oh, yes, a white person just asked a black person where they were from – I unintentionally "blacked"[3] you.'

'Well, I am black' he replied,

'Yes, I had noticed that' was my response. He laughed.

'But your accent is from Birmingham – right?'

'Coventry'.

'Ah, so, you're from Coventry? What is it like to be from there?'

'From Nigeria, too though, that is also where I am from.'

'And that changes your experience, how?'

To suggest that the student's experience is not valid is to reassert the epistemological hegemony that may marginalise an already unsettled student. As Amy Ginther articulates '[d]ysconscious racism is an uncritical mind-set that does not challenge the norms and privileges of a dominant culture' (Ginther 2015: 42). I cannot make my whiteness, and therefore my privilege, disappear, I cannot re-role myself as black. Instead, what I must do in this instance is make visible and therefore valuable the counterstory that is present within the pedagogic narrative. Critical Race Theory calls narratives that unsettle privilege 'counterstories' – i.e. stories that run against the cultural/epistemological values of the institution. These have particular validity in terms of bringing to the fore the way knowledge is situated within socially constructed environments. It is important, as a practitioner, to be attentive to the ways in which my practice is infected by neo-colonial discourse. Thus, it is important to be 'hyper-self-reflexive' about how education is implicated by '[a]cknowledging complicity' with the colonial performativities that exist within that space (Kapoor 2004: 641). In that way I am accepting and owning my own position within a hegemonic system, making it possible to 'unsettle the dominant from within' (Spivak in Kapoor 2004: 640). I accept that I am a white woman working with black students, and recognise that this means certain epistemologies have significance – and I can either face it, or ignore it. I choose to dance with it.

The role that I take when dancing with the hyphen of my race is a complex one, but it must not be a tentative one. To be tentative is to be guilty. To speak is also to risk being guilty – but from that revelation and admission of difference a possible dance between different cultures or races based on equality may emerge. I must take, reveal, make manifest the *role* of the unsettled one that I pertinently experience, in order to reveal the hegemony.

Dancing with hegemony and love

> *I don't want your help. I want to do it on my own. I want to prove myself to you. Great. I say. Of course you can do it. Please do it for you though, not for me.*

Certain students that I meet struggle with being cared for in their position as learner who is loved by the teacher. These students test my tenacity to work the hyphen because they refuse to meet me in dialogue. Their desire to do the right thing takes them out of the dialogical relation between us.

To let themselves be loved.

My favourite element from bell hooks' practice is her assertion that teaching is loving. She says that:

> Teaching tugs at the heart, opens the heart, even breaks the heart – and the more one loves teaching, the more heartbreaking it can be. The courage to teach is the courage to keep one's heart open in those very moments when the heart is asked to hold more than it is able so that the teacher and students

and subject can be woven into the fabric of community that learning, and living, require.

hooks 2003: 19

My enjoyment of hooks' evocation centres around her indication that there are moments when 'the heart is asked to hold more than it is able' and that this practice changes people and epistemologies. For hooks though, the emphasis is on loving teaching, not on loving the students.

Paulo Freire emphasises that universal education demands a weaponised loving connection between teachers and students:

> It is indeed necessary, however, that this love be an 'armed love', the fighting love of those convinced of the right and the duty to fight, to denounce, and to announce. It is this form of love that is indispensable to the progressive educator and that we must all learn.

Freire 1998: 74

The notion of an armed love characterises encounters as being directly intentioned towards the equality of the other. To never diminish the role that we play in the humanization or dehumanization of people within discourses of power. His powerful ideological position places him alongside Plato and his belief that love is *both a product* and a focus for educational dialogue.

In the *Symposium*, Plato utilises moments of dialogue concerning love to elucidate different types of love, from the vulgar *eros*, which was sexual love for another; to the divine *eros* which leads you to understand yourself in relation to God. For me, the Platonic dialogues form an illustration of loving relation between two people, intent not only upon furthering their understanding of the subject of love; but also engaged within a practice of love. What is clear from the text, is that love emerges in two ways, the first being the fabric and matter of the conversation, they discuss the way that love is understood within a cultural context; the second is the *affect* of dialogue between intellectual equals, they engage with one another in loving relation – and love is created. Placing this into a contemporary pedagogic situation, I suggest that when a teacher works in dialogue with students, they assert themselves directly *towards the intelligence* of the other, and the pursuit of a better understanding of both their 'self' and of the *role* that they play with and for each other. Love is therefore the emergent property of that relation.

Dancing with ending

Teaching is a process of composing and decomposing the pigeonholes that surround us all. To teach is to become a student, and to be a student is to teach others. This process of construction and deconstruction may be done through a loving encounter, borne out of intellectual engagement with someone and by lovingly, fiercely and combatively dancing the hyphens that are created between ourselves

and others. Love emerges from subjectification of the other in this dialectical dance.

> *Dear Master Teacher,*
> *There are hyphens between us.*
> *Between self and other*
> *Between you and me*
> *Between the master and slave*
> *Between the profane and the academic*
> *Between black and white*
> *Between insider and outsider*
> *Between correct and incorrect*
> *Fuck that. I resist it. I repudiate the division. You are me, and I am you. We are different and the same. I know you, stranger, and I want us to celebrate our intelligence. Let's Dance.*

Notes

1 I have learnt an immense amount about radical pedagogy from Paulo Freire, who demanded that I consider the way I am 'surrounded and influenced by the climate which generates [dehumanization]' and unconsciously reproduce it through pedagogic encounters (1970: 60).

2 The author and academic bell hooks resists capitalisation of her name in order to reveal the way that power proliferates around the 'authority' of grammar, naming and words on a page. She wants us to deconstruct the way that a person is 'known' through name and the way that capitalisation may support an epistemological hierarchy that may marginalise people.

3 I am working from Frantz Fanon's thinking here. Fanon's assertion is the black man is 'overdetermined from the outside', meaning that his racial characteristics dark skin, facial features, physique—make him not a 'slave…to the 'idea' others have of' but a slave to his 'appearance' (1952: 95).

References

Bhopal, K. and Preston, J. (Eds) (2012) *Intersectionality and 'Race' in Education.* London: Routledge.

Biesta, G. (2010) A new logic of emancipation: The methodology of Jacques Rancière. *Educational Theory.* 2(1). pp. 39–59.

Bryon, E. (2014) *Integrative Performance: Practice and Theory for the Interdisciplinary Performer.* London: Routledge.

Bryon, E. (Ed.) (2017) *Performing Interdisciplinarity: Working Across Disciplinary Boundaries through an Active Aesthetic.* Abingdon: Routledge.

Coleman, G. (2013) Unpublished Lecture on Research in Actor Training. The Royal Central School of Speech and Drama, University of London.

Fanon, F. (1952, 2008) *Black Skin, White Masks.* London: Pluto Press.

Freire, P. and Ramos, M. B. (Trans.) (1970) *Pedagogy of the Oppressed.* London: Penguin.

Freire, P. and Ramos, M. B. (Trans.) (1974) *Education for Critical Consciousness.* London: Continuum.

Freire, P. (1998) *Pedagogy of Freedom: Ethics, Democracy and Civic Courage.* (Trans. Clarke, P.) Lanham, MD: Rowman and Littlefield.

Fine, M. (1994) Working the Hyphens: Reinventing Self and Other in Qualitative Research. In: Denzin, N. K. and Lincoln, Y. S. (Eds). *The Landscape of Qualitative Research: Theories and Issues.* Thousand Oaks, CA: Sage.

Ginther, A. M. (2015) Dysconscious racism in mainstream British voice pedagogy and its potential effects on students from pluralistic backgrounds in UK Drama Conservatoires. *Voice and Speech Review.* 9(1). pp. 41–60.

Heidegger, M. and Robinson, E. (Trans.) (1962) *Being and Time,* Oxford: Blackwell.

Heidegger, M. and Hofstadter, A. (Trans.) (1971) *Poetry, Language, Thought.* New York: Harper and Rowe.

hooks, b. (1990) *Yearning: Race, Gender and Cultural Politics.* Boston, MA: South End.

hooks, b. (1994) *Teaching to Transgress.* Routledge: London.

hooks, b. (2003) *Teaching Community: A Pedagogy of Hope.* New York: Routledge.

hooks, b. (2010) *Teaching Critical Thinking: Practical Wisdom.* New York: Routledge.

hooks, b. (2014) *bell hooks and Laverne Cox in a Public Dialogue at The New School.* https://www.youtube.com/watch?v=9oMmZIJijgY (Accessed 23 July 2016).

King, J. and Akua, C. (2012) *Dysconscious Racism and Teacher Education.* Thousand Oaks, CA: Sage.

Machiaria, K. (2013) *On Quitting.* http://thenewinquiry.com/essays/on-quitting/ (Accessed 8 November 2016).

Maisurie, A. (2011) Ten Years of New Labour education policy and racial inequality: An act of whiteness or neoliberal practice? In: *Blaire's Educational Legacy and Prospects: Ten Years of New Labour.* London: Palgrave.

Plato (2008) *Symposium.* Oxford: Oxford University Press.

Pugh, D. (1993) *Dialectic of Love: Platonism in Schiller's Aesthetics.* Montreal: McGill Queens University Press.

Rancière, J. (1991) *The Ignorant Schoolmaster: Five Lessons in Intellectual Emancipation.* Stanford: Stanford University Press.

Rancière, J. (1999) *Disagreement: Politics and Philosophy.* Minneapolis, MN/London: University of Minnesota Press.

Steele, S. (2007) *White Guilt: How Blacks and Whites together destroyed the Promise of the Civil Rights Era.* New York: Harper Perennial.

Cross-Chapter Discussion

role and embodiment

Jessica Hartley (JH) and Deirdre McLaughlin (DM)

Jessica Hartley: The things that draw us together through our chapters seem to be embodiment, role, metaphor and in particular the way that we work with cultural context. Can we begin with a conversation about embodiment?

Deirdre McLaughlin: As I suggested in my chapter, I think that colloquially when many actor trainers or actors use the term embodiment they are referring to a felt sense; they have a "felt sense" of their lived experience, and very potentially a heightened awareness of the relationship between the body and the mind due to the nature of their training, practice and intuition. However, from an interdisciplinary perspective, the embodied cognition view that I have embraced in my chapter identifies that as a starting point for understanding embodiment we have a body with various sensorimotor capacities (i.e. the source of our 'felt sense'); we sense things, we see things, we feel things, we take things in; and because of our very nature of having a body with those capacities, we experience our world. In addition to this, cognitive embodiment as a concept is rooted in the hypothesis that our cognitive processes are dependent upon perception and action. This is likely an informing factor as to why there has been such a rush of recent interdisciplinary exchanges between cognitive science and acting: the importance placed on action is shared in both fields. From an enactivist perspective, a cognitive system does not passively engage with its environment, it 'enacts meaning' through engaging directly with it in a shared exchange and as a result, this collaboration or interface between an individual's sensorimotor capacities and their environment is essential to our experience of the world. This is the basis of enactivism.

JH: The problem occurs if you are a director or you are a trainer and the actor's understanding of cultural experience is different from yours; so I [the trainer or teacher] encourage you to actually disembody because you're trying to embody my cultural appreciation. In this example, the student ends up being trained to

perform a role according to the teacher, director or actor trainer rather than according to your own cultural understanding. The teacher or director colonises the student.

DM: Yes. I can see the potential for concern or conflict there from a training perspective. As actors, we frequently create imagined environments within which we act. However, the nature of our imagination, these complex environments, and our ultimate experience of these environments is based largely upon our individual perceptions of the world. While we share this world to some extent with our collaborators (our trainers and directors, etc.) and can even establish shared vocabularies to identify them (i.e. in the language of Stanislavski, our 'given circumstances'), we have different bodies and as a result, perceive the world in different ways.

As actors, if we acknowledge the difference in our individual perceptions and establish a shared set of given circumstances which inform the nature of our world in performance, accepting that the agent (or actor) can act upon its environment and the environment can act upon the agent, then as an extension of this hypothesis it would conceivably be possible for two individuals to 'embody' the same cultural experience as an extension of their world. However, the nature of their embodiment and their experience of it would be unquestionably different due to the individual nature of their perception and action, their bodies, and their interactions with their world. Similar, but different.

JH: So then we are talking about the way that a person can perform, and thereby alter the way that they are perceived? And the way that they perceive their own agency? So, from a position of *difference* we can cohabit the same space. Because we are both human and embodied.

DM: We both have bodies and those bodies are embedded in a shared environment. Right now we are both sitting in the café in the Young Vic in London. We have a shared environment in time and place.

JH: But I don't know what it is to be *your* body.

DM: True. And as a result, you cannot know how I perceive my environment or how I enact my world within it. However, we both have a shared understanding (to some extent) of what it is to have a body in the Young Vic and therefore, we might be able to create a shared vocabulary for understanding our experience of it.

JH: There is something interesting here in relation to role, because when I'm training or teaching you and we're talking about your work, then my appreciation of what it is do your work may become superior to yours. The teacher can create distance between Them (students) and us (teachers). Because we may deny the individuality and embodied experience of the other, colonising them with our interpretation of what 'looks right' to us.

DM: As trainers we can teach an actor to approach experience as a verb. By that I mean as an action, or to use Experience's model 'the doing of the doing'. We *can* teach them *to experience*, or to prioritise action and engagement with the

world as tools for formulating experience. What we can't control is their experience.

JH: We *mustn't*. By doing that we objectify them.

DM: And if we accept that an actor's artistry as an individual is based in the nature of their experience, that it's their individuality that we're valuing, that is the emergent property in the model of performer → performing → performance. When reflecting on the training actors within this dynamic frame of the active aesthetic, it becomes clearer that the performance (or experience) emerges in relation to the nature of the performer's action (i.e. performing).

JH: And that's it. The role of this teacher/trainer can either free (although I'm loathed to use that term), the student to articulate their experience for themselves or they can support the student to suppress it.

Going back to Experience's text, she discusses at length witnessing instead of judging. I think that's the role of the teacher, to ensure that the student doesn't learn judgement mechanisms they learn *their* witnessing mechanisms.

DM: We can link that active process of witnessing or self-awareness to an actor's lived experience of 'embodying a role'. The role an actor plays is informed by the nature of their (performed) character, but more importantly by their function, the actions which they undertake in relation to their world (or, to return to the language of Western actor training, their 'given circumstances'). The relationship between these informing factors determines the nature of their embodiment and their individual perception of the experience of playing the role.

JH: That's exactly how I discuss it in my chapter. I suggest that the reason we don't use character is because it's more than that, it forms both character and function.

DM: That conceptualisation of role makes sense to me in relation to understanding training or teaching as a verb or an action within the framework of an active aesthetic whereby teaching as an action may be a way of imparting meaning or facilitating experience... or potentially as a way of *doing* some type of knowledge or learning that opens up a different type of engagement with our world, facilitating knowledge and experience as an emergent property.

JH: What we're doing then is staging this *middle field*; so when as a teacher I *do* teaching I negotiate pedagogical choices in relation to what I am **sensing** how I am **listening** to the students. It's not just subject learning that's going to happen when two people are in a room together, it's about effectively learning in relation to self-knowledge, to awareness of all the potential things we all might be learning.

DM: I wonder then to what extent we might draw a relationship between learning and perception? In an embodied cognition frame, there is a hypothesis, popularised by Alva Noe, that action and perception work in a loop or a cycle. In very simplified terms, we do something, undertake an action, and simultaneously we perceive the effect or experience of that doing. These two processes, action and perception, are functionally intertwined: perception enables action and action enables perception.

JH: Good. Yes, learning is looped. Not only do I learn but I know what it is that I have learned and can articulate it in the doing.

DM: Yes. Thinking about loops and the role they can play in learning and drawing out connections resonates with the use of metaphor in my chapter. I've turned to metaphor in an attempt to articulate the nature of embodiment within an interdisciplinary frame, because through something representative or symbolic of something else (and accepting that the metaphor you are using to do so is indeed good), metaphors invite us to understand one thing both in reference to the other and also within their enactive exchange. If the metaphor is to be successful at highlighting something about our world, we have to understand both elements in the comparison offered. A good metaphor will clarify or identify hidden similarities between these two elements and provide some deeper level of meaning. For example, if I state that 'the body is the mind' or 'Juliet is the sun', these metaphors should reveal more about each individual part through their dynamic relationship to each other.

JH: Yes. With constant vigilance to reconciling why we use metaphor, how it functions; how it might not function for all students that we train. So we use it in that way as a synthesising element but if we have a student with autism in the room – it wouldn't function in that way, it would instead distance the student from the learning.

DM: Yes, understanding variations in how an individual cognisers or experiences their world can be a useful example of the fact that their embodiment is unique to their experience of their body, their actions and their perception. Therefore, a metaphor that may be most effective for him in highlighting the similarity between objects or experiences may not prove to be similarly successful for another individual or student due to any number of these variables.

JH: Yes, whereas someone who has cognitive dyspraxia for example, might only be able to understand in metaphors. When we're working with them and asking them to create truth in imagined circumstances everything is understood as truth. Therefore the metaphor of truth is problematic. When we say Juliet is the sun they know it, it's recognising that part of our role as trainers is to land effective metaphor.

DM: Metaphor (as opposed to simile) is about drawing direct comparisons between two things which may not be literally applicable, understanding derived from this comparison can and will vary from student to student that can change dramatically based on their understanding of these individual elements or their experience of the literal.

JH: So our function is to critically engage (or dance) with the way we use metaphor to resonate directly with students… The act of witnessing is fundamental, again we're coming back to this suggestion that students don't just need to experience, they need to know they are experiencing. How they are experiencing it is the learning when they're doing so witnessing and moving forward in a political environment.

DM: Absolutely. We can facilitate an experience for an actor, but in order for the informing elements of that experience to be replicated night after night in performance, the actor must have a sense or an awareness of how they as an individual perceive their world and their actions working within a dynamic interchange, and it is additionally useful for them (as actors) to understand or have an awareness of the fact that that their perception is individual and likely changing, if only in minute ways, in response to their environment from night to night.

JH: It must be, because we are dealing with people.

embodiment: Performance and Cognitive Science

Combining concepts in the mapping of experience

Deirdre McLaughlin

Introduction

Current trends in the application of cognitive science to our understanding of the actor's process have resulted in an increased attention to the term embodiment. While colloquially, embodiment has come to imply an expression or representation of a feeling or an idea in a concrete or bodily form, the concept of embodiment is widely utilised in the field of performance to more specifically denote a relationship between the mind and body whereby 'mind and body are not two entities related to each other but an inseparable whole while functioning' (Ginsberg 1999: 79). This understanding of embodiment implies that the mind (or 'bodymind') is inherently *embodied* (Shapiro 2010; Gallagher 2005; Wilson 2002; Lakoff and Johnson 1999; Varela, Thompson and Rosch 1991), a position also held by the principal theories of embodied cognition. However, while the relationship between the body and the mind is an important starting point for many performance practices, and more specifically the training of actors and performers, this chapter argues that the relationship between the body and the mind is *always* situated within a 'world' or broader context. Thus, the role of the environment within which the performer, their performing, and their performance[1] are embedded or situated within, must be given further consideration when approaching embodiment within an inter- or transdisciplinary context which integrates the disciplinary concerns of cognitive science through an active aesthetic.[2] More specifically, this chapter utilises popular conceptions of embodiment from actor training, as one of the many sub-disciplines of performance and a specific field within which to explore the processual concerns around performance, as they inform the practice(s) of the actor in the act of and preparation for acting, alongside theoretical contributions from embodied cognition as a specific research programme within the wilder field of cognitive science, to problematise how one might approach the *doing of embodiment* within the framework

of an active aesthetic. As introduced previously within Bryon's chapter in this book on 'performing interdisiciplinarity through an "active aesthetic"', this edited collection includes different disciplines as they 'engage across various understandings of "performance"' (Bryon 2017: 40). In the case of this chapter, I am concerned specifically with acting as one mode of performance making, although the potential applications of this interdisciplinary exchange to a broader field of performance practice are undoubtedly numerous and fruitful, as evidenced by the rapid increase in texts and practices integrating cognitive science and performance over the past 20 years. When drawing upon the field of embodied cognition, the most fruitful 'practice' to explore in relation to acting and within the model of an active aesthetic, or 'way of doing' in an '*active* field', might be to consider the experiencer *experiencing*. Indeed, this chapter will engage directly with the practice of experiencing as an active aesthetic, 'the *doing* of a doing [...] the *practice* of the practice'. This appears in both the act of acting and the experience of experiencing as 'way[s] of doing [...] through which a practitioner and their discipline can emerge, often simultaneously' (Bryon 2017: 40) within the disciplines of acting and embodied cognition.

First, acting and embodied cognition are introduced as inherently interdisciplinary practices, rooted within the larger interdisciplinary fields of performance practice and cognitive science, with a dominant focus on *the act of doing*, the middle field within Bryon's model of the active aesthetic. Next, embodiment is framed within both fields (actor training and the embodied cognition research programme) with the aim of highlighting some of the limitations within current applications of the term embodiment and to argue for a newly contextualised understanding informed through this interdisciplinary exchange. Finally, metaphor or 'metaphor-ing' is proposed as a conceptual linking model which might further serve an understanding of embodiment or *embodying* as a practice within the framework of an active aesthetic and function as a necessary tool in the move towards a future transdisciplinary practice which 'concerns itself with what is *between* disciplines, *across* the different disciplines, and *beyond* all disciplines' with the aim of understanding 'the present world, in which one of the imperatives of the unity of knowledge' (Nicolescu 2005: 144) through both research *and* practice. By embracing metaphor as 'a tool for change and transformation' (Bartal and Ne'eman 1993), a proposal is made for how the active aesthetic might be applied beyond its original offerings to performance theory and practice (Bryon 2014) and as proposed, allow for an extension into an 'undisciplined space' (Moran 2010) which allows for the transdisciplinary emergence of further insights and practice within the exchange between acting and embodied cognition. It is within this undisciplined space or 'middle field' (Bryon 2014) where 'knowledge *happens*' and each discipline 'lives within its own *active aesthetic* as it *practises* its knowledge' (Bryon 2018: 41) – the site of the embodier → *embodying* → embodiment.

Interdisciplinary practices

Acting, much like the larger discipline of performance within which it sits, is inherently an interdisciplinary pursuit.[3] Within a contemporary actor training context it seems almost impossible to critically examine acting and the doings of the actor without the influence of informing disciplines including phenomenology (Zarrilli 2004; Johnston 2011; Bleeker, Sherman and Nedelkopoulou 2015), cultural studies (Sternagel et al. 2012; Zarrilli 2008), neuroscience (Kemp 2012; Blair 2007) and cognitive science (Blair and Cook 2016; French and Bennett 2016; Lutterbie 2011; Shaughnessy 2013; McConachie and Hart 2006) among others. From foundational applications of imagination, empathy and action to addressing more complex issues in training such as embodiment, subjectivity and consciousness, the most fertile ground for many actor trainers has been the integration and blending of techniques, as well as cross-dialogues between and among disciplines which seek to address the complexities of human experience.

Like acting, cognitive science is an interdisciplinary field with influences from the disciplines such as neuroscience, artificial intelligence, computer science, psychology, philosophy, linguistics and education (Frankish and Ramsey 2012; Kövecses 2006, 2010; Shapiro 2010, 2014). These influences further serve to signal that the study of the mind, and related processes such as embodiment, require the intersection of multiple disciplines in the pursuit of a deeper knowledge and practice. Furthermore, within the embodied cognition research programme and the increasingly popular view that cognition is embodied, i.e. that 'the relation [of our] sensori-motor system to cognition is constitutive, not just causal', as opposed to a 'non-embodied approach, [where] the sensory system informs the cognitive system and the motor system does the cognitive system's bidding' (Adams 2010: 619), interdisciplinary dialogues have served as foundational sources of the embodied mind thesis's theoretical positionings from early integrations of cognitive science, Buddhist meditative psychology and phenomenology present within Varela, Thompson and Rosch's influential work *The Embodied Mind* (1991) to Lakoff and Johnson's explorations into the role of memory, categorisation and language (1999, 2003) and embodied approaches to robotics (Clark 1997), ecological perception (Wilson 2004; Shapiro 2010) and dynamic systems (Thelan and Smith 1994). Similarly to the discipline of acting, the embodied cognition research programme, like the larger field of cognitive science from within which it derives, identifies the pursuit of knowledge of the human mind, its processes and experiences, to be necessarily interdisciplinary and therefore serves as a fruitful ground for applications of an active aesthetic within the context of this book and the aims of this chapter in relation to the practices of acting and experiencing. Furthermore, in the investigation of how our sensory inputs, actions and perception inform the generation of knowledge and meaning for the individual actor or experiencer, both acting and embodied cognition recognise that drawing upon more than one branch of knowledge and practice is essential when approaching a deeper understanding of human experience within a constructivist paradigm.

Embodied cognition and embodiment

As an expansive network of interconnected scientific and philosophical disciplines, cognitive science involves the study of the mind, thought and mental organisation. While traditional cognitive science and the philosophy of mind have often considered the body as secondary to our understanding of the mind and the nature of human cognition, embodied cognition, as a specific research programme within the field of cognitive science, embraces the notion of cognition as an *embodied* and *situated activity* (Anderson 2003; Wilson 2004), embracing conceptualisations of human experience grounded on the dynamic interactions of 'brain, body and world' (Clark 1997). Within the context of their 'embodied mind thesis', Varela, Thompson and Rosch were the first to propose this view of cognition, which they have termed 'embodied action' (1991: 172) or the embodied mind thesis, and which serves as the basis for the embodied cognition research programme:

> By using the term *embodied* we mean to highlight two points: first, that cognition depends upon the kinds of experience that comes from having a body with sensorimotor capacities, and second, that these individual sensorimotor capacities are themselves embedded in a more encompassing biological, psychological, and cultural context.
>
> *ibid.*

Varela, Thompson and Rosch's framing of human cognition outlined above prioritises not only the body's role in our mental processes, but also its situated-ness within a wider context or environment (geographical, historical, biological and cultural) – our world. They use the term 'embodied action' in order to further emphasise that 'sensory and motor processes, perception and action, are fundamentally inseparable in lived cognition' and furthermore that embodiment and action 'are not merely contingently linked in individuals', but rather they have 'evolved together' as interdependent processes (173). This proposition of an evolutionary linking of our mind, body and world suggests that embodiment is not a state of being, but rather a state of *doing*, and that embodied actions 'have meaning and agency' (Lindblom 2007: 3) for the embodier. This is a particularly useful point of consideration when exploring the *doing of embodiment* within the framework of an active aesthetic (Bryon 2014, 2017). Drawing on the active aesthetic, the aim of this chapter then is to explore the implications and potentiality of the *actor/embodier* → *embodying* → *embodiment* whereby *embodying* functions as the middle field (or *doing*) from which both the actor/embodier and embodiment emerge. Furthermore, within the previously introduced disciplinary conceptions of embodiment within the fields of actor training and embodied cognition, a key distinction between the functioning of embodiment within these two fields is the role of the world – the 'given circumstances'[4] as framed within the discipline and practice of acting – or the time, place and context we are *embedded* and *situated*[5] within, as framed within the field of embodied cognition. As introduced at the start of this chapter, within

actor training, embodiment most commonly signals the distinct relationship between the body and the mind. However, this may be a slightly limiting view as traditional actor training unquestionably knows and values the importance and influence of the wider context (the world) of an action, popularly termed 'given circumstances' by Stanislavski, as the set framework for an actor's actions or experience. Similarly, within the embodied cognition research programme, embodiment signifies a dynamic relationship among body, mind and world, previously referred to by Varela et al. as 'a more encompassing biological, psychological, and cultural context' (1991: 173). The interrelationship of these elements (subject, action and object) is clearly apparent within both disciplines and a necessary component within the framing of action and, more specifically, *embodied action*. Thus, when considering the doing of embodiment within the framework of the active aesthetic, it is beneficial to reinforce that within these two disciplines, an *actor-embodier* always *embodies embodiment* within the 'world' or 'given circumstances' they are embedded or situated within.

Nevertheless, to determine further how an active aesthetic of embodiment might function practically, it is useful to return to embodied cognition, and more specifically some of its principal claims about the nature of embodiment as they relate to the practice (i.e. the *doings*) of the actor. We have established that embodied cognition emphasises that cognition, our ability to process and understand thought, human experience, and our senses, arises from (or is enacted by) our bodily interactions with the world (Varela, Thompson and Rosch 1991; Gallagher 2005; Thompson 2007; Shapiro 2010, 2014). Margaret Wilson (2002) further details this position and distinguishes the six claims of embodied cognition as follows[6]: (1) Cognition is situated, meaning that it occurs *in the context of a real-world environment*. For the actor, while the world of the play may be a fiction, their job is to live 'truthfully' within it and therefore, function within a dual reality of their practical 'real-world' location and the imagined world which contextualise their performed actions. (2) Cognition is time-pressured, meaning that it *must be understood as a real-time engagement* with the environment. For the actor, there is a corresponding emphasis on the necessity to experience their actions in 'the present' in relation to their time, place and present context, regardless of (or rather, in a dynamic and responding support of) their potentially rehearsed nature. (3) Human beings off-load cognitive work onto the environment, meaning that *we utilise the environment in our information processing*. Practically, the actor may be viewed as similarly 'off-loading' their cognitive processes when they action or notate their script, utilise technology such as a voice recorder to memorise their lines, or write down a director's notes for later consideration and application (Droor and Harnad 2008). Cognitive off-loading can also occur when physical action is undertaken to minimise the cognitive demands of a task (Risko and Gilbert 2016), such as utilising a physical or perceptual change as a technique to manipulate their bodily awareness or mental state. (4) The environment is part of our cognitive system, meaning that *the network of connections between our mind and our world is so dense* that studying the mind alone is 'not a meaningful activity'. For the actor, this point might imply that

investigating the processes of thinking and doing completely outside of the context of their given circumstances is virtually impossible (and likely limiting) given the informing and connected role of their environment. (5) Cognition is for action, meaning that *the function or purpose of the mind is to 'guide action'* and cognitive processes such as perception must be understood in relation to 'situation appropriate behaviour'. Actors are similarly 'for action'; it is the basis of their practice (acting) and indeed the origin of their identifying title as actors. (6) *Off-line cognition is body-based*, meaning that 'even when decoupled from the environment, the activity of the mind is grounded in mechanisms that evolved from interaction with the environment [...] mechanisms of sensory interaction and motor control' (Wilson 2002: 626) and as a result, our environment shapes our cognitive processes even when we are decoupled from it. It could be argued that the actor acting within a fictional set of given circumstances is temporarily 'decoupled' from some of the informing factors of their environment, and yet their mind, which is central to their doing, remains grounded in the interactions between their body and their world. While Wilson's six claims remain just that, claims of the embodied cognition research programme and not verifiable 'facts', when illustrated through the practice of the actor, there is a clear resonance between the shared observations of human cognition and models of experience as identified in the knowledge and practice of both disciplines.

As identified earlier in this chapter, perhaps the most pertinent area of resonance for this interdisciplinary exchange and the problematising of embodiment and *embodying* is 'the active role of the environment in driving cognitive processes' (Clark and Chalmers 1998: 10) – or in other words, the role the environment plays in our perception of human experience:

> If, as we confront some task, a part of the world functions as a process which, were it done in the head, we would have no hesitation in recognizing as part of the cognitive process, then that part of the world is (so we claim) part of the cognitive process.

12

To this end, Clark and Chalmers argue that as humans, we are in a 'coupled system' or 'two way interaction' with an 'external entity' (i.e. the world or context of our cognising) and that this interaction 'can be seen as a cognitive system in its own right' (13). It is their belief that both sides of this coupled system are essential to our cognitive processes and, as such, we must value our environment as taking an active role in our thoughts and actions. This reinforces that the embodied mind exists not only within a human, but extends to their environment, their context and given circumstances. This is one example of what Maturana and Varela (1980) would refer to as a structurally determined system whereby an agent and its environment are 'structurally coupled', meaning that 'the changes of state of the organism [actor/embodier] correspond to the change of state of the medium [environment]' (326). Ziemke (2003), in an early article comparing varying notions

of embodiment within cognitive science, posited that 'the broadest notion of embodiment probably is that systems are embodied if they are 'structurally coupled' to their environment' (1306). He draws upon Quick et al.'s (1999) attempt to offer a 'precise definition of embodiment':

> A system X is embodied in an environment E if perturbatory channels exist between the two. That means, X is embodied in E if for every time I as which both X and E exist, some subset of E's possible states with respect to X have the capacity to perturb X's state, and some subset of X's possible states with respect to E have the capacity to perturb E's state.
>
> *in Ziemke 2003: 1306*

However, Riegler (2002) argues that this concept of embodiment is restraining as its 'attempt to clarify the notion of embodiment' is 'an insufficient characterisation' because 'every system is on one sense or another structurally couples with its environment' (314). As a result, Quick et al.'s definition of embodiment does not actually require cognising and therefore is an example of embodiment and structural coupling, but not embodied cognition. This distinction is key as it relates back to the necessity of the *doing* as modelled by the active aesthetic. If we are to understand the practice of the structural coupling of an embodier to their world (or embodiment), then we must also consider the nature of the *doing* or *embodying* from among which these elements emerges.

Acting and embodiment

There are recurring problematics regarding the application of the term embodiment within actor training – namely, the ongoing reduction of the concept of embodiment to suggest a 'knowing in or through the body' or to signal the unique relationship between the body and the mind. This articulated 'felt sense', frequently experienced and expressed by both the actor and those witnessing the act of performance, has proven itself to be inconsistently understood and frequently reduced to an exclusively phenomenological frame. The resulting overuse of often meaningless phrases such as 'that was so embodied' and 'they just didn't embody it' has commonly left the concept of embodiment devalued and decontextualised within the field of performance practice, rendering it dualistic and reduced within its current application. Most commonly, perhaps, the term embodiment in performance theory may simply serve a purpose to argue that we have moved beyond an overly simplified and yet widely accepted Cartesian mind/body dualism. And while in a contemporary actor training context there has been a move towards embracing the unique relationship between the body and the mind in the training of actors, there is still a way to go in terms of its articulation within theory and practice to truly transcend the Cartesian influence that has long inhabited our research and practice.

While frequently used in colloquial exchanges among actors and actor trainers, embodiment is not a term widely associated with classic Western actor training

texts. When considering the relationship between the actor's body and mind, it is more common to see the term psychophysical or psycho-technique, whose English language origins in the actor training canon are attributed to the Stanislavski system. This has been further highlighted in contemporary texts by actor trainers who explore applications of the term psychophysical within a contemporary training context (Merlin 2001; Zarrilli 2008). However, embodiment serves as a central feature within Stanislavski's training for the actor, specifically within the second part of the training, *Building a Character* (Stanislavski 2009a). Within English language translations of Stanislavski's work, *voploshchenie* is most frequently translated as a 'physical embodiment' (Stanislavski 2009b), an articulation which privileges the relationship between the *body* and the *mind* as opposed to an 'embodied mind' (Varela, Thomson and Rosch 1993; Lakoff and Johnson 1999) which conversely privileges the relationship between body, mind and world.

An expanding community of researchers have made steps to address the problematics of embodiment within interdisciplinary discourses which explore the crossing and colliding of performance and cognitive science. Early work by American theatre and performance scholars Bruce McConachie and Elizabeth Hart (2006) identified the concept of 'mind/brain embodiment' (PP) as a primary challenge of cognitive science for theatre and performance studies, naming embodied consciousness, embodied knowledge and embodied experience among conceptions of embodiment under consideration for those working across cognitive science and performance. Ten years later, interest in embodiment as a primary point of concern for interdisciplinary researchers has only increased, with further studies exploring applications of dynamic systems theory and cognitive science to actor training (Lutterbie 2011), models of 'embodied' acting (Kemp 2012), cognitive approaches to wider performance contexts such as spectatorship, dance and applied theatre (Shaughnessy 2013) and international perspectives on the shared complexities of performance and human cognition when performing within a variety of cultural and disciplinary contexts (Falletti, Sofia and Jacono 2016). However, these offerings, while an essential and valuable step in an ongoing interdisciplinary exchange, are largely rooted in thinking around performance, acting and the actor, and provide few detailed models for reframing the *practice* of acting, which as a *doing* (i.e. the middle field) is an essential component of the active aesthetic.

An active aesthetic of embodiment

In reference to embodiment, what is clear is that both acting and embodied cognition are deeply interested in capturing the time and place where experience or knowledge is '*activated*' or '*acted*'; for Integrative Performance Practice, or IPP, (Bryon 2014), the origin of the 'active aesthetic', introduced earlier in this book by Bryon, or activation occurs in the acting of practising as a state of '*doing*' or '*performing*' and for cognitive science this '*doing*' occurs in our experience or '*experiencing*' of our embodied mind and its processes. At their core, both acting and

embodied cognition interrogate modes and models of *doings* and as a result, they both value the knowledge that emerges in the acts of *doing* (i.e. practice). Furthermore, it is precisely this middle field of doing which allows for non-linear emergence, the dynamic within which brain, body and world provide for the occurrence of embodiment:

> Since it is the event that happens on the stage through the act of performance, to choose or be aware of the fields of operations that contribute to a happening is essential if the desired effect is to have all of these operations working together in a network to allow for that event.
>
> *Bryon 1998: iii*

If we reframe this quotation within the purview of this chapter, we could say that *the event* or the happening *in the act of performance* (i.e. the doing of performance or *performing*) is embodiment. If so, then which 'field of operations' are essential in the dynamic network which allow for this 'event'? As previously argued in this chapter, the underlying notion of a 'system of operations' is present in the disciplines of performance and cognitive science, be they called given circumstances or an environment or world within which we are situated. The complexities of such a 'system' of embodiment as outlined by the embodied cognition programme (the dynamic relationship among brain, body and world) resonate with the conception of a 'network' put forward by Bryon (1998, 2014) and the 'system' put forth by Stanislavski. For the actor, the 'event' of embodiment may manifest as a 'felt sense' of self within the act of performance, and yet this 'happening' does not function without being situated within the world, or a set of given circumstances – an argument which both Stanislavski and Varela, Thompson and Rosch share – which informs the nature of its *doing*. Finally, these 'processes [of embodiment] are recursive, re-entrant, and self-activating, and don't stop anywhere' (Thompson 2007: 366), continually drawing new links and refining networking within an extended cognitive system. In other words, they function as an emergent property of the system. With this in mind, one might argue that the principles of the embodied mind thesis are in harmony with the model of the active aesthetic model. It is from this position, which privileges embodiment as 'the sense that the body/mind is a mutually interdependent dynamic and produces a sense of knowledge in and of practice' (Bryon 2014: 341) from which we will begin to interrogate the proposed application of an active aesthetic with the aim of allowing for a new transdisciplinary research and practice within the field of embodiment.

Metaphors and conceptual linking across disciplines

So, the question then arises – how do we progress in the doing of embodiment when we understand the constitute elements within the framework of an active aesthetic, but lack the dynamic clarity in the doing of acting or experiencing? In other words, it is one thing to know what embodiment is and which elements

allow for its emergence; it is something entirely different to be able to communicate it to an actor/embodier (i.e. the one undertaking action) and ensure that they are able to activate this model in practice and thereby advance the proposed transdisciplinary pursuit. Theatre and performance researchers Rhonda Blair and Amy Cook have recently argued that 'the paradigm shift that keeps trying to arrive [within the interdisciplinary exchange between cognitive science and performance] is about recategorizing what we are talking about when we talk about thinking, or meaning, or touching, or feeling, or embodiment or performance' (2016, 3). For Blair and Cook, this paradigm shift requires a mapping of new territories between cognitive science and performance which 'give[s] us new ways to see and stage – and this to understand and to use and to develop – the implications of embodied, embedded, enacted and extended minds' (ibid.) within the context of performance practices. One of their proposed solutions to embracing this interdisciplinary paradigm shift, and this chapter's proposed key to an active aesthetic of embodiment, is a deeper engagement with metaphor.

A metaphor is a figure of speech in which a word or a phrase is used to represent something else; a correlation which utilises figurative language to connect two concepts, things or actions in order to highlight the ways in which they are similar. While a metaphor may be literally false, their special form of comparison utilises imagination in forms such as pictures, symbols and conceits to illustrate a dynamic relationship. In his philosophical interrogation of metaphor, art historian Nelson Goodman states:

> Metaphor permeates all discourse, ordinary and special, and we should have a hard time finding a purely literal paragraph anywhere. This incessant use of metaphor springs not merely from love of literary color but also from urgent need of economy. If we could not readily transfer schemata to make new sorting and orderings, we should have to burden ourselves with unmanageably many different schemata, either by adoption of a vast vocabulary of elementary terms or by prodigious elaboration of composite ones.
>
> *1981: 130*

According to Goodman, metaphors function within and across disciplines, organising and expressing our ideas and experiences in an active mode of understanding. Through making and organising implicit comparisons – linking fixtures in our lived world through a largely unconscious process of understanding and sense making – metaphors highlight similarities in thoughts, objects, people, and ways of being and doing. And through this process, we might view properties facilitating emergence as a means of being and doing. Like Goodman, metaphor scholars and philosophers George Lakoff and Mark Johnson (1980) popularly conceived of metaphor as a model for understanding the connection between language and thought, and their work in this area is widely applied in the disciplines of performance and cognitive science. This potential for metaphors to express complex human experience, can also be observed within F. L. Lucas's iconic

literary work *Style: The Art of Writing Well*, originally published ten years prior to Lakoff and Johnson's findings:

> *'Every expression we employ, apart from those that are connected with the most rudimentary objects and actions, is a metaphor, though the original meaning is dulled by constant use.'* Consider the words of that very sentence: an 'expression' is something squeezed out; to 'employ' something is to wind it in (*implicare*); to 'connect' it to tie together (*conectere*); 'rudimentary' comes from the root to root or sprout; an 'object' is something thrown in the way; an 'action' something driven or conducted; 'original' means rising up like a spring or heavenly body, 'constant' is standing firm. 'Metaphor' itself is a metaphor, meaning the carrying across of a term or expression from its normal usage to another.
>
> *2012: 203; emphasis original*

In this description, metaphor transcends its literary function to become an active mode of doing and understanding within which, in addition to serving as a fascinating fixture of human language, metaphors can have the power to influence our actions, perceptions, emotions, reasoning and judgement – in other words, our cognitive processes and namely, our embodiment.

If interdisiciplinarity by its nature implies an exchanging or a troubling of the '&' as the place of linking or colliding between disciplines, then metaphor, or metaphor-ing, as an essential component of embodiment within the active aesthetic troubles the 'is' that is applied when one concept is transfigured into another. Historian John Lewis Gaddis (2002) argues that 'science, history and art have something in common: they all depend on metaphor, on the recognition of patterns, on the realisation that something is 'like' something else' (2). While their concepts may vary and be framed (and sometimes constrained) by disciplinary rules, the linking of these concepts in the active aesthetic of metaphor not only transcends disciplines, but is essential to any interdisciplinary or transdisciplinary pursuit. Interdisciplinary and translation specialist Christina Shäffner agrees:

> Whenever language is used it is embedded in a social situation with its specific parameters of place and time, and with communicative partners [...] each communicative situation is embedded in in a specific culture with its traditions, conventions and norms [where] using language involved mental representations and operations of speakers and hearers [and actors] who in turn are members of discourse communities.
>
> *2008: 57*

These 'discourse communities' become generative sites of knowledge and meaning-making, a process which like transdisciplinarity features 'emergence, the process of deriving some new coherent structures, patterns and properties' (McGregor 2004: 2) between and across disciplines. James Geary, self-proclaimed aphorist and

researcher in the field of metaphors, argues that metaphor 'systemically disorganizes the common sense of things – jumbling together the abstract with the concrete [...] and reorganizes it into uncommon combinations' (2011: 2) beyond their originating disciplines. According to Geary, 'metaphorical thinking – our instinct not just for describing but for *comprehending* one thing in terms of another [...] shapes our view of the word' and as such, is far more than a 'cognitive frill' (3) and should be viewed as essential to understanding complex concepts and virtually any interdisciplinary pursuit. However, in order to understand how metaphor might function within a transdisciplinary context, it is valuable to consider current conceptions of metaphor within cognitive science which may have direct implications for performance.

Furthermore, actor trainer and interdisciplinary researcher Philip B. Zarrilli has argued that most dominant thinking on acting does not 'examine either our language or our assumptions behind it' (1989: 37), and this is indeed the dominant critique of the usage of the term embodiment within an actor training context offered by this chapter. This may be in part to do with a dominant (and certainly understandable) interest in the practical *doing* of acting and an understanding that within its pedagogic tradition there have been great inconsistencies in the application of terms and vocabulary among actor trainers due to individual expression, means of translation, and the desire to distinguish one's practice within the broader field. However, drawing heavily on the principles of embodied cognition, interdisciplinary researcher Peter Morville explores the shared and largely unconscious structures of meaning making specifically to identify the relationship between context and language in the development of 'information architectures' (2014). Morville believes that 'our tools, like our bodies, become "transparent equipment"' and that we 'see through them to the task at hand [...] incorporat[ing] tools [...] into our bodymind schema' and then 'in accordance with the principle of least effort, we strategically distribute our work through the whole system of mind, body, and environment' (41–42). For actors/cognisers/embodiers, the experience of embodiment is largely unconscious, and so is the experience of metaphor as an invisible tool of active understanding and as a structure for knowledge-making.

When exploring embodiment across disciplines within the frame of an active aesthetic, it is also valuable to consider that the dominant cognitive view of metaphor is not one of a closed system, but a kind of mapping or network which can function beyond the limits of language and culture. For many cognitive scientists and philosophers such as George Lakoff and Mark Johnson (1980, 1999), the role of metaphor is straightforward – our language is metaphorically structured, and so is our thinking. Their conceptual metaphor theory popularly defines metaphor as a 'cross-domain mapping in the conceptual system' (Lakoff 1992) which is 'central to our existence' (Lakoff and Johnson 1980). And like the active aesthetic, the conceptual metaphor theory is a dynamic system through which operations (concepts) can work in a network to allow for the event of the metaphor. Conceptual metaphor theory 'rejects the notion that metaphor is a decorative

device, peripheral to language and thought' and alternatively 'holds that metaphor is central to thought, and therefore to language' (Deignan 2005: 13), giving it an essential role in the structuring of knowledge as well as our perceptions and expressions of experience. It maintains five tenets: (1) metaphors structure thinking; (2) metaphors structure knowledge; (3) metaphor is central to abstract language; (4) metaphor is grounded in physical experience; (5) metaphor is ideological (Deignan 2005). These tenets hold strong resonances with the principal arguments of the embodied cognition thesis previously introduced, as well as the complex intertwining of body, mind and given circumstances proposed by the Stanislavski system. These metaphorical mappings also serve as cognitive models for the *doing* of embodiment:

> Understanding one domain in terms of another involves a set of fixed correspondences (technically called mappings) between a source and a target domain. This set of mappings obtains between basic constituent elements of the target. To know a conceptual metaphor is to know the set of mappings that applies to a given source-target pairing. It is these mappings that provide much of the meaning of the metaphorical linguistic expressions (or linguistic metaphors) that make a particular conceptual metaphor manifest.
>
> *Kövecses 2010:14*

In relation to performance, dance scholar Ariel Nereson (2009) emphasises that metaphor functions as a key component in the intersection of performance, cognitive science and embodiment. She posits that 'to generate metaphors [...] is to shape meaning' and that while the act of metaphor generation is largely unconscious, humans 'could not organise their experiences without doing so' (2):

> All people involved in understanding the meaning of human experience [...] are actively engaged in creating and using metaphors (along with similes, images, and other similar techniques). Metaphor is employed to give shape, often accompanied by narrative, to 'facts' so that they might make sense and be meaningful, whether they be scientific facts about how the brain works, historical facts about what decisions were made where and when, or artistic representations of people, places, and things. As one of our primary ways of making sense of our world, metaphors originate in our *embodied experience* of the world.
>
> *ibid.*

However, metaphors 'cannot act by themselves, but need to be acted upon in order to [...] effect a change upon our whole being' (Bartal and Ne'eman 1993: 11). And as such, our embodied experience might be most clearly framed across an interdisciplinary exchange where, through a metaphoric process which links the actor and their actions to their world(s), the active aesthetic of an *actor/embodier* → *embodies* → *embodiment* might emerge. In such a model language and meaning

making, as initiated within both hermeneutics and ontology, the metaphor serves to mediate both the subject (the actor/embodier) and their experience of the world (their resulting embodiment) and thereby elevating itself from the domain of rhetoric to a living, active aesthetic (embodying).

Conclusion

This chapter has argued that when approaching an interdisciplinary understanding of embodiment which embraces the knowings and doings of acting practice and the embodied cognition research programme, to conceive of the actor's body and mind as being separate from their world is problematic in both theory and practice. In contrast, when applying an active aesthetic to this interdisciplinary exchange, the dynamic interrelationship that acknowledges the impact of the environment and the body on higher order cognitive processes and the act of doing (or acting) is essential. As a result, when the actor's embodiment is reframed to reflect the dynamic interactions between their mind, body and world, the potentiality for an integrated field of performance expands and allows of the emergence of a transdisciplinary field of performing. Finally, for the practical needs of the active aesthetic as applied to the actor/embodier → embodying → embodiment, metaphor may serve as a key tool in the next phase of this transdisciplinary pursuit, allowing for the creation of a new field of knowledge and practice to emerge from this developing model of interdisciplinary exchange. Thus, embodiment is not a closed system of knowing or doing in relation to one's environment, but an open system which must dynamically respond to its informing components and their operations.

Notes

1 Here the reference to the *performer* → *performing* → *performance* borrows directly from Experience Bryon's integrative performance practice (IPP), an approach to 'analyzing and working across physio-vocal-emotive performance practices' (2014). Bryon's integrative model considers the performer's 'dynamics of integration' (5) and suggests that 'in essence, we are people called *performers*, who do something called *performing*, towards an outcome called *performance*' (11). Building on the framework of Bryon's 'active aesthetic', we might also think about these parts as *the self*, what is *doing*, and what is *done*. However, it is key to note, as outlined both in this book and her 2014 text, this is not a linear process and occurs in a 'dynamic middle space [...] where both the subject [self] and object [what is done] emerge. This model of an individual experiencing an event (performer → performing → performance) is particularly useful when approaching an active aesthetic in response to the actor's capacity to embody their environment, the given circumstances of their performance.

2 See the prior footnote and Experience Bryon's chapter in this text, 'Performing Interdisiciplinarity though an "active aesthetic"', for a detailed definition of an 'active aesthetic'.

3 As Bryon (2014) observes, 'if you ask very young children to sing, they invariably dance and act; if you ask them to dance, they sing and act; if you ask them to recite a poem or play a character, they sound and move with their entire breathing body' (1).

4 The given circumstances, a concept widely attributed to Stanislavski in the field of actor training but applied widely and within many training systems, refers to the story or world of the play – including facts, events, and time and place of action within a text. This can also extend to the conditions of the actor's and the character's life, the actor's and director's interpretations of the play and its elements, the mise-en-scene, and further production details.

5 Within the field of embodied cognition, the argument that cognition is 'situated' refers to the belief that 'cognitive activity takes place in the context of a real-world environment, and it inherently involves perception and action' (Wilson 2002: 262). The term 'embedded' refers to the belief that we 'off-load cognitive work onto the environment' and 'make the environment hold or even manipulate information for us, [which] we harvest […] only on a need-to-know basis' due to the 'limits on our information-processing abilities (e.g., limits on attention and working memory)' (ibid.). This will be explored in more detail later in this chapter.

6 While an attempt has been made to link Wilson's six claims of the embodied cognition research programme to the practice of the actor, the order in which they occur (claim followed by an actor's activity) does not mean to suggest that the claims are superior or a source of validation for the actor's practice. The usage of science to justify the artists' practice or experience is a much larger debate for another time. However, in this circumstance, the order occurs in an attempt to identify a potential disciplinary relationship in terms of principal theories and practices.

References

Adams, F. (2010) Embodied cognition. *Phenomenology and the Cognitive Science*. 9. pp. 619–628.

Anderson, M. (2003) Embodied cognition: A field guide. *Artificial Intelligence*. 149(1). pp. 91–130.

Bartal, L. and Ne'eman, N. (1993) *The Metaphoric Body: Guide to Expressive Therapy through Images and Archetypes*. London: Jessica Kingsley Publishers.

Blair, R. (2007) *The Actor, Image, and Action: Acting and Cognitive Neuroscience*. London: Routledge.

Blair, R. and Cook, A. (Eds) (2016) *Theatre, Performance and Cognition: Languages, Bodies and Ecologies*. London: Bloomsbury Methuen Drama.

Bleeker, M., Sherman, J. F. and Nedelkopoulou, E. (Eds) (2015) *Performance and Phenomenology: Traditions and Transformations*. New York, NY: Routledge.

Bryon, E. R. (1998) *The Integrative Performance Theory: an Anti-Hermeneutic Approach for Opera*. PhD. Melbourne: Monash University.

Bryon, E. (2014) *Integrative Performance: Practice and Theory for the Interdisciplinary Performer*. London: Routledge.

Clark, A. (1997) *Being There – Putting Brain, Body and World Together Again*. Cambridge, MA: MIT Press.

Clark, A. and Chalmers, D. (1998) The extended mind. *Analysis*. 58(1). pp. 7–19.

Deignan, A. (2005) *Metaphor and Corpus Linguistics*. Philadelphia, PA: John Benjamins Publishing.

Droor, I. and Harnad, S. (2008) *Cognition Distributed: How Cognitive Technology Extends Our Minds*. Philadelphia, PA: John Benjamins Publishing.

Falletti, C., Sofia, G. and Jacono, V. (2016) *Theatre and Cognitive Neuroscience*. London: Bloomsbury Methuen Drama.

Frankish, K. and Ramsey, W. (Eds) (2012) *The Cambridge Handbook of Cognitive Science*. Cambridge: Cambridge University Press.

French, S. D. and Bennett, P. G. (2016) *Experiencing Stanislavsky Today: Training and Rehearsal for the Psychophysical Actor*. London: Routledge.

Gaddis, J. L. (2002) *The Landscape of History: How Historians Map the Past*. Oxford: Oxford University Press.

Gallagher, S. (2005) *How the Body Shapes the Mind*. Oxford: Oxford University Press.

Geary, J. (2011) *I Is an Other: The Secret Life of the Metaphor and How It Shapes the Way We See the World*. New York, NY: Harper.

Ginsberg, C. (1999) Body-image, movement and consciousness: Examples from a somatic practice in the Feldenkrais method. *Journal of Consciousness Studies*. 6(2–3). pp. 79–91.

Goodman, Nelson. (1981) *Languages of Art*. Indianapolis, IN: Hackett Publishing Company.

Johnston, D. (2011) Stanislavskian Acting as Phenomenology in Practice. *Journal of Dramatic Theory and Criticism*. 26(1). pp. 65–84.

Kemp, R. (2012) *Embodied Acting: What Neuroscience Tells Us About Performance*. New York, NY: Routledge.

Kövecses, Z. (2006) *Language, Mind and Culture: A Practical Introduction*. Oxford: Oxford University Press.

Kövecses, Z. (2010) *Metaphor: A Practical Introduction*. New York, NY: Oxford University Press.

Lakoff, G. (1992) The Contemporary Theory of Metaphor. In: Ortony, A. (ed.) *Metaphor and Thought* (2nd edn), Cambridge: Cambridge University Press.

Lakoff, G. and Johnson, M. (1980) The Metaphorical Structure of the Human Conceptual System. *Cognitive Science*. 4(2). pp. 195–208.

Lakoff, G. and Johnson, M. (1999) *Philosophy in the Flesh: The Embodied Mind and its Challenge to Western Thought*. New York, NY: Basic Books.

Lakoff, G. and Johnson, M. (2003) *Metaphors We Live By*, 2nd edn. Chicago, IL: The University of Chicago Press.

Lindblom, J. (2007) *Minding the Body: Interacting Socially through Embodied Action*. PhD. Linköping, Sweden, Linköping University Institute of Technology.

Lucas, F. L. (2012) *Style: The Art of Writing Well*, 3rd edn. Petersfield, UK: Harriman House.

Lutterbie, J. (2011) *Toward a General Theory of Acting*. New York, NY: Palgrave MacMillan.

Maturana, H. R. and Varela, F. J. (1980) *Autopoiesis and Cognition*. Dordrecht, Holland: D. Reidel Publishing Company.

McConachie, B. and Hart, F. E. (Eds) (2006) *Performance and Cognition: Theatre Studies and the Cognitive Turn*. New York, NY: Routledge.

McGregor, S. L. T. (2004) *The Nature of Transdisciplinary Research and Practice*. Kappa Omicron Nu Nu Human Sciences Working Paper Series [Online]. Available at www.kon.org/hswp/archive/transdiscipl.html [Accessed 30 January 2017].

Merlin, B. (2001) *Beyond Stanislavsky: The Psycho-Physical Approach to Actor Training*. London: Routledge.

Moran, J. (2010) *Interdisciplinarity*, 2nd edn. London: Routledge.

Morville, P. (2014) *Intertwingled: Information Changes Everything*. Ann Arbor, MI: Semantic Studios.

Nereson, A. (2009) History is Distance: Metaphor, Meaning, and Performance in Serenade/ The Proposition. *The Journal of American Drama and Theatre*. [Online]. 26(3). Available at http://jadtjournal.org/2014/11/17/history-is-distance-metaphor-meaning-and-performance-in-serenadethe-proposition/ [Accessed 30 January 2017].

Nicolescu, B. (2005) Transdisciplinarity – Past, Present and Future. In: Haverkort, B. and Reijntjes, C. (Eds) *Moving Worldviews – Reshaping sciences, policies and practices for endogenous sustainable development*. Holland: COMPAS Editions. pp. 142–166.

Quick, T., Dautenhahn, K., Nehaniv, C. and Roberts, G. (1999) On Bots and Bacteria: Ontology Independent Embodiment. *Proceedings of the Fifth European Conference on Artificial Life*. Heidelberg: Springer.

Riegler, A. (2002) What is a cognitive system embodied? *Cognitive Systems Research*. 3(3). pp. 339–348.

Risko, E. and Gilbert, S. (2016) Cognitive offloading. *Trends in Cognitive Sciences*. 20(9). pp. 676–688.

Schäffner, C. (2004) Metaphor and translation: Some implications of a cognitive approach. *Journal of Pragmatics*. 36(7). pp. 1253–1269.

Shapiro, L. (2010) *Embodied Cognition*. New York, NY: Routledge.

Shapiro, L. (Ed.) (2014) *The Routledge Handbook of Embodied Cognition*. New York, NY: Routledge.

Shaughnessy, N. (Ed.) (2013) *Affective Performance and Cognitive Science*. London: Bloomsbury Methuen Drama.

Stanislavski, K. (2009a) *Building a Character*. (Reprint ed.) (Trans. Hapgood, E. R.). New York, NY: Routledge.

Stanislavski, K. (2009b) *An Actor's Work on a Role*. (Trans. Benedetti, J.). London: Routledge.

Sternagel, J., Levitt, D. and Mersch D. (Eds) (2012) *Acting and Performance in Moving Image Culture*. Bielefeld, Germany: Transcript Verlag.

Thelen, E. and Smith, L. B. (1994) *A Dynamic Systems Approach to the Development of Cognition and Action*. Cambridge, MA: MIT Press.

Thompson, E. (2007) *Mind in Life: Biology, Phenomenology, and the Science of Mind*. Cambridge, MA: The Belknap Press of Harvard University Press.

Varela, F. J., Thompson, E. and Rosch, E. (1991) *The Embodied Mind: Cognitive Science and Human Experience*. Cambridge, MA: MIT Press.

Wilson, M. (2002) Six views of embodied cognition. *Psychonomic Bulletin & Review*. 9(4). pp. 625–636.

Wilson, R. A. (2004) *Boundaries of the Mind: The Individual in the Fragile Sciences: Cognition*. Cambridge: Cambridge University Press.

Zarrilli, P. (1989) *When the Body Becomes All Eyes: Paradigms, Discourses, and Practices of Power in Kalarippayattu, a South Indian Marial Art*. New York, NY: Oxford University Press.

Zarrilli, P. (2004) Toward a phenomenological model of the actor's embodied modes of experience. *Theatre Journal*. 56(4). pp. 653–666. www.jstor.org/stable/25069533

Zarrilli, P. (2008) *Psychophysical Acting: An Intercultural Approach after Stanislavski*. London: Routledge.

Ziemke (2003) What's that thing called embodment?. In: Alterman & Kirsh (Eds) *Proceedings of the 25th Annual Conference of the Cognitive Science Society*. Mahwah, NJ: Lawrence Erlbaum. pp. 1134–1139.

Cross-Chapter Discussion

embodiment and story

Deirdre McLaughlin (DM) and Antonia Batzoglou (AB)

Deirdre McLaughlin: I think our chapters are a very valuable point of cross-chapter discussion. Cognitive science and psychology are both interdisciplinary fields which frequently utilise each other, borrow knowledge, and exchange vocabularies and modes of enquiry. Additionally, because of their shared engagement with self, behaviour, and consciousness, it is not surprising that there is such a long history of applying these fields to our understanding of the actor's (or performer's) process.

Antonia Batzoglou: Exactly. They are both starting from the questions: Who am I? What am I? What is the interrelationship between my brain and my body in the acts of doing and being?

DM: If we explore those questions within the specific context of training actors for the act of acting, we might start by interrogating the position that you train someone to *do* something, to act or react, but how do you train someone to *be*? Beyond the immediate contexts that spring to mind wherein you might train someone to *be* professional or to find ease in *being* still, traditionally, in many popular western models of actor training, certainly the predominant models found in UK and US drama schools and conservatories, *acting is doing*. This part of what makes acting such a useful practice for understanding IPP; acting privileges action and acting as a mode of doing.

AB: Yes, Experience Bryon's breakdown of performer → performing → performance is useful model to explore when considering how it might be applied to the actor.

For example, the model of actor → acting → action could serve to heighten an actor's awareness of their ways of doing and being.

But again, the model focuses on *doing*.

DM: Yes, because it is the model of an active aesthetic – a model for practice, for doing.

AB: In many circumstances, you cannot train actors to be…

DM: Yes, because that state of being is an emergent property, a result of an active doing.

AB: That's right. I am also interested in how you speak about doing and 'the context of action' as it influences embodiment and cognition. Your chapter made me consider how in my own work, I focus primarily in the psychological context and less on the biological and cultural contexts which may inform an individual performance. However, as you state, there are many informing layers of context for any given action.

DM: Drawing specifically on the embodied cognition research programme as one facet of the wider field of cognitive science, if we return to the original notion of the 'embodied mind' put forth by Varela, Thompson and Rosch (1991), we might view our mind as being embedded within a broader context which extends beyond our body – *our world*. This is the root of enactivism, a theory which specifically argues that our cognitive processes and our environment are inseparable and, furthermore, that our perception of our individual lived experiences is rooted in this reciprocal relationship.

As actor trainers, we might most easily link this hypothesis to the relationship between an action and a given circumstance (as indicative of the environment or world). In a framework for understanding the actor's process of performing a character or role which embraces given circumstances, such as the Stanislavski system, the informing context of our world or environment shapes the nature of our doing or our actions. And it is through this dynamic relationship between action and world that our performance emerges.

I find Stanislavski's process of mental reconnaissance to be a useful tool when articulating how an actor might think about the informing role of environment. While mental reconnaissance is a tool for text analysis, it considers the script along seven co-existing planes (external, social, literary, aesthetic, psychological, etc.), and as such I think that it gives a good sense of the multi-layered influences within our 'world' or 'environment' which may have an impact on our cognitive processes and specifically, our perception of our lived experience as actors.

Furthermore, in an attempt to return to the previously proposed model of an actor → acting → actions, where the middle field of doing is acting, it might be useful for us to explore the notion of *embedded* or *contextualised* action as it relates to your earlier point about the actor's awareness of their own actions. There has been some important theoretical offerings on the relationship between action and perception by Alva Noë, who is an increasingly popular theorist in applications of cognitive science, and specifically embodied cognition, to performance practice and actor training. Noë argues that 'perception is not something that happens to us, or in us… it is something we do' (2006). So, for Noë, and for many in the field of cognitive science who adopt an enactive approach to perception, perception is a type of action, a 'thoughtful activity'. Noe highlights sensorimotor knowledge as central to this experience: 'perceptual experience, according to the enactive approach, is an activity of exploring the environment drawing on the knowledge

of sensorimotor dependencies and thought' (228). These sensorimotor dependencies, or capacities, are framed by our individual experience of having a body. Therefore, as actors (or humans) what we *perceive* is determined by what we *do*, and we *enact* our perceptual experience through our bodies and in our world.

AB: Absolutely. Perhaps the sticky point for me comes when I am thinking of the individuals I work with – such as people with ASD, dementia and mental health problems – and the influence of varying levels of cognitive ability.

So, for example, when an individual with ASD is experiencing intense excitement, they may start banging their head against the wall. There are many examples of individuals whose health or lived experience results in their cognition not functioning as expected. But then, do we say that these individuals are not conscious of their being? What influences their perception and so doing? Are they not doing?

DM: Alterations in cognitive ability – or rather, let's say cognitive experience – does not mean that an individual is not conscious just because they do not cognise the world in what might be identified as a normative way. However, their individual perception of their experience may be informed or altered by the nature of their doing, how it is cognised within their bodies, their neurodiversity, and how their resulting perception of the action is informed by the context of their world in addition to their individual sensorimotor capacities.

If we want to reflect on ways of being in the world, or even more specifically on ways doing as an actor, how we articulate our lived experience depends how we approach and understand the act of doing as being central to it.

So, in our ongoing example of the actor acting, is the nature of their doing influenced and informed by self-awareness? Yes, I would say so, as it is an extension of their perception and how they engage their awareness is resultant of direct or indirect action. But going back to your question of being 'conscious of [our] being', if by being we mean our self-identified perception, which might be more specifically articulated within enactivism as a sense of being is situated within the dynamics of my bodymind, its actions, and the world in which I am living. In that context, yes, I am conscious of many aspects of my being – but only insofar as my sensorimotor capacities enable me to be.

AB: Yes, I agree completely with this approach, which also sounds closer to the Jungian idea that we never arrive to see the whole picture of who we are while in a continuous process of self-discovery.

A person with dementia for example, is *being* because they can relate to the environment with others as a part of dynamic interchanges even though they may not cognitively remember facts and details about their name, age, profession, etc.

DM: As fascinated as I am by how our fields inform a greater understanding of acting technique as it relates to human consciousness, an actor does not need to know cognitive science and psychology to do their job. However, as actors and as trainers we can utilise these interdisciplinary dialogues to refine our techniques, actions and language in the acts of training, reflecting on shared perceptions of the experiences of acting and doing.

AB: It is not the academic knowledge itself that is necessary for the actor, but how to use this knowledge in practice. Let's speak more about the notion of context in terms of acting; there are so many different layers of contexts – the context of being on stage, the context of being seen by an audience, the biological and emotional contexts (I am nervous, I am sweaty, etc.), the context of the play, the scenographer's environment, the other's actor's personal and character context. The list goes on and on.

DM: Yes, and these layers of context are interdependent and their relationship is dynamic, creating a system of factors which inform, shape and contextualise action. I am interested in how you view the informing relationship between story and context and I wonder if you might be able to speak a bit more about the differentiation between telling and 'storying' as it informs what story is beyond the logos.

AB: Yes, there is another point where we cross paths. In your chapter you speak about metaphors as a tool for understanding embodiment. For me, story is not perceived only through the words but also through the images that our mind creates while engaging with or witnessing a story. It is through these images and sensations that are evoked where the 'storying' happens and the story emerges. The stories are created in the middle between narrator and listener, in this exchange *logos* is the narrative and the other sensory and embodied elements are allowing the story to re-emerge, to be recreated in the mind. Our body, our flesh, our gaze also 'tells' the story.

DM: The argument that the story must emerge between the teller and the listener makes me think of the dynamic between the actor, the performance and the audience. As an actor, you are required to have some flexibility as you cannot recreate the exact performance anew every night, but instead you must stay engaged with the work through a dynamic interplay of action and awareness. This is the performance which the audience is viewing.

AB: When I act, I feel that there is a subtle difference every night. The route that an actor takes to speak the same text or do a movement sequence may be the same, but the experience of it varies.

I feel that this distinction helps a lot and emphasises what the process of actor training is and what is happening in the act of performing. Yes, in the process of training you constantly learn and explore different ways of acting; you make mistakes, you risk, you fail. In performing, you have created in rehearsals a clear structure that is repeated, but every time, every night the actor/performer also re-creates, redoes an inner structure to actively repeat the structure using images, metaphors, etc. As Bryon says the actor/performer does not do the performance, is performing /acting/moving every night.

DM: Yes, the goals may be very different when training an actor and working with an actor to create a production than when we coach a performer on a given performance. The dynamic relationship between mind, body and world, action and perception, shape their unique doings, beings and awareness of the lived experience of the activities – what it feels like to act or perform. But how

that manifests across different forms of doings or actions will result in different emergent properties (practices or performances).

AB: I would also like us to discuss a little bit more about metaphor and 'metaphoring'. It is a Greek word and being Greek I translate it very specifically in my mind. In Greek it means 'to transfer' so in way you create a third thing, the sun is an orange in the sky. The image of the sun and that of the orange creates a third, a poetic one.

I was wondering what you think about using metaphors when working with actors either in training or directing; instructions like 'I want more lemon in your stomach?' What does it mean and how is it translated or perceived from an actor and how close can it be to what the director actually wants?

DM: I know what you mean and I have used phrases like that when speaking to actors. However, I tend to link emotional awareness to informing bodily sensations: 'open up your heart' or 'listen to your gut', for example.

AB: Yes, 'open your heart' makes more sense to me as I understand it as an active image that invokes a direct physical movement, it muscularly aids me to release any tensions in my chest.

DM: When I use these metaphoric images I try to be careful and observe the actor's experience in the room and listen to their perception of their experience if they are happy to articulate it, as for some actors these images work but they certainly to not suit for all. Again, it depends on the context and use of the language which may create/make meaning for them.

AB: That is the interesting thing we are doing in this book regarding the emergence of knowledge and meaning and how our personal context influences the way we perceive the world, the doing and the being, the exercise, the other actor, the director's instruction.

DM: From your perspective, if 'storying' is rooted in experience and in the doing, how do our individual experiences of a story inform meaning making?

AB: It may be meaning through feeling, something that you may not be able to articulate or identify but you feel it, sensing it, experiencing it. Something that leaves an imprint, it resonates. Meaning is a complicated word and concept.

DM: Yes, most certainly for both of us as we both privilege subjective perceptions of experience. And with the privileging of the individual's subjective experience as an informing factor in the shaping of actions and human experience, it is no surprise that we have both embraced cognitive science and psychology to understand the notions of doing and being as they related to the actor's process. We have a rich interchange of ideas and concepts among our individual disciplines that there seems to be an almost endless potential for ongoing dialogues.

AB: Definitely, there is so much to add about embodiment and awareness, perception, the conscious and the unconscious; the difference between flesh and body and how flesh responds and relates differently to the outer; how unaware we are of all the functions of bodily organs… But perhaps this is a whole other area of interest for a future discussion.

story: Performance and Psychology

Antonia Batzoglou

Introduction: the story of the author

This is a story about stories and the way they emerge from the field between psychology and performance. In this chapter, I am exploring and witnessing story from the perspective of an active aesthetic in the way that story lives within my specific performance practices. The chapter follows the premises that Experience Bryon sets in her introductory chapter, in the sense that interdisciplinarity is active, dynamic and processual and knowledge from one discipline floats in the space between psychology and performance. Here, I problematise and question the notion of story as used in psychology and in performance, aiming to acknowledge and encounter not only literal and linear stories but also those that emerge out of self-manifestation, through one's imagination, movement, sounds, touch or other senses. Story is not examined in service of a narrative but rather as an active event that emerges in the place between one and another in the way of *storying*. The meaning is created and generated in that middle field. What happens when we witness the stories that are created in the act of *storying*?

I am a storyteller.

I 'tell' stories rather than write them – however, 'telling' stories is not simply what I do. It is not in the telling, narrating and enacting where my practice unfolds and relates with the other, the listener/witness.

I am interested in the type of storyteller that Walter Benjamin (1992) claimed to be almost extinct. The one that is 'always rooted in the people'; who weaves the rungs of experiences and tells stories beyond the words; the one who uses their gaze, their hands, their silences to do the storytelling. Storytelling as an almost ancient shamanic act (100). In favour of this premise I practise a way of 'telling' that is rooted in action and in the people; a way that adjoins the disciplines of

performance and psychology in order to allow new stories to emerge between the teller and the listener and perhaps save Benjamin's storyteller from extinction.

At times, I am an actor/performer who communicates stories through text and movement; other times, I am a trainer using stories as starting points for improvisation or as means to enhance the artist's self-awareness; I am a multisensory storyteller using sensory prompts to 'tell' the story of places and artefacts; I am 'building' stories in the moment with groups of children or adults; I am a psychologist and drama and movement therapist sharing stories that aspire reflection and personal projections and motivate the psyche.

My very practice of course has its own story. Interdisciplinary dialogues between performance and psychology started early in my life, influencing my way of learning, my thinking and my praxis. After a history of study and work experience in both the disciplines of performance and psychology, this gained knowledge continues to develop and emerge through a dynamic and active process of interplay between the two. It is the story of this praxis that this chapter aims to explore and articulate, positioning story at the meeting point between psychology and performance. Here I witness the doing of *my* doing; what happens in the way of doing between the two disciplines.

Story is recognised as a problematic word due to the emphasis placed on narrative – *logos* – and the cognitive understanding of it. In psychology, story is the basic structure used to construct and present the self as it is manifested internally and externally. In performance, story may refer to the narrative and characters of a theatre piece (either linear or deconstructed), to the choreography, the libretto, the devised structure of a performance and other 'writing' modes of performance. Instead, this chapter explores and recognises the stories beyond narratives, predetermining 'writing' and seeking the silent stories that our self communicates in the act of being and doing. It reflects on what Todd (1937) stated in her book *The Thinking Body*: 'Living, the whole body carries its meaning, and tells its own story – standing, sitting, walking, awake or asleep, pulling all the life up into the face of the philosopher or sending it all down into the feet of the dancer' (295). Every event is singular and subjective; is in constant flow of changing and becoming offering a possibility for observation that is pregnant with meaning. In this flow of becoming, every act of being and doing – including unconscious events – is contributing to the activated meaning and hold responsibility for the way the event is executed. How then can these lived and personal stories merge with the created stories in performance? How does one become aware of the stories that the self is carrying while creating another 'story'?

In my work, performance appears or re-defines itself differently every time I cross paths between being an actor, performer, performance maker, trainer and psychologist/dramatherapist. From classical theatre productions to experimental devised performances based on auto/+biographical narratives; to multisensory promenade storytelling in specific sites and the use of storytelling in performance training, the aesthetics of my practice may vary. However the way of doing so is based on the same principles. My praxis suggests a dynamic methodology that activates the pertinent questions around the way the self is manifested and

transformed through story in performance practice. The self is perceived as an integration of body, mind, breath, and both conscious and unconscious aspects. The manifestation of the self through story takes place not only through narrative but also, more interestingly for me, it emerges in the space between the performer and the witness, the other. It is this way of emerging stories that I am exploring in this chapter and referring to as *storying*.

Psychology and performance: exchange of stories

Undoubtedly there is an archaic interplay where the two disciplines of psychology and performance meet, collide or co-exist. From the ancient times in Greece when attendance to theatre performances was interconnected to the healing processes taking place in the sanctuaries of Asclepius (Hartigan 2009); to Stanislavski's study of emotional memory for the training of actors; to cotemporary dialogues and the exchange of knowledge in the making of different performance genres, actor trainers, directors, writers and performance makers have long turned to psychology for knowledge, methods and techniques that grant specific aesthetic results in performance.

From another perspective, as actors, performance makers, students or teachers, we are often faced with questions about the self and its manifestation through performance. Theatre and the performing arts are seen as the stage for the collective archetypal stories of the human psyche. A place where the human existence and self are explored and 'discussed', not through intellectual and philosophical dialogues but through highly poetic artistry, through physical and emotional manifestations of one's being and doing and through encountering unconscious manifestations. Similarly to dreams, the performed stories may incite a projection of one's own story and thus self-contemplation, amusement and potential catharsis. What is the self and how is it activated or presented within the creative process and in relation to the story? Is the understanding of the artist's self and its psychological story integral to the performance's story? Where and how do these stories meet and collide?

In an attempt to answer these questions, we are exploring the meeting place between the psychological stories of the self and the performed story. Through the lens of depth psychology, we examine the self and its manifestations through being and doing and position it in the act of *storying* in performance as it emerges through intuition, the senses and feelings.

Furthermore, I am introducing three different accounts of my performance practice:

1. Site-specific and promenade multisensory storytelling.
2. Experimental devised performance.
3. Performance training.

These accounts, used as case studies, tell the story of my practice while discussing the act of *storying* in relation to performance and psychology.

Story of the self

The problematic or mystery around the question of the self has long been raised in philosophical discourses, most notably around the idea of narratives in relation to selfhood. Hannah Arendt (1998) returns to the ancient Greeks, searching for answers in regards to the human condition and the stories that constitute the being as social and political:

> The chief characteristic of his specifically human life, whose appearance and disappearance constitute worldly events, is that it is itself always full of events which ultimately can be told as a story, establish a biography; it is of this life, *bios* as distinguished from *zoë* that Aristotle said that it 'somehow is a kind of *praxis*.'
> *Arendt 1998: 97*

When asked 'who are you?' one often responds with sentences based on 'I am…' and 'I have…' that represent and then manifest as the stories that we tell ourselves and others in order to understand and to describe one*self*. According to Arendt, our answers to the phrases 'I am, I have' are the narratives that construct our self psychosocially and consequently, they offer a sense of being, a sense of self within society (Arendt 1998: xvi). Yet, recounting the self through a list of 'identities', 'possessions' and 'achievements' means regarding the world, and the self in it, only in its factual and material substantiality. Telling self-stories in this way activates an ignorance to, or refusal of, the psychological reality and of the value of intangible aspects of the self. These lists of events say little about the way one engages with people, with life, with self, about the way one feels and relates. Moreover, such a way of telling says little about the stories of one's emotions, desires, dreams and other possible unconscious aspects of the self that form a psychological reality of the human being. Romanyshyn (2001) points out that 'our psychological life is not *in* things or because of them, it is given *through* them' (15).

In addition, Andrianna Cavarero (2000) points out that the self is not only manifested through the narration of one's own story but it is also narratable by another. The emphasis lies on the linear narration of stories, internally or externally, to or by others. Yet Kottman (2000), in his introduction to A. Cavarero's work, points out the inability of 'philosophical discourse to determine in words the individual *uniqueness* of the human being' (Kottman in Cavarero 2000: vii).

Psychology as a distinct term and academic discipline made its appearance in the late fifteenth or early sixteenth century, marking a significant shift in the way we started thinking about and researching the self and the stories of its psychological reality (Romanyshyn 2001). Psychology, which etymologically investigates the *logos* or reasoning of the psyche, enters the philosophical discourse on selfhood narratives and tries to answer questions about the way our mind constructs the stories of our existence and thus a sense of self. Psychology studies the self, the conscious and unconscious mind, and the way a person is deciding or determining motivation, their emotional response and other psychological characteristics.

Here we are interested in the way the self is manifested through being witnessed and felt by another, and in doing so how its 'story-ness' emerges as an act of alchemical amalgamation in the act of doing and being. Following the schools of depth psychology,[1] we recognise the unconscious mind and thus study the way that our mind processes dreams, instincts, somatic and other felt experiences to construct the stories of its unique psychological reality.

We are preoccupied with the story of an integrated self – a Self as described by Carl G. Jung in Analytical Psychology; integrated of body, mind and spirit/breath, of all conscious and unconscious aspects, of the rational and the irrational, of the *logocentric* and *mythopoetic* qualities that constitute the 'I'. The Self is not the ego but:

> [A] more embracing or eternal inner personality that is hinted at by this symbol. Jung defined it as the conscious–unconscious wholeness of the person. Only the ego is capable of realizing psychic contents. Even something as great, even divine as the Self can only be realised merely by the ego. That is the self-realization from a Jungian perspective.
>
> *Von Franz 1980: 8*

An experience of the self as it is understood, felt and imagined in the act of doing and being is creating its own *storying*. In *storying* we are exploring the process of the unconscious made conscious in the moment; the way that intangible elements do the 'telling' or 'making' or re-enacting or sharing of the story. We are discussing the significance of the imagining mind, the unconscious, the irrational and the symbolic aspects that constitute fundamental part of the self. In that sense, the *storying* does not derive from a *logocentric* source of knowledge about the self, but it rather emerges from the *mythopoetic* function, meaning a symbolic and imaginative approach to doing and being. The real merging is taking place between the personal and the imaginative, the mythical and so the collective.

Analytical psychology of C. G. Jung

Carl G. Jung, who started his career as a passionate and promising follower of Freud, gradually recognised Freud's theories as dogmatic and the two parted in 1913. Jung identified a problematic around the very idea of defining psyche and suggested that psychology should give up the pursuit of a rational definition of truth about psyche because 'no philosophy had sufficient general validity to be uniformly fair to the diversity of individual subjects' (Jung 1991: 71). He compared the study of psyche with the discovery of positive, negative, irrational and imaginary numbers in mathematics:

> [...T]he psyche is the greatest of all cosmic wonders and the *sine qua non* of the world as an object...all knowledge [from psychology] is the result of imposing some kind of order upon the reactions of the psychic system as they flow into our consciousness – an order which reflects the behaviour of

a *metapsychic* reality, of that which is in itself real[...] we are in a position to know only everything that is capable of being known, i.e. everything that lies within the limits of the theory of knowledge... psyche does not coincide with consciousness.

Jung 1991: 79–81

This specific idea of the psyche as an entirety of all conscious and unconscious aspects of the human being is central to analytical psychology. Jung recognises that the development and supremacy of the human mind during the last centuries has resulted in a 'forlornness of consciousness in our world due primarily to the loss of instinct' (Jung 2004: 61). However, his belief relies on the grounds that the creation of something new, an acquired experiential knowledge, cannot be accomplished only by the intellect without a playful instinctive capacity that acts from inner necessity. The more power and knowledge men achieve over nature and technology, the deeper they ignore psyche, that according to Jung has 'become a mere accident, a "random" phenomenon, while the unconscious which can manifest itself only in the real, "irrationally given" human being, has been ignored altogether' (Jung 2004: 61).

Therefore, a rigorously undertaken process of self-knowledge, self-exploration and self-narrative will remain one-sided and incomplete if one does not acknowledge and encounter the unconscious. Jung's endeavour to give a description of the unconscious nature of the psyche states that:

The unconscious is not simply the unknown, it is rather the *unknown psychic;* [...] so defined the unconscious depicts an extremely fluid state of affairs: everything of which I know, but of which I am not at the moment thinking; everything of which I was once conscious but have now forgotten: everything perceived by my senses, but not noted by my conscious mind; everything which involuntarily and without paying attention to it, I feel, think, remember, want and do; all the future things that are taking shape in me and will sometime come to consciousness: all this is the content of the unconscious.

Jung 1991: 95

A position towards the unknown unconscious challenges the modern individual to encounter the emotional chaos of the human psyche not by means of their intellect and rational mind, but rather by instinctual foundations and an attitude based on the feeling and sensing functions of our being.

These emergent images, gestures and sounds are seen as stories that create psychological realities; stories that are lived and felt through the body and the heart, rather than the brain, in order to be understood. Romanyshyn (2001) argues for the importance of images and metaphors in the way we experience the world and learn about it. The accounts of these embodied experiences 'reveal not only *what may be seen,* but also *a way of seeing*' (Romanyshyn 2001: 70).

These instinctual and emotional functions of the human being, this *way of seeing*, is essential in the act of *storying* and emphasises the way in which Bryon (2014) honours the field of doing: 'our way of doing, where our alchemy happens and where our real work, our discipline of doing resides' (11–12). The active field is the space between the performer and the witness/participant. *Storying* happens in this middle field as a responsive and action-based process of reactivation of the story through the emergent images, emotions, gestures, words, the gaze and sensations.

The *mythopoetic* attitude in *storying*

This '*way of seeing*', through images, feelings, senses, gestures and metaphors, is recognised as the *mythopoetic* basis of our mind in the way we understand and react to the world (Jung 1960; Hillman 1992). The *mythopoetic* attitude is suggested as a process for encountering these emergent images, senses and feelings. They work as mediators between the conscious and unconscious levels, facilitating self-exploration and awareness of the creative psyche as a unity of consciousness and unconsciousness. As explained by Jung:

> The psyche consists essentially of images. It is a series of images in the truest sense, not an accidental juxtaposition or sequence, but a structure that is full of meaning and purpose; it is a 'picturing' of vital activities. And just as the material of the body that is ready for life has need of the psyche in order to be capable of life, so the psyche presupposes the living body in order that its images may live.
>
> *Jung 1926: 325*

James Hillman (1996), a post-Jungian psychologist, focused extensively on the psychological significance of archetypal images and in addition to the *logocentric* function of the mind, he coined the term *mythopoetic*, referring to the attitude of imagining as a way to create stories of our experiences akin to myths and dreams. A story transpires to be a myth when the objective reality blurs itself with a subjective projected reality. The myth is a montage of speech and images that inspires universal interpretations about humanity. For Hillman, every aspect of life can be seen as a myth or a story and the containing images are carriers of psychological depth in the way we attach emotional meaning to them. The second component of the word *mythopoetic* has its etymological roots in the Greek verb ποιεῖν [*poieîn*]. Its primary definition is 'to create', 'to compose', with a secondary definition of 'to do' having the flavour of an instinctive and naturally occurring action – like it can't be helped. ποιεῖν is not merely about the *how* but also about *who*, the way of doing and being. For example, the way a painting reveals something about the artist, the way a movement, the tone of voice reveals/creates a story about the doer. *Poieo* is an interesting and complicated concept that had preoccupied the minds of psychologists, philosophers and aestheticians. In psychology it is

perceived as the 'language of the psychology and the speech of soul' arguing for creative engagement in psychological thinking and therapeutic practices (Levine 1997). In philosophical discourses and more specifically according to Heidegger[2] in *An Introduction to Metaphysics, poiesis* 'furnishes the analogical unity of the poet and philosopher. *Poiesis* becomes the original site of Being's disclosure, whether this becomes thematic in the case of the philosopher or unthematic in the case of the poet' (Ferrari Di Pippo 2000: 3). However, *poiesis's* conceptual journey is another story. Here *poiesis* remains rooted to praxis of an *active aesthetic*, to the way of doing in performance practice, to the way that the psychological reality of the being is activated through the doing.

Being and doing

Following Jung and Hillman, psychotherapist Lopez-Pedrada studied the psychological and archetypal qualities of Dionysus and pointed out the deity's duality that can be seen as 'a psychic dynamism expressed by extreme images and emotions', a dynamism referring to both being and doing (Lopez-Pedraza 2000: 22). The body is perceived not only as matter and flesh but rather, as Lopez-Pedrada describes it, as the emotional body that is manifested in the capacity of the body to find, express and embody meaning in the world through images, feelings, sensations and instincts. 'The principles of the emotional body are doing and being, and being cannot be expressed itself without doing' (ibid.). Akin to the felt sense of self as described in phenomenology, the emotional body is described as the psycho-physical locus of the emotional being, of feelings and emotions, of likes and dislikes, sensual enjoyment and aesthetic appreciation. It manifests itself in body gestures, voluntary and involuntary signals like tics, nodes, blushing, illness and fantasies (ibid.). The understanding of the emotional body can only be derived from experience, self-discovery, interaction and imagery. To aid our *mythopoetic* mind in understanding the notion of the emotional body, Lopez-Pedrada personifies it as Dionysus, the god of the body and the emotions, closely related to irrationality, madness, sensations and instinct.

The principles of the intuitive and sensation do not differentiate the perception and contemplation of the inner images into thought or feeling, but remain adapted into bodily and/or unconscious functions. Empowered by these principles, the *storying* takes place in the middle field as an active response to the interplay between internal and external stimuli. It is the way of a 'third' where the story appears between persons and things, subject and object, man and the world, psychological life and performing, reality and reflection.

In this chapter's interdisciplinary dialogue between psychology and performance, *storying* does not polarise; does not borrow and apply from one discipline to the other, but rather it floats between, it collides, transgressing the boundaries between the internal psychological story and the act of performing. The *storying* happens with the awareness of the *mythopoetic* and an embodied emotional attitude of the self.

I recognise how my individual interpretation and approach to these disciplines plays a direct role in my way of doing. This is manifested through my performer's ethos and personal presence, and *storying* emerges in the space between the performer and the listener/witness. By embracing the symbolic and intangible, psychological aspects to story, I recognise that the doing happens in the 'bodily depths of human meaning-making through our visceral connection to our world' (Johnson 2008: xi).

Stories from my interdisciplinary praxis

In my praxis, it is not in *what* I am doing but more in *the way* I am doing it; it is in the *how* that my practice is essentially and radically interdisciplinary within the context of Bryon's methodology of *active aesthetics* (2014). The active aesthetic is embraced as a way to look at and examine the interdisciplinary dialogue, not as a series of combined rules and techniques but within the act of doing and specifically from the position of the practitioner as an agent of both disciplines. The *poiesis* of the stories lies in the process and in relating between oneself/performer/trainer and the other/participant/witness. In this process the *how*, the *way* of performing this interdisciplinary dialogue in practice as well as *who* is the 'doer' are seen as inseparable and in continual dialogue.

Storying is not happening only through words, conscious decisions and precise information, but also through the imagining of the psychological reality that the words, the space, the movements, the gaze embody and communicate. The totality of the senses, the body, movement, feeling, thinking and intuition are all modes of knowing in order to engage with *storying* as a way to re-erect it with awareness. The approach articulates a complex body-mind approach including reflexivity, self-questioning, doubt, a search for meaning, and the adoption of the *mythopoetic* attitude and emotional body. Awareness of this *mythopoetic* function determines an active interdisciplinary manner that avoids polarisations.

Three stories of praxis

1. Storying *with elderly living with dementia*

Commissioned by cultural venues such as the Victoria and Albert museum, Tate Modern and Historic Royal Palaces, I have been designing and delivering multisensory storytelling promenade performances for elderly people living with dementia. Performance here is defined as an event of doing that includes storytelling, participation and a process of actively engaging with the material through various modes of performing or making.

Meeting and encountering people whose sense of selfhood narratives are distorted because of the neurological effects of dementia has further challenged the use of story in my performance practice. How does *storying* happen for an individual whose cognitive abilities are demented and their sense of self and reality unstable?

In this context I examine how *storying* happens in the meeting between the self and the other through sensory stimulation; the narration of the story is 'told' and experienced mainly and predominantly through sensory stimulation.

The specific performative event that I recount is part of the project *Sensory Palaces* at Hampton Court Palace; it is two hours long and split between a well-designed route in specific galleries of the venues and a quieter, secluded room – like a learning centre for example. The following story offers an account of the experience.

Imagine Robert who is in his 80s and has a diagnosis of Alzheimer's. He lives with his wife who is also acting as his carer, and through local organisations they heard of the opportunity to participate in a performance event at Hampton Court Palace. They have expressed their interest and have received an invitation to attend the re-enactment of the Christening of Edward VI in the Tudor part of the palace. The invitation includes pictures of the places and the organisers/facilitators, an outline of the activities and the timings of the event. When Robert and his wife arrive, they are welcomed into the learning centre, a quiet room where refreshments are offered, and they are introduced to myself, as the facilitator/performer; the volunteers; and the rest of the participants, a small group of 12 to 14 maximum. The first introductions take place over coffee, tea and biscuits with the intention of establishing a welcoming, trusted and comfortable environment. During this process of 'warming-up' the group is also getting familiar with the sensory engagement that is required and a ritualistic process of sharing and passing around sensory objects. Participants are asked to share with the group their name and something that they enjoy eating or drinking. When Robert's turn comes, he needs to be reminded about the task but then he speaks about his favourite meal in his local pub, a well-done steak and a pint of lager. Around the circle, other participants also share eating preferences and the sense of taste is activated through the recalling of favourite delicacies and beverages and everyone's mouth starts watering. I explain the structure, expectations and the content of the event and I share stories and facts about the palace and its historical inhabitants. As a way of cognitive and psychological preparation for the *storying* of Edward's christening, I use tangible symbols and images to recount briefly the events of Henry VIII's life and marriages, up until the moment when the longed-for son was born. Everyone has a chance to sense the different objects and share comments or questions to familiarise themselves with participation. I explain that all preparations have been made to help us/them reimagine and recreate, by the use of multisensory objects, the royal feast and celebrations for Edward VI's christening that took place in the same palace 500 years ago. Robert speaks little and seems puzzled but he follows with the group as they start the promenade performance. Others are amused and intrigued on different levels of engagement. Prior to the session, I have devised a route that uses the specific sites to relate to the story while activating the senses. Alongside the five common senses I take into consideration proprioception, thermoception and physical needs of the elderly. Throughout the devised route, I also supplement the storytelling by using sensory prompts that activate the

imagination and encourage participation. For example, during the re-enactment of the royal feast around the table in the Great Hall, I pass around plates, cups and knives of the Tudor era as well as fake pies, bread and real herbs and spices used in that period. Robert, while holding and examining the plate, suddenly breaks his silence and shares stories with detailed knowledge and information about the use of pewter instead of silver in utensils and the reasoning behind it. Later I find out that he was a historian with a great interest and knowledge about the Tudor period. The actual holding of the plate and the additional sensory engagement in terms of sight, proprioception and hearing has activated the *storying* in the moment, with Robert as the immediate agent of it. The implicit psychological preparation allowed him to connect with the story in a personal and meaningful way.

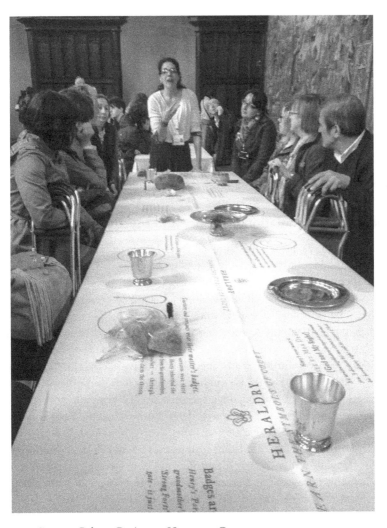

FIGURE 7.1 Sensory Palaces Project at Hampton Court

As we move into the next stage, the baby Prince is introduced and Robert's wife volunteers to dress him with a diaper and robes preparing the little Prince for the Christening procession and ceremony. Her gestures move with ease as she talks about her life-long experiences in caring for babies because of her numerous children and grandchildren. Her eyes are filled with emotion and Robert nods and smiles as he watches her intensely. While these real stories emerge and are performed, I draw lines back to the collective enactment of the christening and thus, other participants comment with humorous remarks and contribute to the preparations. Some become the Dukes, Earls, chaplains, knights, Ladies and midwives who are holding symbolic objects and escorting the prince to the royal chapel for his christening. As we proceed in each step of this multisensory promenade performance, new stories emerge and the group shapes the performance with their input and participation. The senses evoke memories that spark into storytelling and an increasing level of engagement by the participants who are exercising their control over the performance. The *storying* happens in the middle field: between them and myself, between a well-prepared performance plan, an in-depth psychological understanding of their needs and the instinctive and emotional reactions when meeting the participants and their embodied stories. In my way of *storying* participants are intentionally guided to engage mentally, sensually and emotionally in order to evoke their responsibility into the *storying*. The historical has merged with the personal and the re-enactment of the christening offers the opportunity for interplay between a collective imaginative experience and personal narratives of selfhood.

Multisensory stimulation, memory and psychological health

Of course, memory plays a fundamental part in the narratives of selfhood and the demented mind has lost access to its complete bank of memory. Humans process, sense and comprehend the internal and external world through a complex body-mind system of neurological transmission. Shaped like rivers, canals and tree branches, our neurological system sends information to the thalamus, amygdala, hypothalamus and multiple processing destinations in the brain. Sensory input through sight, sound, touch, taste, smell and movement that is destined to become conscious connects further with specific cognitive networks. This constant feedback and dialogue critically influences conscious sensory awareness and therefore experience. Consequently, neuroscience and psychology recognise that our sensory stimulation and experiences impact our psychological and physiological health (Has-Cohen and Carr 2008).

A large amount of stimulation can cause overwhelming and unpleasant experiences while if there is little stimulation and thus, less sensory experiences, we lose interest in the world, others and our ability to engage. In particular for the elderly whose physical and cognitive abilities are demented, well-balanced and designed multisensory activities can facilitate engaging and personal experiences that enhance their psychological wellbeing. A thought through framework, an

active engagement and gradual preparation, in combination with the right level of sensory stimulation, enables elderly people living with dementia to have new experiences, to experience new stories of themselves, to be seen and heard not through the dementia clinical label but through an innovative *storying* of themselves.

This *storying* happens by being in the actual spaces, using the sense of proprioception, imagining and re-enacting the historical events and using the various sensory objects to prompt a personal and active physical and psychological experience. Through sight, hearing, smell, taste, touch and movement the *mythopoetic* function of the mind creates a new self-story, a story of and about the self. From the perspective of neuroscience and cognitive psychology, that also means that the brain continues to be active in organising, remembering and changing new and old information stored in its cells. It also posits that the person can potentially access both cognitive and emotional memory banks and therefore access personal and meaningful stories of their self while also creating new. The more connectivity and neuronal activity there is, the more socio-emotional experiences we have and that makes us feel alive and interrelated. Having established feelings of support and safety within the group, the sensory stimulation may evoke both pleasant and unpleasant experiences, but the participant has an increased sense of agency.

This sense of agency and the making of one's own story at a time in life when one loses agency on most aspects of life, addresses further questions about psychological and socio-political models of Western praxis for the elderly. Here, psychology is not applied to offer answers, solutions or support, but rather to engage their psychological needs and promote a continuous sense of being and doing despite the cognitive impairment.

The performance's aesthetics are not comprised nor infantilised but are instead rethought and devised in a way that the praxis and my role activate and motivate mental and emotional pathways for sensory engagement, reminiscence and self-regulation. The narrative of the prepared stories becomes less significant in comparison to performative tools such as physical and facial communication, repetition and cueing, playfulness, improvisation and a sense of humour. The way of engaging with the participants and of introducing the material is more important than the material itself. When this approach is successfully established, *storying* emerges.

2. Storying *relational biographies in performance*

Since 2013, Vanio Papadelli – a movement artist, teacher, researcher – and myself have been collaborating towards a performance project entitled CANDID. Between two female performers CANDID is a continuously developing devised performance piece that shares, challenges and exposes the dynamics and complexities of female relationships. It also takes the dimensions of a lifelong performance ritual as we have committed to perform CANDID at least once a year for as long as we are alive.

Our methodological approach is based on psychological reading and performative interpretation of female relationships through movement, senses and imagery. Following Jung's school of psychology, we encounter and witness these relationships from a *mythopoetic* premise, and more specifically we engage with the feeling and sensational aspects rather than their linearity, psychological realism and analysis.

The stories of our personal relationship, as well as the collection of other real, mythical and imaginative friendships and sisterhoods, become a diverse mix of sources for our devising process. From personal narratives, interviews with women of all ages and cultures, myths, stories and folk songs – such as the Greek myth of Scylla and Charybdis, the folk song and legend of *The Cruel Sister*, Strindberg's play *The Stronger* – to a dangerous truth or dare game, the exploration of bitter, sweet and sour fruits and Jan Saudek's eccentric photographs of female duets, our collection of 'stories' or stimuli is vast.

However, we are approaching these accounts not for the narratives they present but rather for the observation of stereotypical behaviours and archetypal qualities of female relationships as manifested in our engagement with these. In the process of exploring the material, we enter the studio with the intention to embody and improvise around these ingredients, allowing these to transform our body, face, voice, our feelings. Parallel to this, and outside the studio explorations, the transmutation continues happening in our conversations – live, mediated or written – in exchanges of provocations on a secret Facebook page, in our shared life events and in our dreams. The recorded events are not encountered only as narratives but explored for their unconscious dynamics and the emotional archetypal manifestations of the relational stories. It is a process of alchemical transmutation where the ingredients are thrown together in the alchemical pot to be reflected upon, to be abstracted, to be transmuted to something new. Jung (1995) suggested that creativity and the invention of something new are not accomplishments of the intellect or the thinking function but the results of a playful and instinctive attitude that is acting from inner necessity. The creative self plays and immerses itself with what fascinates it, intrigues it and frustrates it. This practice follows the paradigm of Jung's process of active imagination, using the *mythopoetic body* as our creative tool.

Through CANDID's performative praxis, we do not aim to represent, recreate or re-edit a new story. Instead, we are interested in creating live the situation where *storying* actively and dynamically emerges in acts of doing and being together in front of an audience. The experiences of continuous comparisons, distorted projections, adorations and conflicts, as experienced and witnessed in female relationships, emerge actively in our way of *storying*. The psychological emotional stories and experiences are *mythopoetic*-ally communicated in performance. For example, the use of fruits such as melons, apples and lemons are used in relation to our bodies, adding a sensory and metaphoric experience of sweet, bitter and sour feelings to a psychophysical dialogue of conflict. The eating, sharing, swallowing, spitting or throwing of the fruits is *storying* the emotional reality of continuous comparisons, conflicts or togetherness found in the stories that we have collected.

FIGURE 7.2 CANDID. Photo by Yiannis Katsaris

When we expose these actions and doings in front of another, an audience perhaps, the unforgettable and unspeakable emerge and impart in our expressions, movements and looks, the tone of our voice, the pauses between the words and the sensations, everything that concern us. Then and there is where our CANDID *storying* happens, emerging through the senses as we are hugging, slapping, shaking, falling, spitting, caressing, praising, crying, laughing, and eating together and apart. The provocative and playful movement, the touch, breathing, the words, the tastes, shapes and colours of the fruit, the symbolic and ritualistic actions, manipulation of objects and the abstract imagery create an intimate and intense environment that is fertile for the emergence of *storying* witnessed by another:

> Candid is a two women show born out of real life encounter with an almost poetic resonance. [...] In its heart lies a friendship, the kind we have all experienced, cherished, buried and resurrected throughout our lives. Our bond with a long-lost friend.
>
> *D. Pavlaki, Friday 5 June 2014 in Athens Views Newspaper*

3. Training the actor/performer through story

Throughout my Practice as Research PhD, I have developed an approach to performance training that utilises storytelling, enactment and embodiment of myths as a way to gain awareness of the *mythopoetic body*. The approach is based on the methodological premises of the Sesame approach to Drama and Movement therapy, psychophysical actor training and the theoretical perspective of Analytical

Psychology. Myths rather than stories are chosen for their universal psychological meaning that transgresses time and cultures. Thus, this training approach facilitates for the performer an active process of understanding or cognisance of their creative self while the embodiment of myths trains their sensitivity and mythopoetic intelligence.

Through the exploration of breathing, thinking/imagining and moving, the aim is to activate a more awakened, dynamic, attentive and expressive body that acts and reacts to inner and outer impulses. The body as a thinker and doer becomes *mythopoetic* when the actor/performer attains attunement between the conscious and unconscious mind, senses, emotions and imagination. Attunement here evokes the subtle qualities of listening; of tuning in to one's impulses and stimuli while also listening to the other – another on 'stage' or the spectator/witness. Attunement is recognised as a necessary quality of relationship and responsiveness with what is happening in the present moment, in relation to one's self with another. Nagatomo (1992) describes attunement as the relationship or 'the mode of engagement between a personal body and his/her living ambiance, both internal and external' (ibid. xxv). Here, he is referring to the way of doing in the moment and how it activates presence and personal attitude beyond words and narratives. Similarly Maeterlink states the importance of these qualities:

> What I say often counts for so little; but my presence, the attitude of my soul, my future and my past… a secret thought, the stars that approve my destiny, the thousands of mysteries which surround me and float about yourself – all this it is that speaks to you at … [the] tragic moment.
>
> *Maeterlink in Gordon 2006: 91*

The emphasis is on somatic knowledge – knowledge gained through the act of doing – in contrast to the intellectual one, as well as on one's 'attitude of soul' that I relate to ethos and will explain below. The tone of voice, body posture, physical pains and habits, tics and the wrinkles tell the story of one's life, of who one is and their relationship with the world. The embodied meaning of these personal stories emerges from unconscious bodily encounters and it is communicated non-verbally between performer and spectator. Johnson (2008) in his book *The Meaning of the Body Aesthetics of Human Understanding* suggests that:

> [F]or this immanent or embodied meaning, you must look more deeply into aspects of experience that lie beneath words and sentences. You must look at the felt qualities, images, feelings and emotions that ground our more abstract structures of meaning.
>
> *17*

The awareness of these personal stories informs the being and doing of the actor/ performer who is then called to activate new stories. One's 'attitude of soul' and poetic awareness in the doing of new 'stories' allows for transformation, for *storying*

that emerges in this middle field between psychological personal awareness and the act of performing.

Following Bryon's paradigm of Integrative Performance Practice, which states that 'acting is doing' (2014: 185), it is obvious that the actor is a doer. Interestingly, the Greek word for actor is *ethopoios* / ηθοποιός, a word comprised by the two components, ethos and poios from poiein that is the same root as poiesis or poetic. Ethos here does not merely refer to one's moral values, but rather to one's attitude, stance or character and is thus closer associated with Heidegger's notion of *Haltung*. The actor/performer is then the creator, the maker of ethos/character not only confined in the sense of the dramatic 'role' but in terms of a created attitude and stance, a 'poetic' ethos.

The training follows a specific structure that starts with a physical and mental preparation to quiet the mind and awaken a felt sense of the body. Myths are approached with spontaneity and a playful attitude led by the body. The performers are not seeking an interpretation of the myth's characters and situations but rather an intuitive impulsive response to the myth. The meaning of the myth is not analysed intellectually but rather felt within each individual and the gained knowledge is an embodied knowledge. The way of approaching the myths are through resonance, whatever leaves an impression – either a word, an event, an image or an object becomes the starting point for *storying*. Shifting consciousness from the intellectual function to a more instinctual function, we engage not with the narrative of the myth but rather with the psychological/personal meaning that it brings up for each participant. Jung names this transition as a reduction of the level of ego-consciousness using the French phrase *abaissement du niveau mental*. According to Jung (1959) the reversal of the conscious state occurs vividly from the emerged unconscious images, feelings, thoughts and 'every *abaissement du niveau mental* brings about a relative reversal of subjective values' (28). Through this relative reversal or re-examination of the values in myths, the possibilities are created for the emergence of *storying*.

My role in this practice is that of a witness/facilitator who activates these qualities through suggestions and guidance rather than specific instructions on techniques. The approach values the performer's intuitive and expressive process. Jung described intuition as a function separate from thinking, feeling and sensation, which was characterised by the ability to see connections between things and find the potential inherent within a situation. Although this is the primary characteristic, 'intuition is not a mere perception, or vision, but an active creative process' (Jung 1971: 221). During the creative process, myths are experienced as vehicles towards the self-exploration of the imaginal that resonates and fascinates us for its relevance to our personal psychological abyss. The *storying* of the myth by the performers happens through their embodied engagement with its irrationality and mystery, feelings and images rather than its literal re-enactment of events. The aim is not to recreate the myth but to activate *storying* through personal investment.

Why myths?

Myths, alongside traditional stories, are widely recognised and studied as holders of truth and knowledge about human nature. With the advent of psychoanalysis, Freud and Jung opened the way to a new recognition of myth and dream as homologous agents to comprehend and explore unknown aspects of the psyche. Their psychological readings of mythological phenomena demonstrate the identity and relationship of the mythological realm with the unconscious, dream and imagery. Mythology is recognised as the collective dream of humanity, 'the picture language of metaphysics', through which awareness is achieved and facilitated through the mythological rites (Campbell 1990: 51). Mythology is not only 'possessed of meaning' but rather 'explanatory, that is assigner of meaning' (Jung and Kerenyi 1963: 5).

However, myths are not used as a way of searching for meaning, but rather as a way of moving towards the experience of meaning. Following Jung's school of psychology, the use of myths in my praxis facilitates, for the artist/performer, contact with the irrational, abstract and symbolic or metaphoric qualities of being and doing. The way the myth is introduced resembles the perplexing language of dreams. Not for the search of a direct, rational meaning but for the artist/performer to experience it through their sensations. To be exposed to myth through an experiential embodied manner increases our capability of making and creating conscious connections with unconscious images, of increasing our poetic and symbolic awareness and thus surpass these aspects in our act of performing.

FIGURE 7.3 Training the *mythopoetic body*. Photo by Vassilis Kritikos

The relationship with myths is not a quest for philosophical or analytic interpretation of the given images or symbols, but rather a feeling of immediacy and agency with these. The personal investment and its poetic amplification allow the myth to be recreated or re-imagined physically, emotionally and sensory, and to become collective or even archetypal. Thus, in the process of *storying* the myth/ story emerges in the middle between personal and collective. The *storying* of the myth activates an embodied new and personal meaning that is powerful and emotive, that is not representative.

Conclusion

In every act of doing and being, as we move, breathe, gaze at the world and others, the story of our self as a wholeness of conscious and unconscious mind, body and spirit is emerging and re-created in every moment. In this chapter, we witnessed 'story' in the field between psychology and performance, between the factual and the imaginal, the personal and the collective and we approached *storying* as the pivot of these disciplines. *Storying* as an active process committed to felt and intuitive experiences, emerges in the interplay between our psychological reality and the outer world. In the middle field between psychology and performance the mythopoetic sensibility attunes to the images, feelings, sensations, gestures and other intangible qualities that transpire in the act of *storying*. These subtle qualities are the 'prima materia' for the alchemical process of *storying* in the act of performance. These first ingredients are re-figured, transmuted and re-imagined in creating and witnessing new experiences. I have no more words for this story.

Notes

1 The term 'Depth Psychology' was coined by professor of psychiatry Eugen Bleuler and it is used to indicate those schools of psychology that orient themselves around the idea of the unconscious.

2 For an elaborated discussion on Heidegger's concept of poiesis look at www.iwm.at/ wp-content/uploads/jc-09-03.pdf

References

Arendt, H. (1998) *The Human Condition*, Chicago, IL & London: The University of Chicago Press.

Benjamin, W. (1992) *Illuminations*. (Trans. Zohn, H.). London: Harper Collins Publishers, Fontana Press.

Benjamin, W. (2009) *On The Concept of History*. CreateSpace.

Bryon, E. (2014) *Integrative Performance Practice and Theory for the Interdisciplinary Performer*. New York, NY: Routledge.

Cavarero, A. (2000) *Relating Narratives Storytelling and Selfhood*. (Trans. Kottman, P. A). New York, NY: Routledge.

Ferrari Di Pippo, A. (2000) The Concept of Poiesis in Heidegger's An Introduction to Metaphysics, *IWM Junior Visiting Fellows Conferences*, Vol. IX/3. Available at: www.iwm. at/wp-content/uploads/jc-09-03.pdf [Accessed on 27 October 2016].

Hartigan, K. V. (2009) *Performance and Cure: Drama and Healing in Ancient Greece and Contemporary America*. London: Gerald Duckworth.

Has-Cohen, N. and Carr, R. (2008) *Art Therapy and Clinical Neuroscience*. London and Philadelphia, PA: Jessica Kingsley Publishers.

Hillman, J. (1992) *Re-Visioning Psychology*. New York, NY: Harper Perennial.

Hillman, J. (1996) *The Soul's Code: In Search of Character and Calling*. New York, NY and Toronto: The Random House.

Johnson, M. (2008) *The Meaning of the Body: Aesthetics of Human Understanding*. Reprint. Chicago and London: University of Chicago Press.

Jung, C. G. (1960) *Structure and Dynamics of the Psyche: Vol. 8*. New edition. London: Routledge and Kegan Paul.

Jung, C. G. (1991) *On the Nature of the Psyche*. New edition. London: Ark Paperbacks, Routledge.

Jung, C. G. (1995) *Memories, Dreams, Reflections*. New edition. Illinois: Fontana Press.

Levine, S. K. (1997) *Poiesis: The Language of Psychology and the Speech of the Soul*. London: Jessica Kingsley Publishers.

López-Pedraza, R. (2000) *Dionysus in Exile*. Wilmette, IL: Chiron Publications.

Nagatomo, S. (1992) *Attunement Through the Body*. New York, NY: State University of New York Press.

Romanyshyn, R. D. (2001) *Mirror and Metaphor Images and Stories of Psychological Life*, Pittsburgh, PA: Trivium Publications.

Todd, M. E. (1937) *The Thinking Body: A Study of the Balancing Forces of Dynamic Man*. New York: P. B. Hoeber.

von Franz, M-L. (1980) *An Introduction to the Symbolism and the Psychology (Studies in Jungian Psychology)*. Toronto: Inner City Books.

Cross-Chapter Discussion

story and virtual

Joanne Scott (JS) and Antonia Batzoglou (AB)

Joanne Scott: Morning Tania – just checking in for our cross-chapter discussion. Give me a shout when you're ready to go!

Antonia Batzoglou: Good morning, I am ready to go.

JS: Splendid. Right... what I found very engaging about your chapter is the conception of self as emergent, active, created through action, sound, movement and specifically in the act of 'storying'. I also think it made me think about stories in a different way. Where did this idea of storying start to emerge in your work?

AB: Having trained and worked many years as an actor I initially thought of stories as these 'prescribed' narratives given by an author, a choreographer, a director etc. What I found challenging in my work as an actor is that I saw myself also as a creator who brings other dimensions and layers in those stories... my body, my voice, my way of feeling, moving add to the prescribed story, yet that often caused tensions.

It was after my dramatherapy training and the encounter with the principles of 'Active Aesthetics' when I realised that 'storying' happens anyway anew in the act of doing. It emerges in the way I engage with it and in the way the other experiences it through me. The psychological basis of this perspective lies on Jung's analytical psychology, the role of myths and stories in therapy and the embodiment of these tales as a way to reflect upon the self. Later, I transmuted these concepts and experiences into performance.

JS: Yes – I see that and what I really enjoyed was agreeing with you across the disciplines! I have always had a bit of a problem with the logical linear story in the act of performing in particular, where there seems to be so much more happening and emerging in the doing, and I guess that is also true in terms of therapeutic practices too, as you describe in your chapter.

AB: I also thought of 'storying' when I was reading your chapter and especially when you refer to the act of deciding, acting, shifting buttons, images, etc. in the moment. Your self responds in the moment creating these virtual stories, so what is the source of these for you?

JS: I think a difference though might be that you describe a storyteller as 'always rooted in the people'. This made me think about how my 'storying' emerges through a network of human and non-human actions and interactions. How does that feel to you? Can machines also be part of this storying?

AB: I will be a little bit more specific: You mention that it is a felt experience and I was wondering if intuition informs these actions… in the sense that you have to attune to your inner rhythm, your senses, your inner virtual world (if that makes any sense) and so you act and interact with your mediated prescribed text to create another, a new virtual world will be created through this interplay… am I close?

JS: I find it very difficult to identify a source I think, because in terms of the self and story that emerges in those interactions, I like you, do not think that is 'prescribed', but always emerging. However… I do choose bits of music, text and images which prefigure the event and define it to some extent. So… there must be something intuitive happening, though I am for whatever reason, very sceptical about talking about it in those terms, which is interesting… But I do like the idea of an 'inner virtual world' that meets the other elements of the events and through that something exterior is created as a hybrid, which brings me back to my question about machines and storying. I'm interested from a psychological perspective how you might view that?

AB: That is interesting! I was thinking the same! I was struck with the example of the potter you gave because for me it raised some questions in terms of materiality. You refer to the potter having a tactile felt experience with the clay as his material before the actual product emerges and you compare this to your felt experience but then I was left wondering of a paradox: your immediate sensory experience is with the machine, its buttons, cables, screens etc. but yet this is not your material. Your material is encrypted, contained, coded in these machines and by your pressing and pushing you actualise, 'materialise' these 'symbols'. I thought of the numbers, notes, images, sounds as symbols that are used to give new meanings to the virtual world you are creating.

JS: Yes – I see what you mean. So I guess in some ways, you could say that there is always some kind of distance between me and the material, which is occupied by the technology, and enabled by it too. In terms of your work, do you ever find those kinds of removes or distances, where the tools you use create space, rather than connecting you directly with the performer or experience or client or space or story? Do you think that space can be useful?

AB: Having witnessed your performances, I have a personal experience of what you are saying and doing so I know that you are not acting/reacting with these machines out of well-calculated 'prescriptions' on what to create virtually, there is not distance felt for us, you are very present, you improvise, you play and you

immerse your self into that play and that was fascinating to watch. I see these materials, either they are technological machines or sensory prompts or props as tools – it is not these that do the storying, it is the way we engage with them and thus opening up the possibilities of new stories, new meanings to emerge.

Even if we are not aware of it, there must be an imaginative interplay happening in our mind that enables these performative virtual worlds to be communicated. Perhaps that is why psychologists speak of the mythopoetic function in addition to the logocentric. Perhaps and in a very poetic way… it is like we are dreaming while being awake and we give shape to these dreams.

JS: Yes – so there is something always about the way of doing in terms of how we engage, which is also present in your description of working with people with dementia and the types of storying that happen in those engagements. This description did make me reflect on the term attunement that you employ too… but let's talk a bit about the mythopoetic first. You describe this as 'a symbolic and imaginative approach to doing and being' and you talk powerfully about its function in your work and in the manifestation of self in storying.

AB: Yes, a challenging term as I am always aware that people may read it as a term of pop psychology, ungrounded and eerie.

JS: Yes – that's interesting! You're right – there is something about the word that I might baulk at initially, but… the description of how it works in your three examples was powerful and it made me understand the term differently. I was wondering specifically if you could talk a bit more about the mythopoetic in your work as part of CANDID and maybe attunement too? Just sneaking that in there…

AB: Well mythopoetic is a term emerging from cross-discipline exchanges! Joseph Campbell wrote extensively about the role of myths in society and the way we understand humanity, Freud and Jung applied myths in their psychotherapeutic and psychological interpretations of psyche – even though the link between psyche, well-being and myths/stories goes back to ancient Greece healing practices, to shamanism etc. and then Hillman talks about our capacity to reflect and perceive the world and the self into it through creating personal psychological narratives or myths… the second component of the word means creating, doing.

JS: Is the mythopoetic 'prescribed' in your work with Vanio or does it emerge in the doing?

AB: So in CANDID, we collect narratives of female friendships… we observe and witness the narratives that emerge between us as friends and collaborators, we collect stories from other women of different ages, myths about sisterhood and female rivals, songs, pictures but we don't treat these narratives as our 'prescribed' and performative text. We use them as tools to create new 'stories' that emerge through the act of improvising, moving, feeling them in the studio – perhaps like your practice. We could say that they are encrypted in our machines – our bodies and imaginations – and then we press buttons to rearrange them, to let them remerge as something new. They rarely are representative of the original.

We have also coined the term mythopoetic body as it is through the body and the sensory interplay with fruits and objects where the creating/doing/poeing is happening.

JS: Great! I like that comparison. In terms of what pressing buttons might be in this practice between you, is it about activating some of that content in a particular mode, like a text, or movement? Yes – the fruit play sounds fun! I tend to play with very simple, bright primary things and I can see exactly why fruit is a great medium for your exchanges – it is very sensory and tactile and full of possibility and mess too!

AB: Yes exactly, the imprint that these collected stories have left in us... it is not a very logical and cognitive process - it is more about attuning with these internal traces and playing with them while at the same time we are in constant interplay between us. Attuning with the inner while 'listening' to the other.

JS: Great. So... I have to confess I have some difficulty with the notion of attunement. I think it's another one of those words for me. I think I very rarely FEEL attuned in performing. I feel very broken up and in different places and disconnected and rarely whole and connected... Can attunement manifest like this, do you think?

AB: Attunement comes from music, like the instruments of an orchestra have to attune with each other or tune in. Similarly it is used in performance in the way that performers attune to each other. The simpler example for me will between actors. Imagine one saying one line on a specific tone of voice and the other responding totally differently... it may sound to an audience like if they are not listening to each other.

It is interesting that you feel like that about your practice because I was thinking of attunement when I was reading about your work and having witnessed it.

JS: I see. So, the 'doing' of attunement is about the act of listening and responding? Also, as I understood it from your chapter, that is an inner and exterior listening? This is possibly where it falls down for me!

AB: I always felt that what works so effectively in your performance practice is your ability to attune with these broken pieces, your inner chaos and sense of disconnection that is communicated through the digital and affects us, moves us. As you say, it is relational, lively... I can feel you when I see your virtual worlds. I think you are attuned with these difficult feelings and you express them powerfully. You don't need to be aware of the inner listening and you don't need to rationalise it. For me it is translated like that because of the way I give meaning to things and the disciplines I embody but who cares how it is called? It works.

JS: Thank you, Tania! That makes sense and it is probably why I am so interested in your CANDID work, as you describe something quite broken up and chaotic even and difficult to manage and direct, but powerful. That feels very resonant, though I think that it is probably a different kind of attunement that happens between you both than in my work, because some of my partners are digital and

that means a different quality of attunement, though I have worked with those partners for some time now, as you have with Vanio, so relationships and modes of attunement develop, strengthen, change and morph and become different over that time.

AB: Yes, the tools are different but the way of engaging might not be so different. Does the painter see the whole picture before he/she starts painting? Perhaps not, perhaps it starts with lines and dots and things emerge as his/her hand moves the brush over the surface. What is the brush? ...the tool is different and affects the act of doing but the way may be similar. Gosh I sound like an old lady who always gives examples!

JS: I like your examples! Yes – I absolutely agree. I guess those choices of tools and materials are always such an active part of the act of making, as we have discussed. I was wondering if I could ask one more thing about symbols and myths?

AB: Yes, I like your questions and I think this dialogue will help the reader to follow my chapter.

JS: Fab. So... I really liked the idea of re-thinking digital code, as you suggested above, as a set of symbols that are then materialised in the act of performing – kind of like a latent symbolic language? And... this might be pushing it, but... it did make me think about the Jungian theories you discuss about symbols and myths that we share and that are then activated in your practices in different ways. Is this a weird comparison?

AB: Not at all. If we accept the fact that these codes and numbers are signs of a specific digital language then in your practice they become symbols because of the other potential meanings they generate. Their latent properties are emerging by the way you use and the way we perceive them as audience. They are virtual and actual as you say and so are symbols.

JS: Yes – so the meaning emerges in the act of performing through the different ways of doing and witnessing. In terms of your work with actors and the embodiment of myths, is it fair to say that the myth changes places there and becomes a tool for something else – a form of self-ness – to emerge?

AB: I also checked the etymological origins of virtual outside computing and it was very interesting how it relates with the effectiveness of inherent natural/physical qualities, with potency! So much like symbols!

JS: Yes... it is a very slippery term indeed, but that potency, potential, possibility is something that I also connected with and it does connect it to symbols!

AB: Going back to your question above... the myth and its inherent qualities, images, symbols becomes the ground, the stimulation for something new to emerge, something that resonates personally. I am not interested in a faithful re-enactment of the myth.

JS: Yes – I see, so it is where it intersects with the performer that is the point of interest, rather than a faithful replaying by them. The myth is always active I suppose in this work, like virtuality is for me. In this sense, it is very enlightening to swap some language. Thank you!

AB: Same here; it was fascinating to read and converse exchanging languages especially about the whole concept around virtual being real or not real, the connection with materiality, theatricality, world making versus fictional world and so on. We could continue talking for hours but perhaps we need to put a full stop knowing that more dialogues can happen and emerge in the future.

JS: Absolutely – I would really like to do that. It has been FAB talking to you like this and has given me loads to think about.

visibility: Performance and Activism

Nando Messias

Having donned my white satin opera gloves and feeling like I shall go to the ball after all, I walk downstage to address my audience. My dark hair is parted in the middle and tied back in a low chignon. A ball gown envelops my body while red high-heeled shoes cover my feet. House lights come up slowly. The fourth wall drops. I am no longer immersed in the space of performance, no longer protected by the warming lights of the stage. This is a moment of rude awakening. Nowhere else do I feel more visible, bare, open. The vulnerability of my thin body is exacerbated by exhaustion. My maleness and my femininity stand in contrast: body, gesture and dress misaligned. We are halfway through the performance of *The Sissy's Progress*. I put myself, 'a bloke in a dress',[1] in front of the audience. The tension between sex and gender is pointed in this image. Words are dispensable. It is here that the two worlds of performance and activism collide.

Ready to proceed, I lead the audience outdoors, crossing the threshold that separates the inside from the outside. For Bachelard, 'outside and inside form a dialectic of division' (Bachelard 1958: 211). Like the stage lights had done only a moment ago, this dialectic of division blinds me too. It has 'the sharpness of the dialectics of *yes* and *no*, which decides everything' (Bachelard 1958: 211). Stage and street – inside and outside – are like *yes* and *no*, *day* and *night*, *feminine* and *masculine*. For the purpose of my argument, inside and outside are respective representations of *performance* and *activism*.

If inside I have the freedom to perform the best and most original version of myself, the power structures of the outside world seem less forgiving. Inside I am constantly on the edge of realising my Cinderella dream, in my pale blue dress and white opera gloves. But outside I am in constant peril of losing a crystal slipper. Indeed, 'when confronted with outside and inside,' continues Bachelard, '[philosophers] think in terms of being and non-being' (Bachelard 1958: 212).[2]

As I step outside into the night, the clock chimes midnight. I am no longer Cinderella.

I leave the safety of the theatre behind. Ahead, I face the now familiar danger of the streets of East London. Leading the audience to our starting position, I stand on the exact point where it all happened in 2005. A moment of silence marks the spot. The silence is broken by the brash boom of the live brass band. 'Shut the f**k up!' shouts an interloper. He throws a can out of his window. Another rude awakening. '*Revive. Survive*' reads the side of the can. The irony does not escape me. This street is really not the place of fairy tales.

The street is full of surprises. It is out of my control. It was here on this particular corner that in the summer of 2005 I suffered the homophobic attack that then gave rise to *The Sissy's Progress*, the performance I have been describing above. Standing here at the time of the show, over a decade later, I am confronted with a set of questions. Some of them are of an artistic nature, others existential: *why* do I do this? Do I *need* to do it? Do I have it in me to do it *again* and *again* and *again*? Standing at this particular corner is, after all, an uncomfortable (perhaps even frightening) prospect, so why bring it upon myself?

The answer to all these questions lies perhaps at this crossroads where I now stand, the point where performance and activism intersect. As an activist, my answer is that I feel it is my duty to do this. Not only do I *need* to do it but perhaps, more emphatically, I *choose* to do it. As a performer, my response is that it is my calling. I therefore do it because I *love* it, because it brings me pleasure and self-fulfilment, because not doing it would mean living a life with no meaning.

An obvious question follows: what is the 'it that is being done here? Is it performance or is it activism? To me, it exists between these two disciplines. *The Sissy's Progress* was not intended as a piece of activism. My process of imagining it was like all the others I had gone through before. I selected the music, explored movement, dreamt up costumes and organised these elements in what appeared to me as an ordinary creative process. When conceiving the piece, I didn't set out for it to take on the social dimension it has done since I began performing it. Instead, the process of developing the performance and subsequently unleashing it out there into the world has led me down that path. In this instance, therefore, performance actuated activism.

To appear as a body on the streets

It took me a period of over ten years to turn the very personal experience of the attack to my advantage. What made this attack stand out from the hundred other attacks I had suffered before was that this time the threat of the physical violence was actually carried out. After this event, I became more adept in navigating the danger of the streets without becoming so much of a passive target. Having encountered so many predators, I learned to think like prey. As a performer, on the other hand, I trusted the healing promises of my craft.

'*Revive. Survive.*' The saying on the can of energy drink flashes on my mind. Perhaps the can itself was a gift from the gods, thrown at me with a prophetic message. Like the inscription 'for the fairest one' on the golden apple, the writing on this tin also requests a form of judgement. My task has been to find ways to transform this ugly experience into something positive. My choice was therefore to go back outdoors, despite my fears and reservations, and to reclaim my place on the streets.

As a citizen, I felt it was my duty to 'appear as a body on the streets', to use Judith Butler's words (Butler 2015: 58). This is a crucial phrase: To appear. As a body. On the streets. It was imperative that the performance should take place precisely here, on the streets. Making my body visibly (and audibly) present in the public sphere helps me make the point of the performance. The *how* of the performance, that is, is the *what* of the performance. The simple act of being outdoors in a ball gown, red high-heeled shoes, with helium balloons and a marching band trailing behind me is perhaps already enough of a performative statement.

To appear. As a body. On the streets.

The body utters the message loud and clear.

As a bodily performative, this public performance of visibility exclaims out loud, without the need for words: 'I am here. I am *still* here despite the vicissitudes. I persist. I refuse to be moved on and to be confined to the private space.' The performance claims the right to appear in public while contesting the ways in which queer bodies have been allowed to do just that. It makes that claim precisely by performing the very act of appearing in public, by making one's presence seen on the very street from which one had been barred. It represents the struggle where it *takes place*. In its exuberant and hyper-flamboyant public displays – a live marching band, a male body in feminine garb, helium balloons and loud noise – *The Sissy's Progress* confronts social violence head on. It does so by making visible the often invisible hostility, which is part of the daily reprieve queer people endure. By offering a live engagement between performance and activism, my practice can be seen to participate in the dynamics of Bryon's *active aesthetic*. During the parade, audiences witness verbal abuse, threats and objects being thrown at me (the performer) in front of their eyes, making them attentive to the harsh realities of queer people. In harnessing the tools of performance, the piece raises awareness and fights for political and social change.

The separation between public and private spaces is intrinsically connected with how gender is performed. 'Gender norms,' Butler argues, 'have everything to do with how and in what way we can appear in public space, how and in what way the public and private are distinguished, and how that distinction is instrumentalized' (Butler 2015: 34). Put simply, the power dynamics involved when a man wears a dress indoors are not quite the same as when a man wears a dress outdoors. I wanted the audience, including the casual audience of passers-by, to see the mechanisms of oppression of the outside at play for themselves, with their own eyes. I wanted them to be witnesses. I desperately needed them to experience in their own skins what precarity feels like. I needed them to have an embodied understanding of the effect this form of exposure has in the daily lives of

non-normative people. The comments, the laughter – and the can of energy drink – being thrown at me are the actions I needed the audience to witness. Their presence at the time of the abuse demonstrate – *in performance* – how queer lives are lived. More than simply demonstrating, the performance in fact activated the social dynamics of queer living. If successful, the experience then leaves the audience with the following question: what can I, as a citizen-spectator, do to ameliorate the endemic aggression suffered by queer people?

The impetus to develop *The Sissy's Progress* came from an imperious desire not to be a passive bystander to an outrage that had touched me on such a deeply personal level. I couldn't be just a witness, a spectator. But what was most important to me was that I should take such a stand in public and through performance. This particular 'geographical turn' (Thompson 2015) of relocating to the streets is perhaps what most qualifies *The Sissy's Progress* as a form of activist performance. It emphasises relationships that often occur outside the theatre context. At the time of creation, I was also aware of the physical limitations of the theatre. I was concerned by how every space limits who participates and who does not. By taking the work onto the streets, I hoped to express an urge to expand beyond my immediate environment and to take advantage of the street as a democratic space.

The visible body

My body has often been the focus of social attention. It is, in other words, visible. I have made this public visibility the subject of my work. As a visibly genderqueer person:

> It was the most devastating discovery of my life that I had no real right to life, liberty, and pursuit of happiness out-of-doors, that the world was full of strangers who seemed to hate me and wish to harm me for no reason other than my gender [...] and that hardly anyone else considered it a public issue rather than a private problem.
>
> *Solnit 2001: 241*

I make the words of Rebecca Solnit my own here. I am careful, of course, to introduce a caveat: I am speaking from the standpoint of a queer person, mindful not to undermine her experience as a woman.

Instead, my intent is to form communal bonds between oppressed groups. Indeed, Solnit herself is quick to emphasise that her plight as a woman is closely connected with other subjects living outside the norm. 'For gays and lesbians', she insists, 'are also frequent targets of violence that "teaches them their place" or punishes them for their nonconformity' (Solnit 2001: 244). In fact, Butler makes a similar claim. 'Precarity,' she argues, 'is the rubric that brings together women, queers, transgender people, the poor, the differently abled, and the stateless [...] it cuts across these categories and produces potential alliances among those who do not recognize that they belong to one another' (Butler 2015: 58).[3]

All this brings me to what Butler posits as 'the basic ethical and political question, how ought I to act' (Butler 2015: 23). The exact question with which I faced my audience on the streets. As a performer, a creator and an artist, my question is how to effect political responsiveness through performance. Personally, I do not feel I provide a particular solution to the problem I am outlining. Rather, my efforts are directed towards doing all I can to make this special struggle known while being careful, at the same time, not to portray it as either romantic or heroic. If the act of performance inspires spectators to reflect on the issue at hand, it would suffice to me. These are examinations that propel forward my work as a citizen, as a genderqueer person and as a performance-maker.

The aftermath of the attack has put me in a privileged position, as it were. The experience has given me a lived understanding of my precarious condition in the world. Putting aside the support and care I have received, the assertions that have catalysed my reaction have varied from 'you have brought this onto yourself' to 'you were dressed like a target' and 'you should change your behaviour.' Hardly any of these things have been expressed in so many words, of course. Rather, as is often the case with oppression, they have been insinuated, expressed between the lines, left hanging in the air. Like Solnit, I too:

> Was advised to stay indoors at night, to wear baggy clothes, to cover or cut my hair, to try to look like a man, to move somewhere more expensive, to take taxis, to buy a car, to move in groups, to get a man to escort me—[...] all asserting it was my responsibility to control my own and men's behaviour rather than society's to ensure my freedom.
>
> *Solnit 2001: 241*

Freedom is a key word here. In a Butlerian sense, to be free is to live a life without the threat of violence (Butler 2015: 61). To be free is to live a life that is worth living, a liveable life, a life of equality, with equal rights and equal treatment. An attack such as I suffered, clearly denies my right to appear in public as I will: make up, high heels and more. I saw this kind of abuse as part of the daily lives of other disenfranchised people too. In other words, I wasn't alone in this. The attack I suffered is, to my mind, an attack not on myself alone but on all those living under threat of violence. As Butler has offered, 'if there is an attack, it targets the individual and the social category at once' (Butler 2015: 52). The realisation that I have a personal investment and a responsibility in caring for those around me is an empowering one. It marks the moment when my performances became more than entertainment alone.

The physical attack – and the thousands of other verbal attacks that preceded and followed it – was an attack on my freedom to appear as a body on the streets. 'When we exercise the right to be the gender we are or when we exercise the right to engage in sexual practices that cause injury to no one, then we are certainly exercising a certain freedom' (Butler 2015: 56). 'But what is [...] most important,' Butler continues, 'is that one claims such a position *in public, that one walks the streets*

as one does [...] that one is protected from street violence' (Butler 2015: 57, *my emphasis*). My work as a performer has allowed me the opportunity to raise artistic questions to such concerns, which I do by re-presenting the attack to the audience, by placing my body in all its awkwardness, misalignment and glory out on the streets, by refusing oppression and confinement and, more strongly, by fighting against all determined attempts to make the problem invisible.

Despite all the threats, the actual attack and patriarchy's efforts to 'teach me my place', *I stayed where I was*. Admittedly, it took me three weeks to step outside the confines of my home again and ten years to dream up a performance but this street is charged with meaning and my body, as I see it, is my instrument of change. The site of this change is the street. Its instrument is my body and its method, walking. The tool with which I pursue this change is visibility.

To appear: the issue of visibility

Visibility, I have stated above, is at the core of my thinking as an artist and as a citizen. It is a constitutive part of what makes me who I am; an inescapable aspect of my being. My walking performances play with that idea by enhancing my visibility in public. In doing this, they playfully subvert the notion that we, genderqueers, are asking for the negative attention we receive. These performances are spectacles geared towards the benefit of an audience, whose gaze they actively invite. My work pulls sharp focus on the incessant and often oppressive experience of *being seen*, which structures the lives of so many queer persons. My walking pieces are, therefore, forms of public protest that place the body centre stage.

Conceptually speaking, visibility is intrinsically connected with Butler's notion of 'appearing', which she develops in relation to the Arendtian idea of the 'right to appear' (Arendt 1958).[4] Theorists (Butler 2015; Butler and Athanasiou 2013; Thompson 2015; Weibel 2014) often isolate the events of the Arab Spring of 2011 as the origin of the recent global increase in mass public demonstrations. Street politics were evidently at the centre of these democratic uprisings. Movements such as this are for Butler representative of what she calls 'the performative of the political'. The performative of the political takes place, she explains, 'when the uncounted prove to be reflexive and start to count themselves, not only enumerating who they are, but "appearing" in some way, exercising that "right" [...] to existence. They start to matter' (Butler 2013: 101). This appearing, which is done in the public domain, is a demand for visibility. It is a bodily performative that says, without words, 'we are here'.

If sections of the population are demanding visibility by performatively 'appearing' and exercising their right to existence, it is safe for us to assume that they accept themselves to be 'invisible', or dispossessed, to use Butler's own terminology. They are invisible in the eyes of the social order. This notion produces an interesting paradox. The socially visible, i.e. women, queers, transgender people, racial minorities, the poor, the differently abled, the stateless and all those brought together by the rubric 'precarity', are simultaneously visible *and* invisible.

One is physically visible by dint of embodying non-conformity and, consequently, that same social visibility is the very thing that renders one legally invisible. There is another form of invisibility that I myself have experienced. When social codes of engagement deem one too visible (i.e. hyper-visible), it becomes somewhat unacceptable to look (or stare) at that person. Although this is a practice dictated by apparent politeness, it nevertheless renders the other, as a result, invisible. It is invisibility by way of inversion.

To appear is to become more visible. To become more visible is, in turn, to become more vulnerable. But, if 'bodies on the street are precarious,' says Butler, they 'are also obdurate and persisting, insisting on their continuing and collective "thereness"' (Butler 2013: 197). 'In this way,' she concludes, 'these bodies enact a message performatively [...] refusing to become disposable' (Butler 2013: 197).

Walking as a sissy citizen

My claim to the act of walking comes from three distinct yet inextricable positions: that of a genderqueer sissy walker, that of an activist and that of a performance artist. In walking the streets, I am therefore constantly aware of my condition of hyper-visibility as a sissy, my invisibility (or dispossession) as a genderqueer citizen and my desire for enhanced visibility as a performer.

As a sissy, I work from the premise that 'not everyone can take for granted the power to walk on the street or into a bar without harassment' (Butler 2015: 51). This, in my view, is the prerogative of the more powerful. Butler's above assertion, which I understand in an embodied sense, also motivates my work as an activist. As I have stated above, my body is ever conspicuous in public. My experience of being on the streets inevitably informs the way that I walk. The need to constantly look over my shoulder, for example, and the habit of continually assessing what routes to take and which to avoid make my interaction with the city a constantly live one. Fear is embedded in all the decisions I make outside. I often feel that I have to keep moving for the sake of safety. In short, I lack a place on the streets. I don't belong here.

This ecstatic trait is, according to Michel de Certeau, constitutive of the act of walking itself. It is a characteristic that is therefore not unique to me. 'To walk,' he claims, 'is to lack a place' (de Certeau 1984: 103). 'The moving about that the city multiplies and concentrates,' he continues, 'makes the city itself an immense social experience of lacking a place—an experience that is, to be sure, broken up into countless tiny deportations (displacements and walks)' (de Certeau 1984: 103). This state of 'no-placeness' is perhaps the most fundamental characteristic of walking. Therein lies its power. In walking, human beings have a shared understanding of being displaced. We are together in our no-placeness while alone.

Indeed for Solnit, 'walking is a universal human activity' (Solnit 2001: 16). Perhaps because it is so universal, walking has been the vehicle for thinkers, artists and protesters alike. From Peripatetic philosophers in Ancient Greece to Kierkegaard, Kant, Nietzsche and Wittgenstein, 'philosophers walked' (Solnit

2001: 16). Walking is also a form of meditation. 'Walking, ideally, is a state in which the mind, the body, and the world are aligned, as though they were three characters finally in conversation together, three notes suddenly making a chord' (Solnit 2001: 5). 'Walking,' she continues, 'allows us to be in our bodies and in the world without being made busy by them' (Solnit 2001: 5). Walking can be at once physiological and philosophical, practical and artistic, quotidian and spiritual.

Walking is public, democratic and therefore political. 'Parades, demonstrations, protests, uprisings, and urban revolutions,' Solnit reminds us, 'are all about members of the public moving through public space for expressive and political rather than merely practical reasons' (Solnit 2001: 216). Marches, vigils, processions and parades – all communal interventions in the public domain – have instrumentalised world change. From the Civil Rights movement of the 1960s to the democratic uprisings of the Arab Spring (2011), from the Occupy movement (2011) to the riots in the *banlieues* of Paris (2005), from the anti-war and anti-Brexit demonstrations in London (2003 and 2016) to the anti-rape and anti-female-violence protests in India (2012), from the man standing in front of a tank in Beijing's Red Square (1989) to vigils for the victims of terrorist bombings in Paris (2015), Brussels, Nice and Berlin (2016) to the marches pro and against the impeachment of president Dilma Rousseff in all major Brazilian cities (2016); non-violent public demonstrators have all 'appeared as bodies on the streets'.

This aggregation of bodies in public spaces – Butler's 'the performative in the political' (2013) – is one way that political responsiveness is made possible. These movements are about attempting to exercise a right publicly, formulating a 'no' to injustice, demanding the end of precarity, asking for a more liveable life, all through bodily actions. In other words, what the appearance of this collective of bodies is saying is 'We persist. We are here. We are *still* here. We refuse to be moved on and confined to the private space'.

If parades, protests and processions are political performatives, the walk is itself an utterance. In other words, it is saying something by dint of doing something. 'The act of walking,' de Certeau philosophises, 'is to the urban system what the speech act is to language or to the statements uttered' (de Certeau 1984: 97). In short, one can think of 'walking as a space of enunciation' (de Certeau 1984: 98).[5]

The walker, he explains, 'condemns certain places to inertia or disappearance and composes with other spatial "turns of phrase" that are "rare," "accidental" or illegitimate. But that already leads into a rhetoric of walking' (de Certeau 1984: 99). My personal struggle for bodily integrity, which I have expressed above as part of my continuous decision-making process of which route to take and which route to avoid is an expression of such a rhetoric of walking. Furthermore, the choice to walk down the exact same street where I was attacked – and to do so *in a ball gown with a marching band and an audience* at that – is a further statement.

This performance-walk defies the social rules that decree that I shall not appear as a body on the streets, that my presentation of gender is wrong or shameful and that I don't have the right to protection. My public walk of defiance performs the notion that the street is a public space in which people of various genders (queer

and non-queer), dressed in various ways (extravagantly and not), with clothing conceivably signifying their gender, sexuality, class, nationality and/or religion are free to walk without the threat of violence.

Pedestrian performances

I'm back on the street. Ready to progress, I march ahead, leading the audience on a parade of exuberance and hyper-theatrics. Perhaps this is not a parade, after all. 'Perhaps it is better described as a procession,' if we agree with Solnit (Solnit 2001: 215). 'For a procession,' she explains, 'is a participants' journey, while a parade is a performance with audience' (Solnit 2001: 215). To my mind, everyone here is both spectacle and spectator; we are all on this journey together.

As I progress, I leave my Cinderella dream behind. I am now Ariadne; these streets, my labyrinth. My ball of yarn is composed of the musical notes, balloons, perfume, comments, faces and even insults I leave behind. Their trail can lead me back to safety should I feel at risk of slaughter by Minotaur.

One more step forward, I must be careful not to stumble on the cobblestones. I don't want to fall. As I look down, my attention is drawn to the double yellow lines on either side of the road. Do they signal a prohibition to park or the way to Oz? I am Dorothy on the yellow brick road on a pilgrimage for courage. Wait. That was the Cowardly Lion.

I am Gretel and the trail of crumbs.

In what he terms 'another spatiality', de Certeau proposes 'an "anthropological," poetic and mythic experience of space' (de Certeau 1984: 93). In my Cinderella-Dorothy-Ariadne-Gretel fantasy, I blend fiction with fact, personal with political, performance with activism. This walk is not just a journey from theatre to street and back to theatre again. It is also a mythic, metaphorical and personal odyssey from labyrinth entrance to Minotaur, from Kansas to Oz, from cowardice to courage, from home to gingerbread house.

As we crusade further down the road, we cross paths with a 'Jack the Ripper' walking tour. A group of about a dozen punters walks in our direction. I want to charge towards them in protest against the glamourisation of Victorian anti-female violence they seem to endorse. I must have heard their stories of mutilation recounted a hundred times from my window. Thankfully, they move out of the way and we win this battle, conquering the right of way.

In a different time, but on the same street, our path crosses that of artist Janet Cardiff. Her audio-guide *The Missing Voice (Case Study B)* (1999) leads participants up this very street. This piece can still be experienced today. *The Missing Voice* and *The Sissy's Progress* walk past each other, respectfully, in the same spatial location but in distinct imaginative dimensions, creating parallel universes.

This street includes other places: a dream, a memory, a story, a tale, a past. It contains the memory of the 2005 attack; Jack the Ripper; Cardiff; the smithereens of Cinderella's crystal slippers; Ariadne's thread; crumbs and yellow bricks. The

walk links all these together, passing from theatre to street corner to theatre, from inside to outside. Walking, like performance, is fugacious and hard to capture.

As I have shown, walking is more than merely a mode of transport. It is a vehicle for thinking and protesting. Walkers, as de Certeau has famously claimed, are practitioners of the city (de Certeau 1984: 93). Walking has also been the preferred mode of artists who have wished to lend their work social and political meaning.[6] Feminist protests of the 1970s demanded the end of the culture of victim blaming in cases of sexual violence against women. Suzanne Lacy's *Three Weeks in May* (1977) took to the streets of Los Angeles to demand police protection and accountability.

Catalysis (1970–1973), a series of unannounced street appearances in New York by artist Adrian Piper, expressed dislocation and alienation while offering a socially charged critique of homelessness. 'For *Catalysis I*, she soaked her clothes in a mixture of vinegar, eggs, milk, and cod liver oil for a week and wore them on the subway during evening rush hour and in a bookstore on Saturday night,' describes Karen O'Rourke (O'Rourke 2013: 15–16). 'For *Catalysis IV*,' O'Rourke continues, 'she [Piper] rode on a bus with a towel hanging out of her mouth' (O'Rourke 2013: 16).

Guatemalan performance artist Regina José Galindo protested the presidential candidacy of her country's former dictator in *¿Quién Puede Borrar las Huellas?* (2003).[7] In this piece, Galindo wears a black dress and carries a white basin filled with blood through the streets of Guatemala City. 'She occasionally sets the basin down, dips her feet in the blood, drawing the attention of pedestrians, and then continues her processional leaving the traces of blood as she goes,' describes Butler (Butler 2013: 169). 'The blood-soaked prints are,' analyses Butler, 'at once the way she "signs" her work, mounts a political protest, and dedicates a fierce memorial to the dead' (Butler 2013: 169, see also Taylor 2016).

The groups 'Women in Black' in the former Yugoslavia and the 'Madres de la Plaza de Mayo' in Argentina, both engage in public practices of mourning by performing silent street demonstrations. The 'Madres de la Plaza de Mayo' (or 'Mothers of the May Square') – which includes men – are joined by a number of other people in their walks. These extra 'mothers' are not only performing gender and identity publicly but are also giving 'bodily presence to the demand, "never again"' (Butler 2013: 143). HIJOS, on the other hand, are children, rather than mothers, of the disappeared, tortured or killed victims of the military dictatorship in Argentina. Their 'escraches' are, in the words of Diana Taylor, 'deeply theatrical' strategies of public engagement. They 'directly confront those who carried out human rights violations, and oblige them to relinquish their anonymity' (Taylor 2016: 149). The group creates a poignant inversion with the politics of visibility. 'Instead of *disappearing* their targets, as the military did their parents, they made them *appear*' (Taylor 2016: 152, my emphasis).

Fred Forest's *Hygiene of Art: The City Invaded by Blank Space* (1973) was presented at the São Paulo Biennal under military dictatorship. Forest hired professional sandwich-board men to walk with him in the city centre of Latin America's largest

capital carrying blank signs. Forest's organised street demonstration, in
Brazil's military junta, was joined by ordinary people. The blank placards an̄ū
to the censorship and lack of freedom of speech imposed by the regime.

The synergy between performance and activism is clear in the examples above
where artists have borrowed direct-action strategies from activists and activists, in
turn, have used theatrical approaches to frame their protests, thereby summoning
more attention to their causes.

Conclusion

The paradox of visibility is clear. To be politically invisible, or under-represented,
often leads to social visibility. On the other hand, to be visible in the eyes of the
law – to have power – can render one socially invisible. In other words, he or she
who does not embody the norm stands out in public whereas he or she who does,
'passes' or, to use Peggy Phelan's term (1993), is 'unremarkable'.

I have made an argument for increased political visibility. I am mindful the
danger accompanying this is the possibility of becoming, as a result, unremarkable.
As a queer subject, I am keen to avoid exactly that. The erasure of the very
characteristic that makes me who I am, difference, would spell the end of me.
Nevertheless, I am also mindful lest I romanticise the conditions under which one
becomes disenfranchised and under-represented. The results of such a prospect is,
as we have seen, a life under the threat of violence.

'The binary between the power of visibility and the impotency of invisibility is,'
Phelan contends, 'falsifying' (Phelan 1993: 6). 'Visibility is a trap,' she warns, 'it
summons surveillance and the law (ibid.). There is power in remaining unmarked (or
invisible). Yet, there is a political appeal in achieving visibility. There are advantages
and disadvantages in both ends of the binary; a truism that must not be left unsaid.

Binaries have been one of the structuring frames of the present chapter: inside
and outside, female and male, past and present, performance and activism. I have
focused on visible markers of gender, namely clothing and walking. While doing
this, I have shown how the public space can often suppress the free expression of
queer walkers. Performance, I have argued, represents a space where this freedom
can be re-essayed.

While I have pointed out that the body of the performer becomes hyper-visible
through the platform of performance, I haven't teased out the visibility of the act of
performance itself. As we know, performance is ephemeral. 'Performance is the art
form which most fully understands the generative possibilities of disappearance,'
offers Phelan (Phelan 1993: 27). It is 'poised forever at the threshold of the present,'
she continues (ibid.). Being given to disappear, performance is impossible to capture
without it turning into something else: a photograph, a video, a text, a document.
As such, performance and walking are kindred spirits: gone once they happen.

Performance is simultaneously visible and invisible. Like Proteus, it changes
shape every time someone attempts to capture it. Like Proteus, performance has
something important to say: a secret, the future. This something it has to say is

knowledge and knowledge is power. Since it needs to be captured in order to say what it knows, performance remains forever elusive.

The Sissy's Progress straddles the inside and the outside worlds. It too remains elusive at times. Passers-by who experience it on the streets without the contextual framework of the theatre are often confounded by it: Is it a wedding? A walking tour? A performance? This ambiguity gives it its power. It cannot be captured or held down.

Like Proteus, I have also changed shape in the course of this chapter. I have been Cinderella, Paris, Ariadne, Dorothy, Gretel and Sissy.

A bucket of cold water is hurled at me. It hits my face and runs down my body. My pale blue dress is soaked. I lift my skirt and look down. My red shoes are drenched. Will the water ruin the suede? Will the shoes make me dance until I die? I click my heels together three times, repeating: 'there's no place like home, there's no place like home, there's no place like home.' 'No-place' on the streets. '*Revive. Survive,*' my mantra propels me forward.

The water is a final rude awakening: a humiliating gesture that stands for the brutal reality of the attack. The coldness of the water has a real impact on my body. It awakes me from the dream-like state of the performance with a start, jolting me into reality. The attackers are not here. The musicians are now back in the theatre. It is just me and my audience. This awakening brings an insight. It is up to me to lead the audience back into the theatre. The ruby slippers are not doing the trick. Glinda is not coming to save me. *I* have the power and thus make the decision to start walking again. We must conclude. The audience follows. Back in the safety of the theatre, the lights are warming. They dry the water on my dress, shoes and body. The walls that constitute the inside space bring us all together.

In reflecting back, I realise that *The Sissy's Progress* has been a peregrination. The act of creating and performing it has empowered me as a sissy, a walker, an activist and a performer. Despite the Ariadnes and Cinderellas, the aim here is certainly not to forge an iconography of exceptional or heroic martyrdom. Rather, it is to unleash the creative power of both walkers and sissies.

As I finish writing this chapter, a new attack happens. Again, it takes place on my street. Again, in July, eleven years on almost to the day of the original one. I am left wondering if my work on this place has made any difference. Perhaps the conundrum I am grappling with is of a metaphysical nature: the *genius loci*. Looking back, I count the acts of brutality that have taken place here: a Jack the Ripper murder; the original assault in 2005 and this latest one now. Not including, of course, all the others of which I am unaware. If my efforts haven't been in vain, my audience will have grasped the message. As I reflect on this latest attack, I wonder if living in fear is my *sine qua non*, existential, condition. It is undeniably my material, the cross I have to bear on my via dolorosa.

Despite not having the answer to the problem, I am left with one conviction. I must carry on the work I have started. Performance provides a means of social intervention. My body is the site of confrontation; a body as battleground. I have my training, my political understanding and my imagination. The show must go

on. So as I leave the house, I pile on the makeup a little bit heavier than usual. War paint. I will not be bullied into under-existence. I will not have my right to walk the streets in whatever I choose to wear blocked or threatened. Instead, I will fight for the freedom to be the best version of myself I can possibly be – on the stage and on the streets.

To appear. As a body. On the streets.

Revive. Survive.

Notes

1 'A bloke in a dress' is how a passerby referred to me once during the street procession section of *The Sissy's Progress*.

2 Hannah Arendt also proposes a dialectic of inside and outside. For her, modern life should be understood as divided between the public and private realms. The public space is where action takes place and is therefore the site of the political. The private space (the household), on the other hand, is where family life takes place. The latter, according to a Hellenistic framework, consists of women, children and slaves. Simply put, Arendt's dialectic puts in tension the terms *private* and *public*, *necessity* and *freedom*, *female* and *male*.

3 '"Precarity,"' Butler continues, 'designates that politically induced condition in which certain populations suffer from failing social and economic networks of support more than others, and become differentially exposed to injury, violence, and death' (Butler 2015: 33).

4 See Butler (2015:174).

5 'It has a triple "enunciative" function,' he explains 'it is a process of *appropriation* of the topographical system on the part of the pedestrian (just as the speaker appropriates and takes on the language); it is a spatial acting-out of the place (just as the speech act is an acoustic acting-out of language); and it implies *relations* among differentiated positions, that is, among pragmatic "contracts" in the form of movements (just as verbal enunciation is an "allocution," "posits another opposite" the speaker and puts contracts between interlocutors into action)' (de Certeau 1984: 97–98).

6 Peter Weibel has described this intersection between art and activism as 'the phenomenon of "artivism"' (Weibel 2014: 26). 'Artivism,' according to him, describes 'the wide variety of ways of utilizing artistic means to intervene in socially relevant processes. Artivism refers to the interface of art and activism in the sense of a turning away from *l'art pour l'art*, art for art's sake, and also a turning away from twentieth-century art' (Weibel 2014: 26). Diana Taylor also adopts the term. In the chapter 'Artivists (Artist-Activists), or, What's to Be Done?' in her book *Performance* (2016), she argues that 'artivists (artist-activists) use performance to intervene in political contexts, struggles and debates. Performance, for some, is the continuation of politics by other means' (Taylor 2016: 147). For Nato Thompson, 'the potent merger of art and activism transforms people's understanding of politics—and their relationship with the world around them' (Thompson 2015: vii).

7 Translated as *Who Can Erase the Traces?*

References

Arendt, H. (1958) *The Human Condition*. Chicago, IL: The University of Chicago Press.

Bachelard, G. (1958) *The Poetics of Space*. Boston, MA: Beacon Press.

Butler, J. (2015) *Notes Towards a Performative Theory of Assembly*. Cambridge, MA and London: Harvard University Press.

Butler, J. and Athanasiou, A. (2013) *Dispossession: The Performative in the Political*, Malden, MA: Polity Press.

Cardiff, J. (1999) *The Missing Voice (Case Study B)*, audio walk from Whitechapel Gallery, London, UK.

de Certeau, M. (1984) *The Practice of Everyday Life*. Berkeley, CA, Los Angeles, CA and London: University of California Press.

Forest, F. (1973) *Hygiene of Art: The City Invaded by Blank Space*, performance walk on the streets, São Paulo, Brazil.

Galindo, R. J. (2003) *¿Quién Puede Borrar las Huellas?*, performance on the streets, Guatemala City, Guatemala.

Lacy, S. (1997). *Three Weeks in May*, three-week performance, Los Angeles, USA.

O'Rourke, K. (2013) *Walking and Mapping: Artists as Cartographers*. Cambridge, MA and London: MIT Press.

Phelan, P. (1993) *Unmarked: The Politics of Performance*. New York, NY: Routledge.

Piper, A. (1970) *Catalysis*, a series of unannounced street performances, New York, USA.

Solnit, R. (2001) *Wanderlust, a History of Walking*. London and New York, NY: Verso.

Taylor, D. (2016) *Performance*. Durham, NC and London: Duke University Press.

Thompson, N. (2015) *Seeing Power, Art and Activism*. Brooklyn, NY and London: Melville House.

Weibel, P. (ed.) (2014) *Global Activism: Art and Conflict in the 21st Century*. Cambridge, MA and London: MIT Press.

Cross-Chapter Discussion

visibility and 'the subject'

Nando Messias (NM) and Rachel Cockburn (RC)

Rachel Cockburn: There are many interesting points brought up in your chapter, and certainly it generated many questions for me in terms of 'visibility and the subject'. The first question I had, particularly as I had it myself, is how might the different worlds of activism and performance be understood, and how might they come together? What is the difference between activism and performance? Is it actually to do with taking it on to the street, or is it something else?

Nando Messias: These are some of the very questions I am grappling with in the chapter. They are certainly different worlds in my mind. In reflecting back on the performance, my goal was to make conscious some of the more instinctive choices I had made in the creative process leading up to *The Sissy's Progress*. One way of critically analysing this piece was through the lens of interdisciplinarity, the topic of the present book. I have a long history in performance, both as a practitioner and as an academic. The world of activism, on the other hand, is fairly new to me. Activism is an area I have recently claimed as my own through my work in performance. As I see it, the main difference lies in the purposes, aims and goals of each discipline. The concept of intentionality comes to mind here. What goals does each discipline seek to achieve? What tools, concepts and actions does each discipline employ to achieve said goals? They each have distinct languages and histories. That is not to say that they do not cross paths. At times, they can borrow from each other. By doing so, an exciting and creative dialogue of interchange takes place, bringing forth new possibilities.

RC: Yes, this is an interesting distinction between the intentionality, and it might also be interesting to think about the distinction in terms of different sites and economies. Particularly in terms of the participants/audience – and the different subject positions that are taken up, and how an individual is viewed – becomes visible – as a particular 'subject' for others. For example, the community of a theatre or performance venue are often invested in similar values, and identities,

while the street – or a non-performance venue is a more – or perhaps at least differently – contested space. I am wondering how this might affect how the 'doing' of the practice is approached. It is interesting to think of in terms of activism/performance, or that interesting new term 'artivism'. Do you think perhaps in one sense, artivism/activist subject is the making visible of antagonistic values – particularly intentionality is so intrinsically linked to values? Including that slippery and ambiguous distinction between the 'citizen' and the 'performer' – do you think activist and performance work that engage with each other might activate that dissonance between these two 'subjects'? It is fruitful to think of what might emerge out of this dissonance.

NM: What you say about the inside community being invested in the same values and identities while the street being a more contested place is right. I flesh that out in the chapter when talking about why I felt the need to take the performance out onto the streets. The space of the theatre felt safe and comfortable. Perhaps *too* safe and comfortable. Remaining inside would be, to me, like preaching to the converted. It is safe to assume that most people who came to see the performance would, to some degree, agree with my plight. I could not be sure that that would be the case for those I would encounter on the streets. The tension (or the disturbance, perhaps) created by my presence on the streets was what I needed the audience to see for themselves.

RC: As you say the street as a democratic space – it is interesting to consider how we understand this 'democratic' space.

NM: I agree that what becomes visible on the public space of the streets is the antagonistic struggles of all those who occupy the streets. The various structures that are contested and struggled over this democratic space all come to the surface in the performance. What the performance does is simply to offer a lens through which to focus on one single aspect of this rich dynamic. The performance is, in that sense, my account of the streets. Perhaps this is where my dialogue with your writing begins to take place. I am, myself, the subject and the object of my work. My main form of expression is performance. It is through performing the performance (doing the doing) that the activism is activated. What I am trying to say here is that the 'me' that emerges through the mode of performance is the protagonist of this story I am telling. To that effect, I am the central figure of this narrative. I am aware, however, that this is a one-sided view of the story. In developing it, though, my effort has been to 'speak up,' to respond to a story I had been used to hearing myself on a daily basis. The narrative that claims that I, as a queer subject, do not have the right to walk down this street wearing makeup, high heels, a veiled hat and whatever else I fancy that day without the imminent threat of violence. My narrative is therefore a response or a counter-narrative to what I see as a one-sided story I have been told all my life by patriarchal society. The way I perform the performance can indeed be seen as a form of protest. Or, perhaps more appropriately, I would rephrase that to say it is a counter-protest.

RC: I like the idea of a counter-protest – could you expand on the difference between a protest and a counter-protest as it is a very interesting proposition?

NM: If the violence I suffer is a protest that says society/hegemony is not ok with the way I dress and act and perform gender, then my performance is a counter-protest that says I am not ok with receiving that form of treatment. This takes us back to your question of hierarchies of knowledge, a topic you discuss in your chapter. Who knows best? Who has the last word? Who are the arbitrators?

RC: It was really interesting to hear you speak of the 'interloper' in your chapter, and particularly in terms of their visibility in the performance itself. Is there a sense of the activist/performer being an interloper – the interruption, without (or perhaps with?) invitation, of a certain context or space? As an 'activist' subject do you think the 'interloper' is integral to this mode of practice? Can for example, a performer in a theatre or performance venue actually interlope? What might emerge in terms of – if we want to draw on Bryon's active aesthetic – the doing of the doing here if we think through this act of interloping, what makes the act of interloping visible? What actions are put in play? Who is the subject of the 'interloper'?

NM: Yes, this is an attempt from the interloper's part to attest his investment on the street. I was keen not to omit that exchange from my written account of the performance lest it appear flawless. As a matter of fact, this man's involvement in the performance and on the streets is the very thing I wanted the performance to make visible. I think he is right in protesting against us disturbing the peace and quiet of his home. What I object against is the way he went about his protest and the intention of his actions. The throwing of a can brings some potential consequences with it that cannot be ignored. Whether harm was intended or not, the can threatens not only physical/bodily harm but also psychic, emotional and psychological damage. As a queer subject, I have had to live with the threat of having objects, insults and looks being thrown at me on a daily basis. My reaction to this was to develop a piece of performance that would make this type of dynamic visible to an audience. It is interesting, though, that my loud response (with a booming brass band in tow) elicits the type of reaction that tells me to shut up, to be silent, to remain silent, to shut my mouth… a demand that effectively says that I should not have a voice, that I shouldn't be complaining, that I should go back inside and lock myself in and that I am creating a storm in a teacup. The excessiveness of the performance is a conscious attempt to represent the reactions I have often elicited; this notion that as a queer subject I am *too* loud or *too* flamboyant or *too* sensitive. The doing of the doing you mention is pointed here since this type of unpredictable response from 'uninvited' audiences is precisely the dynamic the piece is interested in fleshing out.

RC: Walking – the examples you offer of walking, overall were violent modes of walking, or at least developed into that, violence on both sides and from the activists – I wonder whether you saw the practice as violent in any way? For example, you use the terms 'we win the battle' in relation to the Jack the

Ripper Tour, 'conquering the right of way'. A democratic space of the street – a space of contestation and struggles – how might this be understood beyond a battle between them and us – to a struggle/contestation between adversaries? Might this be thought through in some way in relation to the active aesthetic? A structural violence, in addition to the specific acts of physical violence. Do certain activist/performance events initiate a dynamic that encourages an emergence of new and contingent affects or struggles between various elements within the site, affecting and bringing forth precarious subjects? A space of contestation where identities, of all involved are affected and articulated, if only for the time of the performance? And this struggle may well be necessarily violent, on a structural level.

NM: You are right. They are violent modes of walking. I often refer to my makeup as 'war paint' as well. Perhaps this is my failed attempt at resilience; a way of saying I will not take abuse lying down, that I am not a victim, that I can defend myself (most of the time, anyway). The Jack the Ripper example you mention though of 'us winning the battle' is a direct reference to my objection against the industry they represent, against the glamorisation of female violence they sell to hundreds of tourists every day. I am really not cool with that. My encounter with them on the streets was an accident. It was not planned. In writing the chapter, this instance stood out for me as a significant example of the active aesthetic and how I dealt with a potential problem (them blocking our passage) while performing the performance. I turned it into something significant to me and meaningful to the performance. It therefore became a battle against the long-standing oppressive violence of the feminine. I connect here with your chapter. You talk about the writing of the writing as a process. I was curious to find out what has emerged out of that process for you. Your reflection seems to point out that my writing comes across as somewhat aggressive or bellicose. I think you have a point even though, ironically, that would be one of the things I wish I could have avoided. My reading of the work having a message is also admittedly fallible. It is how I wish it were read. I am aware, however, that there will be as many possible readings as there have been audience members. So rather than a single message, the debate it hopes to initiate is perhaps its most valuable legacy.

RC: I think what I found in engaging with the writing process is unavoidably the limits of scholarship to fully capture an event, and the limits we have as individuals when analysing an event/performance/subject. Perhaps the most exciting thing for me in the writing process is the act of writing as a creative practice, a struggle, and what might emerge from that struggle. Unfortunately that is not something I have been able to get a hold of myself.

NM: I'm not sure I would agree with you when you say you haven't got a hold of the process of academic writing. Your assessment takes us back to the hierarchies of knowledge. Who is ascribing value to it and according to what value system is the writing being judged? Is it economic, philosophical, cultural, epistemological? Writing, either creative or scholarly, is bound to certain

limitations as is any other form of expression. Your effort to engage creatively with it demonstrates, in my view, an active aesthetic too. The writing of the writing throws up challenges and limitations which you have struggled with *through* writing.

'the subject': Performance and Political Philosophy

The broken subject of performance studies

Rachel Cockburn

This chapter deals with performance studies, performance, and the 'subject'. While there are differing understandings of 'the subject', I am beginning here with the understanding offered by Foucault: 'there are two meanings of the word "subject": subject to someone else by control and dependence, and tied to his [her] own identity by a conscience of self-knowledge' (Foucault 2002: 331). Following this I look at the 'subject' of Performance Studies, not specifically in terms of a disciplinary field of study – i.e. the field of performance, but the scholar subject. And in turn, the performance I am interested in here is not the 'performance' event as the subject (or indeed we could say the object) of analysis, rather it is the performance of the scholar, i.e. the practice of their practice.

In approaching the 'subject' of Performance Studies in this way I engage with the problem highlighted by Bryon (2017: 23–27), that is, the received divide between those that do and those that think, the artist and the analyser. Practice within the academic disciplines and particularly that of Performance Studies and performance, according to Bryon, remains grounded on the distinction between *techne* and *episteme* (Bryon 2017: 9). The Performance Studies scholar is the analyser – the analysing subject – most often with a performance as their object, while the performer's 'thinking' is understood as a practice; a performance practice which is subjective, creative, immediate.

However, my main impetus for approaching the Performance Studies scholar is to suggest a suspension of the particular disciplinary claims that Performance Studies has been grounded upon. Namely, Performance Studies has defined itself as 'subversive', that is political, in its nature as a discipline. Specifically, in terms of the discussion to come, the 'subversive' claims of Performance Studies are dependent on the theoretical concepts of 'interdisciplinarity' and 'liminality'. However, I suggest it is these disciplinary claims which actually point to the apolitical subject of Performance Studies, not only in terms of the subject

understood as a particular field of study, but moreover the scholar subject practising within the discipline of Performance Studies.

In suggesting the apolitical subject of Performance Studies, I do not begin necessarily within the 'active aesthetic' and the 'middle field' (Bryon 2017: 40) as such. Instead I would like to approach the discussion from 'the broken middle'. Philosopher Gillian Rose dramatized 'the broken middle' most explicitly in her book bearing the title *The Broken Middle* (1992). While this discussion does not intend, or indeed have the scope, to offer an exposition of Rose's complex thinking of and through 'the broken middle', I do want to struggle towards an approach from 'the broken middle'. The approach suggested is an 'unsettled and unsettling approach which is not a position because it will not posit anything' (Rose 1992: 155). On the one hand I cannot, and would fail, if I explained what 'the broken middle' *is*, as it is not a thing or a concept as such. However as a way of introducing the approach I offer an initial beginning from this middle. Although Rose is specifically investigating the relation between the 'particular and the state... the middle broken between morality/legality... active/passivity' (Rose 1992: 285) in terms of political philosophy, this can be approached as a micro investigation in terms of the subject working within a discipline – particularly here the Performance Studies scholar. While Performance Studies, as I go on to discuss, posits a mended middle, the actual relation between the subject and the discipline begins from a middle that is broken.

A methodology that begins from 'the broken middle' pays attention to the following: the anxiety of beginning; the suspension of judgement and the ascription of value; and the attraction to the aggregation of authority (Rose 1992: 173). What I hope we encounter and pay attention to, and which I hope to begin with again in the conclusion to this discussion, is an acknowledgement of, and struggle with, these three methodological aspects in and through the practice of the scholar. In so doing, we accept that 'because institutions [and here specifically academic disciplines] are systemically flawed it does not mean they should be eliminated or mended' (Rose 1992: 285). Rather, we work from the middle to allow potential new configurations, differentiations, and possible subjects to emerge; a broken scholar working from a broken discipline(s). However, in order to acknowledge the broken scholar, it is necessary to begin as the subject of discipline.

The subject of discipline

What is understood by a 'discipline' varies on your position and context. In terms of this chapter, and if not also for the book, we might narrow down our terrain to academic disciplines. Firstly, we could choose to consider a discipline through the general characteristics of the object of a discipline. For example, Armin Krishnan breaks the object of an academic discipline down into characteristics such as a body of accumulated specialist knowledge; theories and concepts to organise knowledge; specific technical language and methods; and an institutional manifestation in the form of subjects (Krishnan 2009: 9–10). However a less categorical understanding of academic disciplines is provided by literary theorist Rita Felski, who aligns the

academic disciplines – herself drawing on German philosopher Martin Heidegger – with a specific mood: 'A mood is in each case already there, like an atmosphere, in which we are steeped' (Heidegger in Felski 2015: 22). As Felski points out, 'the prevailing mood of a discipline accents and inflects our endeavours: the questions we ask, the texts we puzzle over, the styles of argument we are drawn to' (Felski 2015: 22). That is to say, when we work within a specific discipline, our way of working is informed – and to a certain extent determined – by the 'mood', a certain historicity that we cannot simply step outside of or assert exteriority from. The mood precedes the scholar and their practice within the discipline. The scholar within a discipline, just like the artist within a discipline, acquires not only quantifiable knowledge and skills but also, in Felski's view: 'a certain sensibility… [which is] "already there"'(Felski 2015: 22). In other words, subject positions have been structured; we know our place, our role, and the intricate relationship to other elements within the discipline, before even taking our place. This leads Felski to set out her second point – the structural problem with an academic discipline – as follows: there is 'asymmetry [that] separates the object explained (whose existence is reduced to external parameters) and the explaining subject (whose categories of analysis transcend such contingencies)' (Felski 2015: 23). In other words, there is an inequality in the relationship between the thing analysed and the subject analysing. As a discipline in itself is a construction rather than some kind of absolute essential thing, we might then ask how this asymmetry has been constructed, and why it has been constructed. To talk about something which is 'already there' is not to say that this 'certain sensibility' is essential, or natural, but that there are historically specific social relations that very much shape both the present field (i.e. the discipline) and the subject (in this case the scholar), and in turn their relation to performance. Yet it is these that disciplines arguably take great pains to obfuscate, even when a discipline takes historical and social relations as its object of study.

At this point, given the current academic disciplinary fields – as I engage with a little later in the discussion – within Higher Education (HE) in my own country (UK) and that of many other countries around the world, it seems timely to return briefly to a text that has become perhaps a little overused and normalised in academic disciplinary fields: Foucault's 'The Docile Subject', taken from his book *Discipline & Punish* (1975). Here Foucault reminds us quite clearly that a discipline is not a neutral field but a field criss-crossed with complex power relations, and socio-historical ways of doing and thinking. Ok you might say, we have all probably read Foucault, I understand I am caught up in this network of power relations and I am probably not free. Right, I acknowledge it. Now, let's move on and produce some more knowledge. Alternatively, let's suspend our judgement and knowledge production and think. Pause.

The docile scholar

Riffing on dictionary definitions of docile – easy to manage, control, discipline, easy to teach, ready to learn – Foucault interrogates the 'docile' subject of discipline.

Key to his analysis of this docile subject is that despite the constructions of binaries dividing the subject (i.e. the individual positioned within a discipline) from the object of analysis, disciplines require a subject which is also an object of knowledge and analysis. Discipline works to 'define the relations a body must have with the object it manipulates... not so much an exploitation of the product as a coercive link with the apparatus of production' (Foucault 1995: 152–153). To put it differently, the individual is both a subject and object that is intrinsic to disciplinary production. It is necessary here to point out that I am not suggesting Foucault is specifically referring to an academic discipline rather than a specific disciplinary form of power. And while a full discussion of Foucault's disciplinary mechanisms and the docile subject is outside the scope of this chapter, I do want to point to two mechanisms, or technologies of power, that are particularly pertinent.

The first is that of rank and hierarchy of knowledge (Foucault 1995: 147). It certainly will not be outside of your own experience to understand either explicitly or implicitly what this encompasses. In Foucault's terms the notion of rank and hierarchy of knowledge creates a 'complex space – spaces that provide fixed positions and permit circulation, they carve out individual segments and establish operational links... they guarantee obedience of individuals, and also a better economy of time and gesture' (Foucault 1995: 148). Underscoring this is the second aspect – normalising judgement: 'a kind of judicial privilege with its own laws... forces of judgement' which, importantly, punish non-conformity, whether that be 'not reaching a level...[or being] unable to carry out a task' (Foucault 1995: 178) to specified criteria. This normalising judgement which is 'at the heart of all disciplinary systems' (Foucault 1995: 178) works intricately with the notion of rank and hierarchy of knowledge to 'produce domains of objects and rituals of truth' (Foucault 1995: 194). The individual's actions and modes of production – whether it be intellectual or artistic production – are determined in relation to the required end results, even if the end is the assertion of a process. The scholar 'belongs' to this production. A docile scholar.

While we could argue that we do not live in and through a disciplinary society presently, what is unarguable, however, is that we do live in and with disciplinary technologies of power that have developed in a historically specific way. Moreover, if recent global events are anything to go by societies – such as the UK and the US have become explicitly more disciplined and authoritarian. The docile scholar is no exception: their disciplined productivity is found in their intellectual labour, their practice of thinking, analysing and the practice of the writing. This includes the knowledge that is valued and hence to be understood as legitimate scholarship – specific knowledge regimes and regimes of truth. The methods that are applied are those legitimated by rank, with the practice of scholarship shaped by the pressure and desire to conform to industry 'standard' that can identify solid, hard outcomes. The docility of the scholar and the disciplinary mechanisms and technologies that incite such docility are becoming more and more visible – and arguably more strained – with the refining and accumulation of ever new frameworks and criteria within HE (likewise in artistic labour with funding bodies and conservatoire

training). In fact HE exists in its present form only because of the ever tightening and adaptation of disciplinary technologies.

The obvious reference for those of us in UK academic disciplines (though similar entities exist in other countries such as the US, Australia) is the REF (The Research Excellence Framework). At the heart of disciplinary research, at least within UK HE, is the overarching desire to 'contribute to economic prosperity, national wellbeing, and expansion and dissemination of knowledge' (REF)[1]; i.e. the production of domains of objects and rituals of truth that align to economic and cultural value (it is worth noting here that within the present UK society the dominant value system is one grounded on economic growth, which itself only functions through structural inequality and asymmetry). Work is assessed according to certain criteria – originality, significance, rigour. And these knowledge products are 'outputs'. What these criteria – originality, significance, rigour – actually point to is determined by, well, nobody knows, but it involves government policy informed by corporate strategies and the consumer-led market model. Not only must 'outputs' have originality, significance and rigour, but they must have impact, i.e. reach and significance that impacts on the economy and wider society.

The disciplinary mechanisms become, perhaps, most explicit in terms of the rate of production set out by the REF window (at present this is understood approximately as the temporal window of 2016–2021, however this remains uncertain). Scholars are working to a 'norm' that, in most cases is beyond their temporal capacity. In so doing, the rate of production disciplines not only a scholar's attitude to their use of work time, but their private time also. Likewise, the criteria is set out in advance in terms of rank. 'Outputs' are given starred levels, from four star to unclassified, rather like the rating system on TripAdvisor.[2] Such a rating system drives, and is driven by, an individual's own desires and self-development as a scholar subject: a desire for a permanent contract; to retain the secure contract one has; a desire for recognition; a desire to be in a position where one is paid to research. This is particularly effective within a wider society that has entrenched low paid insecure employment, housing and precarious access to quality healthcare and education. In other words, engaging with economic precarity through a research project is always going to be preferred over the experiencing of poverty itself. Your thinking, your words, your time, your ethical judgement, your methods of analysis are carved out and circulated through established operational links that offer a particular notion of 'free' or 'critical' thinking. There is the option not to conform, however, if you do not conform then you risk exclusion, specifically from the mechanisms and structures that, while supporting research and scholarship, simultaneously make research and scholarship prohibitively costly for those outside. Scholarship is a time-consuming business, and time is money.

What also becomes apparent within discipline as suggested by Foucault is that collaboration and interdisciplinary configurations are not something new per se, they have been intrinsic to disciplinarity in action with the aim 'of composing forces in order to obtain an efficient machine' (Foucault 1995: 164). In fact, as

Foucault goes on to state: 'mechanisms in which the product of various forces is increased by their calculated combination are no doubt the highest form of disciplinary practice' (Foucault 1995: 167). Following this, the idea that 'interdisciplinary' practice is something new is untenable. A more interesting question to ask of 'interdisciplinary' practice might actually be why has it emerged into prominence at this time and what is specific about the form it has taken, why has it often become identified as 'subversive' or 'cutting edge'? Particularly, why has Performance Studies assumed its subversive and political nature through 'interdisciplinarity'? To investigate these questions the time has come to fall into Performance Studies Scholarship. I am a docile scholar.

The 'inter' disciplining of performance studies

Solidifying in the early 70s, Performance Studies first came into prominence with Richard Schechner, who remained a central figure through to the turn of the millennium. In response to his own question of 'what is performance studies?' he offers the following:

> performance studies is 'inter' – in between... intergenic, interdisciplinary, intercultural – therefore inherently unstable... It cannot be pinned down or located exactly. This indecision (if that is what it is) or multidirectionality drives some people crazy. For others, it's the pungent and defining flavour of the meat.
>
> *Schechner 1998: 360*

By this, Schechner is no doubt suggesting the pungency of the 'inter' is what gives performance studies its political efficacy, rather than suggesting it stinks. But there is something a bit wiffy arising from the multifarious uses of 'inter' in the definition of a discipline, particularly when Performance Studies is at home as an established discipline within at least European and US university humanities departments. In fact, Schechner goes on to claim that performance studies is 'the holy grail of transformative disciplines' that has the ability to oppose 'the establishment of any single system of knowledge', a discipline that is 'multi-vocal, and self-contradictory' (Schechner 1998: 361). Theorist Joe Moran agrees with this nature of interdisciplinarity, asserting the characteristics of: 'flexibility and indeterminacy' (Moran 2010:16). Though Moran also goes on to state: 'within the broadest possible sense of the term, I take interdisciplinarity to mean any form of dialogue or interaction between two or more disciplines' (Moran 2010: 16). Interestingly, Performance Studies as a discipline is set out as an 'inter' discipline in and of itself; grounding the discipline on 'flexibility' and 'indeterminacy' before it, as a discipline, forms a dialogue with another discipline. Subversion seems to be grounded on a self-subversion. Maybe that's the pungent meat.

Liminal investment

If, indeed, Performance Studies is this 'unstable' and 'inter' discipline as Schechner has claimed, then the key conceptual tool utilised in the economy of the discipline is the 'liminal', grounding many other key concepts that have become currency in Performance Studies. The concept of the 'liminal' was first introduced into Performance Studies by Schechner through his collaborations with anthropologist Victor Turner (1977) and his work on the liminal phase in culture and the ritual practices of Arnold van Gennep. For Schechner, taking his cue from the fields of anthropology and sociology, the liminal is the 'inbetweeness', the 'betwixt and between' of performance; that is to say, the liminal grounds the 'inter', the subversive and transformative potential of Performance Studies as a discipline. Though this concept was introduced in the 1970s it has remained integral to the discipline of Performance Studies. In *Perform or Else* (2001) Jon McKenzie identified the extent to which liminality has been entrenched: 'the persistent use of this concept within the field has made liminality into something of a norm... we have come to define the efficacy of performance and our own research, if not exclusively, then very inclusively, in terms of liminality' (McKenzie 2001: 50), that is, a '*liminal-norm*' (McKenzie 2001: 50). Here activities within the discipline of Performance Studies are understood through liminal transgression. That is to say, it is the frame of this ambiguous 'inbetweeness' of the liminal that marks a performance practice as a resistant practice, as analysed and explained by the performance theorist scholar. But, with the liminal we encounter the asymmetry stated earlier between the object explained and the explaining subject. Moreover, with liminality, Performance Studies steps right over the disciplinary relations of power and the docile scholar.

Dwight Conquergood has raised the problem of the structural asymmetry of the liminal in discussing the 'betweeness' of theory and practice of performance studies as a discipline. Writing in 2002, Conquergood highlights the institutional academic bias – what Foucault might have termed hierarchy of knowledge – in performance studies by pointing firstly to what he understands as the potential of the discipline: '[Performance studies] makes its most radical intervention... by embracing both written scholarship and creative work, papers and performances' (Conquergood 2002: 151). In order to meet this potential Conquergood argues that performance studies must: 'refuse and supersede this deeply entrenched division of labour, apartheid of knowledges, that plays out inside the academy as the difference between doing and thinking, interpreting and making, conceptualising and creating' (Conquergood 2002: 153).

Considering the challenge was set in 2002, to what extent has it been met by Performance Studies and those working within this 'inter' discipline? We certainly have not seen the supersession of the division of labour and knowledges. On the contrary, we have seen its extension, as is evidenced in the current HE climate (here I am referring to the UK HE system, though a similar climate can be found in the US) particularly relevant in the arts and humanities, i.e. the home of Performance Studies. Rather than a refusal of the divisions of labour what has

actually emerged is an ever-increasing demand on an individual to produce 'outputs' (REF) through various knowledges and types of academic and intellectual labour. And, importantly, the outputs of Performance Studies is produced by the division of labour brought about by rank and hierarchy of knowledge, and normalising judgement. That is to say, Performance Studies' most 'radical intervention' of 'embracing both written scholarship and creative work' (Conquergood 2002: 151) might well be understood as a hyper-production – a mode of production that involves joining separate modes of labour together in a bundle to meet the criteria of production. On offer is a liminal product that transcends, or more precisely, obfuscates the separate modes of labour and knowledge that produce it, while at the same time relying on these ever increasing divisions of labour as its material. In economic markets, product bundles offer a number of products as one combined product – just think of the broadband/ phone/TV packages that large media companies like Virgin or Sky offer. This is a prevalent feature of highly competitive product markets, and it would be quite naive not to recognise knowledge and art production as such competitive markets. In fact, such a liminal bundle can be understood as a basic mode of commodification that asserts a subversive, indeed innovative, liminal product by obfuscating the various divisions of labour practices that go into producing it. In effect, the development of 'interdisciplinary' practices of disciplines have been developing in order to meet the requirements and demands of the knowledge and culture market. As Steve Fuller has warned, 'universities restructure themselves to face an increasingly competitive market... the ability to undertake interdisciplinary research is seen as a mark of "flexibility"; and "adaptivenenss", which are highly valued in today's "knowledge economy"' (Fuller in Graff 2015: 2). Therefore, not only does the fetishisation of interdisciplinarity obfuscate the structural asymmetry in modes of production within the discipline, but it also disciplines the docile object – the subject of the scholar – within Performance Studies. And the 'liminal' is the predetermined conceptual ground that gives a specific investment to, and understanding of, inderdisciplinarity. This in turn encourages a reductive relationship to the performance – it is all about the liminal brand and packaging.

Escape to the aesthetic

Of course one way to escape all this talk of the obfuscation of labour and the apartheid of knowledges is to take a flying leap from anthropology and sociology into the 'aesthetic' – as Performance Studies itself has attempted with the 'aesthetic turn'.

Coming in to prominence in the late 1990s, the aesthetic turn has been set out by a number of Performance Studies scholars. For example, Susan Broadhurst (1999) defined what she understands as the 'liminal aesthetic' as a 'quest for the primordial', thereby drawing on the lineage of Schechner and anthropology, but with the added 'aesthetic features, such as heterogeneity, indeterminacy, self-reflexiveness, eclecticism, fragmentation, a certain "shift-shape style" and a repetitiveness that produces not sameness but difference' (Broadhurst 1999:

168–169). These aesthetic features are informed by postmodern discourse prevalent in 1999. Present here is also a different attitude to the political efficacy of Performance Studies in that this is a scene of 'immediate aesthetic intervention with an indirect effect on the political' (Broadhurst 1999: 168–169). Unlike the radical subversion and inherent resistance claimed by figures such as Schechner and Conquergood, Broadhurst places the emphasis of the liminal aesthetic's potential in its core values of 'free creativity, invention, and experimentation' (Broadhurst 1999: 171); a clear reference to Friedrich Nietzsche's 'will to power' (Broadhurst 1999:171), a concept that has come to stand for the championing of the autopoietic 'primitive force of art' (Nietzsche 1924: 244). Surprisingly, Broadhurst is not alone in this valorisation of the liminal's aesthetic features. Jill Dolan has drawn on the liminal aesthetic state when speaking of utopia: 'theatre and performance can articulate a common future, one that's more just and equitable. Such desire to be part of the intense present of performance offers us if not expressly, then usefully emotional, expressions of what utopia might feel like' (Dolan 2006: 520). Or likewise, Erika Fischer-Lichte in *The Transformative Power of Performance* (2008) sets out an aesthetic state that is 'capable of transforming the experiencing subject' (Fischer-Lichte 2008: 174). As Fischer-Lichte argues: '[in terms of emergence of meaning] the perceiving subjects remain suspended between the two orders of perception, caught in a "betwixt and between"… a threshold which constitutes the transition from one order to another; they experience a liminal state' (Fischer-Lichte 2008: 148). However, this has been set out by the Performance Studies Scholar (the explaining subject) through the object of analysis: the perceiving subject (the subject explained) in a manner which is apolitical. For example, Fischer-Lichte offers an analysis of various performance practices, such as Schlingensief's *Chance* (2000) and Abramovic's *Lips of Thomas* (1975) in terms of the liminal state that is produced for the audience and its ability to collapse various binaries. As she states, the spectators can be transferred into a 'state [i.e. a liminal state] which alienates them from their daily environment and its rules and norms' (Fischer-Lichte 2008: 179). Moreover, as no 'guidelines' are offered, 'liminality therefore can provide a tortuous or lustful experience for the spectators' (Fischer-Lichte 2008: 179). Here, the performance event, and the subjects (the audience and the performer) are viewed through a specific lens – that of liminality. In doing so the political aspect – that is, the struggle – of the subject, and an actual relation to the material socio-historical world, is eradicated, or at least momentarily transcended, if we are to believe Fischer-Lichte et al. The work of Fischer-Lichte, Dolan and Broadhurst, assumes again the a priori concept of the liminal. This is a concept that allows an obfuscation which leads, albeit from a different approach, to Schechner's 'holy grail'; a holy middle. Its relation to performance can perhaps be likened to the old knights of the crusades, who desired to consume the water of the holy grail to grant themselves immortality.

The broken scholar

To conclude this discussion the question then is this: how can we begin from a broken middle, and not the 'holy middle' of Performance Studies? In so doing, might we approach the practice of scholarship – a thinking and a doing – that as Rose suggests, acknowledges 'actuality not force or fantasise it' (Rose 1992: xi).

Here we return to the methodology that begins from the broken middle; a methodology – an 'agon of authorship' as Rose terms it – that is an approach which is 'unsettled and unsettling...[and which] is not a position because it will not posit anything' (Rose 1992: 155). First, the methodology is attendant on: anxiety of beginning (Rose 1992: 173). We should consider how to begin, be attendant on the history of the discipline and not only its internal conceptual claims. The conceptual grounds of a discipline are not to be assumed in advance as a useful tool to interpret or understand practice. 'Liminality' and 'interdisciplinarity' have ideological underpinnings that obfuscate actual social and historically determined relations, and divisions of labour and knowledges. Second, the methodology is attendant on the suspension of judgement and the ascription of value. What judgements and values do we ascribe before we begin to practise, to think, to analyse and to write? If we are to make a claim of 'subversion' as scholar subjects of Performance Studies have done, then we cannot assume a specific judgement as subversive or political, we must struggle to suspend our judgement, to suspend the values we ascribe to ways of doing and thinking. Finally, if the methodology is attendant on the attraction to the arrogation of authority (Rose 1992: 173) then the broken scholar subject must struggle with authority. That is not to demand the resistance or rejection of the authority of the discipline, but the practice of the scholar must be engaged in a permanent struggle. If not, then what we have are not explorations of new configurations, or differentiations, but affirmation of disciplinary concepts, knowledges and divisions that are already dominant; offering through practice what the field and the experts expect to hear and already know.

If there is value in performance scholarship, and there is performance scholarship at present that has value, then it is in the potential of an approach from the broken middle whereby the potentiality and the actuality of the field of performing might come into a 'reconfiguration, oppositional yet vital – something understood' (Rose 1992: xi), an understanding from a broken discipline. In this way it is not a question of eradicating and stepping outside of conceptual frames of liminality and interdisciplinarity as such – that might well be an impossible task, neither is it a question of stepping outside of the disciplinary context, and the disciplinary relations of powers that inscribe, incite and shape us as subjects. Rather the broken scholar accepts, and works from, the broken middle to suspend any mending, fixing, making holy of actuality. The role of the broken scholar is to inhabit the broken discipline and struggle to reconfigure, to differentiate, and consider anew the present field of performing and how we might think through it. It is this approach that might begin to resonate with the active aesthetic, attendant on: 'the doing of the doing, the practice of the practice' (Bryon 2017: 39). As broken

scholar subjects we attempt, even if it is an impossible task, to suspend the 'act of constructing, ordering… determining, or evaluating' (Bryon 2017: 42), and situate ourselves within the broken middle.

Notes

1 Information in the discussion is relating to the REF 2014 and can be found at: http://www. ref.ac.uk/media/ref/content/pub/assessmentframeworkandguidanceonsubmissions/GOS %20including%20addendum.pdf [Web accessed: 30 August 2016].
2 For further information on TripAdvisor and its ratings system see: https://www. tripadvisor.co.uk [Web accessed: 25 September 2016].

References

Broadhurst, S. (1999) *Liminal Acts: A Critical Overview Of Contemporary Performance And Theory*. London: Cassell.
Bryon, E. (Ed.) (2017) *Performing Interdisciplinarity: Working Across Disciplinary Boundaries through an Active Aesthetic*. Abingdon: Routledge.
Conquergood, D. (2002) Performance Studies: Interventions And Radical Research. *TDR/ The Drama Review*. Summer 2002, Vol.46, No.2. pp. 145–156.
Dolan, S. (2006) The Polemics And Potential of Theatre Studies And Performance. In: Soyini Madison, D. and Hamera, J. (Eds). *Sage Handbook of Performance Studies*. p. 508. London: Sage.
Felski, R. (2015) *The Limits Of Critique*. London: University of Chicago Press.
Fischer-Lichte, E. (2008) *The Transformative Power of Performance: A New Aesthetics*. (Trans. Jain, S. I.). London: Routledge.
Foucault, M. (1995) *Discipline And Punishment, The Birth Of The Prison*. Trans. Sheridan, A. New York: Vintage Books.
Foucault, M. (2002) *Michel Foucault, Power, Essential Works of Foucault 1954 – 1984, Volume 3*. (Ed. Faubion, D. Trans. Hurley, R.). London: Penguin.
Graff, H. J. (2015) *Undisciplining Knowledge, Interdisciplinarity in the Twentieth Century*, Baltimore, MD: John Hopkins University Press.
Krishnan, A. (2009) What Are Academic Disciplines? Some Observations on the Disciplinarity vs. Interdisciplinarity Debate. *ESRC National Centre For Research Methods*. *NCRM Working Paper Series*.
McKenzie, J. (2001) *Perform Or Else: From Discipline To Performance*. London: Routledge.
Moran, J. (2010) *Interdisciplinarity: The New Critical Idiom*, 2nd edn. Abingdon: Routledge.
Nietzsche, F. (1924) *The Will to Power, An Attempted Transvaluation of All Values*, Volume 2, Book 3 & 4. Ed. Levy, O. Trans. Ludovici, A.M. London: George Allen & Unwin Ltd.
Rose, G. (1992) *The Broken Middle*. Oxford: Blackwell.
Schechner, R. (1998) What is Performance Studies Anyway. In: Phelan, P. and Lane, J. (Eds). *The Ends of Performance*. New York: New York University Press.

Cross-Chapter Discussion

'the subject' and voice

Rachel Cockburn (RC) and Konstantinos Thomaidis (KT)

Konstantinos Thomaidis: Thank you for sharing your chapter and its engaging discussion of a difficult '&' – that of performance studies and political philosophy. There are a couple of points in particular that prompted further thinking for me. Let me start with the notion of the subject, for example. The second definition of the subject you provide refers to experts engaging in a disciplinary act (analysing or effecting performance, for example). I wonder what other categories could be productive in discussing their practices. Focusing on the person, the doer, for a moment, a couple of other terms, with different genealogies and resonances, come to mind: the individual and the self. Juxtapositions with 'the subject' might be of use in interdisciplinary exchange, specifically because they reveal the histories, assumptions and values each term connotes, in other words, specifically because they shift the emphasis from knowledge-as-object to knowledge-as-practice. When a 'performer' is (seen, understood, discussed, trained as) an *individual*, I sense an underlying opposition at play; the performer is an individual rather than part of a collective or ensemble, or is idiosyncratic, distinctive within the marketplace of performance. The performer as *self* comes with the tools and concepts of psychoanalysis; what shapes the self as an artist? What hinders the expression of 'the true self'? How does the performer find their self? On the other hand, the performer as subject, to my eyes, partakes in the nexus of ideology; the term or appellation refers to what the performer believes is performance, how it should be practised, for what reasons and for whom (in accordance with a set of generally accepted values).

As my inclination is always to return to voice(s), I tend to think of Althusser when referring to the ideological making of the subject in his famous 'hailing' scene, when an individual is addressed by a policeman and responds to the call. It is in that moment that the individual becomes a subject, by accepting the call, recognising themselves in the call, and by simultaneously establishing and

perpetuating the power relations that go with participating in such a call-and-response. Extending this scheme, if we are to speak of the subject of performance studies, who does the calling? And who responds? For what reason? Who decides when an individual/scholar – or why not, a self (someone for whom conducting research 'rings true'/'close to home' or is a practice fundamentally definitional for who they are) – becomes a subject/scholar?

Rachel Cockburn: A generous response, with many interesting thoughts. Though first, which might not be as clear as I had intended in the chapter, but the main disciplines I initially aimed to address were performance and political philosophy, performance in the context of performance studies – and the tricky concept of the 'subject.' Performance studies was something thrown my way further down the path, and I am still grappling with negotiating that and political philosophy. I say this just as a way of giving a sense of the direction I am coming from. And in turn, how it informs my response.

There are many slippery and tricky terms in this terrain, and certainly I think considering the three – the individual, the self, and the subject – is both extremely interesting and quite the can of worms. The sense of opposition at play you point to in terms of the individual/self and the subject, while I see it can be understood as an opposition, for my part I do not see them in actuality as oppositions. Though they are oppositions in terms of how they are understood perhaps.

In terms of political philosophy at least, whilst Althusser's notion of interpellation is very apt, I see the constitution of 'the subject' as something more immanent to the individual themselves. For example, following a biopolitical way of thinking – though I am cautious not to go down that rabbit-hole here – the networks, technologies and regimes of self are not external to the individual but shape the very way we understand ourselves as individuals, the very way we might come to identify our 'true self,' and we can only do this if we are subjects. Arguably, is the notion of a 'true self' not also an ideological construction?

KT: This is precisely the point that I am getting at. I am not trying to establish a(n essentialist, ahistorical and presupposed) distinction between terms or positionalities. I am more interested in the *circumstances and contexts* of their use and application – which means, in *when* and *for what reasons* someone chooses to examine (or address) the performer as a subject, as a self, or as an individual. Returning to voice-related practices for a brief moment, a performer can simultaneously be a self (to be deconstructed and restructured according to the way a specific training understands the 'true self'), an individual (that builds on the above scenario of selfhood in a personal way so as to be marketed as unique), and a subject (enacting a tacit politics of participation and/or exclusion from professional communities). The question for me would be: why does the trainee voicer need to be addressed as (such) a self in the first place? Are there ways to resist this delineation or foreground the *ideological* workings of such modes of address and such practices within voice pedagogy?

RC: Not knowing much at all about voice studies/practice in performance or forensics, I am responding to this from the outside a little. The thing that came

to mind reading your chapter, time and again was the classical political distinction first set out by Aristotle – that between voice and speech – *phone* and *logos*. I am brutally paraphrasing here, and perhaps you know it better than me, but basically *logos* is political speech, *logos* being that which distinguishes the qualified life of *bios politikos*, whereas *phone* is voice – babble, incoherent utterances, belonging to the animal. Of course, that distinction set out so bluntly by Aristotle has been softened down the centuries, but certainly there is the distinction still present in the world we live in today... And I was very interested in this sense of how you are looking at the voice – not speech – and taking it in its material, affective, utterance form so to speak, rather than speech. But at the same time, the voice is qualified through a scientific frame, or 'expert' that renders it intelligible and validated, to be spoken about.

I was particularly interested in terms of the distinction you make in the end between voice - stable and predetermined, and voicing as unruly and processual. Does speech not come into this as the predetermined? Or where does speech come into this at all? Why not? Is this interesting to consider at all in terms of the political aspect of the work, and more specifically in relation to the 'subject'? Perhaps this distinction between voice and speech is moot, but I was just interested thinking this through in terms of some political theory distinctions.

KT: There is much debate around the terms and their respective genealogies. Currently, I tend to deploy 'voice' as a more open term that can encompass speech but, crucially, other material manifestations of phonation (non-verbal sounds, for instance), voices understood as internal (voice of conscience and verbal hallucinations), and voice as a metaphor (the voice of the oppressed). This use helps me go beyond a politics of speech (exchange of formulated ideas) towards a politics of voice, which *can* refer to linguistic political discourse but also an embodied politics of vocality.

Taking cue from your text and response here, but thinking mostly of my practice as a voice practitioner-scholar, let me divert further towards voice. This is a highly personal(ised) take, but going through the philosophical and critical literature of/on voice, it appears that there are two, fundamentally apposite, approaches to voice and subjectivity-making. One strand conflates voice with subject; voice announces the self and claims its (personal, social or political) 'place' in a unique, unmistakable way. Whenever someone voices, the unheard underlying 'sub-text' is 'This is me saying: ...' Think of seeing a friend on the street. They turn to you saying 'Good morning'; according to this strand of thought, your friend delineates themselves as separate, unique, unrepeatable in addressing you: '(This is me, your friend, and I say to you) "Good morning."' This understanding of voice has been taken up by sociology and political analysis, assigning 'voices' to groups, or helping marginalised and disenfranchised groups 'find their voice'.

The other strand, drawing on psychoanalytical theory, presents a more complex scenario: the embryo hears the mother's voice as a surrounding, resonating presence inside her body, the voice literally bathes the embryo into

a 'one-ness' with the mother and it recognises her voice as its own – or as an extension of the connection that is the dyad it forms with the mother. When the newborn starts developing a sense of the self as separate from the mother, the voice also emerges as a separation: the baby starts experiencing the voice as something the mother responds to with her own voice. The realisation comes that they both have a separate voice; the personal voice is an outcome of a separation, of the breaking down of the assumption of oneness. According to this line of thinking, each voicing act is underlined not by an announcement of identity but by a yearning for that lost oneness, for a voice that will resound back. In the above example, the sub-text in your friend's address would be: '(I am addressing you and I yearn for a response to my voice when saying) "Good morning."' In the first case, voice is an excess of selfhood, in the second a fundamental lack. Practically, I am not convinced that any uber-scenario stands its ground as an overarching, all-applicable formula, but the distinction helps me ask: is your critique addressed to 'the subject'/knower as excessive, delineated, concrete, announcing him/herself? Are there ways to generate 'the subject' as lacking and vulnerable, as always intersubjective?

RC: The political philosopher Ernesto Laclau has a very interesting distinction of 'the subject' and 'subject positions,' which is informed quite a lot from Lacan's work around the subject and, of course, lack. He makes the distinction between the subject which is the unrepresentable 'empty place' – I think he means here the 'I,' and 'subject positions.' There is a lack of full identity in the subject and it is for this very reason that the subject necessarily has to invest in socially determined subject positions – 'artist,' 'academic,' 'student' etc. – and the values, beliefs, modes of knowledge within which these are articulated. This process of identification involves a struggle, so to speak, of the various subject positions. And, thinking about what you say above, perhaps it could be possible to think of this struggle in terms of the identifications of the subject/self/individual, and the voice/speech. If when the subject identifies with a specific subject position, the subject is reduced to a specific subject position, then this struggle is exciting to think about in terms of practice – whether it be the practice of the scholar or the voice practitioner, or both.

What I am asking here is can the performance studies scholar resist reduction into a subject position and what practice might that generate, or not? Certainly, this is interesting to consider in terms of the distinction of voice and speech. How do we understand the voice within performance studies scholarship beyond that of simply the authorial voice? The question for performers – how does a performer resist being a performer 'subject position', and work from the place of the subject – particularly in terms of a disciplinary practice? And not necessarily as the 'true self' or some *via negativa*. Of course addressing these questions is not necessary in the making of performance practice, though it is an important consideration if we want to ask how the 'political' subject of performance might be understood. I think this is getting at your point at the end of this last section.

voice: Performance and Forensics

Konstantinos Thomaidis

Claire, the protagonist in David Greig's play *The Events* (2013), has recently survived unimaginable tragedy.[1] As a liberal Christian priest, she has been running a multicultural choir, a project designed to welcome people in her country and help them integrate through vocal exchange and the resonantly affective immersion of choral singing. However, a fanatic young boy, obsessed with returning to an assumed state of ethnic purity within the national territory and advocating protection against the influx of foreigners, commits massacre, shooting down or injuring most members of the choir. Claire is the only one surviving this atrocity physically unaffected.

What was just described in this rather crude synopsis of *The Events* might present itself as a powerful yet straightforward storyline. Audiences, however, are only able to synthesise and imaginatively reconstruct this version of the events that lie at the heart of the play by the end of the live performance.[2] What spectators witness, as the performance unfolds, is a series of fragments detailing Claire's attempts to come to terms with the shootings, to engage in a life-affirming – or, at least, consolatory – process of meaning-making, and to reach some kind of closure. These attempts are mostly dialogic in form and involve Claire's female partner Catriona, a therapist she converses with, the Boy's father, a right wing extremist politician whose views seem to have influenced the Boy's actions, and a priest to whom Claire confides her thoughts when seeking advice. At the very epicentre of these exchanges lies the question 'What happened?' as audiences try to piece together information and get a broader picture of the committed crime. Correspondingly, both in the dramatic fiction and the performative encounter between spectators and performers, a question that lingers is, 'Who is the perpetrator of the crime and why did he commit it?'

Given the fragmented nature of the text, this question becomes a key dramaturgical device, implicitly extending an invitation to audiences to collect and

interpret data, to painstakingly unpack their forensic validity while delving deeper into the emotionally charged process of psychological recovery enacted, almost ritualistically at points, by Claire. Why was the crime committed? What is the profile of the shooter? How can the very process of such a 'profiling' drive the dramaturgy of the piece? Why is voicing – ranging from spoken interchanges and almost poetic monologues to choral singing and chanting – so central to the performance of *The Events*? What engagement between stage and auditorium does this expansive voicescape activate? What new knowledges can emerge if voice in this case is not examined monodisciplinarily as either authored text (linguistics) or composed sound (musicology and sound studies) but *interdisciplinarily* as performed text and experienced sound (performance studies) and, crucially, as identifying evidence (forensics)?

Taking cue from such questions – questions that mobilise a dynamic and proliferative intercrossing between performance studies and forensics – this chapter offers the first systematic investigation of voice in the piece. Such an analysis expands, and at points challenges, the rapidly growing body of critical work on *The Events*. The play has been primarily read as a compelling metaphor for contemporary politics. This reading has emerged from a line of enquiry mainly drawing on Greig's approach to writing and well-known political concerns around globalisation (Holdsworth 2013; Zaroulia 2013; Wallace 2015: 201–203) as well as on the historical events that loosely inspired the script, notably the mass killings conducted by Anders Breivik in Norway in 2011 (Gray 2013; Greig 2014a; Wallace 2016; Zaroulia 2016). This chapter returns to what might at first appear as a thoroughly examined moment in recent European theatre history to point in the direction of what has potentially been left unexamined or at least did not receive appropriate scholarly attention. This chapter's interests lie with *the role of voice* in such performance-instigated debates on contemporary politics. Consequently, what it attempts to do is to interweave a questioning of vocality in the piece with what I perceive as the underlying invitation to forensically unpack the perpetrator's character and motives.

Beyond its localised interest in the piece, this chapter primarily deals with broader questions around voice and suggests new possibilities for its critical interrogation outside purely representational modes of analysis. The first section details predominant understandings of voice in performance studies and forensics, and this parallel but also contrapuntal examination reveals definitions of voice as contested and context-specific. The second and third sections extrapolate the concepts of the 'expert listener' and 'earwitness reliability', both developed within the emerging field of forensic speaker identification, to re-energise them as methodologies for a radically alternative experiencing of *The Events* – and voice in performance more generally. It is for this reason that what needs to be outlined from the outset is that the core concern here is a methodological one. This chapter does not merely extend an anti-visuocentric critique of the strategies with which performance studies has traditionally silenced the critical understanding of voice practices.[3] Nor does it only aim to provide a musicology-inspired analysis of vocal

utterance in the piece to open up broader discussions around how voice can be understood and, significantly, experienced in performance. Crucially, this chapter is the very first endeavour to activate an interdisciplinary encounter between performance and forensics in search of a new methodology for listening-in to performance and, through this, for rethinking conceptualisations of voice in the very act of practising vocal listening. How can we then rethink what voice is and what voice does in performance, and which are the particular benefits of drawing on forensics for this purpose?

Invoking voice in performance and forensics: working through interdisciplinarity

Literature on performance and forensics is meagre, with only one monograph currently in the making (Frieze, forthcoming). When honing in more specifically on the question of voice in a terrain jointly occupied by performance studies and forensic analysis, academic writing is virtually non-existent. As a first step towards filling this critical lacuna, this chapter is not primarily designed to offer an overview of the intersections between the two disciplines or summarise relevant discussions. Rather, the tactic deployed here is one of strategic localisation; the performance of *The Events* is used as a productive case study out of which questions can emerge about the integration of, or incongruities between, disciplinary epistemic and methodological panoplies. The hope is that the answers provided within the context of this particular play will make audible aspects of its performance in ways that would not have been possible, or at least equally resonant, in/through monodisciplinary discursive practices.

There is currently no substantial historical overview of the rise of voice as evidence or, broadly speaking, as an area of interest and deliberation within forensics. However, an oft-cited pivotal moment is the trial of Bruno Hauptmann in 1935 (Karpf 2007: 256–257; Kennedy 1985; Kreiman and Sidtis 2013: 237–239; Solan and Tiersma 2003: 373–378). In 1932, Charles Lindbergh's child was kidnapped and, later, Lindbergh identified in his testimony Hauptmann's voice as that of the kidnapper despite the fact that more than two years had passed since the ransom exchange event during which he overheard the kidnapper and that Lindbergh had only heard the voice of the ransom collector/perpetrator once, from considerable distance. Although other supporting evidence was also procured, Lindbergh's aural identification was central to Hauptmann's conviction and execution in 1936. A similarly evocative case in the literature is the voice identification of Adolf Hitler after an assassination attempt in 1944 (Karpf 2007: 257; Hollien 2002: 20–21). The Allies were eager to verify whether the person still making public speeches was Hitler himself or a double, and the laboratory set up at Purdue University in Indiana, despite the poor quality of some of the available recorded samples, was able to reach the convincing conclusion that Hitler was still alive – and voicing. The 1960s was a period during which voice identification received wider attention due to the development of 'voiceprint' technologies, which purported to visualise the unique

vocal imprint of speaking subjects. Coulthard (1999) further locates the birth of the forensic linguistics discipline in 1968 with the publication of Jang Svartvik's *The Evans Statements: A Case for Forensic Linguistics*, which through the analysis of grammatical inconsistencies in transcribed testimony, evidenced interference with the original spoken text of the accused, potentially by officers that processed the document. As manifested in the frequent appearance of relevant publications in the period, more experts began to testify at court during the 1990s and this led to the foundation of the International Association of Forensic Linguistics in 1993 and the publication of its attached journal *Forensic Linguistics: The International Journal of Speech, Language, and the Law* in 1994.[4]

Currently, expert voice recognition is accepted in American courts if subjected to a process of cross-examination (Solan and Tiersma 2003), even though this type of testimony is still not admissible in some states and its admissibility by and large depends on the case. In the UK, voice verification and identification can be admitted if supported by expert testimony (Karpf 2007: 259, 364). Such reliance on what Hollien (1990) has described as 'the acoustics of crime' is particularly significant in a range of cases, from bomb or other threatening calls to crimes committed by non-visually-identifiable criminals (masked offenders, crimes perpetrated in the dark or in another location to that of the witness). Specialists in forensic phonetics might be asked to recognise significant features of a voice, for example accent or regional dialect, or provide expert opinion on whether voice recording technology has been interfered with when audio samples are submitted as evidence (Coulthard 1999: 108). More frequently, however, either the listener expert or the earwitness 'may be presented with a single voice and asked to state whether it is or is not that of the perpetrator' or 'may hear a set of speakers in a voice line-up and be asked to identify one of them as the perpetrator of the crime' (Kreiman and Sidtis 2013: 237).

Before elaborating further on the application of a forensically inclined listening/ earwitnessing of the piece, it is useful to establish why voice is treated here as the problematic word setting this interdisciplinary endeavour in motion. In the realm of theatrical performance, and the broader research paradigm of performance studies, what one might mean when referring to voice might seem obvious. However, the paucity of working definitions of voice in this particular area is remarkable. None of the foundational texts of performance studies deals directly with voice: in the *Dictionary of Theatre Anthropology*, Eugenio Barba and Nicola Savarese (2006) do not offer any elucidation or attempt at a definition, neither does Richard Schechner (2006) engage with voice or vocal practices in his *Performance Studies*.[5] If what voice is can be that elusive (or taken for granted), could we at least approach this subject through existing methodologies of analysing it? Once again, there are no publications explicitly dedicated to this area of enquiry but some insights can be drawn from key texts on performance analysis. Erica Fischer-Lichte's classical theatre semiology, for instance, is 'only interested in the communicative function of language and the voice, for "the actor's voice always functions as a sign," and "as the sign of particular corporeal and/or psychological

attributes of the character'" (Pavis 2003: 137). In other words, semiotic analysis of performance interrogates voice as one of the signs that if/when placed alongside other signs, can generate specific meanings in the context of particular productions. Voice is effectively textualised and proposed as another 'custodian of meaning', understood within a differential field of signs and conceivably removed from the event-ness of performance (Bryon 2014: 40). Pavis criticises this approach to voice by stressing its bodily contours: voice is material, generates physical affects, and is always connected to a body sounding forth. However, his analysis, largely inspired by Barthes, is also subsumed in the semiotic. His model is predicated upon voice as a one-directional vector from stage (actor) to auditorium, and the analytical tools proposed have the sole function of dissecting the performer's mode of delivery (breathing, melody, intensity, structural patterning of words and phrases) (Pavis 2003: 131–140). This approach is even more explicit in Pavis's *Dictionary of the Theatre*: here, for example, the thematic index at the forefront of the alphabetic entries lists voice as a lexical item under the headings of 'Staging' and 'Actor and Character' but not under 'Reception' (1998: xiv–xvii).

The situation is equally complex within the remit of forensics. Voice as an object of study can equally pertain to what Coulthard (1999) calls forensic application of linguistic analysis, Baldwin and French (1990) understand as forensic phonetics, Rose (2002) treats as forensic speaker identification, while Hollien (2002) and Primeau (2014) promote as forensic voice identification. This apparent terminological multiplicity is partly due to the origination of this developing field within linguistics (and phonetics, in particular). What is of interest here, however, is to extricate the underlying assumptions supporting much of the discourse around voice in these discussions. Voice is that which simultaneously exceeds and encompasses text. Rose proposes a model of forensic analysis that integrates an understanding of phonemics, speech acoustics and speech perception with a distinguishable but overlapping concern about voice quality (2002: 175–302). In this respect, there is an affinity with Pavis's approach to analytically disentangling the communication of the linguistic message from the prosodic, affective, and lived components of vocality. This affinity extends to the fundamental presupposition that voice unmistakably speaks of identity. If in both Fischer-Lichte's and Pavis's propositions voice is (either solely or additionally) a symbol of selfhood/ characterisation, the core concern in forensics lies with using the acoustic phenomenon of voice as the means through which to determine someone's identity; in Karpf's words: 'the belief that the individual's voice is as distinctive as their fingerprint has become so unshakeable that voice verification has been welcomed by both commerce and government, offering the promise of security in transactions and surveillance' (2007: 254).

Approaches to voice between the two disciplines, however, also diverge. In forensics, the task of attaching a voice to a person is not simple or straightforward. Depending on the type of criminal investigation, a forensic specialist might be required to participate in several processes of *speech recognition* (reconstruction and/or transcription of inaudible speech clues through phonetic indicators) (Coulthard

1999; Primeau 2014) or *speaker recognition* (Baldwin and French 1990: 107–111; Rose 2002: 81–92). Speaker recognition itself can also refer to two distinct processes: *speaker identification* (attempt to identify an unknown speaker comparing a sample of that unknown voice to several vocal samples from known speakers) or *speaker verification* (confirming or rejecting claims to identity from an unknown voicer against a set of samples including a known sample from the person whose identity he/she claims). Furthermore, voices in a forensic context can receive such treatment as investigation through aural-perceptual analysis, phonetic inspection and critical listening, or via aural spectrographic analysis and voice biometric processing through identification software.[6] Definitions of voice depend on *practices* of voice identification, the overarching *purposes* of such processes and the very *medium* through which such processes are realised. Forensic approaches to voice, although situating voice within the matrix of identity, are at the same time self-consciously critical of such approaches to assigning voice to self and, as will be shown in the final section, do not only deal with the voicer but place equal emphasis on voice as an 'in-between' (Thomaidis and Macpherson 2015: 3–6), irrevocably implicating the perceiver.

Why is it, then, important to work interdisciplinarily between performance studies and forensics? On the one hand, the law and juridical language have been fundamental in shaping Austin's understanding of the locutionary functions of utterances, leading to his understanding of the performative, which was, in turn, crucial to the development of performance studies (1975: 43, 65, 88, 153–155). Trials also play a central part in Schechner's proposition of the broad spectrum of performance (2006: 211–214, 250–251, 260–261). At the other end of the interdisciplinary encounter, and given the evolving nature of the methodological instruments employed by voice identification experts as well as the discipline's current reliance on tools that were developed either within linguistics or for the purposes of audio-visual recording and sound processing, it is not surprising that voice identification practitioners recognise their vocation as both an art and a science (Baldwin and French 1990: 1; Primeau 2014: xi). Coulthard pushes the comparison between voice in theatre and voice as evidence further:

> [A]ll utterances are shaped for a specific addressee on the basis of the speaker's assumptions about shared knowledge and opinions, and in the light of what has already been said earlier [...] It is for this reason that truly 'authentic' conversation would be impossible between actors on the stage: the real addressee of any stage utterance is in fact the audience. [...C]haracters [...] break the quantity maxim and say to each other things they already 'know'[...], in order to transmit economically essential information to the audience. [...] When we come to consider the fabricator of forensic texts, we can see that he is in a situation directly analogous to that of the dramatist – he is creating his text with the overhearer, in this case the judge and jury in Court, in mind and is anxious to make incriminating information as unambiguous as possible.
>
> *1999: 112–113*

Karpf summarises the permeation of the theatrical as a constitutive mythology in the working practices of forensic voice identification: 'voice identification is a romantic idea [...] and a *dramatic* one: it seems to accord with some theatrical fantasy of the unmasking of the criminal--betrayed by their voice' (2007: 258; added emphasis). Voices are not inherently theatrical, but their theatricalisation serves a requisite purpose in collecting auditory and acoustic evidence within the crime scene, in the same way that a legally inflected examination of speech acts allowed Austin to define performativity.

These shared but also divergent lineages, alongside the overlaps and marked differences between the treatment of voice in performance and forensics, rather than posing an insurmountable obstacle to such interdisciplinary encounters, are particularly useful in exposing voice *per se* as a productive problem. If definitions of voice and practices of vocal understanding vary between disciplines, then the question is not which overarching methodology could apply *across* disciplines but which methodology is necessitated in the act of engaging with voice *inter*-disciplinarily. Which methodology emerges then when a performance where voice is central *and* used to build evidence is experienced through forensically informed listening?

Activating an interdisciplinary methodology: listening for vocal clues as evidence

Forensic voice identification methodologies are still in development (Coulthard 1999: 122) and very much contested (Edmond, Martire and San Roque 2011), or at least undergoing rigorous cross-examination that favours a more synergetic approach to investigative processes (Elaad 1999: 223). Unlike other methods of forensic identification, such as fingerprints, 'voiceprints in the end always come down to opinion, even if expert. [...] there's inevitably an interpretive element to voice identification' (Karpf 2007: 258). One of the key debates about the formulation of appropriate voice-based evidence revolves around the notion of *expert testimony*, which is now admissible in specific circumstances, as outlined earlier. Expert forensic listening is largely based on training and experience, typically involves a combination of auditory (aural-perceptual) and acoustic (technologically mediated) processes, and its results are submitted as percentages of the *probability* that a voice exemplar matches the incriminating voice sample. Such likelihood ratios express 'the probability of the evidence given the competing defence and prosecution hypotheses' (Rose 2002: 66; see also 57–62). This does not imply that this type of expertise cannot reach convincing conclusions; phonetic linguists have in tests performed better – albeit not always significantly – than everyday listeners in set tasks (Elaad, Segev and Tobin 1998; Schiller and Köster 1998; Shirt 1983).

Kreiman and Sidtis suggest, nevertheless, that, alongside offering opinions on voice identification of specific samples, 'expert testimony can be of great value in informing juries about the limitations of this kind of evidence' (2013: 259). In

provoking official dialogue around earwitness testimony, voice identification processes are not only to be treated as a means of arriving at a (condemning or acquitting) verdict – they can also actively contribute to knowledge production about the current state of affairs in audio-based forensics and facilitate the development of appropriate epistemologies in the very act of applying them. In other words, the voice identification expert undertakes the double task of utilising current tools and expertise while exposing their disadvantages and imperfections. In this light, the interdisciplinary methodology proposed in this chapter is not conceived as the *performance* of a pre-existing model, neither does it originate with a '*performer*'/researcher prescriptively defined within/by the discrete disciplines of performance or forensics.

When I attended *The Events* in Brighton in 2014, the piece had already been on tour for months and I had read the published script, several reviews and articles as well as the composer's notes. Given that these knowledges formed an active part of my engagement with the performance, and in line with the broader interdisciplinary concerns of this edited collection, here I do not propose a *reading* of the vocal *signs* in the piece; rather, I observe the activation of my interdisciplinary interest in forensics and performance, prompted by voice-related questions and nascent findings that formed my *experience* as an audience member particularly attuned to the specifics of vocal practices. The remainder of this section, acknowledging and foregrounding my positioning as a voice practitioner-scholar, offers a forensics-inspired 'expert listening' of the vocal clues in the performed play. This methodological experiment is a nascent 'field of doing' (Bryon 2014: 61), an emerging process facilitating the practice of a transdisciplinary concern with vocality. To build on Experience Bryon's (2014: 61) terms, it is practised as an 'active aesthetic' and proposes that the doing of a voice practitioner may not exclusively be the aesthetic performance of voicing but also *the act of generating vocal knowledge in the process of listening to voice* as a trained voicer/expert.

The performance of *The Events* offers a rich sonic field, ripe with utterances traversing the full speech-song continuum – voicings that, given the piece's preoccupation with dissecting a criminal act, could be treated as vocal evidence.[7] In an early scene between Claire and her therapist, Claire is emphatically attempting to solidify the Boy's attributes as a criminal. The therapist, however, refuses to reduce the Boy's identity, and therefore the logic of his deeds, to a single unifying definition. When confronted with Claire's insistence, he resorts to admitting that 'to understand him properly, we would need to interview him. To explore his family background. Without that all we have is speculation' (Greig 2013: 26). Dramaturgically, this palimpsest of character-defining perspectives and the simultaneous attempt to give the perpetrator a voice of his own are embodied by the choice (written in the text and embraced in all UK stagings) to have all characters other than Claire performed by one young male actor listed in the *dramatis personae* as 'The Boy'. This choice could be read in various ways: the Boy is a figment of Claire's imagination acting as a sounding board for her thoughts and proliferating question marks. Or, Claire's life has been haunted by the event to

such an extent that every encounter with other people is essentially an encounter with the perpetrator.

Which are, however, the clues in the Boy's vocal persona, as resounding in the performance space? In the original production, director Ramin Gray cast as the Boy Rudi Dharmalingam, a British actor of Indian origin, while Clifford Samuel, a Black-British actor of Nigerian origin, performed the part in the tour. Visually, this is an interesting subversion of the perpetrator's profile; someone who vehemently despises multiculturalism is embodied as the Other. What a sole emphasis on the visual bypasses, however, is the sonic profiling of the character. In the original production and the radio broadcast, Claire was played by Neve McIntosh, a Scottish actress speaking in her natural accent.[8] In stark contrast, the Boy used received pronunciation, a standardised version of Southern English speech. The succession of encounters between ('accented') Claire and all other ('non-accented') characters resembles a line-up of suspects; who is to blame? Psychology? Politics? Family? If treated as a *vocal* line-up (Nolan 1983; 1997; Kreiman and Sidtis 2013: 257), however, earwitnessing becomes almost impossible. All 'suspects' or 'accomplishes' bear the same voice, despite linguistic variability. The Boy has the most extensive linguistic repertoire in that his idiolect (personal, idiosyncratic use of language) and register (the purpose for which language is used) are adaptable and inconsistent when voicing all other personae, almost in the way a ventriloquist would. At the same time, all characters share the same fundamental frequency, tone, inflection and prosodic qualities with the Boy. In his performance, the actor never engages in vocal disguise; to the contrary, rather than aiming for vocal plasticity, the acoustic field is dominated by an extreme case of vocal subsumption, with all voices sounding disturbingly similar to that of the perpetrator. The question of familiarity and unfamiliarity is central to its forensic treatment because it is markedly influential in the way a voice is remembered or perceived as a threat (Kreiman and Sidtis 2013: 241). In this logic, the Boy's and Claire's accents can be heard as articulatory cues challenging any comfortable audience positioning, depending on whom audiences perceive as sounding 'non-familiar'. It is not insignificant that a play written by a Scottish playwright that opened at a Scottish festival in the year leading up to the Scottish referendum uses voice to ask 'Who is the (aurally defined) foreigner?' – and, implicitly, 'Who is perceived as a threat?'

Adding to the play's plural vocality, and further complicating the process of forensic speaker recognition (*Who is the person emitting the voice?*), is Greig's central dramaturgical device. Apart from Claire and the Boy, the play involves a choir. This could be seen as the actual choir rehearsing with Claire either before or after the shooting. An obvious association here is with practices of classical Greek drama (Greig 2014b) and, specifically, the use of the chorus as representing, challenging and interrogating notions of community or highlighting the fact that the characters' individual actions are at the same time a public act. Once again, and while being very relevant, such analyses of the choir emphasise the visual, effectively addressing it as a plurality of bodies accompanying the main characters and alluding to a real or phantomic, communal 'us'.

What does the experience and *vocal* examination of the singers' concrete presence and functionality reveal? Are their voices to be subsumed, as in other analyses, into one unified or unspecific vocal practice, that of communal/choral singing? Are they simply supportive or secondary to the two actors' voices? Are their voices to be edited out as unwanted 'noise floor' (Primeau 2014: 13) or 'distracter voices' (Kreiman and Sidtis 2013: 257) in the process of voice indentification? A critical listening to/of the choir's vocal interventions might be useful. At the opening of the performance, the first song we, as audiences, get to hear is a Norwegian Coffee Song, sung by Claire's choir. The lyrics can be loosely translated as 'Gather, roast, grind, boil the coffee / And we fetch it and we roast it / – One more cup? – Yes, thanks' (Sea Green Singers 2013). According to the composer's notes to the choristers, the reason why the pitch rises and the tempo goes faster every time the song is repeated is to produce 'a bit of lightness and joy' (Browne 2013: 7). Two relevant observations can be made here; in the penultimate scene of the play, when Claire visits the Boy in prison, the person who longs for a hot drink is the Boy. Secondly, Browne notes: 'the song gets faster each time. [...] The last time should be so fast that it's almost impossible to get the words out' (2013: 7). In other words, the song is not only designed to create an atmosphere of exultation and joy, but also to induce a state of physical exhaustion within the choir, or at least, demand from it a higher level of physical awareness and/or exertion from the voicing physiology. The next time the Boy performs (as) himself, he is also in a highly athletic setup, jumping rope and spitting out fast-paced responses to quasi-journalistic questions.

The second choral intervention is a highly evocative one, almost reminiscent of the luscious harmonies that act as a soundtrack to emotionally charged scenes in films or musical theatre. The only word that is uttered is 'soul' and the intended atmosphere is 'subtle' and 'magical/ethereal' (Browne 2013: 8). Claire in this scene is confessing her anxiety about resorting to terms – like 'soul' – that might be interpreted as spiritual. The choir comes in when she recalls the moment the Boy, in his shooting spree, burst open the locked door of the room in which she was hiding and entered (Greig 2013: 15). The vocalised underscore, however, does not duplicate Claire's thoughts on spirituality; rather, it fades in the same moment in the performance when the Boy enters her memory.

Throughout the performed dialogue, there are implicit pointers that the Boy, as a theatre persona, is a sonic one. In the exercise scene, the first question he responds to is whether he has a favourite song. His answer is '"Bonkers" by Dizzee Rascal!' (Greig 2013: 18), an electro/hip house track produced by a Black-British rapper that further complicates the Boy's stage 'self'. A scene later, the Boy listens loudly to 'Bonkers' through his earpieces (Greig 2013: 23), and the first impression he makes on Claire when he announces that he is about to kill any foreigner in her choir is that of 'the tss-tss-tss of music bleeding from his headphones' (Greig 2013: 49). When the choir sings for the third time, they perform a choral arrangement of 'Bonkers'. The lyrics that would be the most obvious choice to extrapolate are the refrain: 'Some people think I'm bonkers / but I just think I'm free.'[9] However,

what the composer incorporated in his arrangement and asked the choristers to sing is the first stanza, which gives the impression of asking the listener to question what is superficially there: 'ev'ry thing in my life ain't what it seems / [...] I act real shallow but I'm in too deep' (Sea Green Singers 2013). It is as if the chorus distances itself from distancing. They are not making an external comment on the Boy's mental state; instead, they are inviting the audience to share an insider's perspective beyond appearances.

After Claire's encounter with the Boy's father and one of his friends, she is seen rehearsing with her choir once again. The song this time is 'How Great Thou Art'. This choice is particularly resonant on a number of levels. On the one hand, it is a popular Christian hymn, particularly in the Anglo-Saxon world; it was voted first in popularity in the UK in BBC's Songs of Praise religious programme (BBC 2013). On the other hand, the song extends and interrogates the logic of vocal conflation of geographies, established through the playful use of the characters' UK regional accents against a backdrop of a storyline inspired by event set in Norway. Similarly, the hymn originated in Sweden and found its widely circulated contemporary form through translations into German, Russian and then English. The lyrics are ones of praise to Christian God's omnipotence and one of wholehearted devotion. It is intriguing, however, to listen in more carefully to how the song is dramaturgically deployed in performance. The choir starts singing the first stanza, but Claire, audibly upset, interrupts them and instructs that they 'try humming it this time' (BBC 2014).[10] After a full round of murmuring, the refrain, with its twice repeated words 'then sings my soul, my saviour God, to thee / how great thou art, how great thou art', is performed.

The lyric at which Claire interrupts the choir, effectively muting any linguistic content through the act of replacing the lyrics with humming, is: 'I see the stars, I hear the rolling thunder.' This is yet another piece of vocal evidence in the search of the perpetrator's identity. In the scene during which the Boy shares his worldview and ideological affiliations in an interview-like format, the Boy establishes links between his preparations – his 'warrior' practice – and 'Viking warrior shamen' (Greig 2013: 16) who would spend time in the woods invoking their spirit animal in preparation of going down the mountain towards the village to unleash their killing rage upon their enemy's people. Significantly, the moment when the trainee warrior becomes a killer is rendered as follows: 'he would march down the mountain like *the coming of thunder*' (Greig 2013: 17; added emphasis). Even though the choir attempts to draw consolation and moral support by making God the addressee of the song, the sonic space defined by the metaphor of the thunder is not one of justice and solace, but a vociferous reminder of mass murder. It is not surprising, then, that when, in a later scene, Claire attempts to teach and conduct a shamanic ritual song, a call-and-response melody accompanied by drumming and stomping, the hoped-for cleansing effect is far from achieved. Claire collapses, while choir participants find the song upsetting and express their resistance to return to rehearsals. Claire's voiced intention was 'to bring back our [the choristers'] souls' (Greig 2013: 40), but Greig offers a much bleaker version of what was

actually invoked; when the choir breaks, the stage directions, rather enigmatically, read: 'A short nature documentary about foxes' (Greig 2013: 43). There is particularly resonant haunting taking place in this moment as, listening back to the interview/exercise scene, the Boy, when asked if he has a spirit familiar, declares unequivocally: 'my spirit familiar is a fox' (Greig 2013: 19).

The penultimate choral song is, in the composer's words, 'a display of rampant ego and as such should be a big sound with big attitude. [...] The style here is gospel meets stadium rock' (Browne 2013: 9). The ego-perspective amplified in the song is resolutely that of the Boy, as the song is a sung rendition of one of his earlier statements: 'By the time he was my age Jesus had founded a world religion. By the time he was my age Bob Geldof had saved Africa. By the time he was my age Gavrilo Princip had fired the shot that started WWI. If I'm going to make a mark on the world I have to do it now' (Greig 2013: 17–18).[11] The rhythm is upbeat and the tune almost infectiously participatory, to the extent that the sonorous affect might overshadow where the lyric content originated from. More importantly, when piecing together the Boy's identity, this song serves the performative purpose of revealing this presumably singular perpetrator as a multiplicity, as a living lineage of people and practices, as a chorus of singled out historical precedents.

After reaching some sort of resolution, Claire returns to the rehearsal room hoping that her choir will be there, that despite her previous emotional outbursts and unwillingness to forget, new members will sign up. The final song is one of the most complex vocal statements in the piece. The composer aimed to expose 'the internal conflict we humans have between being together and being separate. This song completes the story with a simple statement about togetherness' (Browne 2013: 9). The lyrical content, accompanied by simple harmonisation that edges more, but not clearly, to a major scale, refers to inclusivity and presence; foreigners, ex-offenders, addicts form its linguistic world and the line that is reprised in the end is: 'We're all in here.' Whereas the Boy sits silent, Claire addresses the audience as if they are potential choristers, gently encouraging them to join in if they feel like it. Clare Wallace rightly observes the multiplicity of questions such a moment raises for our sense of community within the microcosm of the performance venue: 'What does this moment of singing together, in which audiences might participate, signal? The resumption of conformity? A declaration of faith in community perforated, but not destroyed, by the absence of those murdered? An aesthetic questioning of the boundaries consensus defends?' (2016: 38). Although in the performance I attended the audience did not respond to the call to sing, this sense of an invitation to participate vocally, to recognise the affinities between the audience and the choir, was palpable as the choir got progressively closer to the audience and the singing more committed and affirmative. In the next section I will engage with Wallace's invitation to rethink community. However, I will offer a *different listening* of the piece, a way of practising sensorial attentiveness within the aural field of performance without solely placing the focus on the aural cue/emission but also acknowledging the constitutive entanglement of the listener (and

in this case, the presupposed listening 'community') in the process. This different listening will be informed by examinations of reliability within speaker identification methodologies and, in this case, will be instigated by a return to the core forensic question activated by Greig's performed dramaturgy: 'Who was the perpetrator?'

Listeners' reliability: unpronounced communities

During the play's run, both in London and on tour, local choirs were employed to perform the choristers, all in all involving 78 choirs across the UK.[12] This fact resonates with Wallace's intriguing questions around community, but further observations gathered through personal ethnography can also be of use here. In the performance I attended in Brighton in 2014, I overheard several discussions in the auditorium, centring on the fact that spectators' friends, relatives or neighbours participating in the local choir were involved in the piece – and, as one might expect, such comments were interspersed with the odd giggling and pointing when these people were on stage. This observation, if considered alongside the pragmatic logistics of big choral ensembles inviting friends and relatives or even offering comps, reinforces the sense of an affective community between choristers and audiences. These are not actors representing a community and reflecting it back onto itself. These are amateur singers who are *parts* of this community and are recognised as such – at least by a percentage of spectators.

How does this, however, relate to the forensic process of collecting vocal data about the perpetrator? If audiences are conceived in this discussion – at least partly – as earwitnesses, another methodological concern borrowed from forensics should be introduced, namely that of earwitness reliability. Forensic voice identification is not only concerned with the attributes of the voice *as emitted signal* but primarily with its *reception*:

> Speakers can differ in many ways [...] but the factors that underlie most differences between speakers (age, sex, race, physical size, etc.) are not in general the focus of forensically oriented studies, which instead emphasize factors that are likely to interfere with recognizing the voice.
>
> *Kreiman and Sidtis 2013: 240)*

In court, both the voice identification expert and any earwitnesses are called to question themselves as listeners; how successful are they in distinguishing between voices? How accurately can they recollect the qualities of voice and for how long?

If, in performance studies, the analysis of voice as sign is predicated on the postulation of a credible auditor, forensic voice identification literature decisively de-naturalises such an assumption by examining a wide array of factors that may impact on earwitness reliability. Such factors include: the listener's inherent ability to remember and recognise voices; the degree of attention and amount of exposure to the voice during the crime (number of opportunities to listen to a voice, ability to both listen to a voice and see the face of the perpetrator); and the witness's

confidence in identifying a particular voice; relevant training and ability (sustained practice and professional experience, ability to extract the salient features of a voice and retain it in one's memory for longer, familiarity with particular accents, languages or idiolects) (Kreiman and Sidtis 2013: 250–256; Solan and Tiersma 2003: 393–412). In addition, courts may accept or disregard earwitness or voice expert testimony on the basis of established criteria of admissibility, known as 'Biggers criteria' (Kreiman and Sidtis 2013: 239; Solan and Tiersma 2003: 378– 393). These include: for how long and in what conditions the witness was exposed to the voice when the crime was committed, the degree of attention to the voice, how accurately the criminal was described by the witness when the crime occurred, how certain about the identification they were, and the temporal distance between the occurrence of the crime and the identification. The technology employed to record or transmit the voice, as well as the testing methodology applied to voice identification, are also subject to scrutiny.

Voice, examined in this way, is revealed as a process rather than as a (complete, identifiable, locatable) sign in the chain of signification. Taking interdisciplinary cue from this sense of distrust towards *voice-as-perceived*, or at least the necessity to establish the credibility of the listener, it is time to synthesise findings and propose a radical listening of the voicescape in *The Events*, one with resounding implications for discussions of community. Visually and in terms of spatial configuration, throughout the play there are two identifiable characters – Claire (the victim) and the Boy (encompassing all other accomplishes and versions of culpability) – and the choir, appearing as an iteration of an emphatically affective 'us'. However, the 'expert listening' proposed in the previous section, supported by a questioning of the perceiver, destabilises visions of the utopian, hopeful, or inclusive communal. The choir sings the Boy's favourite song and renders one of his texts in singing. It opens the performance with a song alluding to the country of origin of Breivik, the mass killer who triggered the creation of the play. The choir is there when the Boy's spirit animal is invoked, and its harmonies enter the sonic field when Claire recalls the Boy. When Claire says 'I have to see him. Face to face' (Greig 2013: 48), the choir enters singing, and immediately after the song, Claire admits: 'I see a boy' (Greig 2013: 49). Isn't it possible then that all vocal clues suggest that the choir *is* the Boy? And if 'we', as audiences are invited to affectively connect with the choristers as community, is it not possible that 'we' are not just listening witnesses, but equally implicated in the crime? Might Greig's orchestration of the vocal indicate, then, that the Boy is not an exception or an outsider but an integral or constitutive part of 'us'?

If the piece is sonically rich and requires rigorous, if not expert, listening-in; if the Boy and the choir have the most extensive vocal repertoires within the sonic phenomenology of the performance; if the choir not only represents the local community, but vocally stands in for it and affectively invites it to participate; and if the vocal choices of the choir reveal it to also *be* the Boy; then, a sustained forensic listening to the piece provides a complex and unsettling answer to the question of where blame lies. This answer might interrupt the logic of community

forging, enhanced by the bodily intimacy between performers and audiences in the finale or the semiotic distancing between the murderer, the choir of 'victims' and the bystanding witnesses/spectators as discrete 'signs' in the performance space. 'We', as *spec*tators, are not a community uncomplicatedly united in the aftermath of atrocity; 'we', as *audi*ences, unite in the face of adversity that we (may have) brought upon ourselves. As if, in the processes of forensically unpacking performed vocal evidence, our subject position hauntingly shifted from that of the earwitness to the revelation that 'we' might be the perpetrator – or in some measure, his unknowing accomplices.

This is in many ways an unresolved, or uncomfortable, experiencing of the performance. When listening to voices as evidence and when questioning our own reliability as listeners in this process, we, as audiences, might find ourselves equally participating in the circulation of affect that bonds us as a temporary community *and* distrusting the assumptions on the basis of which such a community is fabricated. The Boy is not an easily delineated voicing self; his songs, music, lyrics and rhythms are also taken up and sounded forth by the Choir. Similarly, my perception of 'his' voice required a dialogue between listening as an expert and a questioning of my participation in a community of listeners who are potentially unreliable or, at least, accountable for constructing what we listened to. In this chapter, the interdisciplinary examination of performed voices through an unconventionally activated forensic methodology revealed both the voicing persona and the perceived voice as being actively in the making. On this basis, and to propose a conceptual move of wider applicability, can such interdisciplinary undertakings be extended to shift attention away from *voice* as stable and predefined – in other words as sign or essence – to *voicing* as unruly and processual – in other words, as practice and experience?

Notes

1 *The Events* opened at the Traverse theatre, Edinburgh, in August 2013, transferred to the Young Vic, London, for a sold-out season, and subsequently toured extensively in the UK and abroad. For further information, see Actors Touring Company (2015).

2 This analysis is based on my attendance of the play (Brighton Dome, May 2014) and multiple listenings of its radio version (BBC 2014), in cross-examination with the published script (Greig 2013). The composer's scores and notes were accessed online (Sea Green Singers 2013).

3 Adriana Cavarero (2005) developed a sustained philosophical critique of logocentrism and its subsequent muting of the uniquely embodied voice. For an extension of this line of thinking towards vocal performance studies, see Thomaidis (2015). In this chapter, the primacy of semiotic analysis in theatre studies, of understanding performance as a chain of signifiers, is treated as a direct outcome of logocentrism.

4 For information on the association, see IAFL 2016. The journal can be accessed here: https://journals.equinoxpub.com/index.php/IJSLL.

5 For a broader critique of Schechnerian-inflected performance and performance studies, from the perspective of their relation to analytical models premised on representation, see Bryon 2014 (39–40, 49–50). Bryon proposes a movement away from separated (and

separable) performers/doers and performances/outcomes and towards performing/ways of doing, through an active aesthetic (2014: 11–15, 35–52). This conceptual move is further expanded as an activator of interdisciplinarity in the Introduction to this volume.

6 My understanding of voice in forensic contexts owes mostly to Baldwin and French (1990), French (1994), Hollien (2002), Karpf (2007: 255–273), Kreiman and Sidtis (2013: 237–259), Primeau (2014) and Rose (2002). Not all sources serve the same purposes or are of the same academic caliber, but a combined reading allows the interdisciplinary reader to extricate some underlying principles and presuppositions in this disciplinary area. Karpf's text addresses a general readership, but the author is well-read and therefore the chapter on voiceprints and voice theft can be an intriguing point of departure. Baldwin and French are concerned with phonetics and are largely critical of technological advances, especially when these are purported to be more reliant than experts. In Primeau's and Hollien's texts, the (more or less) implicit purpose of supporting (and advertising) specific methodologies might be disconcerting for a scholarly reader, but the books offer insights from professional practice and an accessible induction to programming software. A more detailed and well-referenced work is Rose's monograph, whereas a succinct but almost exhaustive summation of work in the area can be found in Kreiman and Sidtis.

7 Greig's sensitivity to music and vocality is acknowledged by collaborators: 'David is pretty obsessed with all kinds of music, as I am, and any conversation about a new project between us often begins with a conversation about what the character of the music might be' (Wilson in Wallace 2013: 227). In an earlier play, *Pyrenees*, a character, Anna, recalls having a voice coach that told her, in relation to regional inflection, that 'people carry a landscape in their voice' (Greig 2010: 244).

8 For a systematic examination of 'sounding Scottish' in Greig's work, read Inchley (2015: 63–80).

9 The official video of the song, originally released in 2010, can be accessed here: https://www.youtube.com/watch?v=ISy0Hl0SBfg.

10 This scene is not incorporated in full in the published script. My analysis draws on my attendance of the performance and the radio version (BBC 2014).

11 The sung lyrics are slightly modified (Sea Green Singers 2013).

12 For videos of choir rehearsals and discussions of the choir's role, see: https://www.youtube.com/playlist?list=PL-ieBTWRUfslRH6li_jfxD0cCIgRzJm_k.

References

Actors Touring Company. (2015) The Events (2015). *Actors Touring Company* [Online]. Available: www.atctheatre.com/productions/the-events-2015 [Accessed 31 October 2016].

ATC London. (2014) The Events. *YouTube* [Online]. Available: www.youtube.com/playlist?list=PL-ieBTWRUfslRH6li_jfxD0cCIgRzJm_k [Accessed 31 October 2016].

Austin, J.L. (1975) *How to Do Things with Words*. Cambridge, MA: Harvard University Press.

Baldwin, J. and French, P. (1990) *Forensic Phonetics*. London & New York: Pinter Publishers.

Barba, E. and Savarese, N. (2006) *A Dictionary of Theatre Anthropology: The Secret Art of the Performer*. London & New York: Routledge.

BBC. (2013) The UK's Top 100 Hymns. *BBC: Songs of Praise* [Online]. Available: www. bbc.co.uk/programmes/articles/3DnJQz7zsF1JrB3rZ8yQ86w/the-uks-top-100-hymns [Accessed 31 October 2016].

BBC. (2014) The Events. *BBC: Friday Dramas* [Online]. Available: www.bbc.co.uk/ programmes/b04807jn [Accessed 31 October 2016].

Browne, J. (2013) Events_Choir Pack MASTER. Unpublished.

Bryon, E. (2014) *Integrative Performance: Practice and Theory for the Interdisciplinary Performer.* London & New York: Routledge.

Cavarero, A. (2005) *For More than One Voice: Towards a Philosophy of Vocal Expression.* Trans. Kottman, P.A. Stanford, CA: Stanford University Press.

Coulthard, M. (1999) 'Forensic Application of Linguistic Analysis', in Canter, D. and Alison, L. (eds) *Interviewing and Deception.* Aldershot: Ashgate. pp. 105–125.

Edmond, G., Martire, K. and San Roque, M. (2011) Unsound Law: Issues with ('Expert') Voice Comparison Evidence. *Melbourne University Law Review* 35(1). pp. 52–112.

Elaad, E. (1999) A Comparative Study of Polygraph Tests and other Forensic Methods. In: Canter, D. and Alison, L. (Eds). *Interviewing and Deception.* Aldershot: Ashgate. pp. 209–231.

Elaad, E., Segev, S. and Tobin, Y. (1998) Long-term working memory in voice identification. *Psychology, Crime, and Law* 4. pp. 73–88.

French, P. (1994) An Overview of Forensic Phonetics with Particular Reference to Speaker Identification. *Forensic Linguistics: The International Journal of Speech Language and the Law.* 1(2). pp. 169–181.

Frieze, J. (Forthcoming). *Theatrical Performance and the Forensic Turn: Naked Truth.* London & New York: Routledge.

Gray, R. (2013) 'Director's Note', in D. Greig. *The Events.* London: Faber and Faber.

Greig, D. (2010) *David Greig: Plays 1.* London: Faber and Faber.

Greig, D. (2013) *The Events.* London: Faber and Faber.

Greig, D. (2014a) David Greig: 'I always knew I'd put The Events in front of a Norwegian audience'. *The Telegraph* [Online]. Available: www.telegraph.co.uk/culture/theatre/10742089/ David-Greig-I-always-knew-Id-put-The-Events-in-front-of-a-Norwegianaudience.html [Accessed 31 October 2016].

Greig, D. (2014b) 'Writers Room: The Events – Q&A with writer, David Greig', *BBC Blogs* [Online]. Available: www.bbc.co.uk/blogs/writersroom/entries/43b12cea-daef-3dae-b90d-770e56aa209f [Accessed 31 October 2016].

Holdsworth, N. (2013) David Greig. In: Rebellato, D. (Ed.) *Modern British Playwriting 2000-2009: Voices, Documents, New Interpretations.* London: Bloomsbury. pp. 169–189.

Hollien, H. (1990) *The Acoustics of Crime.* London: Plenum.

Hollien, H. (2002) *Forensic Voice Identification.* London: Academic Press.

IAFL. (2016) *International Association of Forensic Linguistics* [Online]. Available: www.iafl.org [Accessed 31 October 2016].

Inchley, M. (2015) *Voice and New Writing 1997-2007: Articulating the Demos.* London: Palgrave Macmillan.

Karpf, A. (2007) *The Human Voice: The Story of a Remarkable Talent.* London: Bloomsbury.

Kennedy, L. (1985) *The Airman and the Carpenter: The Lindbergh Kidnapping and the Framing of Richard Hauptmann.* New York: Harper Collins.

Kreiman, J. and Sidtis, D. (2013) *Foundations of Voice Studies: An Interdisciplinary Approach to Voice Production and Perception.* Chichester: Wiley-Blackwell.

Nolan, F. (1983) *The Phonetic Bases of Speaker Recognition.* Cambridge: Cambridge University Press.

Pavis, P. (1998) *Dictionary of the Theatre: Terms, Concepts, and Analysis.* (Trans. Shantz, C.). Toronto: Toronto University Press.

Pavis, P. (2003) *Analyzing Performance: Theatre, Dance, Film.* (Trans. Williams, D. Ann). Arbor, MI: University of Michigan Press.

Primeau, E. (2014) *That's not my Voice! A Practical Understanding of the Art & Science of Modern Voice Identification.* US: Primeau Forensics.

Rose, P. (2002) *Forensic Speaker Identification.* London & New York: Routledge.

Schechner, R. (2006) *Performance Studies: An Introduction.* New York: Routledge.

Schiller, N.O. & Köster, O. (1998) The ability of expert witnesses to identify voices: A comparison between trained and untrained listeners'. *Forensic Linguistics.* 5. pp. 1–9.

Sea Green Singers. (2013) The Events – Files. *Sea Green Singers* [Online]. Available: http://sgs.lpi.org.uk/seagreensingers/theeventsplay.htm [Accessed 31 October 2016].

Shirt, M. (1983) 'An auditory speaker-recognition experiment comparing the performance of trained phoneticians and phonetically naïve listeners'. *University of Leeds Papers in Linguistics and Phonetics.* 1. pp. 115–117.

Solan, L.M. and Tiersma, P.M. (2003) Hearing voices: Speaker identification in court. *Hastings Law Journal.* 54. pp. 373–436.

Thomaidis, K. (2015) The Re-Vocalization of Logos? Thinking, Doing and Disseminating Voice. In: K. Thomaidis and B. Macpherson (Eds) *Voice Studies: Critical Approaches to Process, Performance and Experience.* London & New York: Routledge. pp. 10–21.

Thomaidis, K. and Macpherson, B. (Eds). (2015) *Voice Studies: Critical Approaches to Process, Performance and Experience.* London & New York: Routledge.

Wallace, C. (2013) *The Theatre of David Greig.* London: Bloomsbury.

Wallace, C. (2015) Suspect Culture. In: L. Tomlin (Ed.) *British Theatre Companies 1995–2014.* London: Bloomsbury, pp. 179–206.

Wallace, C. (2016) Yes and No? Dissensus and David Greig's Recent Work. *Contemporary Theatre Review.* 26(1). pp. 31–38.

Zaroulia, M. (2013) Spinning through Nothingness: Suspect Culture Travelling. In: G. Eatough and D. Rebellato (Eds). *The Suspect Culture Book,* London: Oberon Books, pp. 45–48.

Zaroulia, M. (2016) "I Am a Blankness Out of Which Emerges Only Darkness": Impressions and Aporias of Multiculturalism in *The Events: Contemporary Theatre Review.* 26(1). pp. 71–81.

Cross-Chapter Discussion

voice and visibility

Nando Messias (NM) and Konstantinos Thomaidis (KT)

Nando Messias: I have just read your chapter. I really enjoyed reading it. It is thorough and exciting. A few things came up during my reading. I was particularly intrigued by:

1. The idea of voice and identity:

You talk about the voice functioning as a sign, the sign of particular corporeal and/or psychological attributes. I cannot help but see this from the standpoint of gender and queer studies, which is, of course, my field of expertise. I have long had a fascination with 'queer voices' (my own included). Although my research has centred around queer bodies, voice is perhaps the only one aspect of these bodies I have thus far failed to investigate. This probably stems from a personal anxiety of hearing my own voice; a fear of speaking or (even worse) singing on stage. This anxiety originates from the possibility of being judged or laughed at for having the queer voice that I have; an anxiety which no doubt reflects my personal experience. I was taken, though, by how much voice is indeed connected to identity. Not only psychological or corporeal attributes of characters but also, forensically, how experts and technology can place or identify a certain vocal pattern by its accent, dialect or ticks. This, as you have also emphasised, draws an interesting discussion on the broader, political implications of such concepts as nationality, ethnicity and, let us not forget, class. In contrast with the idea of 'home', naturally, we find the figure of the foreigner, the Other, which is key in your analysis of *The Events*. Queer identities are also concerned with such aspects of identity (i.e. nationality, ethnicity, class) as well as gender and sexuality. Queer politics, however, emphasises the importance of maintaining rather than erasing difference. In other words, in a world that often demonises difference, queer politics celebrates the intersectional aspects of one's identity. I'm now left reflecting on how voice translates and sounds out all these intriguing facets of one's difference. I'm also

thinking of inclusivity, a term you use in your investigation of the play later in your chapter.

Konstantinos Thomaidis: Non-erasure and inclusivity, as I read them in your response, resonate deeply with my research and with the way I interact with your writing. Voices, in the way I think about them at least, are practised ideologies and histories; not only of our past but also of expectations, exchanges, investments, intersubjectivities. Limiting them to a single narrative or the uniformity of the sign ('this is my voice' or 'this is the character's voice'), as in training systems that advocate the erasure of the impact culture had on the voicer to help them find their 'natural' or 'neutral' voices, is – in the way I read you text, at least – an act of erasure. Why can I not have multiple voices? Why can I not avoid allocating voice to self? How can we re-conceive voice in ways that foster new inclusivities?

The way I engaged with your insider's account of *The Sissy's Progress*, the performance makes a powerful statement not only about visuality and bodily performativity but also about voice. I noticed, for example, that at crucial points you mention that words were not needed or that you stood in silence. You write about passers-by's comments, laughter, or insults. For me, your silence is not the opposite of voice or its absence; it is one of the potential vocal possibilities you chose to engage (please qualify the notion of 'choice' in accordance with the specific ideological matrices at play in this case). Resisting voicing, for the reasons you outlined just above, is an engagement with vocality. In other words, if the only option available to the ears of the perceiver is an excess of audibility ('I (may) sound *too* genderqueer'), then not voicing might be an equally potent vocal statement. Similarly, what I hope transpired through my thinking-through of forensic earwitnessing, is that voices are not only emissions – there are also perceptions (and the earwitness or listener expert has to account for their parts in constructing the voices they then attribute back to their sources). In this line of thinking, your silent but palpably visible listening of comments, insults and laughter is part of the voicing process; you may not emit voice but the voice heard is not simply what was emitted by others. It is also, and for me equally significantly, what you make us listen in these voices; your silence brings awareness to the politics of this voicing in the very moment of its occurrence. I do not hear these voices as complete signs or sound emissions; your silence makes me hear how they land on you and, consequently, implicate me in either silencing or voicing. How you expose voice as an in-between makes me, your audience, your reader, your direct or indirect addressee, vocally implicated. And this is where spaces for inclusivity begin to open up.

NM: 2. Voice analysis in performance:

I was interested to find out more about what you call 'an anti-visuocentric critique of the strategies with which performance studies has traditionally silenced the critical understanding of voice practices' with reference to Adriana Cavarero and your own other published work. My creative process typically begins with an exploration of images. It is therefore 'visuocentric' by definition.

Curiously, as I read your chapter, I find myself at a stage of my artistic practice where my main goal is to push myself to work outside my comfort zone. Coincidentally, my challenge has been specifically to explore my own voice in performance, a side of my body I have thus far neglected. My exploration of voice in performance is very much linked to a conceptual relationship with the idea of 'using my own voice' or 'making my voice (as a transgender person) heard' publicly, of 'speaking out for myself,' etc. Pavis' statement of the voice as having bodily contours really sparked my imagination; the voice as being material, generating physical affects, and being always connected to a body sounding forth. What a powerful image! I wonder what type of a body the sound of a queer voice would delineate if all visual clues were to be taken away.

KT: Voice studies is a relatively young discipline; our tools are in the making and part of our emergence is the attempt to renegotiate the burden of analytical concepts and methodologies – which is what I am trying to do in my chapter and which is precisely what you describe here. Cavarero, among others, brought attention to the ways in which visuality (its metaphors, modes of thinking, and schemes) has been the predominant *modus operandi* in Western metaphysics and found new opportunities for working against abstraction and idealisation in voice, its materiality and uniqueness. My work is in dialogue with these efforts but, at the same time, I do not wish to establish a polar opposition between visuality and vocality. The ways in which your writing exposes visibility as imbricated with in-visibility and hyper-visibility go to show that visibility is not a one-shape-fits-all concept (and practice). Vocality is similar; all voices partake in specific material conditions and are to different degrees disciplined (thinking of Foucault here), therefore vocality becomes generative or resistant to the extent it poses challenges to its naturalisation, challenges that may involve the invocation of its lack or excess (hypo-vocality and hyper-vocality, to borrow from your terms). Instead of establishing a clearcut polemic (voice against sight, ears against eyes) – although this is currently a useful ideological unpicking to pursue within voice studies – I take inspiration from a notion you briefly mention in your chapter, that of vulnerability. You intimate that making yourself visible makes you vulnerable. It seems to me that this is a shared concern in our writings: your visible walk and my forensically inclined listening of *The Events* help us rethink walking, visibility, gender, ethics, voice, listening, community. And I wish to ask: is there a way to make our concepts, our methodologies and our practices less natural, ripe for reinvention, vulnerable? Both visuality and vocality can help us achieve this goal, if activated towards the unpicking of hegemony.

NM: 3. The double movement between utilising tools and expertise while at the same time exposing their disadvantages and imperfections:

This seems to describe a productive paradox. The process of development of a method is simultaneously one of success and failure, I would say. Voice identification processes are, as you claim, a means of arriving at a verdict but also, and perhaps more interestingly to me, a process of knowledge production,

facilitating the development of epistemologies and applications. To quote, 'the voice identification expert undertakes the double task of utilising current tools and expertise while exposing their disadvantages and imperfections.' In other words, the 'exposure of disadvantages and imperfections' (or failures, to use another word) seems to be the driving force of development of new insights. In this sense, the logic is somewhat reversed if we think that what is often deemed as failure is, in this case, utilised as valuable tool to gather new information and knowledge. This seems to be the crux of your proposed 'active aesthetic,' if I understand correctly, where, I quote, 'the doing of a voice practitioner may not exclusively be the aesthetic of performance of voicing but also *the act of generating vocal knowledge in the process of listening to voice* as a trained voicer/expert.'

KT: I think your reading touches on the core of my concerns. A methodology is not *there* to be used; it is a situated becoming and part of the process can be the shared-ness of its making—which is where the potentiality of failure acquires significance. I hesitated to use the term in the above extract, precisely because it would come with a particular history in the context of this discussion. Forensic linguistics is also a relatively new discipline and attributing failure to its methodologies would seem to be picking sides in a debate amongst its proponents and critics that I cannot feasibly justify. Extrapolating the notion that a listener expert is not a given someone but someone that in the process of practising their expertise needs to prove their status as experts had, for me, a certain liberatory power when thinking through voice in performance contexts. I sense a similarity with what you propose when writing: 'If parades, protests and processions are political performatives, the walk is itself an utterance. In other words, it is saying something by dint of doing something.' The type of walking you practise is a performance but is also a methodology of thinking through that performance and performativity in general. You walk and you practise knowledges of/about walking and, at the same time, the very act of walking re-examines walking as a practice – this is the type of vulnerability of practices to which I just alluded and which is closely linked to the resistance to erasure and the call to inclusivity of the first part of our discussion.

NM: And lastly, 4. The dynamic of audience participation you describe in your experience of *The Events:*

You describe a break of the fourth wall when Claire addresses the audience to encourage them to join in with the choral singing. I also break the fourth wall in my performance, *The Sissy's Progress.* In fact, I begin my chapter with a description of how and why I do this. You explain this moment as creating a 'sense of community within the microcosm of the performance venue'. This is a powerful statement. It describes very clearly what I myself was trying to build inside the theatre during the first half of my performance: a sense of community within the microcosm of the performance venue. My intention was to create communal bonds between audience members so that they would feel safe enough to go outside, onto the streets, into the macrocosm of public space, for the second half of the performance. You follow your considerations on page 230

with a series of questions, the first of which struck a chord with me. You ask: 'what does this moment of singing together, in which audiences might participate, signal?' I was tempted, of course, to draw connections with my own chapter and with my own practice. My desire when inviting the audience to walk with me outside was to make them witnesses of the violence to which queer subjects are exposed on a daily basis. An attempt on my part perhaps to draw awareness to an issue that has touched me on such a personal level. Perhaps even a desire to bring them with me as if to attest, through performance, that I am not alone or, to use the lyrics of a song you have quoted, a statement that says 'We're all in here' (or *out* here, in my case). Perhaps like Claire, I too, was offering an invitation to the audience to 'rethink community' while sharing her central forensic question 'who was the perpetrator?'

KT: These are powerful thoughts. If you do not mind, I wish to build on the parallels you draw between yourself (or your emergent, in-performance self) and Claire. Because you both bring our attention to violence. I have not attended your performance and I cannot know to what degree the participating audience was made aware of the autobiographical background of the piece. However, in your writing, the actualised physical abuse and the verbal abuses thrown at you throw up resonant question marks. 'Who is the perpetrator?' In the logic of vocal in-between-ness and vocal implication I outlined earlier, the 'community' of audiences and bystanders is not that distanced from the 'actual' perpetrators as we may wish to imagine. Because when I am in the presence of verbal abuse, I always have the option to align myself with the abused and act accordingly. The significance of these questions in your performance, I think, has much to do with the exposure of identity-making, the fissures and layers you perform and embody in the piece. This is what my chapter aims to do. If we look at the Boy and the Choir as easily separated, it is simple to align ourselves with the Choir/community of victims and know that the Boy is the criminal. But if we follow the listening-in I propose, according to which the Choir is also the Boy, *The Events* exposes the making of such alignments.

In a similar way, and correct me if I am wrong, the co-presence of the abuser and the abused in *The Sissy's Progress* exposes the way we enact our political alignments. As your ideas on visibility, hyper-visibility and precarity suggest, do I, as your audience, (choose to) think that you brought this upon yourself because you are excessively visible (and silent) or do I take cue from your visibility (and silence) to hear the politics of hate? And what do I *do* with the verbal abuse? (Since you are drawing on Butler, I am reminded of her writing on hate speech and the potential it affords when re-appropriated.) I also think of what we could mean when referring to communities in both our case studies. In what conditions can the dead multi-cultural choir, its embodiment by a local choir and the audience be seen as 'a' community in the instance of *The Events*? Are you and your audiences 'a' community, if the abuse is only addressed to you? What if the Boy, in my listening-in of the performance, is not the Other to the community? What if the abuser in your case is, for example, non-visibly

genderqueer? Which are the communities that emerge during the microcosm of the performance (as a spatio-temporal event)? Can we 'perpetrate community' without 'perpetrating difference'?

INDEX

Taylor & Francis eBooks

Helping you to choose the right eBooks for your Library

Add Routledge titles to your library's digital collection today. Taylor and Francis ebooks contains over 50,000 titles in the Humanities, Social Sciences, Behavioural Sciences, Built Environment and Law.

Choose from a range of subject packages or create your own!

Benefits for you

>> Free MARC records
>> COUNTER-compliant usage statistics
>> Flexible purchase and pricing options
>> All titles DRM-free.

REQUEST YOUR **FREE** INSTITUTIONAL TRIAL TODAY

Free Trials Available
We offer free trials to qualifying academic, corporate and government customers.

Benefits for your user

>> Off-site, anytime access via Athens or referring URL
>> Print or copy pages or chapters
>> Full content search
>> Bookmark, highlight and annotate text
>> Access to thousands of pages of quality research at the click of a button.

eCollections – Choose from over 30 subject eCollections, including:

Archaeology	Language Learning
Architecture	Law
Asian Studies	Literature
Business & Management	Media & Communication
Classical Studies	Middle East Studies
Construction	Music
Creative & Media Arts	Philosophy
Criminology & Criminal Justice	Planning
Economics	Politics
Education	Psychology & Mental Health
Energy	Religion
Engineering	Security
English Language & Linguistics	Social Work
Environment & Sustainability	Sociology
Geography	Sport
Health Studies	Theatre & Performance
History	Tourism, Hospitality & Events

For more information, pricing enquiries or to order a free trial, please contact your local sales team:
www.tandfebooks.com/page/sales

Routledge
Taylor & Francis Group

The home of
Routledge books

www.tandfebooks.com